Visual culture in Spain and Mexico

Anny Brooksbank Jones

MANCHESTER UNIVERSITY PRESS

ANCHESTER AND NEW YORK • distributed exclusively in the USA by Palgrave

The right of Anny Brooksbank Jones to be identified as the author of this work has been asserted by her in accordance with the Copyright, Designs and Patents Act 1988.

Published by Manchester University Press
Oxford Road, Manchester M13 9NR, UK
and Room 400, 175 Fifth Avenue, New York, NY 10010, USA
www.manchesteruniversitypress.co.uk

Distributed in the United States exclusively by
Palgrave Macmillan, 175 Fifth Avenue,
New York, NY 10010, USA

Distributed in Canada exclusively by
UBC Press, University of British Columbia, 2029 West Mall,
Vancouver, BC, Canada V6T 1Z2

British Library Cataloguing-in-Publication Data is available

Library of Congress Cataloging-in-Publication Data is available

ISBN 978 0 7190 5679 6 paperback

First published by Manchester University Press in hardback 2007

This paperback edition first published 2011

The publisher has no responsibility for the persistence or accuracy of URLs for any external or third-party internet websites referred to in this book, and does not guarantee that any content on such websites is, or will remain, accurate or appropriate.

Printed by Lightning Source

Contents

List of illustrations vi
Acknowledgements vii

Introduction 1

Part I Mexico

1 After-image of the global city 15
2 Urban imaginaries 38
3 A scandalous family album 62

Part II Spain

4 Words from other worlds: the Guggenheim Museum, Bilbao 85
5 Countdown: figuring risk and the Real 115
6 Symbolizing Gernika 145

Conclusion 184

Bibliography 188
Index 207

List of illustrations

1 'Street circus at traffic lights, Mexico City' (Julio Etchart) 17
2 'Cuidacoches' (Nacho López, from the series *México de Noche*) © 382519. SINAFO-Fototeca Nacional 23
3 'Trolebús' (Nacho López, from the series *México de Noche*) © 382524. SINAFO-Fototeca Nacional 55
4 'Harem' (Daniela Rossell, from the series *Ricas y famosas*) 76
5 Guggenheim Museum, Bilbao (side view) (Ken Brodigan) 101
6 Guggenheim Museum, Bilbao (rear view) (Ken Brodigan) 106
7 Antonio sees Charo entering the underground car-park. Still image, *Días contados* (Imanol Uribe/ Aiete-Ariane Films) 138
8 Antonio follows Charo into the underground car-park. Still image, *Días contados* (Imanol Uribe/ Aiete-Ariane Films) 140
9 Gernika oak, August 2005 (Ken Brodigan) 151
10 Old Gernika oak, August 2005 (Ken Brodigan) 152
11 'Atocha', *Independent*, March 2004 (Dave Brown) 175

Acknowledgements

This study would have been quite different without the support of a long list of individuals and institutions. It was completed with a Research Leave Award from the Arts and Humanities Research Council, and benefitted from funding from the Fundación Cañada Blanch and a period of study leave from the University of Sheffield. Illustrations appear with kind permission of: Julio Etchart; the Fototeca Nacional, Mexico; Daniela Rossell; Imanol Uribe; Dave Brown; Robin Reyn of EthicalArts; and Ken Brodigan. Special thanks are due to Dr John England, of the University of Sheffield's Department of Hispanic Studies, for first bringing the work of Daniela Rossell to my attention. The task of assembling these images has been greatly eased by: Ben Carlson of Greene Naftali Gallery, New York; Lic. Rosa Casanova García, Juan Carlos Valdez Marín and Sonia del Ángel of the Fototeca Nacional, Mexico; and Yolanda Mulero and Andrés Santana of Aiete/ Ariane Films, Madrid. Kathleen P. O'Malley of the Hood Museum of Art, Dartmouth College also gave generously of her time. While any errors are entirely my own, the book would have been quite different without the help and advice of: Ana Alberdi and Jon Arginpxona of the Casa de Juntas, Gernika; J. Frederick Janka of Nina Menocal Gallery, Mexico City; Ignacio Durán Loera, Minister for Cultural Affairs at the Embassy of Mexico, London; Cecilia López of the *Revista de Estudios Visuales*, Murcia; Mark Millington and Paul Julian Smith, with warm thanks for their support in the project's early stages; Andrea Noble and Erica Segre, who supplied valuable material and suggestions; and, once again, my editors at Manchester University Press. Each time the frustrations of the project began to seem insurmountable Carol Borrill's 'reality checks' cut them down to size. The end result is dedicated to Ken Brodigan, who was for a time the still point at the heart of all this activity.

Introduction

This volume is about visual culture in an era of globalization and risk. It is framed by two recent exhibitions in Madrid. The first, Arco 2004, saw the inaugural Congreso Internacional de Estudios Visuales, while Arco 2005 marked a key moment in the globalization of Mexican art and in broader debates around the international art market. The first took place in the weeks preceding the Madrid bombings, the second was itself the target of an attack, and I am writing about them in the week of the London bombings.

Events in London are too raw to serve as examples of anything else, but they highlight the extent to which such attacks have become a paradigmatic form of risk in the late modern era. Although medical and environmental risks, and anxieties associated with lifestyles, work and finances are closer to the lives of most of us, terrorism is widely perceived as more global than most other forms, potentially more lethal, and threatening whole communities anonymously from within and without. Partly for this reason, it has become the focus for a more generalized sense of insecurity and ambivalence in a time characterized by rapid change. These insecurities arise partly from a perception that traditions, norms and old certainties are losing their power to structure our lives in late modernity. This is linked to the diminishing faith in certain abstract social relations: the loss of support for traditional party politics, for example, as power comes to seem increasingly dispersed within globalizing structures, or the sense that the we can no longer confidently rely on expert systems when scientific opinion on so many key questions differs, or when hospitals charged with securing our health are themselves becoming an important source of new illnesses (Giddens 1991). In this context we are increasingly called on to make choices based on our own individual interpretations of what we take as evidence, and to do so

increasingly without the support – practical, intellectual, or emotional – of traditional family networks and life-partners (Beck and Beck-Gernsheim 2002). Because we are called on to *act* on the basis of these calculations, with all their rational and non-rational, biographical and other components, this has consequences. Since we assume risks can be managed through human intervention we associate them with choice, and for some this can be a source of excitement – in the form of extreme sport, for example – and enhanced autonomy as much as anxiety. But we also associate risk with the wrong choice, responsibility and blame. A medical image of a foetus in the womb, for example, may enable us to calculate and confront risks to the as-yet unborn, but it increasingly also *obliges* us to do so: that is, to assess complex multicausal explanations and to act on the basis of that assessment in ways that may change our lives and, over the long-term, the society in which we live (Beck 1992). These changes rarely lead to the wholesale transformation of traditional practices, however; more often they result in continuities and novel discontinuities, with willed or unintended consequences. In particular, they are making the already fuzzy boundary between public and private more permeable still, as the question of risk becomes a core aspect of government policy-making, of institutional as well as individual well-being. But continuing debates around the safety of the combined Measles, Mumps and Rubella vaccine, for example, demonstrate that government policy cannot relieve us of individual responsibility in such cases if it does not allay our fears.

There is one vital aspect of individual and social well-being that resonates in the essays in this volume: it is how we deal 'psychologically with risks that would otherwise paralyse action or lead to feelings of engulfment, dread and anxiety' (Lupton 1999: 78). Deborah Lupton outlines three possible responses. Especially within more traditional groups, she suggests, individuals may simply avoid the need for decision-making by pragmatically accepting that fate will take its course. Alternatively, they may adopt a resolutely optimistic, pessimistic, or (as in the case of new social movements) contestatory response to perceived risks. Or they may choose to place their trust, however provisionally, in an institution or an individual: in an insurance company, for example, or a guru. In such cases there may nevertheless be what Tony Giddens calls 'fateful moments' when these supports seem to let us down, when the protective shield is breached and our existential and moral assumptions are challenged (Giddens 1991: 40). In practice, individuals tend to move between these three responses according to context, and may well engage simultaneously in more than one, however contradictory the results. Where rational calculation is involved in a response to risk it tends to interact

with (and is not always prioritized above) personal preferences, bodily dispositions, habits of mind, intuition, wider cultural assumptions, or biographical factors. Non-rational elements like these cannot be dismissed as markers of gullibility, however: as discussed in Chapter 6, they reflect a sense that rational calculation does not serve in all socio-cultural contexts and, to that extent, they could be said to observe a higher rationality.

The essays in this volume explore the visual articulation of risk. They examine how certain producers and users of visual culture – photographers, film-makers, artists, architects, entrepreneurs, historians, politicians and cultural anthropologists – mediate risk in late modernity: how they work to conjure, (melo)dramatize or displace risk that may never be subjectively experienced in unmediated form, how they sequester or substantialize it, how they frame half-perceived risks, invest them with meanings, render them in more practically- or psychically-manageable forms.[1] It will be assumed that the motives behind the choice of therapeutic, consolatory, or alarmist representations are not always accessible to the cultural mediators themselves, and still less often to academic enquirers. Any conclusions tentatively drawn on this point will therefore be derived from a detailed, situated analysis of the visual object itself.

The model of risk deployed in this volume is weakly constructionist: it assumes that some risks are more concrete and others more speculative or symbolic. More concrete risks include the near-certain fatalities associated with a major nuclear accident, for example, or the high incidence of tobacco-related cancers: these I take to be real, if culturally-mediated, hazards. More speculative examples include anxieties which may have little or no factual basis but are perceived and projected onto the future as risks, often in response to claims amplified in the public sphere via the media. As I suggest in Chapter 5, the end of the last century saw a significant increase in these, from imminent asteroid collisions to the global chaos of the millennium bug. Because risk, by its nature, exists only as a calculation, however, the distinction between these two categories is highly tentative.

The volume's second focus is globalization, often as the background to risk. In general use, the two tend to be elided in references to properly global risks: climate change, for example; the globalization of once-localized risks such as threats to the state or virulent diseases that migrate with travellers from their point of origin; or the risks of globalization itself. Although the second of these is touched on, I am concerned here chiefly with the third. Like risk, the notion of globalization arouses excitement in some, scepticism in others, and anxiety of varying intensity in the majority. These differing responses partly reflect the fact that

there is no unitary definition of globalization; instead, this slippery notion tends to be evoked in partial narratives or metaphors. My own analysis starts from the assumption that while the international era can be traced back to pre-Christian traders and medieval pilgrimages, it did not develop significantly until the early phases of colonial expansion around 500 years ago; that the transnational era arose in the early twentieth century, with the development of organizations whose centres were not based (or not based principally) in a single country; and that globalization arose from the increasingly intense and complex interrelations and interdependence of centres of production, circulation and consumption to become 'un poder diseminado' or disseminated power that operates through institutional structures, organizations of all sizes, and material and symbolic markets (García Canclini 1999: 11). The complexity of these interrelations, their scope and their implications is a key factor in the uncertainty surrounding globalization, and shapes the way in which it is imagined. For heads of transnational companies, García Canclini argues, it refers chiefly to the countries in which their organizations operate, the nature of their activities and those of competitors; for Latin American governments who deal primarily with the US it is effectively a synonym of 'Americanization'; for members of the Mercosur trading bloc it designates relations between Europe and Latin America's southern cone; for Latin American families with relatives in the North it tends to refer to their interrelations with the part of the US in which the relatives live; and for Latin American stars such as Carlos Vives or Salma Hayek it refers to the US market-place in which they find new audiences. Globalization, Alberto Moreiras reminds us, is 'not yet accomplished' and only a small number of politicians, financiers and academics believe otherwise (2001: 37). But while 'muchos globalizadores andan por el mundo fingiendo la globalización' (many globalizers travel the world feigning globalization) even the poorest and most marginal groups live with its material effects (García Canclini 1999: 12).

The essays in this volume highlight the material consequences of globalization. But they focus chiefly on how globalization is imagined – and, above all, visualized – in order to understand something of the complexity of globalizing processes and their cultural mediation. This complexity, and the speed, scope and intensity of its embedding, underlies the extremes of euphoria and anxiety that resonate in some responses to globalization. While certain core aspects are informed by an explicit agenda, however, I assume here that globalizing processes as a whole are contradictory, ethically indifferent, and generate potentially positive as well as negative energies. Their contradictions are clearest in Chapters 4 and 2 of this volume. The first discusses how Basque politicians have

drawn on global cultural capital to displace anxieties around regionalist tension and economic decline; the second, how Mexican artists have grasped global opportunities when looking for alternatives to a national project that has lost its force. In the first case, the globalization of art markets and cultural tourism encouraged an international entrepreneur to negotiate with regional bodies over the heads of their central government; in the second, it has actively contributed to the 'vaciamiento simbólico' or symbolic hollowing out of the national project which it was then called on to replace (García Canclini 1999: 21). In neither case does globalization homogenize differences in any simple sense; indeed, where violent inequalities exist it tends actively to exacerbate them. In these two examples it capitalizes on cultural heterogeneity, reproducing and decontextualizing it in institutionalized forms of 'abjected difference' (Moreiras 2001: 37). And when the novelty or exoticism wanes the caravan, with its restless deterritorialized energies, moves on. This does not mean that largely positive visions of a global public sphere are not projected and promoted, as in the recent Live8 concerts; but it does suggest that actually existing conditions are unable to guarantee them (Castells 1997b, Buck-Morss 2005: 146). Globalization, in short, is not the only form of social order and it is widely assumed to be more coherent and comprehensive than, in reality, it is. But the efforts of García Canclini, Moreiras and others to think outside it underline just how difficult it is to imagine, much less construct, compelling alternatives.

Now, the use of visual cultural forms to explore the possibility of alternatives is complicated by the fact that visuality in general, and the image in particular, has been widely portrayed as complicitous with globalization. This is true especially (though not only) within Art History, the discipline that has until recently determined which visual cultural forms are legitimate objects of analysis and in what terms. In a memorably combative special issue of the journal *October 77* (Summer 1996) some of the most influential Anglo-Saxon writers on visual and cultural-theoretical topics were asked by guest editors Rosalind Krauss and Hal Foster to respond to a questionnaire concerning the emerging field of visual culture.[2] Most relevant here is its proposition that visual (cultural) studies is reducing visuality to the phantasmatically 'disembodied image', independent of its medium, and in the process 'helping, in its own modest, academic way, to produce subjects for the next stage of globalized capital' (Krauss and Foster 1996: 5, 5). The object of the editors' critique is primarily the very particular understanding of visual culture celebrated in self-styled 'postmodern' visual cultural studies. For one of its best-known advocates, Nicolas Mirzoeff, 'the unceasing flow of images' is the defining quality of 'disjunctive and fragmented' life

within globalization (1998: 3–6). Mirzoeff rightly underlines a tendency towards increased secularization, technologization and fragmentation in culture. But he fails to note that, like the faster and wider circulation of certain types of image, this co-exists with earlier or contradictory tendencies: the search for new values, for example, the rise of new forms and understandings of religion, of slow culture, of the regional and the local.[3] In a more nuanced account from a Latin American perspective, Jesús Martín-Barbero locates debates around the 'end of art' amid 'the contradictions of a modernity heavily laden with premodern elements, but which becomes the collective experience of the many thanks to social and perceptual dislocations of a clearly post- or late-modern stamp' (2000: 71). These dislocations, he argues, are undermining categories established by modernity over more than a century, making them 'incapable of accounting today for the ambiguous and complex movement which dynamizes the cultural field' (71). While Martín-Barbero is highly critical of the market's role in this dynamizing movement he acknowledges that these processes may represent a source of new opportunities for critics and artists of the periphery. But for the guardians of disciplines such as Art History which were founded on those categories the risks are clear.

Krauss and Foster have every reason to be anxious, for the risk they are trying to conjure away does not come only from external institutional and economic factors. As Martin Jay notes, 'the pressure to dissolve art history into visual culture has been as much internal as external, arising from changes within "art" itself and not merely resulting from the importation of cultural models from other disciplines' (1996: 44). The paintings of Miró, Gunther Gerszo or Francesca Llopis, for example, cannot be assessed unproblematically in the same terms as each other, as the neo-conceptual art of Teresa Margolles or Eduardo Abaroa, or as video work by Claudia Fernández or Silvia Gruner. New art forms and new visual media are confounding established aesthetic categories and may, in this sense, be ahead of art's philosophical underpinnings. This tendency, which Benjamin registered in the 1930s, is notable today chiefly for the accelerating pace of change. Assessing and attributing value to art has never been simply a function of academic and philosophical traditions. The difficulty of assessing it today is due partly to the fact that it is increasingly a function of economic exchange, driven by a relatively small network of museum directors, influential gallery owners, entrepreneurs and patrons within a global market-place. Art is debated in the wider public sphere chiefly when these evaluations – expressed in price-tags, exhibition contents, and novel perspectives on the private lives of artists – clash with public expectations as articulated in, and at least partly

defined by, the media. The combined effect, as *October 77*'s contributors assert, 'may well mean the end of art' or, more accurately, 'the liquidation of art as we have known it' (Buck-Morss 1996: 29, Kolbowski 1996: 48).

The questionnaire circulated by Krauss and Foster is, in part, an attempt to shore up their discipline against these processes by undermining what they see as the greatest single threat to it. The rise of interdisciplinary visual (cultural) studies, they insist, is being promoted within a context of institutional rationalization, intellectual and epistemological convergence, staff cuts, a drive to spice up tired disciplines at a time of declining student recruitment, and pressure on publishing industries to maximize profitability. What is more, this Trojan horse for globalization developed around forms of visuality that Art History traditionally excluded, and is now moving into its territory. It is from this perspective that Krauss and Foster dismiss what they term 'visual culture' as 'a partial description of a social world mediated by commodity images and visual technologies' in which the 'disembodied image', stripped triumphantly by technological rationality of its sensuous particularity within a secular and instrumental field, becomes more important than the art object with which it is progressively conflated (1996: 3, 3, Armstrong 1996: 27). Some of these charges recall the ones levelled against cultural studies in its expansionary phase from within literature departments (Kirkpatrick 1997, Moreiras 2001). If they are not wholly baseless here it is partly because they are levelled explicitly at the highly tendentious 'cyberspace model of visual studies' advanced by Mirzoeff (1998: 27). Yet a glance through the visual culture anthologies published over the last decade reveals just how atypical that model is.[4]

When the inaugural issue of the *Journal of Visual Culture* in 2002 attempted to define its object, the only point on which contributors agreed was that visual culture is neither a synonym for visual cultural studies nor restricted to global advertising imagery. In Mark Poster's polemical presentation, for example, it figures simply as 'media studies'; for James Elkins it is 'predominantly about film, photography, advertising, video and the internet. It is primarily not about painting, sculpture or architecture, and it is rarely about any media before 1950 except early film and photography' (Elkins 2002: 94, Poster 2002: 67). Both definitions exclude all or most of the chapters in this volume. Closest to my position is Martin Jay, who registers the term's extension to 'all manifestations of optical experience, all variants of visual practice', while acknowledging that not all of them repay detailed analysis (2002: 87). Jay's position, like my own, is positively undisciplined, in the sense that its focus is the opening up of a new field rather than the setting or policing of territorial boundaries.

The chapters that follow reserve no special priority or censure for the image as squandered in globalization. Where they do discuss it, however, it is as one element in a larger 'system that fabricates and frames images, that substitutes them, that speeds up their circulation and enhances their productivity' (Hopenhayn 2000: 148). To assign all responsibility for this process to the visual material itself is to conspire in a new 'denigration of vision' – and one that, from Krauss and Foster's point of view, ejects the art historical baby with the bathwater (Jay 1993, Moxey 2005). Images may be invested with meanings that, by virtue of their openness or the speed with which they are circulated, may be interpreted without intellectual mediation; they may be used to render information as spectacle and as more emotionally engaging; and they may be routinely recontextualized or domesticated for this purpose (Sarlo 1995, Boyne 2003).[5] But this rhetorical power and epistemological elasticity – what Buck-Morss rather tendentiously calls the 'carácter evasivo' or evasive character – of the image are not of themselves risk factors (2005: 145). Where this particular use of visual cultural material is concerned, the proper object of critique is its mobilization in globalizing and other contexts. It cannot simply be damned by association with them and ignored, any more than critics can afford to ignore globalization itself. Images 'representan e instituyen lo social' (represent and institute the social) and to work in the world, as Zygmunt Bauman recalls, we need to know and understand how the world works (García Canclini 1999: 62, author's emphasis, Bauman 2000: 212).[6] If bland media imagery risks impoverishing our imaginary repertoire then it becomes still more important that our visual horizons are widened rather than narrowed, that we engage with a wide range of visual material, that our analysis of them is richer and does not neglect their broader sensual, material, and cognitive dimensions and their denser contexts, along with the historical, mnemonic and other complexities these imply.

To facilitate this thicker description, the first three of the chapters in this volume centre on instances of visual culture from Mexico (specifically Mexico City) while the second three relate to Spain and, in particular, the Basque Country. Mexico City is represented here chiefly in photographs: of two young boys, commuters, and the homes of Mexican millionaires. Spain figures in a much-prized film and in two of the Basque Country's most globally-replicated symbols, Picasso's 'Guernica' and Gehry's Guggenheim Museum in Bilbao. This combination produces some marked contrasts and some striking commonalities. Chapters 1, 2, and 5 examine anxieties around urban disorder and insecurity; Chapter 2 also touches on the ambivalence that expert knowledge has created and cannot resolve; Chapters 3 and 6 look at the construction, reconfiguring

and displacement of narratives of the past; and Chapters 3 and 4 explore the implications of consumer culture for individual, regional and national identifications.

In some cases, I was first drawn to the object of analysis for its visual qualities; in others, for its wider resonances. In every case I have worked to ensure that formal and other specific qualities are not subordinated to generic or thematic concerns. The questions raised here are not always the ones envisaged: I began with a desire to avoid debates around identity and nation, for example, which seemed to me rather stale and predictable. Yet it soon became clear that globalization depends, at least for the moment, on the nation state, that identity and nation are key focuses of perceived risk, and that many commentators and practitioners continue to place them at the centre of their work. The analyses draw critically on a range of disciplines and foreground local source material, while acknowledging that it is never *only* local. This gives a slightly different character to each chapter; because scholarly studies of recent Mexican art and photography are relatively limited, for example, so too is the range of sources cited. In some chapters the focus is more squarely on globalization, in others it falls on risk. I have opted, as a matter of principle, to foreground these differences rather than try to conjure them away. Time, perceptions of time, and the articulation of past, present, and future, modernity and the premodern, are central to many of these arguments. In general, history is understood here as narratives constructed from messy detail around intractable, falsifiable points: the bombardment of a township, an earthquake, the death of a General. Those watching the news emerge after the London bombings of July 2005 witnessed bare facts being marshalled into narratives by representatives of the security and emergency services and the news media. Such processes are anything but an interpretive free-for-all: depending on the political and other assumptions on which our judgements rest some narratives will strike us as much more plausible and more powerfully explanatory than others – as was seen in the Spanish public's angry response to official representations of the Madrid attacks in March 2004.

This volume is animated by the belief that processes like these inform, and are informed by, social imaginaries. By 'imaginaries', I mean the shared (though, as my examples illustrate, not uncontested) understandings through which we make sense of what we see, and through which specific forms of visuality, sociality and (inter)subjectivity are legitimized, naturalized, or challenged. In this sense, while the volume maintains a steady scepticism towards the more inflated politico-institutional claims of cultural studies, it does not assume that cultural analysis is simply

words and word-play. As I argue in Chapter 6, we need to acknowledge the partiality of our perspectives on the past and the present responsibly and with care, de-sedimenting our own rhetoric and others' with their wider contexts and consequences in mind. In particular, much ink has been spilt demonstrating that certain widely-accepted narratives are less plausible and coherent than they seem; and rather less on narratives that are not wholly plausible yet may not be wholly wrong-headed – or dispensable. For, plausible or not, they may have their effects, interacting for good or ill with other elements to shape our understandings of the world and our place in it. Like narratives of identity, many people use them to guide their conduct, and some are ready to die for them.

The questions explored in this volume lie at the very heart of contemporary cultural, social and political life. As I write, Mexico is embarking on the most spectacularly visual, media-led, elections of its history, with all this implies for the continuing transformation of its public sphere. And in Spain a long and difficult political process is now under way, in and outside of Congress, that wrestles with old understandings of radical Basque nationalism in order to engage newer ones. The essays that follow offer fresh contexts for evaluating the visual dimension of these processes – while remaining alert to the fact that contexts, too, carry risks.

Notes

1 These processes are not confined to late modernity. In earlier periods of rapid social change – following the Mexican Revolution, for example, or during the Spanish Civil War – the individual and institutionally-sponsored responses of cultural producers to perceived risk were able to acquire wider public meanings. Today, however, the cultural mediation of risk includes a sense that risk has become more generalized yet also more individualized (Beck 1992).

2 A Spanish translation of the questionnaire and the responses to it has been published in *Estudios Visuales*, 1, November 2003, 82–125.

3 Mirzoeff's euphoria in the face of rapid technological and associated changes has striking precedents in the nineteenth century, suggesting that, while 'unique in detail', it is 'characteristically modern' rather than postmodern in character (Marvin 1988:4).

4 Recent examples include: Jenks (1995b), Walker and Chaplin (1997), Evans and Hall (1999), Sturken and Cartwright (2001), Fuery and Fuery (2003), Howells (2003) and Brea (2005). Berger (1972) is an early but highly influential forerunner.

5 For an illustration of this process see my case-study of the televisual representation of environmental issues in Spain, '(Un)covering the environment: some Spanish perspectives' (Brooksbank Jones 1998).

6 Walker and Chaplin (1997), Mirzoeff (1998), Evans and Hall (1999), Sturken and Cartwright (2001) and Howells (2003) all assert with varying degrees of

explicitness that the purpose of their introductions is to give readers new to the field the critical tools to read visual culture, to 'gain a better understanding of how visual media help us to make sense of our society', on the grounds that without the ability 'to read visual culture, we are at the mercy of those who write it [sic] on our behalf' (Sturken and Cartwright 2001: 3, Howells 2003: 4).

Part I

Mexico

1

After-image of the global city

In this first of three chapters centring on Mexico City, the risks of globalization and the risks to it are examined not in relation to the hackers or identity thieves who seek to exploit it, but to the photographic image. The visions of globalization contrasted here derive from transnational business, a cosmopolitan Catalan academic, and a nomadic Uruguayan photographer. This combination reflects the fact that globalization is driven predominantly by economic priorities with consequences that condition cultural imaginaries and have material cultural effects. For if 'capitalist development does not necessarily lead to the material impoverishment of the population – as many believed, and some still do', its global forms are nevertheless exacerbating existing inequalities and 'open[ing] up new spaces for spiritual and cultural impoverishment' (Bartra 2002: 231). This is highlighted in research into the early impact of the North American Free Trade Area (NAFTA) agreement, an example of the supranational integration with which many Latin American governments are responding to globalizing forces (García Canclini 1996c).[1] One way of approaching images, their manipulation and study is as responses to these processes. Like supranational trade and cultural agreements, however, they are also helping to shape them, and new knowledge about them. For this reason, critical academics need to explore the potential of images to reorient globalizing energies as part of a wider strategy of imagining alternatives to them.

This is the declared aim of Susan Buck-Morss, an authority on Frankfurt School critical theory. Like Krauss and Foster (to whose special issue of *October* 77 she contributed), she views 'graphic density' as a defining feature of globalizing culture (Riego 2003: 56). More than this, she takes photographs to be its paradigmatic form, its 'imagen-superficie' or image-surface (Buck-Morss 2005: 159). Her argument is not without

its blind-spots. She contends, for example, that whereas art is made or produced, the photograph is simply captured or taken, and is less a product of human activity than a material trace of pre-existing forms. This claim radically underplays the role of the photographer and technology (especially digital technology) in making photographs (Evans 1999, Wells 2000, Fontcuberta 2003a). It enables her to represent photographs as defective copies of reality, as distorting scale, traducing texture and luminosity and neutralizing depth, as image-floozies that circulate promiscuously without revealing their origins or credentials. To the extent that contextual information fixes meaning, she argues, its absence shifts attention away from interpretation towards the image as *event* – an event particularly well-suited to movements of global circulation and exchange. Her focus leads Buck-Morss to ignore the fact that photographs are as likely to have their meanings stabilized and regulated in family albums and other archives as they are to circulate globally (Bourdieu 1990, Evans 1999). And in practice even the most globally iconic images rarely shake off all trace of the contexts in which they were produced, while the most disembedded, deterritorialized images are (at least provisionally) re-embedded and reterritorialized in new contexts.[2] But her conclusion is unarguable: the critical objective is not the recovery of what lies below its surface, but the need to enrich and extend the image, to give it definition and time; and in this process, she contends, a new culture emerges (Buck-Morss 2005: 159).

It is with this in mind that my analysis of Julio Etchart's 'Street circus at traffic lights, Mexico City' (Plate 1) presents some of the volume's key concerns.[3] It explores the figuring of risk in the megacity; it acknowledges links established in influential histories of the image between the rise of photography and the rise of capitalism, while problematizing the assumption that photographs, *by their very nature*, collude with global forms of capitalism; and it does this by embedding the image provisionally in Mexico's rich tradition of urban photography. The three chapters that make up this part of the study adopt a progressively narrower focus: the first considers the place of the capital and its residents in a certain global imaginary; the second looks at the capital's commuting multitudes; the third examines a singular family group. Taken together, they register the extent to which photography is 'ubiquitous technology' that, in different contexts, may be treated as a fine art practice, drawn on by a range of disciplines as a source of documentary truth, or routinely aligned with the more middlebrow 'world of leisure and individual self-fulfilment' (Kunard 2003:157). This chapter addresses the first two of these: it moves between the scene and life-world connoted and their technological and aesthetic mediation, between the image's formal

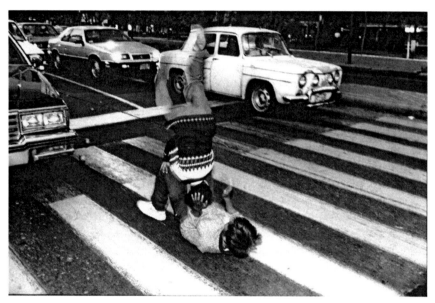

1 'Street circus at traffic lights, Mexico City' (Julio Etchart)

qualities and its documentary charge, and it probes the risks resonating in each.

Taken in the half-light of evening, Etchart's image is cut diagonally, from lower left to upper right, by the boundary line of a pedestrian crossing; and from upper left to lower right by a lane marking, crossing markings and the flow of traffic. In the far lane, a battered car precedes more modern ones. But all are stationary: because of the traffic lights conjured in the title; and because this is a photograph. The bodies of two boys are positioned on the crossing: one lies on his back, aligned with a crossing marker; the other is suspended at a right-angle to him, in mid-somersault. The blur of his legs at the intersection of the two diagonals suggests motion, inverting the conventional movement of legs on a pedestrian crossing, turning the urban world momentarily upside down. Behind this iconic tension lie others. For all these straight lines plot a circle, underlined in the image's title, that colludes with the circulation of the traffic it obstructs. The boys at its heart, meanwhile, form a parabolic figure: for the photograph sets up a very particular urban geometry that displaces the dizzying aerial views and thrusting verticals favoured by one tradition of city photography in favour of a single human vertical, produced when one young person fleetingly, acrobatically, supports another.

The association of the technology, aesthetic paradigms and subject matter of photography with cities can be traced back to the

mid-nineteenth century. Some of the world's earliest photographic images of the city were produced by members of expeditions and other travellers (Ryan 1997). But the most ambitious and systematic projects were undoubtedly the Victorian surveys designed to document urban change. One of the best known of these was undertaken in the second half of the nineteenth century by Thomas Annan, who was commissioned to produce photographic records of Glasgow's slums prior to their clearance. His picturesquely-deserted tenement blocks and court-yards offer a striking contrast with the brightly-lit, voyeuristically intrusive images of Danish-born Jacob Riis who exposed slum areas and lives previously inaccessible to his middle-class audience in the New York of the 1880s. This early social monitoring function overlaps with police, medical, ethnographic and other scientific (and unscientific) uses of the period: from the mid-nineteenth century, for example, photographs were used to chart and regulate the activities of Mexico City's prostitutes, prison inmates, homosexuals and 'vagrants' (Debroise 2001b: 41–7).

So, from its early years photography has been associated with colonization, with confronting and exposing the secrets and dangers of the city, and with charting, containing, dissipating or dramatizing social risk: gradually 'those mysterious and threatening city streets were being visually inspected and hauled into the light of day in much the same way as the wild places and strange peoples of the earth were being recorded by map-makers, artists, scientists and photographers' (Price 2000: 78). It might be argued that the contemporary residue of this impulse animates Etchart's image. But there is a complicity in his documentary practice – he met the two performers in the street, watched and talked to them before asking to photograph their acrobatics – that is alien to most early pseudo-scientific social monitoring. Not to all of it, however. In order to produce his photographic record of urban occupations, for example, Charles Nègre routinely stopped workers going about their business in mid-nineteenth-century Paris and sought their permission before photographing their activities.[4] While the capital's buildings are often present in these images, Nègre's emphasis remains squarely on its constitution through human labour. Walking the city streets he and other photographic pioneers began to establish a new spatial order and scale and new formal paradigms, transforming the ways in which the urban environment was seen and imagined. The more processual, street-level, city views they helped to inaugurate would be supplemented from the early 1900s with panoramic, and later aerial, perspectives connoting a starkly singular viewpoint, visual objectification, control and possession, with echoes of the earlier surveillance (Clarke 1997: 76).[5]

By the second half of the nineteenth century, observes Mexican photography's most cogent critic, its insertion into national culture 'was not only widespread, but profound' (Debroise 2001b: 20). The 'differing demands and priorities of the clientele and the multiple functions that the medium was made to serve in Mexican society' made portraiture the most popular form until the late 1870s, and the construction, recording and regulation of supposedly typical or deviant social types were aspects of this (26). A vogue for landscapes imbued with symbolic resonance would peak in the two decades that followed.[6] But the early years of the new century saw the consolidation of a documentary tradition that connects more directly with Etchart's image. One of its most enduringly influential figures, Agustín Victor Casasola, was official photographer of Porfirio Díaz until the dictator was driven into exile by the Revolution in 1911.[7] As this role suggests, Casasola was known less for the social critique that would later become routinely associated with documentary production than as a pioneering press photographer. His work appeared in newspapers such as *El Mundo Ilustrado* (the first to include photographs, from 1896), and *El Imparcial*. A few weeks before Díaz's exile, however, Casasola had set up Mexico's first news agency, Agencia Fotográfica Mexicana. This would become the basis of the photographic archive that bears his name and that of his sons. The Archivo Casasola, which comprises work by almost 500 photographers, was bought by the government in 1976 and today forms the core of the Fototeca del Instituto Nacional de Antroplogía e Historia (National Institute for Anthropology and History, or INAH). While it is best known as a uniquely rich source of images from the Revolution, Casasola's later work would include photographs of urban life, and especially work and leisure.

But it was from the 1930s, with the work of Manuel Álvarez Bravo and the (younger) French photographer Henri Cartier-Bresson, that photographic images of Mexico City found a wider international audience.[8] While it is unclear how much influence they exerted on each other, their inclusion in international histories of the form rests above all on the key role both played in the development of photography and photographic aesthetics by helping to wrench them from the pictorialist tradition – a tradition that had sought to elevate photography's status by assimilating it to painting. Theirs was a new, modern, and generally sharper focus. By the standards of the time, however, Álvarez Bravo was a notably oblique social commentator. Postrevolutionary Mexico City was dominated by an (albeit fitfully) Soviet-aligned left avant-garde presided over by the towering figure of Diego Rivera. Despite his declared membership of this group, Álvarez Bravo's work did not share the explicit political

commitment of the muralists and their circle, and he was never affiliated to any party (Hopkinson 2002). Although, or perhaps because, he insisted that 'in life everything has a social content' he produced very few images in a conventionally documentary style (cited Kismaric 1997: 26). In this sense, his subject matter was closer to the Frenchman's, although the two men did not meet until their styles were relatively mature and their approach to their subjects was strikingly different. In Cartier-Bresson's work the 'messy contingency' of urban life composed itself into an image that was 'both productive of visual information and aesthetically pleasing [. . .; a] formal flash of time when all the right elements were in place before the scene fell back into its quotidian disorder' (Price 2000: 98). These dislocated, decisive moments, described by critic Fernando Leal as 'assaulting life with a snap', suggest a quintessentially photographic conjunction of 'that which is known to exist but which escapes description, and that which can be described and is perceived through the senses' (cited Kismaric 1997: 30, Kunard 2003: 157). Technological factors played a key part in this. The possibility of photographing life on the capital's streets mid-flow, in all its fleeting contingency, would simply not have arisen without the invention in the inter-war years of the hand-held 35mm camera. While Álvarez Bravo also took advantage of the fact that action could now 'be interrupted and stilled' his approach was more deliberate than Cartier-Bresson's (Kismaric 1997: 24). This was partly because he was readier than the Frenchman to compose his urban scenes, with the complicity of his subjects, in order to produce the parabolic resonance he sought, using titles to heighten their ironies. But this deliberation was also linked to his use of a hand-held Graflex camera, once Tina Modotti's, which allowed greater textural range and detail in the printing but required more time between exposures than did Cartier-Bresson's Leica. It is tempting to see the blurring in Etchart's image as evoking something like a decisive moment, the freezing of the capital's contingency and vital flow in the deliberate monochrome interruption and stilling of an action. But parallels in structure, subject and treatment are clearer in Álvarez Bravo's 'Niño corriendo', from the 1950s, in which the slightly blurred figure of a small boy resting his bag on his head is caught in the base of a triangle formed by telegraph poles against the grainy, pitted surface of a wall. I shall argue that Etchart's two performers are not isolated and 'captured' in quite this way, however; they figure as the subjects rather than the objects of an image in which social documentary predominates over visual ironies or expressive functions.

Like Cartier-Bresson, Álvarez Bravo was helping in his idiosyncratic way to produce new forms of knowledge for new times. He had a keen

eye for the dislocation of rural traditions in urban settings: for emerging tensions between the seemingly eternal time evoked in crosses, candles and coffins, for example, and the advertising images of capitalist modernity. Bodies caught up in these tensions often appear dead, sleeping, or lost in another world; or they are flattened or abstracted in x-rays, diagrams, mannequins, or juxtaposed with inanimate objects that seem more life-like, or cut by veils and shadow.[9] By the 1950s Nacho López, renowned photojournalist and one-time student of Alvarez Bravo's, would himself be exploiting bizarre juxtapositions; but this time to document, and in the process ease, tensions associated with the large-scale integration of rural migrants into a new vision of Mexican modernity. Cartier-Bresson spoke of 'prowl[ing] the streets all day. Feeling very strung-up and ready to pounce, determined to "trap" life – to preserve life in the act of living' (cited Mraz 2003: 183). López's subjects, by contrast, took part in 'una representación preconcebida de sí mismos' (a preconceived representation of themselves) (Castellanos 1996: 50–1). For he had no qualms about intervening in the flow of urban life to reveal, or produce, the truths he wanted to document, sending *agents provocateurs* into the city streets, for example, and photographing the reactions of passers-by.[10] This underlines the greater autonomy of photojournalists when compared with the earlier generations of press photographers such as Casasola; for as well as the possibility of 'directing' scenes in this way López was allowed the time and space to envisage, plan, and construct a narrative using a sequence of images.[11] Although the roots of the photo-essay (as this narrative became known) go back to the 1930s it was the 1950s, with their increased literacy rates and a larger middle-class readership, that saw its popularity rocket.[12] Working for illustrated magazines such as *Hoy, Siempre, Mañana* and the scurrilously irreverent *Rotofoto*, López played an active role in inducting these new readers into the identity-building strategies of the modernizing state. Like Hector García (who had studied with him under Álvarez Bravo), López saw the role of photography as primarily documentary and testimonial and the most enduring work of both men is marked by Mexico's postrevolutionary social consciousness (Kismaric 2004).[13] If their work has aged more successfully than that of the preceding generation of photojournalists – Casasola's son Gustavo, for example, or the Hermanos Mayo – it is also partly because both in their different ways 'deliberately positioned themselves on the razor's edge between pure documentary and personal expression' (Debroise 2001b: 196).

This combination of testimonial, documentary and understated expressive components, the social consciousness, and the willingness to intervene to produce a revealing moment, all resonate in Etchart's 'Street

circus'. A comparison with López's 'Cuidacoches' (from his *México de Noche* series, taken around 1950) (Plate 2) underlines these parallels. It is an urban night scene in which the glare of the headlights on the road surface conspires with the image's grainy texture to mimic the markings of a pedestrian crossing. The diagonal calibration of space in Etchart's image is prefigured here in a stream of blurred cars passing behind the central figure, the eponymous guardian of the car. In sharper relief, but for the blurred cap of his uniform, he leans against the gleaming, perfectly-focused front bumper of his charge which dominates the lower left foreground. Yet 'Cuidacoches' resists being read as a simple indictment of social inequities or the dehumanizing effects of the social relations they presuppose: the spatial subordination of the attendant to the vehicle, like the uniform that works to reduce him to a role, are offset by the illustrated newspaper he is reading: it connotes a certain level of education, engagement with a wider life-world, a measure of mental autonomy or reserve that exceeds his uniform.[14] López's perspective derives, in part, from his schooling in the postrevolutionary culture of the 1920s and 1930s, a period when poorer Mexicans figured not as victims of abstract external or internal forces but as the makers of the Revolution and key actors in its solidary national project. With their affirmative vision of the city and its changes, his images encouraged citizens (particularly those recently arrived from the countryside) to participate imaginatively as well as physically in its construction. While the contexts and effects of their photographs are quite different, I shall argue that Etchart's work shares something of that affirmative impulse.

Although the names of López, García, Álvarez Bravo and Casasola figure as key reference points in most histories of Mexican photography, there are many others who might have been included here.[15] But traditions are produced as much by institutions and processes as by individuals. Álvarez Bravo's long career began in a context marked by the co-option of visual culture for the consolidation and institutionalization of the new, postrevolutionary, Mexico and the surrealist incursions of old Europe: López's was shaped by the radicalism of Lázaro Cárdenas's presidency but also by the surge of postwar growth that followed. From 1940, the revolutionary legacy, with its emphasis on progressive social projects, had begun to be displaced by a series of presidents more concerned with a renewal of the national industrialization process set in train before 1910. As noted, the 1940s and 1950s saw the rise of illustrated magazines and newspapers for the newly-educated masses who would build modern Mexico. Major cities were transformed in this period and López, García and other photojournalists played a central role in helping residents to visualize these changes and encouraging

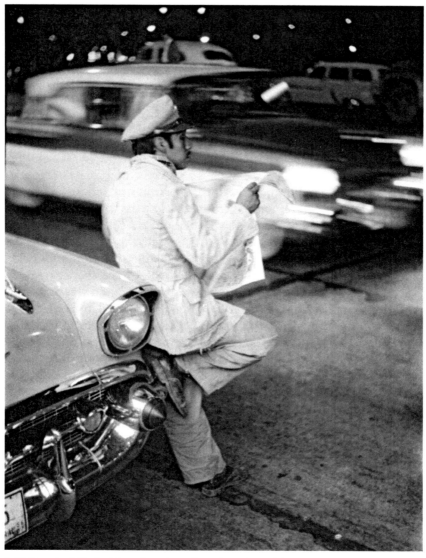

2 'Cuidacoches' (Nacho López, from the series *México de Noche*)

identification with the economic nationalism underpinning them.[16] These media became 'the new mirrors of collective identities' and photography served in the construction of mass culture through 'advertising, entertainment, news and civic education' (Morales 2000: 152). To this extent, Alfonso Morales observes, 'the path that led Mexico to a partial and somewhat superficial modernity was strewn with photographic

images' (2000: 152, 154). During the course of this modernization – which was non-consensual, riddled with corruption, and marked increasingly by worker and (in the late 1960s) student unrest – visual culture would become progressively disengaged from the state. In the decades that followed this would ease the imbrication of photographic images (and, as Chapter 2 notes, of art more generally) in globalizing processes.

In the late 1960s and 1970s, however, the left ideological commitment manifest in other aspects of cultural life in Mexico, and in Latin America more generally, found explicit expression in photography, which 'discovered or rediscovered its calling as a mode of protest' (Morales 2000: 154). The rapid and sustained expansion of industries closely identified with the state, under the monopoly party rule of the Partido Revolucionario Institucional (Institutional Revolutionary Party, or PRI), secured economic growth and stability into the early 1960s. As the decade progressed, however, a weak agricultural sector and rising middle-class living standards began to exacerbate the disparity between rich and poor, eroding earlier advances; urban migration was accelerating, with shanty towns springing up around the capital and other large cities; economic growth was faltering. Mexico was entering a period of 'stagnation, crisis and instability' (Hamnett 1999: 250). PRI sustained its hegemony with a combination of overtly brutal repression and its 'technocratic ability, at both national and regional levels, to negotiate and manage its rule through corruption [and] the fabrication of consent (the strategic satisfaction of needs)' (Kraniauskas, in Monsiváis 1997: x). By the mid-1970s, the developing sense of crisis was heightened by the installation of right-wing dictatorships in key nations across the region, and by the implication in this process of Mexico's northern neighbour. It was against this background that the region's first photographic colloquium was organized, in 1977, by Mexican photographer Pedro Meyer and critic and art historian Raquel Tibol. Participants in the First Exhibit of Latin American Photography broadly affirmed the primacy of larger social aims over formal qualities or technical proficiency, and underlined the 'overwhelming imperative to exhibit, make known and call to attention the raw realities of Latin America and, through photography, force a confrontation with European and North American experiences' (Debroise 2001b: 7). This denunciatory emphasis was reaffirmed in the second colloquium, held in Mexico three years later. Its vision of the poor as more or less passive sufferers of external and internal oppression was soon challenged, however, by the concerted reconstruction effort that followed the Mexico City earthquake of 1985. News images of solidary labour helped to displace the familiar

representations of victims mired in urban poverty in favour of more affirmative representations 'of a painful identity, combatively earned' (Monsiváis cited Debroise 2001b: 10). If this resonates with Etchart's 'Street circus', taken in the late 1980s, it is partly because of the persistence – and worsening – into the new millennium of embedded socio-economic inequalities that the Revolution was designed to resolve (Tello 1993, Meyer 2002).

This persistence is highlighted for most of the capital's visitors by the presence and activities of street children, the insistently visible subject of so much narrative and so many photographs. Etchart's performers are two of the reportedly hundreds of thousands of Latin American children who live and sleep on city streets or the millions more who eke out their living there and return to their homes at night (Green 1998). Evidence of their astute exploitation of the spaces and opportunities available to them – and a vivid antidote to victim-centred and idealized analyses of their lives – emerges from this account of a day in the life of two eleven-year-olds living on their wits in Cali, Colombia at the time 'Street circus' was photographed.

> They had made an arrangements with Pedro, a security guard, to spend the nights in a quiet corner of one of his buildings in exchange for bringing him cigarettes, food, and occasionally, liquor. Upon leaving 'home' they walked over to El Centro, where the early market was still open. On their way they stopped to watch a story-teller who, after talking about the mysteries of women in the Amazon, passed around his hat for money. By offering to do this for him they were able to earn a few pesos. Moving on, they stood very close to a fruit vendor, neither leaving nor asking for anything. They eventually were given a piece of pineapple, which they ate very quickly as they walked on. Seeing an old woman carrying a heavy box in the street, they offered to help her and in exchange she gave them a few more pesos.

> A few blocks later they stopped at the El Paradiso restaurant where they went each morning to exchange washing the front sidewalk with a hose (which they also used for washing themselves) for leftover food from the previous night. They went down a quiet side street and began separating the good from the chaff. They ate the few pieces of leftover meat, before throwing the bones as close to a tree as possible in a makeshift contest. Dessert was a conglomerate of sweets that was moulded together in an indiscriminate mass that they ate with their whole hands as they laughed loudly. They put the major part of the food, about two pounds of bread and yucca, back into the bag and took it a few blocks to where they knew a blind man begged. In exchange for their leftovers, they received a few pesos and a couple of cigarettes.

Walking past the movie house on their way to the bus-stop, they saw that a new Mexican cowboy movie was playing. They got on the bus and Roberto put on a pitiful expression and began to sing soulfully about the difficulties of having a sick mother whom he was trying to support. He got a few pesos. [. . .] Meanwhile, Antonio lodged himself in the exit well, standing in the way of exiting passengers, offering them his hand so that they might climb down more easily. Some passengers were indignant, but some found his scheme amusing and gave him a peso.[. . .]

In the early afternoon the boys headed back to the town centre and got off the bus when it became bogged down in congestion. They spotted a car with a single passenger and an open window. One of the older boys [who had joined them] pounded his fist on the passenger side of the car. The loud noise startled the woman driver and while her attention was distracted the other older boy slipped over on to the driver's side, reached into her car and grabbed her shopping bag. Then all four of them ran under a bridge, where they discovered that what they had stolen was only a few pieces of cloth. On their way to Bosconia (a street children's project) for the four o'clock afternoon lunch, they passed a street vendor and exchanged the material for a dozen cigarettes and a few pesos.

After lunch they went to a cowboy movie and took seats in the first row. During the movie they made loud catcalls of appreciation, laughing, clapping their hands and whistling each time someone was killed or when a disadvantaged person gained back his land from the government. After the show, they searched the place for cigarette butts.

By now it was evening and they walked down the fashionable sixth avenue, where they were looked upon with disdain by the middle-class shoppers. They stopped in a side-street where a young, affluent couple was dining. When the boys asked for food the couple tried to ignore them until finally, the man told them in a loud voice to leave. While Roberto approached the woman from one side and asked once again for something to eat, Antonio came from the other direction and grabbed a piece of meat from the man's plate. Running and laughing, they receded into the darkened street, and returned to Pedro, the [. . .] security guard. They gave him part of it as they tiredly entered their vacant corner, which they called their 'home'. Putting their blankets over themselves, they spent the few minutes before falling asleep planning, not much differently than other eleven-year-olds, what they would do tomorrow.[17]

Like the bus passengers, many of the drivers held up in Etchart's image will be frustrated, bored, irritated by the circus performance, but some will hand over a few pesos. And something of the Cali's boys' resourceful reciprocity echoes in the image of one boy supporting another, in a spectacle of their own making but a context that is not. The performers

put their lives in jeopardy and their faith in each other in a game of skilled edgework with a powerful material and metaphorical charge.

For these boys are fixed not only in a photograph and an urban economy but also in a certain global imaginary. And since the nineteenth century, argues Peter D. Osborne, the development of this imaginary has been closely associated with travel photography.

> Though implicated by its realism in the material world the absence in the photograph of the objectifying referent left the image open to the roamings of the imagination and to the all-important identification processes. Through this duality travel photography acted to bind the viewer psychically into the reality of the global system it pictured (Osborne 2000: 12).

This capacity (which recalls the charges of Krauss and Foster) has special relevance for a nation that has been repeatedly, almost obsessively, photographed by foreign travellers: in the 1920s and 1930s Sergei Eisenstein and his cameramen were among the stream of foreign artists who, attracted by the capital's post-revolutionary intellectual and artistic ferment, came in search of 'marvelous things to photograph' there, while Edward Weston and, later, Cartier-Bresson were concerned 'to avoid being swept away by the picturesque, the romantic' (cited Mraz 2003: 5). Their work was shaped by this experience and, in turn, helped shape Mexicans' own self-representations – the development of photographers such as Álvarez Bravo, for example, and the new understandings of Mexicanness to which they contributed – while predigesting their nation for foreign visual consumption.[18]

Julio Etchart has an oblique relation to these processes. Although he grew up in Uruguay (a nation historically less socially and economically polarized than Mexico) he has been based for most of his adult life in the UK. He travels extensively as a photographer for a number of globally-active NGOs, among them Save the Children and War on Want, and collaborates with the progressive press in the UK, Spain, France and Germany, as well as two photographic agencies – one of which, Reportage Visuals, he co-founded. In this respect, and for all its recognizably Mexican and wider Latin American resonances, his work is shaped by a certain cosmopolitan social and aesthetic imaginary. It is the imaginary of an itinerant. His website declares him 'at home wherever in the world he happens to be': like his street performers, his home territory is everywhere and nowhere.[19]

Cosmopolitanism has been charged with conspiring with globalization to render cultural otherness as either 'fertile grounds to be cultivated and harvested or as wild kingdoms, full of threatening beasts to be tamed' (Maddox 2004: 32). But in Latin America, where its roots lie so often in

political exile, the case is more complicated. Etchart's image does not in any simple sense idealize, generalize, exoticize, marginalize, demonize or melodramatize the two acrobats; they appear as active, creative, individuals at the heart of an everyday scene. In this sense, they are not simply aestheticized, or exploited to 'bring home' to middle-class viewers a space thronged with dangers and excitement, maximizing their pleasures by reframing its uncanny qualities. For if the shoes are uncannily white the patterned jumper is homely, and the threat conjured in the spectral blurring of hands and legs is not of a type to detain voyeurs. It comes partly from the eruption into a conventionally alien environment – a still image – of the ghost of a movement. More poignant than the absent-minded nodding of López's car-watcher and more compelling than the truisms of high-speed sports photography, this blurring connotes action that is not simply stilled, the flow of a life-world not quite frozen. Between the photograph-as-fragment and its suturing into the urban continuum it represents a movement of conditioned autonomy, towards viewers or away from them. And by deferring those continuity-effects it offers an oblique challenge to the workings of ostensibly seamless global imaginaries.

In his discussion of travel photography's links with the development and functioning of global capitalism, Osborne traces photographs' commodified status as what as Oliver Wendell Holmes (writing seventy years before Walter Benjamin) termed 'the sentimental greenbacks of civilisation' (Osborne 2000: 11). This status derives, Osborne suggests, from a

> global economy of visual knowledge [in which] the photographic image [. . .] offers the incitement to travel, to purchase the real in the form of visual consumption. [. . .] In this complex of travel, global distribution of imagery and circulation of money much of the reality of nineteenth-century capitalist culture was being manufactured. [. . .] Economy, technology and culture meshed as transportation and communications systems were worked in tandem towards the same end – the creation of integrated national and global-political economic orders (Osborne 2000: 10–12).

If the teleological impetus he attributes to the process seems overstated, the relationship energizing it is not. More relevant here, however, is the unevenness with which its effects have radiated from nineteenth-century North America or Victorian Britain to today's great cities. Osborne evokes the hyper-complex world system of late twentieth-century neo-capitalism with its 'abstract space' made up of countless, variegated pathways from roads and air-routes to fibre-optic cabling and wave frequences along which flow commodities, people, information, digitalised finance, political instructions and images (Osborne 2000: 11).

But even in the financial centres of what have come to be called global cities – Tokyo, for example, New York or London – these flows are more uneven than Osborne acknowledges, and at constant risk of blockage. Etchart offers a peculiarly potent representation of this risk, of circulation detained, in Latin America's largest megalopolis; here, the massification of residents, goods and information actively inhibits visions of the capital as a whole, promoting instead 'percepciones fragmentadas y discontínuas' (fragmented and discontinuous perceptions) (García Canclini, Castellanos and Rosas Mantecón 1996: 28). Where the spectacular architecture of financial dynamism jostles with squatter settlements among the advertising hoardings, social inequalities and urban violence, globalization is 'vivida como una invasión extraterrestre' (experienced as an alien invasion) (Norbert Lechner, cited García Canclini 1999: 23).[20] Like the business managers, artists and migrants mentioned in the Introduction, Mexico City residents devise narratives to order these fragments and to render this experience, in imagination, more coherent and more hospitable. There are other influential narratives being constructed from very different perspectives to different effect, however, and it is to one of these I now want to turn.

The narrative in question comes from another Hispanic cosmopolitan, social theorist Manuel Castells, whose all-embracing account of the emergence of a new global imaginary is set out in his three-volume *The Information Age: Economy, Society and Culture*.[21] Perhaps because he is in neither business nor government, his pioneering vision is not included in García Canclini's list of narratives – though it underpins some that are. Its founding assumption is that technological, economic and cultural transformations associated with globalization are reconfiguring relationships of production, power and experience; and that this, in turn, is creating a new society characterized by new meanings and practices. But it is the blindspots in his narrative that resonate in Etchart's photograph; for the visual, privileged though it is in late- or postmodern culture, figures in Castells's narrative chiefly in metaphors of non-seeing. Above all, since the technological imaginary he describes is grounded in binary relations, whatever is irreducible to these relations remains out of the picture. Etchart's image raises the possibility of evading these binary relations and illuminating their blind spots, probing the implications of the processes Castells describes and the risks implied in their proceeding unchallenged.

Globalization, cosmopolitanism, and photography all turn on the question of space, and space – including the space of photographs – is produced through historically-conformed social relations. Etchart's cars, for example, move through space configured, marked up and framed by

law, custom, and social practices, all of which combine to give it 'a form, a function and a social meaning' (Castells 1997a: 411). Castells is concerned with different kinds of space, however, with different values and answering to different laws. He organizes this new spatial logic around the relation between 'the space of flows' and 'the space of places'. Global information society 'is constructed around flows: flows of capital, flows of information, flows of technology, flows of organizational interaction, flows of images, sounds and symbols' (412). This, he argues, takes three main forms. First, there are the flows of electronic impulses on which information society depends: telecommunications and broadcasting systems, for example, microelectronics and related technological aspects. Then there is the interaction of the nodes and hubs that facilitate these and other flows: global cities, for example, and 'the decision-making systems of the global economy' (414). And third, there are the organizational energies of the dominant, cosmopolitan, managerial elites who direct these flows. The space of flows is not the only spatial logic at work in network society, Castells acknowledges, but as long as it is promoted by this dominant group it will remain the dominant logic.

The plausibility, extent and effects of this domination, and of Castells's insistence on it, may be questioned from the second of his two spaces, the space of places. This is made up of the locales in which we live, 'whose form, function and meaning are self-contained within the boundaries of physical contiguity [and marked by the] historically-rooted spatial organization of our common experience' (Castells 1997a: 423, 425). Whereas the space of flows, 'of power and wealth[,] is projected throughout the world [. . .] people's life and experience is rooted in places, in their culture, in their history' (415–16). Castells avoids an idealizing nostalgia by noting that places are not uniformly socially interactive or rich; they are not natural communities, but locations where meaningful interaction and community-building may come about. Above all, he observes, places offer scope for the individual imagination and face-to-face subcultures increasingly marginalized in the technologically-determined space of flows. And it is from here, Etchart obliquely proposes, that those flows may be placed in jeopardy.

Castells is advancing a set of powerful, general claims here about the relationship between what he characterizes as global and local forces. The implausibly categorical distinction between them, the reach and authority he ascribes to forces defined as global, and the fact that he engages only very occasionally and superficially here with the intractably specific, make his argument vulnerable to the type of critique implied in Etchart's image. As suggested, this is partly because of his overdependence on reversible binaries. Just a decade before the street circus was

photographed, for example, electronic communication was widely char-
acterized as a crude and insubstantial substitute for the immediacy of
face-to-face relations. In Castells's space of flows, however, it is the face-
to-face that figures as unsophisticated and marginal. The spread and
(albeit patchy) socio-cultural embedding of communications technology
is a factor in this. So too, he argues, is the increased speed, readiness,
range and breadth of access available through electronic media such as
internet and mobile phones, which in turn have promoted flatter but
more complex and engrossing social relations. And these, he contends,
have conspired in turn with a decline in the West's Romantic sense of
human difference: difference from other species on the one hand, and
from forms of artificial intelligence on the other.

But the global academic is generating his reversible binaries from
within the space of flows. Etchart's image is testament to the fact that, by
the last decades of the twentieth century, the binary bases of such con-
ventionally modern categories as public and private, work and play,
detail and generality were increasingly under challenge.[22] The image that
engaged me immediately when I saw it in a book a decade ago, and that
I reproduce here and now in another book and a very different context,
was sent to me a few weeks ago as a high-resolution email attachment by
a photographer I have read about, spoken and written to but never met.
Ironies like these, the clichés of a certain postmodern theorizing, are
helping to make binary thinking increasingly unsustainable. Yet, for
Castells, the processes that are spawning these ironies require all infor-
mation to be binary if it is to be intelligible:

> all kinds of messages in the new type of society work in a binary mode: pres-
> ence/absence in the multimedia communication system. Only presence in
> this integrated system permits communicability and socialization of the
> message. All other messages are reduced to individual imagination or to
> increasingly marginalized face-to-face subcultures. (Castells 1997a: 374)

In 'Street circus' this marginalization of the face-to-face, of messages,
interests and values that do not conform to this system's logic, their
reduction to 'individual imagination', all acquire special resonance.
Castells imagines time as neutralized by communicational immediacy;
and he sees space as polarized, so that presence or absence in the system
is experienced as inclusion or exclusion. But Etchart's blurred after-
images elude characterization as simply present or absent: partly because
they are in a photograph, where presence conventionally appears, like
starlight, under the sign of absence; and partly because after-images hold
out against the neutralization of history and memory, against the air-
brushing of bodies from the space they have fleetingly made into place

(Osborne 2000: 10, Resina 2003). In doing so, they obliquely underline that the global is not imagined globally; it does not emanate spontaneously from technology but is constructed by situated social subjects in narratives that owe rather more than Castells acknowledges to 'individual imagination'.

And to individual nightmares. Global megacities like Mexico City, in his account, serve increasingly to 'articulate the global economy, link up the informational networks, and concentrate the world's power' (Castells 1997a: 404). At the same time, locales within these megacities 'become disembodied from their cultural, historical, geographic meaning and reintegrated into functional networks' (Castells 1997a: 375). A major consequence of this is the reconfiguring of city space:

> dominant functions and values in society are organized in [. . .] flows of information that escape from the experience embodied in any locale. [. . . D]ominant values and interests are constructed without reference to either past or future, in the timeless landscape of computer networks and electronic media, where all expressions are either simultaneous or without predictable sequencing. [And it] is within the framework of these timeless, placeless symbolic systems that we construct the categories, and evoke the images, that shape behavior, induce politics, nurture dreams, and trigger nightmares. (Castells 1998: 350)

With their exclusion from that 'we', Etchart's street performers become the stuff of a global theorist's nightmares. For the megacity may be the hub of certain communication flows but it also the repository of locales and residents. And from this space of places, Castells suggests, groups, individuals, and (especially in the Latin American context) social movements mobilize around their locales, or around religious or other identifications, to redefine their place in society or transform social structures more generally. Etchart's street performers have no place in this dialectic, however. Like the two boys in Cali, they have no home ground from which to mount a strategic or systematic challenge to the workings of network society, however conceived – even were they inclined to try. Instead they operate tactically, in its interstices, in streets not designed or intended for unsolicited entertaining, selling, or windscreen-cleaning. They work sometimes in solidarity and sometimes (given the scarcity of resources) in competition with others in similar situations. For while their use of public space may be half-sanctioned by habit, by the permissive tourist gaze, or by some sense of responsibility or reciprocity among their patrons, it may be contested informally and formally. Living as they do with the intractable contingency that puts any system at risk, in and between social structure (on the highway) and urban life-world,

they are routinely characterized as vermin, and sometimes treated as such (Green 1998). Castells's narrative places children like these at the event horizon of globalization: in the 'colonias populares[, popular settlements that make up] about two-thirds of the megapolitan population, without playing any distinctive role in the functioning of Mexico City as an international business center'; or in 'hinterlands' unconnected with the megacity and its global networks and which 'play an increasingly subordinate function, sometimes becoming irrelevant or even dysfunctional' in relation to key centres or 'nodes' of international activity (Castells 1997a: 380). These hinterlands swarm, he declares, with disorderly bodies, 'disconnected from networks of valuable functions and people, [. . .] either functionally unnecessary or socially disruptive [and] ready to sell their irrelevance or to make "the others" pay for it' (164, 404). The street acrobats, whose unruly energies are only half frozen in the opening and closing of a photographic shutter, seem almost at home in this dark vision.[23]

But these supposedly irrelevant bodies are rather less disconnected from global capitalist networks than Castells suggests. For while their images circulate in photographic, art and academic networks, their bodies also circulate. The political and economic policies that have favoured the development of these networks since the 1980s have also tended to reduce opportunities for stable employment among the majority of the capital's residents, to depress the wages of those who do find work, and to erode social support for the remainder. In these circumstances members of hard-hit communities exploit and create opportunities in more or less inhospitable contexts, moving out of their locales and between informal and formal sectors as circumstances change (Salazar Cruz 1999). Many residents of Mexico City's colonias populares make their living in an informal (or 'black') economy on which the formal economy is increasingly reliant. They may also serve as an industrial reserve labour-force or as a source of cheap subcontracting for assembly industries, enabling local and especially transnational businesses to slash labour costs still further (Chant with Craske 2003). And even street children may undertake odd jobs or more regular paid work. If these marginal bodies hold up the global flow at some points, they support it elsewhere.

Yet Etchart's street children do not figure on Castells's global radar. Instead, their energy has to be intuited from photographic traces, deduced from his calculations, or inferred from the more apocalyptic sections of his narrative, in which raiders from the dystopic hinterlands wait to descend like wolves on the global city. These are 'hinterlands' partly because they are unpenetrated by what he describes as 'advanced

services': insurance, for example, real estate, advertising, finance, or marketing (Castells 1997a: 378). While not all would see this as catastrophic misfortune Castells, in a moment of astronomic hyperbole, refers to places thus deprived as ' "black holes" of marginality' (379). That is, as long as they have no developed sense of common purpose or identity from which to challenge it, Castells's narrative registers the street children as a point of absolute gravitational collapse, a threat it can as yet only infer from other data. It does so in a way which, while not uncritical, reminds us that presentation can also be participation. He acknowledges that a failure to bridge the space of flows and the space of places, both culturally and physically, is likely to promote the development of 'parallel universes whose times cannot meet because they are warped into different dimensions of social hyperspace' (428). But his dialectical vision risks accelerating this process by repeatedly reinscribing the familiar blindspots – blindspots that a photograph can incidentally expose.

In this case, the photograph's power derives partly from its contextualization in a certain tradition of Mexican urban photography and social documentary. But the assimilation to this tradition of a cosmopolitan figure at home 'wherever in the world he happens to be' belies the critical will that constructs it. If, as I have argued, Etchart's image resists being made into solid ground and sutured into the global city, it cannot be used now to sum up the lives once fleetingly caught there, nor Mexico City, nor its globalizing contexts, however characterized. Nor can it unproblematically represent what lies beyond these contexts: like Castells, Etchart himself is too much a part of them. But he works with the intellectual, technical and aesthetic means at his disposal to connote this 'beyond', and to block its reduction to the simply abject.[24] What eludes the speed and communicative efficiency of globalization figures here as risk and obstruction, as interstitial, unpredictable and intractable redundancy. The result is not a moment of pure negativity, however, and there is little sign to date that those who do not benefit from globalization will rise up in multitudes to liberate themselves from its hegemony; not least because its inequitable distribution of goods and bads favours not only forms of solidarity but also competition and complicity. But in the after-images generated by the acrobats there resonate the memory and the possibility of alternatives to unified global visions – what Monsiváis calls 'phrases prefiguring a language' – and with them a reminder that, despite claims to the contrary, globalization 'is in action in peripheral societies still only as a dominant horizon' (Monsiváis 1997: 139, Moreiras 2001: 35). This possibility animates the global anti-globalization movement, for all its contradictions, and the alternative imaginaries gestured towards by García Canclini. Joan Ramón Resina suggests

that, by dynamizing our otherwise inert perceptions, after-images may help to displace the narratives and projections that drive globalizing rhetorics (2003). What these dynamized perceptions cannot do is recover the 'before' of the image or look below its surface for a moment in the lives of two young boys who, if they exist today, are now men. But they can amplify and enrich it, and give it the definition and time that Buck-Morss calls for, as part of a wider strategy of reimagining globalizing energies.

Notes

1 The NAFTA Agreement came into effect in January 1994 between the US, Mexico and Canada.
2 I take the terms deterritorialization and reterritorialization not from the anti-psychoanalysis of Félix Guattari, but from García Canclini's use of them in *Culturas híbridas* (1989). Here they denote how culture, in globalization, may lose its seemingly natural relation to specific territories or locales, sometimes becoming re-embedded and remobilized elsewhere. Examples he cites include the appropriation by Mexican rug-makers of motifs from Picasso's paintings.
3 The image is taken from *The Fobidden Rainbow: Images and Voices from Latin America* (ed. Amanda Hopkinson (1992)), in which Etchart's images are interspersed with brief essays (by Rigoberta Menchú and Eduardo Galeano among others), and quotations from some of the photographic subjects.
4 Annan's work, commissioned in 1868, is characteristic of the Victorian photographic survey: see Frizot (1998b: 348–9) and www.edinphoto.org.uk/pp/pp_annan_thomas.html. Riis offers an early instance of social reform journalism – and one hotly debated for his often brutal avoidance of complicity with his subjects and the later reification of his sometimes rough and ready images as photographic art. See Warner Marien (2002: 205–7) and http://images.google.com/images?q=jacob+riis+images+&hl=en&lr=&sa=N&tab=wi&sourceid=tipimg. On Nègre, see Jammes (1963) and http://images.google.com/images?q=charles+negre&hl=en&lr=&rls=GGLD,GGLD:2004–39,GGLD:en&sa=N&tab=wi&sourceid=tipimg.
5 Within Mexico, Compañía Mexicana Aerofoto were pioneers of aerial photography and their work featured prominently in the illustrated magazines. There, it provided the capital's citizens, for the first time, with a visual impression of their rapidly changing urban environment beyond the fragments in which they lived and worked. For more on this see Chapter 2.
6 For details see Debroise (2001b), Chapters 3–8.
7 See, for example, *¡Tierra y libertad! Photographs of Mexico 1900–1935*, Oxford, Museum of Modern Art (1985) and http://images.google.com/images?q=agustin+casasola&hl=en&lr=&rls=GGLD,GGLD:2004–39,GGLD:en&sa=N&tab=wi&sourceid=tipimg.

8 See Cartier-Bresson's *Mexican Notebooks* (Fuentes 1995), and images displayed at http://images.google.com/images?q=cartier-bresson+images+&hl=en&lr=&sa=N&tab=wi&sourceid=tipimg. For examples of Álvarez Bravo's work see Kismaric (1997), Álvarez Bravo (2001), Hopkinson (2002), Huque (2002) and images at http://images.google.com/images?q=alvarez+bravo+images+&hl=en&lr=&sa=N&tab=wi&sourceid=tipimg. On Mexican photography, especially from its origins to the 1950s, see Debroise (2001b); on the contemporary period see Morales (2000). On photojournalism see Mraz (2003); on Mexican urban photography see Castellanos (1996).

9 The surrealist overtones of this approach hardly need underlining, and both men found themselves drawn into Surrealism's ambit by the International Exhibition of Surrealism mounted in 1940 by André Breton in Mexico City. See Kismaric (1997: 31–5).

10 These included curvaceous actress Matty Huitrón and a man carrying a full-sized mannequin. For examples, see Mraz (2003: 120, 121, 123, 125).

11 López's interventions anticipate the fact that (like Álvarez Bravo before him) he would later experiment with film-making. For a discussion of the distinction between photojournalists (who tended to construct their narratives around news events) and photo-essayists (who ranged more widely), and their place in Mexican photography see Mraz (2003: 16–21).

12 Some of López's best known images document rising literacy among poor (and especially male) rural migrants: see, for example, the splendid and widely reproduced image from 1949 of a 'campesino' (or peasant) reading a torn newspaper and, a year later, of a boy who reads sprawled across the kerb (both in the Fototeca Nacional, reproduced in Mraz (2003: 87, 86)). As well as permitting a longer period for the photographer to frame up candid shots, images like these affirm their subjects', and their consumers', shared interest in national affairs, while incidentally calling to mind the photographer's own role in the visual appeal of the material being read.

13 For a nuanced comparison of their work see Debroise (2001b: 196–7).

14 The image, now in the Fototeca Nacional, is reproduced in García Canclini, Rosas Mantecón and Castellanos (1996: 19).

15 On the many histories of Mexican photography see Morales (2000).

16 This process is underlined in images of the construction workers building the new Mexico. See, for example, López's 1951 image of workers on the Latin American Tower (Fototeca Nacional, reproduced in Mraz (2003: 113)). By shooting from below, at an angle and against the sun he idealizes their silhouetted, auratified, figures, conferring heroic stature on the brave makers of the nation. At the same time, the fact that they are not at the apex of the triangle formed by the crane's boom and its cables, but balancing on the steel beam supporting it, recalls the muralists' postrevolutionary vision of the interdependence of man and technology in the construction of the new Mexico. In the same year, Faustino Mayo approached the subject quite differently (Archivo General de la Nación, reproduced in Mraz (2003: 114)). His own half-silhouetted construction worker walks across a steel girder that,

cutting the bottom third of the image almost horizontally, marks a vertiginous new building. At right angles to it, on opposite sides of the image, his upright figure and a second girder frame the city that, far below and behind him, sprawls into the smoggy distance. His gait seems almost casual; more than a heroic constructor of the future, he appears as one individual among the many making this great city. As discussed in the next chapter, by the 1980s this confidently panoramic perspective and López's vision of the capital as 'un conjunto de símbolos del nacionalismo' (a collection of national symbols) would give way to more fragmented representations of the city (Castellanos 1996: 53).

17 Taken from Duncan Green (1998: 67–70), who is quoting at length from Lewis Aptekar, a US psychologist, who (with their permission) spent a day shadowing the two boys while researching his *Street Children of Cali*. See also Loaeza (2005).

18 From the mid-1940s, through the work of the Club Fotográfico de México, Mexican art photography played an increasingly important role in this process. Founded by well-to-do foreign amateurs in the mid-1940s and '"nacionalizada" por los socios mexicanos' (nationalized by Mexican members) in 1949 it offered them readier access to international photographic organizations and stronger distribution channels for their work throughout the 1950s and 1960s (Castellanos 1996: 51–2). The process had begun much earlier, however; on the work of German-born, Mexico City-based, photographer Hugo Brehme in the 1920s, for example, see Debroise (2001b: 60).

19 See www.julioetchart.com/home.html.

20 It is worth noting, in passing, García Canclini's own status as a cosmopolitan intellectual, an Argentinian literary critic who moved to Mexico in the 1970s to became one of Latin America's most influential (and widely-travelled) cultural anthropologists.

21 Castells, who was born in Barcelona, developed his most influential theoretical work while at the University of California at Berkeley. His three-volume study comprises: Vol. 1, *The Rise of Network Society* (1997a), Vol. 2, *The Age of Identity* (1997b), and Vol. 3, *End of Millennium* (1998).

22 While binary thinking may not represent the most serious threat facing street children, it is interesting to note that even Duncan Green's informed and sympathetic discourse is not above idealizing them as either brutalized victims or creative 'urban pirates' (Green 1998: 63).

23 This disorderliness might suggest a carnivalesque quality in the image: the relations inscribed here strike me as too dark for this, however, too urgent, and not readily reversed.

24 Over and above its standard definition as 'miserable' or 'degraded', here and throughout I broadly follow Julia Kristeva in using 'abject' to suggest threatening, transgressive, objectified elements that the subject ejects in order to live fully *as a subject*. Here, it designates the excluded elements on which the apparent integrity of Castells's narrative depends.

2

Urban imaginaries

Chapter 1 presented a photograph of Mexico City as a critical corrective to one influential form of global imaginary. This chapter considers the use of photographs to chart the daily experience of living and travelling in the capital. It centres on a research project, co-ordinated by Néstor García, Ana Rosas Mantecón and Alejandro Castellanos in the early 1990s, that traces how residents recreate Mexico City in their imagination and through their practices as they negotiate its vast, risk-riddled spaces.1 This is contrasted with 'snapshots' from the urban strolls of two of Latin America's best-known cultural critics, Carlos Monsiváis and Beatriz Sarlo. In all three cases, photographs figure as 'the symptom, the setting and the witness of [a] prevailing angst, and occasionally a palliative for it' (Morales 2000: 150).

All cities, observes García Canclini, are composed of houses and parks, highways and traffic signals, but 'se configuran también con imágenes' (they are also configured through images) (1997: 109). These images may be the professional output of architects and planners, but they may equally be drawn by residents from heterogeneous press stories, for example, films, or television.2 Chapter 1 looked at the role of photographic images and traditions in conforming the nation and its capital. This chapter opens with an overview of the role art played in this process up to the 1990s, when all three studies under discussion were published.3 The focus is on specific debates and processes associated with the production of visions of Mexico: by the state, by individual artists, and by the local and transnational networks, entrepreneurs, and institutions that condition artistic production and projection. The overview concludes with the place of the global city in these processes.

As noted in Chapter 1, since the Revolution visual culture has been a key resource in the 'rediscovery', building, legitimation and projection of

the new Mexico. Between the 1920s and 1940s, and particularly during
José Vasconcelos's term as Education Minister (1920–24), artists were
encouraged through a programme of sponsorship and commissions to
play a leading role in embedding the state's vision among the largely illit-
erate masses.[4] This vision tended to idealize certain previously marginal
or abjected elements (for example, aspects of indigenous and pre-
Columbian – especially Aztec – culture) and was fuelled by a cultural
mythology that stressed national unity by sublimating a lengthy history
of violence, injustice and exclusions. This idealization of Mexico's past
was a feature of the early years of muralism, a movement spearheaded
by Diego Rivera, José Clemente Orozco and David Siqueiros and ener-
gized by a conception of art not 'as an expression of individual satisfac-
tion [but as] a fighting, educative tool for all' (Skidmore and Smith 2001:
232).[5] National identifications promoted through the work of the mural-
ists and their circle – not always with the artists' complicity – would come
to displace the European, and especially French, aesthetic models per-
sisting from the dictatorship of Porfirio Díaz as, for the first time,
Mexican art acquired an international profile. From its founding in 1927
well into the 1950s, the guardian of this official art tradition would be
the Escuela Mexicana de Pintura, Escultura y Grabado, and at which
both Rivera and Frida Kahlo gave classes.

The implications of Mexican art's international profile, as documented
in Kahlo's clashes with North American patrons, for example, or her
refusal to be assimilated to European Surrealism, foreshadow later
tensions between national and global art networks (Herrera 1989). They
also foreground the extent to which, from the immediate post-
revolutionary period, the state's exploitation of visual culture has been
inflected by the activities of non-Mexican entrepreneurs. Cartier-Bresson
was one of a stream of cultural producers – Edward Weston and Tina
Modotti, for example, Paul Strand, Sergei Eisenstein – attracted to
Mexico by the vitality of the environment the muralists created around
them in the 1920s and 1930s. In the 1940s, visitors would include North
American and European impresarios and patrons seeking refuge from the
cultural isolation imposed by World War II. It was these international
cultural actors, and tourists beguiled by what they saw as Mexico's local
colour and exoticism, who encouraged the development of the gallery
system that broadly continues today.[6] As post-revolutionary visual sym-
bology and its international appeal became more established, however,
art's prestige grew among the Mexicans who were profiting most from
the new regime; and, as familiarity and a changing international climate
dulled the appeal of their nation's supposed exoticism for foreign con-
sumers, local buyers began to replace them. They would help to ensure

that, like the ruling political party that promoted it, Mexico's post-revolutionary visual symbolism would prove extraordinarily enduring. As one recent assessment notes, it penetrated 'el imaginario colectivo nacional' (or national collective imaginary) to the point where it became hard to imagine later models matching, still less displacing, it (Ashida and Zugazagoïtia 2005: 441).

By the 1950s, although their association with the revolutionary state persisted, the idealized rural and indigenous themes associated with the Escuela Nacional were beginning to lose their resonance in an increasingly urban Mexico. Despite its declining power to engage and dynamize new generations of artists, however, it remained strong enough to block the emergence of compelling alternative visions and art practices. This prompted some of its critics to look to international movements. In the 1950s and 1960s a heterogeneous collection of (chiefly) painters – now referred to loosely as the Ruptura group, and including Juan García Ponce and José Luis Cuevas – rejected Mexico's state-sponsored art in favour of the more individualistic abstract and expressionist tendencies then being promoted in the US by Nelson Rockefeller and the Guggenheim family. Their audience in and outside of Mexico was relatively limited, however, as it was for proponents of other externally-legitimated models such as Surrealism and Bauhaus.

The artistic climate changed dramatically with the increasingly centralized state's violent suppression of student demonstrations on the eve of the 1968 Olympics. The national and international outrage this generated brought to crisis the identification of Mexico's visual culture with its increasingly discredited political culture, jolting some younger artists into radical new directions. This was the time of 'Los Grupos' (the Groups), of art collectives and conceptual and performance-led experiments. Marked by the student mobilizations of the times, activists took to the streets to denounce the subordination of the historic national project to US economic and foreign policy and worked to recast the relationship between aesthetic and political narratives without simply rejecting either (Sloane 2000, López Cuenca 2005). The fitful and unfocused character of these interventions ensured that their impact was limited, however.

As the years of expansion concentrated national wealth into progressively fewer hands, some less conservative members of the economic elite had been willing and able to support contemporary artists. Despite the economic downturn of the early 1970s, the state's own commitment to visual arts was reaffirmed in 1974 with the purchase of the collection and premises that would form the basis of the Museo de Arte Contemporáneo Carrillo Gil, in which some of this new work would be

exhibited. By the end of the decade, however (and despite the discovery in 1976 of large new oil reserves) national economic difficulties were being compounded by wider international ones in the wake of the world oil crisis.[7] In the years that followed, this brought Mexico to the brink of defaulting on its debt repayments and (in an attempt to avoid potentially cataclysmic repercussions for the international banking system) the World Bank and the International Monetary Fund agreed what they presented as a rescue package. It was tied to a programme of harsh neo-liberal economic and social measures which would be used to justify drastic cuts in social and cultural funding.

But the enforced exposure to external markets that was (and remains) fundamental to neo-liberal economics was associated with larger changes. Above all, it accelerated the partial displacement of official nationalist discourse, reworked by successive governments since the Revolution, by one of economic globalization. Despite little evidence of support among the majority of the population, negotiations were soon under way that would culminate in the NAFTA agreement between Mexico, the US and Canada. In the course of them, Mexico's pre-Hispanic and post-revolutionary artistic capital would be used to supplement the manifest imbalance in economic capital between the three parties and to project 'una imagen de solvencia histórica y cultural' (an image of historical and cultural solvency) (Ashida and Zugazagoïtia 2005: 443). Within hours of the agreement's implementation in January 1994, however, images of the Zapatista uprising in Chiapas would dramatically undermine that strategy by insisting on an altogether different historical legacy that successive PRI governments had failed to address.

In Mexico (and in many other, more homogeneously developed, nations) the early stages of globalization were associated with a reworking of traditional modernist models: in some cases this was a defensive response to the waning of national identifications; in others it was under the sign of an irony now routinely associated with postmodern cultural discourses. In the art circles of the 1980s and early 1990s it included the reappropriation of revolutionary nationalist symbology – pre-Hispanic sculpture, for example, the face of Zapata, bleeding hearts, the Virgin of Guadalupe – within pop and quasi-expressionist frames. This 'neo-mexicanismo', as it came to be called, was taken up enthusiastically by galleries in the capital ready, in the words of one critic, to market 'the image of a supposedly authentic Mexicanness, national folklore, color, fantasy and exoticism, rediscovered by European collectors passing through New York' (Santamarina 2000: 88–90).[8] Its audience included not only consumers sensitive to the ironies of the new approach, but also Mexicans for whom the traditional symbolism still retained much of its

earlier intensity. As a result, local demand for this work grew, encouraging the establishment of new galleries outside the capital. Another key factor in this growth and limited decentralization was the privatization, under the new neo-liberal impetus, of many state-controlled enterprises. This sparked a brief period of intense economic effervescence, and encouraged a wider opening up of Mexican art to national and, especially, foreign investors. Like the international pension and other funds that had helped to convert art into a market and an investment opportunity in the 1970s and early 1980s, this had the effect of dramatically inflating prices for work seen as commercial while ignoring the remainder.

Emboldened by this new interest, and by the embedding of the discourse of globalization from the later 1980s, some young artists began to turn their back on nationalist-informed art conceived for internal markets: they censured what they saw as its projection of outworn notions of Mexican identity, along with its complicity (willed or otherwise) with the ideological project of the nation state; they challenged the pictorial hegemony of neo-Mexicanism and the legitimacy of traditional media; and they established alternative art spaces 'destinados sobre todo a su propia formación a través de la experimentación artística, la curandería y la escritura' (designed primarily for their own artistic training and experimentation, and for curating and writing) (Arriola 2000, Medina 2005b: 353, Power 2005). So it was that, while decades of state-sponsored nationalism had made Mexican artists less ready than some of their Latin American counterparts to engage with the first wave of globalization, in the course of the 1990s it would help to stimulate radical new art practices, educating and encouraging practitioners to mobilize creatively the cultural and social paradoxes arising from their position 'en línea de fuego de la expansión del capitalismo global' (in the line of fire of expanding global capitalism) (Medina 2005b: 353). At the start of the decade Belgian artist Francis Alÿs and British-born Melanie Smith, key figures in the global success of contemporary art produced in Mexico, set up their own informal art centre in the capital. Soon after, a group of Mexican art students set up workshops at 44 Temístocles St. While the Temístocles group did not last long, it helped to establish the vogue for new artist-run spaces, and several members – among them Eduardo Abaroa, Pablo Vargas Lugo, and Daniela Rossell (the photographer whose work figures in the next chapter) – would find a global audience. But as Medina notes, their rejection of dominant artistic and political genealogies, combined with the shortage of public collections and, initially, of private buyers for their work, left these young artists doubly orphaned.

These were years of political and economic crisis. Carlos Salinas de Gortari (1988–94) presided over a period of accelerated and ill-judged neo-liberal reforms, corruption and political violence (including assassinations) at the highest level, and a bitter struggle between traditional and neo-liberal factions within the ruling PRI. The Zapatista uprising in his final year highlighted in the starkest terms the contradictions between official discourses of modernity and revolutionary nationalism; above all, it underlined the gulf separating the small elite enriched by Mexico's headlong economic integration from the swathes of casualties. It cast a pitiless spotlight on the factitious bases of the Salinas regime, triggering the political and economic shifts that would vaporize almost overnight much of Mexico's cultural capital and precipitate a dramatic decline in the fortunes of collectors, galleries and artists alike.[9] Against this background, some of those whose activities had previously been confined to national art networks responded by seeking new external markets, particularly via the proliferating international art fairs. The establishment of the Foro Internacional de Teoría sobre Arte Contemporáneo (International Forum for Contemporary Art Theory), which was designed to promote wider understanding of Mexican artists, dates from this period. So, too, does the creation of new international exhibition spaces. The year 1991 had seen the high-profile opening of one of the most important, the Museo de Arte Contemporáneo de Monterrey (Monterrey Contemporary Art Museum, or MARCO); the initiative of a group of wealthy businessmen supported by North American interests, it rapidly found a place in global art networks.[10] A year later another contemporary art museum opened in Oaxaca, a town well-established on the international tourist trail but with less manifest global pretensions and a strong artistic tradition: Rufino Tamayo was born there, as was Francisco Toledo, who was a moving force behind the new museum.[11] By the decade's end, the inauguration of the Jumex contemporary art collection would cement for its international patrons Mexico's status as a global art 'hotspot'.[12]

Over the course of the 1990s, some young artists discovered that their rising global profile promoted their incorporation within an emerging contemporary national art canon, as well as a progressive institutionalization of the independent spaces in which they had operated and exhibited. Then, as now, conceptually-based work – broadly, work that foregrounds ideas rather than aesthetic concerns – benefitted particularly from these developments. In Alberto López Cuenca's polemical assessment, this is because it is instantly accessible and politically bland, especially when compared with the radical conceptual art of the 1970s.[13] In a country where the local market is relatively weak, he argues, where

there are no more than a dozen contemporary art galleries of interna-
tional weight, where private contemporary art foundations are hardly
any stronger, and where state support for new work is only now becom-
ing more generous, its producers have become the first generation of
'*maquiladora*' artists: they are conforming to late-capitalist models of
production and consumption by assembling interchangeable elements
(codes and strategies drawn from the *lingua franca* of international art)
to order, for transnational clients. The end result is volatile, he con-
tends, dematerialized, readily transportable to the next Biennale and
'entendible donde quiera que se exhiba' (intelligible wherever it's exhib-
ited) (2005: 17, 20–1). There is more than an element of truth in his
claims; but they fail to acknowledge just how far the most disembedded
art is partially re-embedded and reconfigured at the point of exhibition –
a process that is examined in Chapter 3.

The broader postcolonial ironies of this dynamic were inadvertently
underlined in 2004 by Harald Szeeman, co-curator of the I Bienal de Arte
Contemporáneo in Seville. He characterized the flow of art from the
periphery to a European centre as evidence of a productive decentraliza-
tion and deterritorialization, born of the wider desire of international
curators to 'get hold of the density of phenomena' (2004: 18). Olivier
Debroise notes this latest reconfiguration of the trope of the 'other'
through whom we come to know and affirm our selves, but reserves his
fire for its commercial dimensions. A new geopolitical logic is driving
once monopolistic art centres to absorb work from the periphery, he
observes, in order to broaden and renew their energies and appeal. In
particular, art produced in Mexico is being used to prop up a decaying
biennale system now largely reduced to globalized art fairs that derive a
veneer of academic legitimacy from parallel workshop and lecture pro-
grammes (Debroise 2000, 2005). Debroise is not referring here to the
genuinely critical exhibitions mounted in recent years. 'El insidiosa gusto
de lo global. Arte para un siglo post-México', for example, convened by
Cuauhtémoc Medina for the University of Puebla; 'Coartadas', curated
a year later by Magali Arriola for the Centro Cultural de México in Paris;
'Superficies coloreadas' curated by James Oles for MexArtes in Berlin
in 2002:[14] all in their different ways insisted on the irrelevance for
the works shown of simplistic and widely-discredited notions of
Mexicanness. Considerably less critical, however, was the retrospective
mounted in 2002 at P.S.1 Contemporary Art Center in New York.
'Mexico City: an exhibition about the exchange rate of bodies and
values' accelerated the global institutionalization of a tiny core of con-
temporary artists while presenting the capital 'como un atractivo
postapocalipsis urbano' (Schmeltz 2005: 36). The international boom it

helped to consolidate has spawned a number of other shows, including 'Mexico attacks!' (Lucca, Italy, 2003), 'Made in Mexico' (Boston, 2004) and, on the back of commercial art fair ARCO, 'Eco' (Madrid, 2005).

Mexican gallery-owners and art entrepreneurs are right to attribute at least some of the current boom to their own and their artists' energies; they also register the dynamizing effects of a more cosmopolitan perspective; and for the moment at least they are less concerned than are Debroise or Medina about what happens when the caravan moves on. But this is not necessarily true of the small group of increasingly cosmopolitan Mexico-based artists – those already mentioned, but also Silvia Gruner, for example, Claudia Fernández, or Thomas Glassford – whose work currently circulates through these global networks. Having drawn from the official neglect of the 1990s a form of ideological freedom, they are now facing global pressures they could not have anticipated, with consequences that are not easy to predict.

It has been argued that globalization does not create inequalities so much as reorganize them (García Canclini 1999). Faced with this uncertainty, however, there are some Mexico-based artists and critics who stress the risks, for artists with no strong national identification, of cultural dilution in a seemingly voracious cosmopolitan cultural circuit; and the risks, too, for a country weakened by foreign debt, of sitting in on the lavish banquets of global cultural entrepreneurs in distant cities (Olivares 2000a, Abaroa 2005). Some of these artists actively foreground a sense of collective history, identity and place in their work, though rarely without an intense ambivalence. In some cases this ambivalence may retain vestiges of the postmodern understanding of Latin American hybridity propounded in the late 1980s and early 1990s – though it found little echo in the Mexican art scene of the time (García Canclini 1989, Medina 2005b: 354). It may also have something to do with the fact that Mexican art has itself become more internally globalized than is usually acknowledged. As noted, a significant number of the artists whose international stocks are currently highest were born and educated outside of Mexico: Thomas Glassford and Miguel Ventura in the US, Marcos Kurtycz in Poland, Melanie Smith in England, Gerardo Suter in Argentina; and the same is true of some of Mexican art's most influential critics, historians and curators: Osvaldo Sánchez, for example, Debroise himself, or Ery Cámara. As Montes (2005) notes, for artists charged with mediating, bearing witness, or reporting on what is seen for distant others, being based in Mexico is more important than being *born* there. This is another counterweight, crude but potent, to simplistic identity claims around contemporary Mexican art and its analysis.

As this highly schematic narrative suggests, the present unease around notions of national and urban identity derives from a number of interrelated factors: its historic association with a now decadent political party and project; changing social structures; globalization, cultural integration, and their debilitation of national borders; and, in the specific context of contemporary art, the cavalier reduction of a heterogeneous body of work (to clichéd tropes, supposedly essential characteristics, core items or artists) by international curators pursuing their own programmatic, ideological, or commercial priorities. The strains of resisting these appropriations while supporting increased visibility for work produced in Mexico are evident in a certain weariness in Medina's introduction to the 'Eco' catalogue (2005a). In his own contribution, Debroise argues pragmatically that the only way of countering definition by others is to define oneself (2005: 184). Medina disagrees in principle, yet his practice underlines the difficulties this presents. It is not thematic, ethnic, geographical or national factors that unite the exhibitors, he argues, but the fact that Mexico 'transitó de la revolución institucional a la crisis permanente' (has journeyed from institutional revolution to permanent crisis) (2005a: 16). While more respectful of the historical realities, replacing postapocalyptic chaos as a generating principle of contemporary art with 'crisis' hardly avoids the reductionism he criticizes in others. But what he does with the term is suggestive. The most interesting art being produced in Mexico today, he argues, emerges from this sense of crisis, from the ruins of a modernization that has been delayed, betrayed and deformed, and from the 'padecimiento de un cuerpo social, si bien transformado en medio de sofisticación subjetiva'; in this sense, it is the product of a new 'estética *modernizado*' (the suffering of a social body, albeit transformed into a medium for subjective sophistication – an aesthetics of the *modernized*) (Medina 2005a: 14–15). And it is in their critical understanding of globalization as a failed modernity, he argues, that these Mexican artists are most cosmopolitan, most symbolically effective, and able to render historical change in a new sensibility.

Mexico City's role as the crucible of modernity since the 1940s, as the screen for changing projections of modernity and the theatre today of some of its most egregious failures, has ensured its resonance under different forms in much of this contemporary art. To international curators and entrepreneurs seeking a substitute for national identity in globalizing times (and particularly those less ready than Medina to acknowledge modernity's shortcomings) the capital's claims can seem irresistible.[15] But this is partly because its institutionalization as a source or repository for identifications, as the quintessence of Mexicanness, continues to be

sustained by some of Mexico's most audible voices. And among the most engaging of these is Carlos Monsiváis.

Monsiváis was not the first to represent the experience of living in Mexico's megalopolis as chaotic. Particularly with the publication in 1995 of his collection of essays *Los rituales del caos*, however, he has helped to lend drama, a qualified legitimacy, and international profile to the view that the failed promise of modernity has made this chaos irredeemable and distilled it in the capital. The terms in which Mexico City is now routinely hyperbolized – as 'una de las regiones más contaminadas del planeta[, . . .] un eterno embotellamiento[, . . .] un mundo sin ley[, . . .] un monstruo, un desastre urbano, una pesadilla moderna' (one of the most polluted places on the planet, an endless traffic jam, a world without law, a monster, an urban disaster, a modern nightmare) – are largely indebted to him, though his broader perspective is considerably more nuanced (Gallo 2005: 13). In less apocalyptic formulations this chaos becomes the source of 'a vital cultural experience both enriching and destructive[. . ., from which] creation springs' (Olivares 2000a: 13). This optimism of the critical will is a world away from Medina's proposals. Its pre-Hispanic overtones recall Gonzalo Celorio's characterization of the capital as 'una ciudad de papel' or city of paper, where cultures tend to proceed by displacement rather than accumulation – Tenochtitlán displaced by the colonial centre, the viceroy's city by the independent one, the nineteenth-century capital by the post-revolutionary one – and where lost cities persist in the words of those who described, calibrated, liberated or redefined them (Celorio 2005: 41). Monsiváis has helped to construct this paper city, from within the thick of it, for almost four decades; but his vivid foregrounding of visual culture is a reminder that in Mexico, 'as in other territories dependent on the iconosphere, nothing happens without the commerce of images' (Morales 2000: 150–1). The essay featured here, perhaps the best-known of his urban 'snapshots', is a vivid interweaving of the verbal and the visual. 'Identity hour or, What photos would you take of the endless city?' lists 'the most frequent images' of Mexico City:

- multitudes on the Underground (where almost six million travellers a day are crammed, making space for the very idea of space);
- multitudes taking their entrance exam in the University Football Stadium;
- the 'Marías' (Mazahua peasant women) selling whatever they can in the streets, resisting police harassment while training their countless kids;
- the underground economy that overflows on to the pavements, making popular marketplaces of the streets. At traffic lights young

men and women overwhelm drivers attempting to sell Kleenex, kitchenware, toys, tricks. [. . .];
- mansions built like safes, with guard dogs and private police [. . .];
- masked wrestlers, the tutelary gods of the new Teotihuacán of the ring;
- the *Templo Mayor*: Indian grandeur;
- '*piñatas*' containing all the most important traditional figures: the Devil, the Nahual, Ninja Turtles, Batman, Penguin;[16]
- the swarm of cars. Suddenly it feels as if all the cars on earth were held up right here [. . .];
- the flat rooftops, which are the continuation of agrarian life by other means [. . .] There are goats and hens, and people shout at helicopters because they frighten the cows and the farmers milking them [. . .];
- the contrast between rich and poor, the constant antagonism between the shadow of opulence and the formalities of misery;
- the street gangs, less violent than elsewhere, seduced by their own appearance, but somewhat uncomfortable because no-one really notices them in the crowd. (Monsiváis 1997: 31–2)

In this '*postapocalyptic city*', he observes, 'chaos displays its aesthetic offerings' (Monsiváis 1997: 35, 33, emphasis author's own). Yet to leave this chaos is 'to lose the formative and informative advantages of extreme concentration, the experiences of modernity (or postmodernity) that growth and the ungovernability of certain zones due to massification brings [and residents'] celebration of the incredulous in which irresponsibility mixes with resignation and hope', and where 'in practice, optimism always wins' (34–5).

Clearly, this optimism is hard won; it is easy to understand the frustration of Medina and others on seeing it reproduced and reified by curators who know the suffering of this social body chiefly as cultural tourists (Medina 2005a: 15). It is indicative of the cultural and political change he has documented in the city that Monsiváis himself has steered a changing course between cultural optimism and pessimism over the last four decades. His powerful affirmation of 'lo popular urbano' (the urban popular) rests partly on its deployment as a bulwark against 'los riesgos alienadoras de la socieded capitalista y de masas' (the alienating risks of capitalist mass society): that is, against the pace of urban growth and the rise of the culture industries in a period of intensifying economic crisis, and against a political will to 'diversify, modernize and internationalize' to the detriment of forms of national democratic solidarity (Monsiváis 1997: 30, Bencomo 2002: 125). And it affirms a vision of Mexicanness that rejects the massified version projected by global media in favour of one derived from a particular and (however ironically) nostalgic

interpretation of aspects of the national past. But his sense of the popular as a defence against cultural and political risk was transformed by the tragic materialization of a much older risk. In the early 1980s, the economic and political consequences of the debt crisis had radically weakened the traditional top-down authority of the state; the devastation caused by the Mexico City earthquake in 1985 brought this weakened authority to crisis.[17] At the same time, the bravery of the rescue teams and ordinary citizens who laboured alongside them in hazardous conditions underlined, in dramatic terms, the ability of civil society to create, organize, and channel its own democratic energies. The experience conspired with the effects of neo-liberal economic and social restructuring to produce a period of intense and generalized political activism. The explosion of parents' groups, civil defence groups, employers' groups, workers' groups, women's groups, ecological and peasant organizations, neighbourhood and community bodies seemed for a time to open up the possibility of radical democratic change (Loaeza 1993: 128).

Mexico's tradition of 'revolution from above' suffered a sustained assault during this period – and one intensified in the aftermath of the Zapatista uprising – from which it has not recovered. Monsiváis watched these developments intently, setting aside his vividly vernacular personal style to offer a 'visión fotográfica' (photographic vision) of events as they unfolded (Bencomo 2002: 144). But as the decade ended it became clear that the chief beneficiary of the changing relations of state and society were not citizens who had been excluded from the benefits of the old regime; it was the those who had gained most during the earlier period of economic boom. This development (which is discussed in the next chapter) severely tested the faith of Monsiváis and many other critical intellectuals in the notion of social transformation. They watched as the growing confidence and proliferation of individual and collective social actors conspired with the loss of a clear oppositional focus to block the emergence of a concerted opposition. The 'pueblo' had become a multitude, and one whose heterogeneous social and political energies complicate all three of the photographic projects discussed here.

The second of these projects serves to offset the otherwise relentless focus on Mexico City while throwing a distinctive sidelight on features of urban experience highlighted in the other two. In *Instantáneas: Medios, ciudad y costumbres en el fin de siglo* (Snapshots: media, city and customs at the century's end) (1996), Argentinian cultural critic Beatriz Sarlo walks the streets of Buenos Aires, charting her encounters with volatile aspects of contemporary audio-visual culture and daily life in a combination of photograph album, scrap-book and travel diary. For Monsiváis, the streets of Mexico City reveal the pulsing of 'lo popular'

through the social body: what Sarlo sees is the market's imaginary at work. And what fragments journeys, what holds up the flow of city travel and repeatedly distracts the photographic gaze, are a chaotic transport system, inadequate public services, the aggression of frustrated travellers, the insistence of poverty and (as we shall see) the high-handedness of citizens made vulnerable by the lack of clear laws. But above all, she insists, it is the capital's construction as a market dystopia, a giant hoarding whose material supports level the city's richest and poorest districts: every wall, taxi-rank and square, every open space, every level of every building is covered in advertising (Sarlo 1996: 48).[18] Like Krauss and Foster, she reads in these images and wrapped buildings the banal language of capitalist space as it seeks to educate potential consumers in the possibilities of consumer exchange.

John Kraniauskas has described the writing of Monsiváis as 'cinematic, his point of view a camera eye' to the extent that it prefers 'the openness of a shifting proximity over a centred critical distance' (in Monsiváis 1997: xv). Sarlo's critical gaze is more centred, and marked by a sharper aesthetic detachment: her photographs all have an acknowledged point of view, and it is close rather than complicitous. In 'Identity hour', the Mexican obliquely acknowledges both the vividness and the reductiveness of his urban snapshots. He glances only half-ironically at a 'typical repertoire' of the capital's commonplaces – places that, like familiar photographic images, are not wholly evacuated of affect by replication – before driving tumultuously on, gesturing as he passes towards the mobile multitudes, the social fragmentation associated with urban massification, the potent mix he detects there of resignation and hope (Monsiváis 1997: 33). But Sarlo's snapshots are more like biopsy slides, slicing through the social body to reveal a pathology at work there. They are less urgent than his, their critique is more sustained and (for all the allusions to familiar streets, sights and districts) their framing is more deterritorialized. Epigraphs refer her walks through Buenos Aires to Benjamin, Nabokov, Deleuze and Guattari, Lewis Carroll, Goethe, Barthes, Robert Musil, Bakhtin, Eugenio Montale, and Merleau-Ponty, among others, as if to chart a parallel intellectual journey as she searches among 'contaminación visual' (visual contamination) in search of clusters of meaning that resist interpretation (Sarlo 1996: 48).[19]

The research project of García Canclini, Rosas Mantecón and Castellanos does not use photographs to chart a certain relentless homogeneity in the cultural experience of the capital, nor yet ungovernable heterogeneity – although their findings reveal both. The researchers are concerned less with articulating the raw experience or mute meanings of urban late modernity than with how residents work to ward off, contain,

or reconvert the risks and alienation routinely associated with it. Its context is a broader examination of how the subjective and fragmented images with which citizens create their capital differ from the more abstract and orderly diagnoses of planners and public policy-makers. To this end, the project team use photographs to chart changes and continuities in the way residents construct their capital in imagination and 'put it into practice' in the course of their travels. They selected fifty-two travel-related images of Mexico City and asked repondents to indicate which coincided most closely with their personal image or vision of the city.[20] Where they noted continuities or changes they were asked to describe them. The ten focus groups were made up of intensive travellers: on the one hand, delivery people, vendors, traffic police and taxi-drivers, all of whom defined themselves as working-class; on the other, students living away from their place of study, and sales and marketing personnel, all defined as middle-class. The phenomena photographed ranged from traffic jams and pollution clouds to street demonstrations, letter-boxes, and the ubiquitous advertising hoardings. Some images (of older buses, for example, or ramshackle cars) were designed to suggest continuities. Others showed more recent features, such as the metro and satellite dishes. Group members were asked which seemed most representative of their travel experience and what they thought travel meant for city dwellers. In order to maximize opportunities for comparisons and contrasts, the images were taken from the 1990s and from the 1940s/ 1950s.

In an attempt to neutralize what they present as formal distractions, the project team restricted representations of each of the two periods to the work of a single photographer.[21] For the earlier period this was Nacho López. But there are risks attached to using his photographs simply as neutral, evidential, reproductions. As noted in Chapter 1, his perspective was profoundly shaped by the presidency of Lázaro Cárdenas (1934–40) and his photographic practice and writings exhibit a cardenist will to bind disparate postrevolutionary interests. His images of the urban everyday bear witness to his socialist convictions and sustained testimonial intent; he visualizes a heterogeneous Mexico at odds with the rise of Northern business interests and Cold War chauvinism under President Miguel Alemán (1946–52) and – in a period of 'unregulated, non-consensual modernization' – presents the nation as itself a project under construction (Segre 2001a: 206). His images register what Castellanos terms 'la escisión definitiva' (the definitive split) at that time between urban and rural imaginaries, affirming something like an urban national popular not so far removed from the one invoked by Monsiváis, in which the 'pueblo' (people) becomes the diverse, collective, hero of

new nationhood (Castellanos 1996: 50). In practice, López does not always avoid the essentializing, exoticizing tendencies he rejects in theory, nor live up to his aim to make the rural migrants and other urban 'olvidados' (forgotten Mexicans, marginalized spatially and in Alemanist politico-economic rhetoric) visible as social actors rather than victims. This tension between his acute photographic critique of the contradictions of *alemanismo* and his apparent blindness to his own contradictions resonates in what Segre calls his 'distilled antinomies in black and white' (2001a: 206). These are arguably clearest in his writing, however:

> Lights and shadows of Mexico! The permanent contrast of its people: misery and opulence, serenity and violence in their hearts, the present and the past in daily life. Passion, blood and pain. All are part of the Mexican essence. (Cited and translated Mraz 2003: 190)

This hyperbolic heroization of his subjects throws into question the heterogeneity he affirms elsewhere. Because his critique of photographic realism was a powerful influence on the city's photojournalists in the decades that followed, however, López's visual strategies bear more than passing significance for the formation of the urban imaginaries of the capital's residents. The place of his work in official constructions of the national 'patrimonio cultural [. . .] inmaterial' (non-material cultural heritage) is underlined by the fact that most of it is now housed in the Fototeca del Instituto Nacional de Antropología e Historia (García Canclini and Rosas Mantecón 1996: 65). In a Mexico that has seen the power of other once-hallowed symbols dramatically reduced in recent years, this is not fortuitous. In this sense, too, his photographs cannot be read simply as innocent reflections of another period.

The photographer charged with representing the Mexico City of the 1990s is Paolo Gasparini. Like Julio Etchart, he is an altogether more cosmopolitan figure than López: born in Italy in 1934, he left for Caracas in 1955, spent the mid-1960s in Cuba, and has travelled extensively ever since. He has been winning national and international accolades for his work since the 1950s: early influences included Italian neo-realism and later, and more enduringly, the left humanism, technical precision and sometimes brutally frank perspective of his friend Paul Strand. From his early work as an architectural photographer, however, to the recent comparative studies of Mexico City, Los Angeles, and São Paulo he has probed the material and imagined relations of residents, urban space, and social structure; and he was working on the urban culture programme of the UAM (Metropolitan Autonomous University) when the project was conceived. Gasparini is aware of the more fractured photographic responses in recent decades to new cultural and spatio-temporal

uncertainties, to unfamiliar modalities of social and political risk, and to a prevailing loss of faith in 'el "realismo fotográfico" [como] modo de aprehensión y de re-elaboración de ideas comunes, de mitologías cotidianas' (photographic realism as a means of apprehending and re-elaborating shared ideas and everyday mythologies) (Debroise 1987: 49). Yet these responses are expressed here at the level of subject rather than style – in the young men on buses absorbed in their mobile phones or Walkmans, the boys crowding around video-game consoles. Like the decision to use only monochrome images, this reflects the research team's will to impose 'cierta coherencia estilística' (a certain stylistic coherence) on the images deployed (García Canclini and Rosas Mantecón 1996: 63). In order to avoid complicating further the thematic richness of their subject matter, that is, they attempt to place questions of visual strategy and style in check. For Gasparini's monochrome is not simply a homage to López; it responds to the project's need for 'un material relativamente neutro, que dier[a] una visión "objetiva" sobre los viajes en la ciudad' (relatively neutral material that offers an 'objective' vision of urban journeys) (García Canclini and Rosas Mantecón 1996: 64). The qualifying 'relativamente', the use of the subjunctive, and the inverted commas are all critical here. They serve both to acknowledge and summarily displace the fact that black and white's association with unmediated documentary neutrality is even more questionable today than it was in López's time.[22]

Gasparini's pastiche, however respectful, cannot summon the power of López's immanent critique of photographic realism, his 're-negotiation of the criteria of visibility as well as the modalities of visualization' (Segre 2001b: 58). But like Sarlo, and like Monsiváis (with whom he has worked), he has been committed to tracing how capital cities' least-favoured travellers experience 'entre fracturas, quebrantos y fracasos[, . . .] una maldición después de otra' (fractures, afflictions and failures, one scourge after another) (Gasparini 2004: 1). The disjuncture that concerns him was unimaginable fifty years ago: it is linked to new forms of deterritorialization and displacement, to globalizing capitalist energies that are dynamizing spaces, galvanizing bodies, and transforming imaginary repertoires. In this sense, the two sets of images juxtaposed in the project can be read as registering the shift from a binding of differences to the loss of imaginary differentiation within transnational capitalism – a symbolic network that is radically reducing the possibility of an outside (Moreiras 2001). In López's images the 'outside' is visualized as unambiguously extra-national. He represents individuals creating nation and community from within, sometimes conflictually. His visual and spatial rhetoric works to neutralize difference as residents travel the capital together, their progress charted or rescaled by the horizontal lines

(cables, fences, roads) that cut through the towering verticals of build-
ings and, with them, through a certain architectural understanding of
modernity. In one photograph, a trolleybus passes before a shop frontage
surmounted by three Coca-Cola signs (Plate 3). They run like a strap-line
across the top fifth of the image, the remainder of which consists of a
view, through the trolleybus window, of four middle-aged passengers
caught in mid-conversation. The signs evoke in spatial terms the rising
profile and influence of Northern business interests and, with them, a
certain extra-national understanding of modernity. And by including the
window-frame in the image, López registers the distance from which this
influence is being assessed. Although the signs are suspended like surtitles
above their heads, the travellers seem wholly oblivious to them. The hor-
izontal lines graduating the internal space – the handrails, the window
frames – are blurred in the foreground and more defined towards the
image's centre (the plane supporting the travellers' heads) while strong
verticals reinforce the sense of spatial tensioning.[23] The presence of the
shop signs, with their cool imperative ('tome' / 'drink' Coca-Cola), is
both charted and fixed by this internal grid; in the process, it seems, a
marker of 'social disjunction' and disarticulation is simultaneously reg-
istered and displaced (Segre 2001a: 209). When, more than forty years
later, Gasparini photographs a McDonald's sign, however, it is the very
heart of the image; perversely naturalized, it emerges where the sur-
rounding greenery converges with two monolithic buildings alongside an
empty path.[24] Even when his travellers are shown crossing the capital
together they are invariably focusing on something else – video-screens,
mobile phones – as if each took for granted the other's unintelligibility.
The national or urban popular celebrated by Monsiváis, it seems, no
longer has a clear or even a clearly fantasized referent; the culture mobi-
lized or consumed here is implicated in wider networks with unknow-
able others.

 Even at their most fractal, however, his images suggest that this does
not preclude some form of connectedness, the *possibility* of solidarity,
while insisting on its limits. For while his young men do not look at one
other, they do appear in groups rather than in isolation. This recalls his
grouping of individual images in his most recent exhibitions to form
what he presents as murals (Gasparini 2004: 2). The increased scale and
visibility that this permits, he contends, its combining of photographic
and architectural space with murals' traditional politico-aesthetic
authority, might one day enable images like these to emerge from mor-
tuarial exhibition halls into public squares and to inaugurate public
debate there. In this sense, his suturing of photographic fragments is ani-
mated by a will to social binding that recalls López's; once again, it

3 'Trolebús' (Nacho López, from the series *México de Noche*)

seems, the images used here to evoke the disarticulated experience of megalopolitan travel are informed by a strong cohesive intent.

Sustaining this, and factored into the project from its conception, is the assumption that among travellers and more generally 'los mecanismos de construcción del sentido común en la vida diaria [. . .] son siempre colectivos, nunca individuales' (the mechanisms whereby shared meanings are constructed are always collective rather than individual) (García Canclini and Rosas Mantecón 1996: 69). Yet, despite the negotiation and consensus-seeking encouraged by the dynamics of the focus groups, responses generated by the photographs proved far more diverse than the researchers anticipated. Of the fifty-two images discussed, the two most widely seen as representative (and which were chosen by eight of the ten groups) were one of men pushing to get onto a bus and another of a peripheral road clogged with traffic. While respondents agreed on the capital's disorderliness and insecurity, it seemed, they imagined it in different ways. Traffic police saw the city as a place where order could, in theory, be imposed and were more alert than other groups to where this was not happening: they commented on the failure to observe traffic lights, for example, or the (for them, inexplicable) absence of photographs of mothers double- or triple-parking as they dropped off children at school. Taxi-drivers and delivery people, on the other hand, tended to see travel as a succession of more or less random complications and problems to be surmounted: they admitted

driving through red lights, for example, to compensate for blockages else-where and parking on pavements in the absence of convenient alternatives. In none of these cases do travellers make a strategic attempt to change or explicitly challenge rules, García Canclini (1997) notes: instead they respond creatively, with a series of tactical, provisional and highly differ-entiated negotiations to what they see as the intractable realities of urban life. But because these tactics do not obey any larger rational imperative, he argues, they contribute to a type of citizenship that reproduces system-atic inequalities, with responsibility for problems being displaced onto iso-lated culprits: immigrants, politicians, shanty-town residents, planners, the unemployed.

It requires a certain creativity to render these instances as expressions of the *collective* construction of daily life. And while the project offers other, equally interesting, sidelights on how residents – and researchers – manage heterogeneity these, too, bear little mark of a collective will at work. Travellers' imposition of coherence on their surroundings is a case in point. For the majority of respondents, 'importa menos saber cómo funciona efectivamente la sociedad que imaginar algún tipo de coherencia que ayude a vivir con ella' (knowing how society really functions is less important than imagining some form of coherence that will help them to live with it) (García Canclini 1997: 129). Because the megacity is perceived as unknow-able as a whole, for example, inhabitants make no attempt to know it all. 'Uno puede haber nacido, crecido y jurado no abandonar esta ciudad', as José Joaquín Blanco observes, 'y, sin embargo, apenas conocerla: vivir en ella es sólo ejercer [. . .] algunos de sus lugares' (you can have been born, grown up and sworn never to leave this city yet never really know it; living in it is really only 'putting into practice' certain parts of it) (2005: 116). The stories and interpretations travellers invent to make their experience of the city more intelligible and less inhospitable tend to be fragmentary, inconsistent with each other and with official narratives (of how the capital functions, and how it ought to function) which themselves require imagi-native negotiation. Though critical of those official narratives, this pub-licly-funded project is not discontinuous with them. It is designed to supplement them, to render them more thoroughly informed by an aware-ness of factors shaping inhabitants' daily use of their city, their imaginary mapping of it, and the construction of their own eclectic, negotiated nar-ratives around it. In this sense, and like the members of their focus groups, the researchers offer no sustained challenge to official representations which are themselves partial and contradictory.

López's photographs can be read as celebrating, in order to secure, the emergence of a new, solidary and modern Mexico. Gasparini's are animated by a very different set of narratives – official and unofficial, and

no more coherent than any others – that obliquely question what it means to be Mexican in a period of globalizing modernity. The images of satellite dishes, computer screens, the mass displacement of bodies, all project a much larger dynamic binding cities and residents in an irregular, mutual conformation. By consistently failing to reflect on these larger forces shaping their city, the researchers contend, by palliating their consequences tactically, residents contribute to the emergence of a type of citizenship that is unable effectively to engage the dynamics of advanced capitalist modernity. Underlying this contention, once again, is an awareness that the citizens López and others helped to construct, however factitiously, as 'pueblo' have given way to multitudes. This was brutally highlighted by the Zapatista uprising, which erupted into the national and global fields of vision during the course of the project, blasting away the crumbling vestiges of PRI's nationalist discourse and exposing the structural exclusions and other contradictions of the neo-liberal modernization programme onto which it had been grafted. The city, it became clear, could no more bind these disparate interests – interests united more around present and future risks than by a shared understanding of the past and its role in shaping national and local space – than could the state. Writing in the rebellion's immediate aftermath, Monsiváis speculated on the raw potential of the rebels to galvanize multitudes and displace the massified consumers of media spectacle. But he would later register the subjection of these multitudes to newer, more horizontal, forms of control and wider-ranging forms of discipline (Hardt and Negri 2000: 330, Bencomo 2002). García Canclini and his collaborators were also writing in the uprising's aftermath and they, too, might have expected to find in travellers' creative appropriations of space the promise of new forms of politicized subjectivity. But they, too, were clearly disappointed with what they saw.

Although globalization has stripped the 'national referent' of much of its force in recent decades, it continues to rely for key aspects of its functioning on the existence of nation states (Moreiras 2001: 10). While this is likely to ensure its continuation in the medium term, the Mexican state's ability to generate compelling counter-narratives and visions has, as noted, been seriously compromised. In particular, having energized its projects and their projection for almost a century with the power of images it no longer has a monopoly on them. The partial embedding of consumer modernity has been supported by images that signify the satisfaction of *desire in general*, excluding individuals from the productively critical labour of imagining and articulating alternative visions of what used to be called the good life. In this sense, travellers who are immersed each day in the imaginary production of the megalopolis – disembedded

from some traditional social structures but not from others; increasingly detached from familiar sources of security, support and understanding; re-embedded in social forms and forces too new or too pervasive for them to recognize; and left to wrestle individually with the consequences – are not well-placed to devise alternative ways of living in it. To this extent, there is a kind of rationality that the research team barely acknowledges in travellers' preference for a tactical, imagined, micro-coherence, a coherence within which heterogeneity figures chiefly in obstacles and risk. But the researchers' desire to supplement official visions of the city rests on a determinedly modern assumption that, without a sufficiently critical, compelling and coherent frame for such efforts there is no context in which alternatives (oppositional or other-wise) could be imagined.

Today, it seems, the most compelling visions of Mexico – some officially sanctioned, others not – emerge in the spectacular extra-national constructions of global visual culture. But, as noted, the dynamic that sustains these shifts, and their thrilling intensity for certain contemporary artists and others, is a volatile one. Exoticism has a short shelf-life, and the glib or opportunist reduction of visual culture produced in Mexico to a tiny group of names and tropes within the global iconosphere is a fragile basis for its future development. For the moment, like the capital's commuters, members of that group are devising tactical, *ad hoc*, responses to these new and unpredictable circumstances. For those whose art practices are informed by Medina's 'estética modernizado', however, Mexico's displacement by the next global art hot-spot is likely to figure as a painful vindication.

Notes

1 The project was undertaken as part of the Urban Cultural Studies Programme of Mexico City's Universidad Autónoma-Iztapalapa, between 1993 and 1995, in collaboration with the Consejo Nacional para la Cultura y las Artes and the Fototeca of the Instituto Nacional de Antropología e Historia. The results were published as *La ciudad de los viajeros: Travesías e imaginarios urbanos: México, 1940–2000* (García Canclini, Rosas Mantecón and Castellanos 1996) a year after its completion.

2 For a detailed analysis of his argument see Brooksbank Jones (2005). His observations are part of a wider international reassessment of urban visions and visuality in the 1990s. On this see Silva (1992), LeGates and Stout (1996), and Castellanos (1996).

3 The shortage of academic studies on contemporary Mexican art has been widely noted. Princeton-based literary, and latterly art, critic Rubén Gallo has begun to address this in a recent study of Mexican art in the 1990s (2004).

Its tendency uncritically to assimilate work produced in Mexico to externally-generated (literary and other) models, however, and its occasional inaccuracies mean that it needs to be read alongside other assessments cited below.

4 On the crucial but often overlooked role of anthropologist Manuel Gamio and North American journalist Katherine Anne Porter in the construction of Mexican artistic identity in the period, and of Gerardo Murillo (Dr Atl) in helping to embed this in folk art, see Debroise (2001a). Vasconcelos's own role in the construction process was more ambivalent than is usually acknowledged; see Miller (1999).

5 In this respect muralism would prove less successful as a public, political, art than the graphic work of Luis Arenal, Leopoldo Méndez and other (mostly Communist-aligned) members of the capital's Taller de Gráfica Popular, or Workshop for Popular Graphic Art (1937–c.1977). Their efforts consolidated the place of graphic art in Mexican popular culture, whereas muralism's impact at home came later and was at first derived largely from its international success.

6 In the absence of a strong academic tradition of contemporary Mexican art studies, and at a time of influential international art fairs, the more established of these galleries have played an increasingly key role in advancing understanding, and the national and international profile, of a core of contemporary Mexican artists. (See Cámara 2000: 168). As Sloane notes, it has also led indirectly to the marginalization of any work not perceived as commercial (2000: 63).

7 On the economics of these processes see Aizpuru (2004). Ashida and Zugazagoïtia suggest that it was only the support of a small core of wealthy collectors and internationally-known intellectuals such as Octavio Paz, Juan García Ponce and Fernando Gamboa that sustained a small core of young artists and the galleries promoting them during this period (2005: 441).

8 Emblematic of this cultural and economic 'boom' was the exhibition 'Splendor of Thirty Centuries', curated in 1990 by North American and Mexican experts for New York's Metropolitan Museum. As Ashida and Zugazagoïtia note, it drew together periods, people and work with little or nothing in common to form an apparently seamless continuum that evoked 'un perfil de lo que supuestamente sería la esencia de la cultura mexicana' (a profile of the supposed essence of Mexican culture) (2005: 443). The fact that this high-profile event was not held in the Museum of Modern Art is perhaps explained by the fact that, despite growing interest in some of the young artists being promoted by new (and especially corporate) collectors, its curators opted to include nothing produced after the 1950s.

9 While the violence did not decline under his successor, Ernesto Zedillo, there was some strengthening of democratic structures (see, for example, Ward and Durden 2002). In the year 2000 these would contribute to the dislodging of PRI from national government (by the centre-right Partido de Acción Nacional or PAN) for the first time since the Revolution, and much debate among public intellectuals concerning the fate of the postrevolutionary project. This is discussed in Chapter 3.

10 For a contemporaneous charting of these processes see the weekly *El ojo breve*, the influential *Curare* and (now defunct) *Poliéster*.

11 The year 1991 would also see the inauguration of inSite, a site-specific initiative designed to create an artistic bridge between San Diego and Tijuana. Curated jointly by Mexican and North American experts, the project is now in its fifth year.

12 The Colección JUMEX was established by Eugenio López, young billionaire heir to Mexico's leading fruit-juice company. Though notionally open to the public, its heavily-fortified premises are accessible only by prior appointment.

13 While his general claim is compelling, López Cuenca is clearly wrong to suggest that all neo-conceptualist work lacks political edge: the Mejor Vida Corp project of Minerva Cuevas, for example, offers an acute and witty critique of consumer capitalism.

14 In English, 'The insidious taste for the global: art for a post-Mexican century'; 'Alibis'; 'Highly-coloured surfaces'.

15 There has been a marked shift within cultural, economic and other policy fields in the last two decades away from Mexico City, particularly as seemingly intractable transport problems, pollution and rising crime have tended to militate against major new initiatives there, contributing to a wider trend towards political and, later, economic decentralization from the 1980s. (Nor should it be forgotten that 25% of Mexicans do not live in cities.) In 2000 García Canclini reported that 'a branch of the Guggenheim and two cultural mega-complexes are planned for Guadalajara, while Monterrey is set to host Barcelona's Universal Forum of Cultures in 2007 with private and public sector co-operation (2000: 26).

16 *Piñatas* are containers, filled with sweets and candy figures, which are hung up during fiestas. When hit with a stick, they release their contents. Monsiváis notes their syncretic juxtaposition of pre-Columbian, pop-Catholic, and 1950s and 1990s mass media cult characters.

17 The effects of the earthquake were most devastating among buildings constructed in the course of the rapid modernization process that began in the 1940s. Public administrative buildings, which were concentrated (along with key government buildings and UNAM, the National Autonomous University) in the central areas, took the brunt of the force, drastically compromising the administration's ability to manage the relief effort. A lasting consequence was the rapid acceleration of the decentralization process begun in the previous year. For a detailed near-contemporary assessment of these events see Garza (1987). The research project undertaken by García Canclini, Mantecón and Castellanos is part of the continuing reassessment of the capital's urban development programmes in the wake of them.

18 This phenomenon is at least as striking in Mexico City. The dramatic increase in scale can be traced there to the early 1930s, although the mid-1950s saw the introduction (especially in Avda Insurgentes) of spectacular examples as high as surrounding buildings and usually advertising women's underwear, cigarettes, footwear, or white goods. For examples see Conaculta-

INAH/Lunwerg (2004: 116, 158–9). There are superficial parallels between the urban strolls of Sarlo and Monsiváis and Benjamin's reworking of Baudelaire's *flâneur*; but there are also important divergences. See Baudelaire (1970, 1972), Benjamin (1973, 1979) and Tester (1994).

19 The allusions to intellectuals associated with very different places cannot be read simply as an irony of globalization; her compatriot Domingo Faustino Sarmiento, for example, the nineteenth-century statesman and educator, routinely supported his own arguments with reference to European authorities.

20 The researchers also produced a twenty-minute video of clips from films based in the city. These consisted of six films from the earlier period, including Galindo's *Campeón sin corona* (1945) and *Esquina bajan* (1948), and Buñuel's *La ilusión viaja en tranvía* (1953), and eight later ones, among them Olhovich's *Muñeca reina* (1971), Novaro's *Lola* (1989), Systach's *Anoche soñé contigo* (1991), and *Modelo antiguo* (1993) by Araiza.

Respondents were first asked individually to describe (in no more than three minutes) a typical day; they were then asked to select, as a group, the ten photographs most representative of how they travelled and what travel meant for them, focusing particularly on changes and continuities across the periods and noting any experiences which were not represented in the photographs; this process was then repeated with the twenty-minute video-clip. Responses to the video were omitted from the finding, however, as respondents reportedly found it awkward to review, while 'la explícita teatralidad de las películas' inhibited viewer identifications (García Canclini and Rosas Mantecón 1996: 66–7).

21 References in the project to formal aspects of the visual prompts are rare. This dimension was to have been addressed by the inclusion of a group of photographers among the respondents; in the event, members' work commitments led to its collapse before the project was complete.

22 Sontag notes that black and white is conventionally 'more tactful, more decorous than color – or less voyeuristic and less sentimental or crudely lifelike' (Sontag 1978: 128). On photography's status as *analogon* or 'message without a code' see Barthes (1981). By restricting his comments to monochrome press photographs Barthes felt able to bracket the rhetoric of the photographic image. John Tagg famously takes issue with him, noting that even the press photograph is not an objective, material emanation of its object but the material product of a maker and her/ his apparatus set to work in specific contexts, by specific forces, for more or less defined purposes. For a critique of his useful, albeit determinist, analysis see Price (1994: 9).

23 This may be an example of 'crossed trajectories' refocusing or reconstituting cultural identity in López's work: on this phenomenon see Segre (2001a, 2001b). I am grateful to her for drawing these essays to my attention.

24 The rigid formality of the golden arches suggests a machinic recapitulation of the splayed curves of the Restaurante Xochimilco frontage photographed by López forty years earlier. Both images can be seen in García Canclini, Rosas Mantecón and Castellanos (1996: 76).

3

A scandalous family album

This chapter examines a quite different and highly controversial approach to social binding, which turns on questions of individual subjectivity and democratic subjecthood.[1] The volume's first two chapters explored the use of photographs in the formation and critique of certain global and urban imaginaries. Here, in this last chapter centring on Mexico City, the focus narrows again. Its subject is tensions between personal and national imaginaries, as illustrated in the scandal provoked by an idiosyncratic family album.

In April 2002 New York's Greene Naftali Gallery held a solo exhibition of 'Ricas y famosas' (Rich and famous), a series of photographs by Mexico City-born Daniela Rossell.[2] Three months later a selection was included in the P.S.1 Contemporary Art Center's 'Mexico City: an exhibition about the exchange rate of bodies and values', in New York. The series was the fruit of a project begun in 1994, when Rossell was a twenty-one-year-old drama student loosely connected with Mexico City's Temístocles group. As noted in Chapter 2, the group was made up of young experimental artists critical of the neo-Mexicanist art practices and symbology then in favour among the nation's art-buyers. So dominant were these practices, however, that the group's critique and the work it informed at first found only a limited audience within Mexico. Initially, Rossell's photographs were no exception; by the end of the decade, however, she was one of several members who were finding a wider international audience and, largely for this reason, increased attention within Mexico.[3] But she could not have predicted the scale or the nature of the response that those New York shows would generate, the 'escándalo globero' (global scandal) they would unleash, the death threats, and the critical vitriol (Güemes 2002: 3). The photographs were, after all, of her friends and relatives in their home settings.

But this family album exposed to public view the wives, daughters, mistresses and lifestyles of Mexico's traditional political oligarchy.[4] Intimacy and possessions hitherto preserved from public view assumed a blistering vividness when juxtaposed in the course of the P.S.1 exhibition with more familiar representations of Mexico City: the 'vendedores ambulantes, accidentes de tránsito, pobreza urbana y violencia' (street sellers, traffic accidents, urban poverty and violence) (García Machuca and Sánchez 2002: 1). Within Mexico, this visual shock, magnified through the media in the Americas and Europe, sparked bitter debate around the project. The menacing telephone calls came not from the PRI oligarchy's traditional critics, however, but from her subjects: the relatives and erstwhile friends who – not anticipating that these family shots would be exposed, in all their candid archness, to the gaze of a wider public – had assigned her right to the images.[5]

Behind the hostility of many of her critics is the fact that Rossell situates her project explicitly within Mexico's 'rich tradition of ethnographic photography' (Rossell 2002a). The most respected figures in this tradition – Álvarez Bravo, for example, López, or Graciela Iturbide – return repeatedly to poor or indigenous Mexicans or the daily lives of city-dwellers.[6] As Carlos López Beltrán points out, however, Rossell is not interested in anthropology and ethnology as more or less austere windows on primitive otherness: instead, 'muestra y cuenta el raro y desubicado mundo de las filthy rich cows' (she shows us the strange and directionless world of filthy rich cows) (2001: 149–50).

Unsurprisingly, Rossell sees it rather differently. It is, she says,

> como una vuelta de tuerca en relación con la histórica fotografía documental mexicana [. . Dice Rossell] 'en lugar de documentar la vida de los pueblos indígenas, la pobreza urbana o exóticas escenas populares, yo he elegido el hábitat, las costumbres y tradiciones de la minoría más pequeña de México: los ultra-ricos' [. . El proyecto] tenía como único objetivo documentar las cosas que este particular grupo de gente decide poner en su casa, el ambiente que habitan y el estilo con el que eligen identificarse.

> a twist on traditional Mexican documentary photography. Says Rossell, 'instead of documenting the lives of indigenous groups, urban poverty, or exotic scenes from popular culture I've chosen the habitat, customs and traditions of Mexico's smallest minority: the ultra-rich'. The project's sole aim was to document the things that this particular group decide to put in their homes, the environment they inhabit, and the style with which they choose to identify themselves.

What separates her methods from those of her distinguished co-nationals, the 'vuelta de tuerca', is partly the emphasis on possessions, style and identification.[7] But there is also the fact that she is herself a member of

the minority whose habitats and lifestyles she sets out to document. This exposed her to charges of complicity with her subjects, a complicity at odds with the objectivity claimed for classical ethnographic practice. By the same token, it might have been expected to preserve her from the charge (levelled in recent times against Álvarez Bravo and his one-time students López and Iturbide) of a certain complicity with the camera's objectifying gaze. It did not, however: the response of some of her subjects underlines the extent to which they came to see themselves as objectified by the images, or by the scandal generated around them. Their own collusion in these processes will be examined shortly. But it was not her ethnographic aims that most incensed Rossell's critics. Their heaviest fire was reserved for her vision of a community that rejected national paradigms in favour of style, family connections, and the personal. Their assault on her own and her subjects' political identifications was one aspect of this. Rossell's images affirm her family's lifelong identification with the Partido Revolucionario Institucional (PRI), the hegemonic force in Mexican politics from its founding in the aftermath of the Revolution to its defeat in the national elections of 2000.[8] But this does not mean that every individual in the collection is associated with the PRI. It is not fortuitous that Mauricio Fernández, for example, former PAN candidate for Nueva León, poses here alongside his family tree. For Rossell's project centres not on Mexico's *priísta* 'familia revolucionaria' or revolutionary family, but on an incestuous 'clan cortesano' (clan or court) surrounding, and drawing its influence from, successive presidents (Salazar Cruz 1993: 355, Guillermo Tovar y de Teresa, cited La Palabra 2005: 2). The PRI was already in crisis when the first of these photographs was taken and had been dislodged from power by the time they were exhibited in New York. Rossell's images are a stark reminder that, in the case of the Díaz Ordaz family, for example, the inheritors of the 'monarcas sexeniales'[9] include representatives of both the PRI and the Partido Verde Ecologista de México; that PAN candidates like Fernández are relatives or close business allies of the *priísta* elite; and, more obliquely, that Mexicans expecting a major democratic breakthrough with the PAN's election victory in 2000 were likely to be disappointed. As Luis Salazar Cruz observes, party alternation does not of itself bring democracy without democratization and the strengthening and decentralization of institutions (1993: 374).

The PRI logo that underpins the identifications in 'Ricas y famosas' thus serves less as the emblem of a mass political party than as a shibboleth affirming membership of a clan. It is the ultimate decorative item or attribute, before which Rossell poses in dark glasses on the rear cover of *Ricas y famosas*, the volume based on the series. Inside, and in settings

where one would expect to see family portraits, her subjects can be seen posing with casually proprietorial air alongside images of Revolutionary heroes. In one striking example a young woman sporting a skimpy lurex top, pink hot pants and a Stetson sits in a front-lit and deeply shadowed room on a saddle-style chair. One crimson-stilettoed foot rests on a stuffed alligator which, like the chair, is mounted on a leather-topped desk. On the rear wall, dwarfed by her shadow, is a neo-Mexicanist image of Zapata. On the table beside her is another and, spatially aligned with it, a photograph and a video of her father, Beto Banuet, as a PRI electoral candidate.[10] Towering above them on this altar/table she flicks cigarette ash, with a gesture of theatrical desecration, onto the icons below. In terms that will have resonated with her Temístocles collaborators, Rossell is affirming the decathection of 'la "herencia" revolucionaria' (the legacy of the Revolution) and its symbology (Salazar Cruz 1993: 346).[11] In other images, the national flag figures as one personalized decorative item among others: one that affirms the lineage of the bearer as unequivocally as do the family trees displayed elsewhere.

The pose assumed here represents a theatrically explicit challenge to the conventional force of genealogy as a guarantor of politico-cultural memory and value; it asserts the reduction of political life to decadent lifestyle, the evacuation of political icons in decorative items, of dangerous, handsome beasts in leather goods, footstools, ashtrays. But this is not what shocks us. The appropriation for non-political ends of the image of Zapata, of Alberto Díaz's Che Guevara, or (following his own appropriation of Zapata) of Sub-Comandante Marcos has become a truism of cultural analysis – just as the ease with which family contacts enable well-connected Mexicans to move between parties and to circumvent formal political structures for personal gain has become a truism of political analysis. The heart of the scandal lies elsewhere. For critics like Juan Villoro it lies in the casual truculence with which these images remobilize the PRI's seventy-year-old tradition of affirming its legitimacy with reference to the Revolution and its figure-heads. Until their displacing in 2000 this tradition helped the PRI to present itself as co-extensive with normal political life in Mexico – to the point where the debilitation of the narratives that sustained the party is routinely conflated with the debilitation of political discourse as such. For historian Lorenzo Meyer, Rossell's images are incontrovertible proof of the end of history and politics as they had been understood in Mexico for three generations. The displacement of the PRI by the right-wing Partido de Acción Nacional (PAN), he argues, marked the final exhaustion of the postrevolutionary project to construct a new Mexico characterized by increased social integration and solidarity, and by the elimination of

poverty.[12] Behind each meretricious and irresponsibly excessive interior on show, Rossell's critics insist, lies the 'escándalo auténtico' (the real scandal): the brutally defiant affirmation of that project's failure (García Machuca and Sánchez 2002: 1, Meyer 2002). Carlos Tello is not alone in attributing this failure partly to the fact that wealth, especially among the richest groups, has been squandered in conspicuous consumption or invested in other nations' economies: '[e]scaso ha sido el compromiso que asumen los ricos con el país y su progreso' (the rich have shown little commitment to their country and its progress) (1993: 60).

But López Beltrán is not surprised. If there is an implied social contract in Mexico, he observes, there is nothing in it to the effect that

> a quienes les toca en fortuna ser ricos deban moderarse en aras de una elim-
> inación de la pobreza, o una mejor repartición de lo que hay. No me gusta
> que así sea pero todo lo que vivo apunta hacia ahí. La ética del mochaore-
> jas (sólo yo y mis familiares contamos) es la misma de la del líder sindical
> y la del empresario y la del conductor de microbuses. Su estricta aplicación
> lleva a los palacetes de los Salinas y al robo hormiga en la secretaría de
> salud. (López Beltrán 2001: 153)

> people lucky enough to become rich should behave with moderation with
> a view to eliminating poverty, or to distributing what's available more equi-
> tably. I'm not happy about it, but all my experience points in that direction.
> The same self-serving ethics of 'only me and my family count' can be found
> among union leaders, business men and taxi-drivers. Its strict application
> leads to the palatial homes of ex-president Salinas and his family and to
> routine pilfering in the health department.

But lack of social solidarity is only one aspect of what Villoro and Meyer are criticizing. The histrionic opulence of these settings is read as symptomatic of the political deceit, graft and corruption through which it was accumulated: the men financing these habitats are (or were) public servants and their business associates whose venal practices, they suggest, diverted national wealth into the construction of the private, sequestered, morally- and aesthetically-bankrupt lifestyles on display here. By way of illustration, in one image the granddaughter of ex-president Gustavo Díaz Ordaz and stepdaughter of Raúl Salinas (a brother of discredited ex-president Carlos Salinas) poses before a portrait of herself and her mother which was painted by her stepfather while he was serving a prison sentence for money-laundering and masterminding a political assassination.[13] It is images like this that lead Meyer to conclude that analysts of Mexican society should welcome Rossell's work 'de la misma manera que en oncólogo debe reconocer la utilidad de una buena imagen del cáncer, aunque le repugne' (in the same way that an oncologist must

acknowledge the usefulness of a clear image of a cancerous growth, however repugnant he finds it) (Meyer 2002: 3).

But while they entered the international field of vision primarily as political allegory and pathology, Rossell's photographs have been repeatedly remobilized. In Villoro's reading the vilification of Rossell's subjects is extended from the political to the aesthetic sphere, as their habitats are recast as symptoms of a corrupt and debased taste. And it has to be said that, intentionally or otherwise, many of the photographs collude in this. Perhaps the most striking example is a corner shot of a high, baroquely mirrored and gilded room. This room is stuffed with gold-brocaded sofas and velvet-covered chairs. Lit low, from the left, satins blaze, while at the centre of the image heavy crystal candelabra, ebonized and gilded lamps, and candlesticks make illumination an ornamental motif as much as a functional and constitutive element of the scene. On the florid overmantel, the walls and tables, and the visible sections of the richly carpeted floor, rococo, baroque, oriental, art nouveau and art deco references jostle with a calculated abandon. A mirror above the ornate fireplace reflects the modernist plaster base of a balcony, with its black wrought-iron surround. At the heart of this visual cacophony are three figures. In the centre, arms akimbo and staring defiantly at the camera, a woman of indeterminate age with a razor-sharp blonde bob, kohl-rimmed eyes and crimson lips is wearing a strapless party frock with swirling red, black and gold panels and, at its waist, a huge gilded butterfly. The room, its lighting strategies and decorative motifs were created, one senses, as a setting for this exotic creature. Yet the choice of make-up, costume and pose seem designed to render the woman herself one more decorative object.[14] If, despite this, she does not appear entirely 'at home', it is perhaps because she figures as one object among many in the home of a male other – an object that (like the illumination) conflates decorative and functional aspects. To her right, and looking still less at home, stands Rossell's sister, a sullen, cerise-clad blonde. To her left, surrounded by the lacquered marquetry boxes, ornately-framed photographs, miniatures, and pastoral figurines, sits the only happy and relaxed character in the composition: a life-sized figure of a grinning shoeshine boy. From his glowing cheeks to the gilded suit and black satin ribbon around his boater, he is the very embodiment of shine. It transfigures him as a certain neo-colonialist sentimentalization transfigures him, softening the contrast between the white of his shirt and his ebony face, as he sits cigarette in hand and legs jauntily crossed.

Idiosyncratic though this image seems, it is characteristic of many of Rossell's photographs: in the sheer superabundance of decorative articles, vivid colours, visual trickery, the gilding and mirrors; the affectation

and the extravagant poses; and the seeming absence of any single, externally-legitimated principle, geographical or temporal focus guiding the selection of objects and styles. In other images the place of the shoeshine boy is taken by idealized figures of female slaves, or by stuffed toys, stuffed antelopes or lions. In several of the photographs, work by canonized artists is displayed alongside crudely sycophantic portraits, unsettling both. Occasionally, the same item will figure in very different settings: an image of Zapata, for example, or a baroque candlestick. This tends to neutralize any residual claims they might have had to elite cultural status and confers instead a quasi-totemic one, linked to their possible acquisition in the same antique shop or department store, or the involvement of the photographer as much as the subject in the staging of the scene. Catholic imagery, as vacantly decorative here as the revolutionary icons, is reserved for darker interiors, colouring them with 'el muy guadalupano mito de la mezcla sin conflictos' ('the typically Guadalupan myth of combination without conflict) (Reguillo-Cruz 2002: 59). Rossell's critics have read these settings as manifestations of 'un eclecticismo inculto', the 'apoteosis del mal gusto [. .] donde la vulgaridad adquiere la indeleble condición de una pesadilla supercoloreaeda' (uneducated eclecticism, the apotheosis of bad taste, where vulgarity takes on the character of a technicolour nightmare) (Snobissimo 2002: 2, Villoro 2002: 48). Federico Campbell rails at length against their

> vulgaridad afectada, el olor a postizo, el lujo arábigo, el gusto, el decorado, los personajes, sus relaciones, sus ositos de peluche, sus pelucas rubias, sus animales disecados, los dientes de marfil, el poder, la riqueza. (Campbell 2002: 1)

> studied vulgarity, the pervasive artificiality, the luxurious lifestyle, their taste, the interior decoration, the characters, their relations, their teddy bears, their blond wigs, their stuffed animals, their ivory teeth, the power, the wealth.

For Guadalupe Loaeza, a penetrating commentator on Mexico's moneyed classes, a rather different form of power and wealth are being traduced here.[15] Rossell's settings are 'so kitsch, so ugly and common, so lamentable in a country like Mexico where there is so much [artistic] wealth and history' (cited in Tuckman 2002: 21). With these words, a certain history of the embedding of aesthetics in politics is reaffirmed, and the genealogy in which Rossell half-ironically anchors her work is once again denied her. Loaeza recalls, once again, the extent to which the energy, influence and potent originality of Mexico's twentieth-century artistic patrimony – its photography, but above all its muralist tradition,

the form of wealth previously accessible to most Mexicans and most visible to non-Mexicans – has been associated with the postrevolutionary project whose senescence resonates in Rossell's images. More than thirty years earlier, John Berger had suggested that oligarchic culture required art objects to be unique, mysteriously exclusive (1972: 23–4). But for Loaeza the habitats of the PRI oligarchy (characterized here by a brilliantly-lit absence of mystery, by illusion and replication) are cut off from this essentially European understanding of taste. They are *nouveaux arrivés* with no sense of tradition, criminally undiscriminating.

> Aquí en nuestro país . . la gente se enriquece muy rápidamente, siempre con el apoyo del poder, con esta complicidad con esos señores del gobierno. Estamos hablando de gente sin educación, sin cultura, sin tradición, sin puntos de referencia . . Son como los narcos cuando se enriquecen y tienen que lavar el dinero. Acaban comprando esculturas de mármol, comprando porcelanas, alfombras persas. (Loaeza, cited in Oc ¡VIVE! 2002)

> Here in Mexico . . people become rich very quickly, always with the help and complicity of those powerful men in government. We're talking here about people with no education, no culture, no tradition, with no points of reference . . They're like drug-traffickers who get rich and have to launder their money. They end up buying marble sculptures, fine porcelain, Persian carpets.

From her position within a very different politico-aesthetic tradition – one obliged to affirm itself because it, too, is under threat – Loaeza confronts a critically weakened adversary. In this she finds common cause with Roger Bartra. He would reject of out hand Loaeza's 'exaltation of national values' within a context of cultural globalization (Bartra 2002: 232). But it is not in a global homogenization of culture that he sees the greatest risks for those seeking alternatives; it is in the tendency of the church, educational institutions and the media to promote a volatile mix of globalization and cultural provincialism. He finds the apotheosis of this process in 'the culture of drug trafficking, a combination of parochial Catholicism with a cruel and reckless appetite for riches, of ranchera kitsch with transnational business' (2002: 232).[16] The abject role of 'the culture of drug trafficking' in both of these accounts is significant. But more important here is the dynamic through which Rossell's project reveals these elements at work – at work in a once-closed oligarchic community that has been able to elaborate its own genealogy and rules of conduct, underpinned by a resolutely non-Kantian aesthetics based largely on compliance, self-gratification and self-interest. Intentionally or otherwise, she exposes these habitats, and the values that appear to inform them, to a wider community. In the process she provides her

detractors with a focus for critical consensus; one in which political and aesthetic delegitimation converge, reconfiguring habitats created in their owners' images, making them symptoms of a crude and brutal 'narco-taste'. For Loaeza, this is a largely defensive process; for Meyer it is the first stage in a potentially therapeutic one. From his less nostalgic and less pathologizing perspective, Bartra concurs that the opening of closed communities to the public sphere is one element in the promotion of new cultural processes and new democratic forces in post-PRI Mexico.

Energizing these critiques, however, and many others directed against Rossell's images, is a powerful will to cultural othering – one that enables commentators uncomfortable with the aesthetics on display to imagine 'que aquéllo pertenece a un mundo paralelo sin nexos causales con el que habitan' (that that belongs to a parallel world having no causal nexuses with the one they inhabit) (López Beltrán 2001: 139). In reality, López Beltrán argues, Mexico's churrigueresque temples, cake-shop window-displays, taxi interiors, the decor and contents of grandmother's sitting-room, all demonstrate that the exuberant ornamentalism of the homes in Rossell's photographs 'marca y demarca muchas elecciones decorativas entre nosotros. Por más que unos cuantos nos adjudiquemos otro "buen gusto" tenemos que reconocer que la cultura visual de este país es muy otra' (marks and marks out the decorative choices of many Mexicans. However much a few of us lay claim to another 'good taste' we have to acknowledge that the visual culture of this country is quite different (140).

He has a point; though to suggest that Rossell's images somehow typify national visual culture – which, whatever it might be, is no more reducible to baroque temple or taxi interiors than to masterly murals – is as misguided as to suggest that they are wholly alien to it. The images in 'Ricas y famosas' were conceived as part of a personal collaborative project on a domestic scale. They were not designed to speak of, for, or even *to* the nation, though they have been taken as doing all of them. They have been read in this way partly because of their ambiguity, posed as many of them are at the point where excess becomes indistinguishable from theatrical irony, converting accumulated possessions to props. Rossell has contributed to this ambiguity for what appear to be largely defensive reasons. Rubén Gallo, a personal friend whose support she acknowledges in the volume *Ricas y famosas*, reports how, at its exclusive launch party, she sends a double to impersonate her and to read a prepared statement vindicating 'artistic freedom' and distancing herself from the criticism voiced in the press. [. .] 'I have a right' declares the stand-in, 'to the ambiguities I present in this body of work' (Gallo 2004: 52).[17]

If this sounds like a pragmatic attempt to retain artistic credentials without permanently alienating friends, the ambivalence can elsewhere look more like simple inconsistency. Nowhere is this clearer than where the documentary or ethnographic intent of the series is concerned. This sits uneasily with her desire to ensure that her subjects appeared to advantage in the photographs: 'belles et jeunes sans cellulite et sans rides' (beautiful, young, without cellulite or wrinkles); but that desire is itself contradicted by the claim that 'quelquefois [. .] elle a encouragé les sujets quand ils ont voulu manifester du mauvais goût. "Je vois bien qu'ils ont l'air totalement ridicules, mais c'est la réalité" ' (at times she encouraged subjects when they wanted to display bad taste. 'I can see they look utterly ridiculous, but that's the reality') (Cyberpresse 2002: 3).

Rossell did not anticipate the icy reality into which her project would be plunged, however. For despite the anonymity sought by some of her subjects – and granted by Rossell to all of them with the removal of the photographs' captions – it did not require much work on the part of *Reforma*, and other sectors of the press, to identify the 'ricas y famosas' in question. They include the daughter of one discredited ex-president, Carlos Salinas de Gortari, and the granddaughter of another, Gustavo Díaz Ordaz.[18] It was Díaz Ordaz's order to open fire on demonstrators in October 1968 that brought Mexico's student movement to a violent and bloody end. The international shock and ignominy associated with the event, and with his name, made this a decisive moment in modern Mexican history which, in the absence of serious or sustained political opposition, prompted the rise of a critical section of civil society against the PRI.[19]

For Gallo, the presence of Díaz Ordaz's granddaughter in the series and the recurring revolutionary symbology imply a critique on Rossell's part of historical amnesia among the young people pictured here (2004: 65). Now, for those who (unlike him) do not know her personally, newspapers images of her sticking out her tongue, offering two-fingered salutes to photographers or partying with girlfriends are a reminder that she is no older than many of her subjects; and that wielding a camera need not confer privileged insight into the historical or other resonances of what comes before its lens.[20] And this may even be to the good if, as Salazar Cruz claims, a residual cross-party 'cultura historicista' grounded in 'la legitimidad revolucionaria' is one factor holding back substantive democratic change (historicist culture, revolutionary legitimacy) (1993: 346–7). It is, nevertheless, from that particular historical perspective that responses from intellectuals on the left to one striking image of Díaz Ordaz's granddaughter need to be viewed. She gazes into the camera from deep within a baroquely gilded and ebonised setting,

sleek, blank and world-weary, and framed by flattering portraits of herself and her mother. She is wearing a gold 'Peep Show $1' tee-shirt and white tennis skirt, and one pristine sneaker-shod foot rests on the head of a stuffed lion.[21] In the middle-ground, on a gold and marble table and parallel with her upper body, stands a life-sized gilded cockerel. Despite this casually commanding pose the composition's colour-matching renders her, once again, one object among others; she is upstaged by her accessories rather as the other women in these photographs are routinely upstaged in public on the arms of fathers, husbands and lovers.[22] Hence their shock when these interior worlds were exteriorized and their identities (expressed as a function of male relations) were revealed. Hence, too, their anxiety that the location of their habitats might become public knowledge, encouraging less well-connected Mexicans to seek a resolutely non-ideological redistribution of national wealth. There resonate here Martín-Barbero's observations on the link between 'miedos' and 'medios', fear and the media, the risk of exposure with all it implies (2002: 24). Gallo reports that Rossell herself was 'afraid of lawsuits, afraid of angering the models, afraid that her intentions would be misrepresented' (2004: 67–8). This, too, is a factor in her ambivalence.

Central to that ambivalence, however, to the desire both to hide and to show, is a certain duplicity of objects. At their most simple, objects can render even poor habitats more distinctive, homely and secure (García Canclini 1993). But the nature of that distinction and the signs of its accumulation can actively attract intruders, whether public intellectuals or private entrepreneurs. In the circumstances – and particularly if 'taste is the basis for all that one [. .] is for others' (Bourdieu 1984: 56) – it is not difficult to see why the critical assault on Rossell's subjects has focused so pitilessly on the nature and qualities of the objects with which they surround themselves. But what this very public gaze overlooks is the complexly mediated interdependence of public and private concerns, of democratic subjecthood and individual subjectivity. For, as Rossell's photo-ethnography repeatedly reminds us, objects do more than transform habitats; they register and inflect transformations taking place elsewhere. These images were captured at a moment when the waning of the traditional talismanic power of public revolutionary icons – with all their patriarchal associations – was about to be dramatically confirmed. They show women supplementing that power with recourse to a quite different set of objects for their own personal ends. There are the ebony or fine porcelain figurines and full-size turbaned concubines bowed down by the heavy symbolism of chains and coins. And, replicated in gilded salons and modernist penthouses alike, there are the miniature slaves that

support trays for knick-knacks or barely functional candle-holders. Once again, 'the brash contradictions that mark everyday life' are rendered as decor, and conjured here with an almost delirious intensity.[23] Jostling with these emblems of earlier conquests are the displays of stuffed bears, antelopes, lions and tigers, each recalling the vogue for late nineteenth-century 'camera hunting', in which photographs of *ferae naturae* in their habitats served as idealized trophies of empire.[24] In another challenge to debilitated nationalist symbology, Rossell's objects derive their resonance from decisive moments in extra-national and globalizing narratives.

The juxtaposition of life-sized beasts with their stylized, unlegitimated nursery versions is a 'vuelta de tuerca', or twist, that re-engages the personal dimension of these narratives. Distilled in the phalanxes of teddy bears and other stuffed toys is a certain understanding of love as consumption and compensation, as an act of individual possession – a toy story that sits uneasily alongside the nineteenth-century drama of empire, the early twentieth-century battle for the nation, or technical twenty-first-century debates on democratic consolidation. Underscoring this disjuncture is a destabilization of visual scale which, supported by lighting effects, puts the illusion of depth repeatedly in check. Hallucinatory colour flattens out images bounced between mirrors; sinister shadows melodramatize children; young women act big in evening frocks or pillow-fight like infants; older ones appear tearful or playful among the larger-than-life dolls that serve as their props and companions.[25] Posing alongside their bears, lions and antelopes, the women grow or shrink to fill the space vacated by them, snarl in imitation of them, drape themselves in their skins and fur – even, in one case, eat a snack called 'Cheetahs'.[26]

These, then, are in no simple sense 'natural' habitats. But nor can they be read simply as symptomatic of socio-political decadence. For cultural critic Cuauhtémoc Medina the dissonant objects on display here, like the *trompe l'oeil* features, the props and the masques, are a material expression of the distinction to which wealth gives access. And as he acknowledges, this distinction is not only material. Objects and other elements are deployed here in the construction of refuges grounded in compensatory or defensive fantasies.

> [La] multidud contradictoria de fantasías adquiridas desordenadamente en casas de antigüedades, tiendas departamentales, safaris, viajes e infinidad de supermercados [documenta] el esfuerzo desperado de una clase por crearse 'otro lugar' distinto al collage de miseria campesina, industrialización bárbara y urbanismo parapléjico que los demás habitamos. (Medina 2002:1)

documented in the multitude of contradictory fantasies haphazardly acquired from antique shops, department stores, on safari, on trips, and in endless supermarkets, is the desperate attempt of a class to create for itself 'another place' unlike the collage of rural poverty, barbaric industrialization, and paraplegic urban planning that the rest of us inhabit.

Although he is one of very few critics to foreground the role of imagination in the construction of their habitats, Medina – like Meyer, Loaeza, Villoro, and most others – is concerned chiefly to put the women in their place. In an act of something like social reinsertion he drags them into the wider world he believes they try to banish, restores them to a reality more urgent than the cellulite and wrinkles invoked by Rossell. Yet while the challenge offered by the images almost irresistibly invites this response, he fails to address the question of degree. For even those who live in 'industrialización bárbara y urbanismo parapléjico' do not live *only* there; even women who live in shanty-towns abutting the capital's wealthier districts occasionally buy Avon cosmetics, style their hair, spend resources they barely have on things they do not need. This does not absolve those for whom consumption – in its seemingly pathological, consumerist, variant – figures as a life project; but it acknowledges that even the poorest sectors cannot be assumed to live their lives entirely in the realm of necessity.[27] Traditional documentary ethnography registers the constructive dimension for all social groups of the accumulation and exploitation of objects.[28] Rossell's photographic 'vuelta de tuerca' affirms this potential as it undermines the regime of truth and sense that frames it. The result is a more reflexive, individualistic ethnography, a world away from the solidary studies of López or Álvarez Bravo: one that foregrounds the role of fantasy in the use of objects, and in the unstable and heterogeneous worlds they conjure. The feline iconography referred to earlier, for example, recalls not only a 1990s Versace cat-walk aesthetic or sleek 1950s femmes fatales but also a more ancient association, in Mesoamerican art and writings, of jaguars, pumas and tigers with powerful warrior and priestly elites.

There is one photograph in the collection that, more explicitly than any other, binds these contradictions to the mechanics of identificatory processes. It presents seven of Rossell's subjects, draped in silks and voiles, reclining on rugs and cushions on low steps that lead up to an imposing life-sized mural of the interior of a harem Plate 4). They are attended by an older woman who is turbaned, robed in lime-coloured silk, and bearing the traditional rose water and petals. But these are not odalisques caught unknowingly at play by a European eye as they await the Sultan. Almost all look directly at the camera while hiding behind the distant, languid or challenging expression they feel best becomes them.

The image derives its intensity, in both a public and private sense, from art: it mimics a certain orientalist cliché but also, more obliquely, the work of art that we assume others' lives to be when they are witnessed from outside, in a flash (Lury 1998). That the creation of our own identity is always less logical, firm, fulfilled, less profound than we imagine others' to be, that it is less magical, more 'bricolaje' and *trompe l'oeil*, is affirmed everywhere in the image. For in this setting the animal skins are less evocative of their sumptuous nineteenth-century French model than twenty-first-century Italian designs, and the rugs less reminiscent of the Far Orient than a more resolutely local Habitat. Individual or 'family' fantasies are referred back to their source in a generally available image repertoire – films or advertising, for example, popular or high art, television shows, magazines, store window-displays – and partially, provisionally recast through the work of imagination and the camera's lens. The play of commercial art and life is encapsulated in the bottle of Absolut Vodka in the left foreground. Oblique in its transparency, at the very edge of the image, it archly refers spectators (via the cinema advertisement then current) to the exotic transformations produced not by ancient Maya or Nahua imaginaries but by alcohol and a fish-eye lens. Like the nineteenth-century European interloper we observe these women in camera, concealed (as they supposed) from any gaze but the photographer's, and unaware of the public viewing and very public reversal that awaits them. We watch as, in the privacy of their imaginations and through the intoxicating lens of Rossell's Pentax, they see themselves mutating from sullen dependents and snared trophies to exotic or domesticated 'objets sauvages', fascinating, and stagily perverse.

These private images are a source of personal pleasure among consenting adults. They become obscene only when paraded on the public stage by critics for whom even the most sequestered pleasures are not produced in a vacuum. Critically contextualized and recontextualized in this way the photographs assume a significance that resonates well beyond the PRI élite or their extended clan. Individual subjectivities, they insist, cannot simply be bracketed in the struggle for democratic subjecthood; but nor can individual autonomy (even when expressed behind high walls and electronic gates) expect to remain independent of wider social transformations. In this sense, Rossell's ethnography and its reception alert us not to the end of a certain Mexican history and the demise of cherished structures and concepts, but to their uneasy co-existence with newer ones.

These tensions are clearest in the logic of 'serial objectification' that structures social relations in 'Ricas y famosas'. The women who re-enact in their makeshift harem the archetypal orientalist scene of gendered

4 'Harem' (Daniela Rossell, from the series *Ricas y famosas*)

power are doing so partly to procure, in controlled conditions, their own othering. This is part of a larger dynamic within which women widely perceived as trophies, 'barraganas', the wards or consorts of powerful men, are seen manipulating and defining themselves through other objects, objectifying other subjects, in order to realize *themselves*, fully, as subjects.[29] But like the consumer imaginary that drives it, identification through objects thrives on display, deferral, and the inequitable concentration of resources, and is structurally incapable of delivering all it promises. That Rossell is alert to this is registered in two of the many images of slaves and servants that recall the commodified object's status as a reification of human practical activity. The first and last in the volume *Ricas y famosas*, these images function as inverted commas marking the limits of the serial objectification process; they both acknowledge and are oddly resistant to it.

 The first opens the original edition of the volume and sets the parameters for all that follows.[30] It shows the ranks of staff who support a single wealthy household: the Portanova family's Acapulco home, Villa Arabesque. They pose in massed ranks on a flight of black marble steps before a Moorish archway, flanked by gilded obelisks, potted palms, and

life-sized ebony elephants. The contrast between this clichéd exuberance and the workers' regimented sobriety would be comic were it not for the dignified demeanour of the people posing here with the tools of their trade and symbols of their usefulness. They are graded by uniform (dark blue for handymen, white elsewhere, with dark glasses and mobile phones for security staff) and by ethnicity (the more menial the job, the darker the skin).[31] The cleaners and laundry workers, the office assistants, the electrician, the cashiers, the groundsmen and general labourers, the chefs, kitchen and cellar assistants and, above all, the security staff appear here as the depersonalized attributes or accessories of Rossell's subjects, as objects signifying the household's status and resources. Even before their uncompromising rematerialization by her critics, their demeanour affirms them as the source of the labour and energies sustaining the rarefied environments in which their employers' artifice flourishes. Neither abject nor simply object, they appear as subjects implicated in their own as well as others' serial identifications. Once again, Rossell hints at a more reflexive response to the traditional dichotomies of public and private, reification and self-identification.

The second photograph, and the last in the volume, is of a solitary maid. Her shyly candid gaze is a world away from the posturing of women more at home before the lens, and introduces the probability that (unlike them) she has not chosen to act as subject for a photograph but been co-opted as a photographic object.[32] Yet there is something in her reserve that (as Barthes notes in a very different context) pierces the viewer's eye; neither the photographic frame nor the sober uniform, it seems, can contain her apparent haecceity. As a consequence, what may have begun life as a somewhat facile ironic counterpoint to the earlier images is able to signify the insistence of the subject before the viewer's and the camera's conventionally objectifying gaze. But, as if in response to this intractability, her image was suppressed in the volume's second edition and replaced with that of a younger and more malleable maid; in a less soberly professional pink uniform she poses, her body turned slightly from the camera, hands on her hips, wearing a half-coquettish, half-exasperated expression. While clearly not 'at home' with the role she has been assigned, her demeanour suggests that it is not wholly alien to her. It is this young woman who opens the second edition, and the domestic household of Villa Arabesque that closes it.

The substitution of that first maid recalls once again the wider tendency within post-NAFTA Mexico to sequester markers of socio-political tension – a tendency that Rossell's images elsewhere collectively and decisively undermine. But in this case a member of an older generation of indigenous women, essential but phantasmal supports of this arcane

world and its play, has been airbrushed from a scene she did not want to be in. And with her goes the collection's only example of a more traditional, non-theatrical, subjecthood. In her absence it is far easier to forget, as so many of her critics do, that what Rossell sets before us are not women but objects: posed, framed and edited images of women acting as images, as something else, in order to become (they imagine) more fully themselves. But the critical scandal around the photographs has caused them to accrue wider significance within the new, more reflexive, modernity that is displacing the one inaugurated by the Revolution. In the quest for social and political renewal, the resolutely privatised values that conform these local habitats can no more substitute for failed national projects than can the ethical indifference of the globalizing frame that helped to undermine them. But the dynamics and idiosyncratic expression of those personal projects can yield insights not readily available elsewhere. They indicate that outworn political connections are not surrendered, for example, but remobilised under new conditions to different ends. They insist that the fictive and theatrical bases of identificatory processes do not make them wholly individual, arbitrary or ineffective; and that the increased social complexity that is making these and most other calculations more risky and more provisional does not preclude or disable them. In this sense, the photographs are not simply indices of corruption or symptoms of socio-political decline but representations of social actors negotiating rapid social change with the resources available to them. With the willed or accidental complicity of her critics, Rossell's photographs enable transformations in private lives to resonate in public contexts. They place before us individuals and groups, bodies and imaginations, in the process of responding to wider transformations and the risks they entail; and, however scandalously, helping to shape them.

Notes

1 An earlier draft of this chapter appeared in the journal *Romance Studies*, in November 2004 (Brooksbank Jones 2004b).
2 This was her second solo show at the gallery; the first was in 2000.
3 This international profile (and her family connections) may be a factor in the sponsoring of *Ricas y famosas* by Colección Jumex, Televisa, Laboratorio Mexicano de Imágenes – and Gran Centenario Tequila.
4 See the volume based on the series: Rossell 2002b (1st edition) and 2002c (2nd edition). For some of the most striking of these images see Villoro's article for *El País* (2002: 42–50) and http://images.google.co.uk/images?q= daniela+ rossell +images.
5 In a contribution from the floor to a seminar held during the ARCO international art fair (Madrid, February 2005), Olivier Debroise noted that

Rossell had originally named her subjects but had withdrawn the captions at the insistence of one of them, Paulina Díaz Ordaz.

6 Álvarez Bravo affirmed the primordial influence of 'Mexican art and Mexican life', in an unexoticized form, in his work, and sought to promote international awareness of the mural art of Rivera, Orozco and Siqueiros. López, as noted in Chapter 2, contributed to the imaginative mapping of the capital and – especially poorer – residents' place in it (Warner Marien 2002: 323). This does not mean that they necessarily sanctioned the appropriation of their work for official purposes or the effects of its institutionalization. On Graciela Iturbide, see Iturbide (1996), Medina (2001) and images at http:// images.google.com/ images?q=graciela+iturbide&hl=en&lr=&rls=GGLD,GGLD:2004–39,GGL D:en&sa=N&tab=wi&sourceid=tipimg. Barry Schwabsky traces a 'haunted, phantasmatic reality' in Rossell's work reminscent of Álvarez Bravo's (2002: np). As he acknowledges, however, Rossell's saturated colours are a world away from her co-national's 'old chiaroscuro'. Rubén Gallo is also wide of the mark when he suggests 'striking similarities' between her work and that of American photographer Tina Barney (2004: 57). For Barney's colours are, again, cooler and more subdued, the interiors are less brilliantly cluttered, and the tone (while not always naturalistic) less claustrophobic and brittly theatrical. Closer to home are some of the images in the series 'En sus casas' (In their homes, c.1970–80) by Mexican photographer Antonio Caballero. Although Caballero is known as much for photographing underdressed women as overdressed ones, his shots from c.1970 of actress Fanny Cano in her heyday have many features in common with Rossell's work. The kitsch paintings, religious icons, and heavy gilded screens before which Cano poses; the harem pants and evening wear; the velvet, gilded furniture and fur-covered bed piled with cushions: all anticipate the interiors in which, thirty years later, these decorative tendencies would find their apotheosis. See Toluca Project (2004).

7 There are obvious parallels here with the popular anthropological photography of fashion magazines such as *Marie Claire* or *Company* (Ramamurthy 2000: 195).

8 Despite two changes of name, this hegemonic potential was manifest from the party's establishment in 1929 under Plutarco Calles. The then Partido Nacional Revolucionario 'incorporated existing state machines in return for federal government patronage. This implied the permanent subordination of state-level political leaders to the national executive [. .] Party would increasingly predominate over personalities and regions' (Hamnett 1999: 235). In 1938, under Lázaro Cárdenas, it was renamed Partido de la Revolución Mexicana and transformed into an explicitly corporative entity, strengthening further the political force of state patronage. Increasingly bureaucratic and centralized, the party went on to tighten its monopoly control in the favourable economic climate of the next three decades. Eight years later, under Miguel Alemán, it assumed the name by which it is known today. Throughout this period, families that had enriched themselves during

the immediate postrevolutionary decades continued to exercise considerable influence. It is largely, but not only, from this élite that Rossell's subjects derive their own oligarchic status.

9 The term, which means 'six-year monarchs', reflects the power (and personal patronage) of presidents during their six-year term.

10 Rossell's sister Angélica and her mother Margarita Rovirosa also figure among her subjects, as do her maternal grandfather (former PRI governor for Tabasco Leandro Rovirosa Wade) and his wife. The list also includes minor celebrities such as harpist Mónica Ramos, self-styled psychic Inger Barder, and pop-singer and actress Itati Cantoral, daughter of composer Roberto Cantoral. For a near-exhaustive listing of other figures in the series see Snobissimo (2002)

11 By 'decathection' I mean here a withdrawal of psychic (or more broadly emotional) energy – in this case, from the postrevolutionary project.

12 José Iturriaga notes the slight decline in the size of Mexico's élite groups between 1895 and 1940 (from 1.44% to 1.05% of the population) and the doubling of the middle classes (from 7.78% to 15.87%) in the same period (cited in Meyer 2002: 1). Yet the figure for Mexicans living in poverty has proved exceptionally resistant to change. Having fallen slightly in the period of economic growth from the 1950s to the crisis of import substitution policies in the mid-1970s, it rose again with the imposition of austerity measures in response to the debt crisis of 1982. By 1994, almost 56% of the population were estimated to be living in poverty; two years later, in the wake of further economic mismanagement and despite social programmes designed to offset the worst effect of neo-liberal economic policies and the implementation of NAFTA, it stood at just under 70% (Iturriaga, cited Meyer 2002: 2). The dislodging of the PRI in 2000 marked the final supersession of a goal that had been a defining – if increasingly hollow – feature of Mexican politics for almost three generations.

13 Rossell's maternal grandfather was himself a close friend of Carlos Salinas, while her paternal grandfather (an architect by profession and close friend of former president José López Portillo) was at the centre of the abortive and much-criticized project to build the 51-storey Hotel de México (see Gallo 2004: 59).

14 The baroque sensibilities that first assembled the cornucopias and shells, flying putti, the classical figures flanking fireplaces, were cultivated by wealthy families whose own habitats were not 'intimate settings for private life', spaces where one could 'be oneself', but theatres for social activity in which to project one's possessions and how one would like to be seen (McCorquodale 1983: 85). Rossell's subjects elide these two tendencies, creating habitats that resemble stage sets and in which self-expression through objects predominates. But like the *trompe l'oeil* mural work – a traditional short-cut to wealth, status and depth that mirrors the photographic illusion – features designed to render individuals moving among them more substantial and more imposing serve here actively to desub-

stantialize the women.

15 Something of the wit and insight of her critiques emerges from the extracts anthologized in Gallo (2005). Relevant full-length studies include *Manual de la gente bien* (1995) and *Los de arriba* (2003), both pubished by Plaza y Janés.

16 The place of the transnational is figured most insistently here in the presence of multiline telephones on bedside tables, suggesting availability for urgent business across time zones. By contrast, the mobile phones of the security staff conjure the twenty-four-hour network working to protect these enclaves from less welcome visitors.

17 Gallo notes that the double was Wendy de los Cobos, the girlfriend of Rossell's father. She appears in *Ricas y famosas* posing not-quite-seductively in a bathrobe under a neo-Mexicanist image of Zapata. A maid, in anonymous rear view, is absorbed among the other possessions on display as she dusts books in the background.

18 The granddaughter of Gustavo Díaz Ordaz is also the step-niece of Salinas. On the incestuousness of the clan to which Rossell belongs, see above.

19 The 'massacre of Tlatelolco', as it came to be known, galvanized the intellectual classes (who had, in general, enjoyed mutually beneficial relations with the regime to this point) in opposition to the president. This critical tradition has been maintained by Meyer, Villoro, Bartra and many other public intellectuals in a period that has until recently seen little effective (formal or informal) political opposition.

20 For Rossell in party mood see, for example, Snobissimo (2002).

21 Like the young woman in the Stetson whose foot rests on an alligator's head, this pose stagily re-enacts the quarry's symbolic subjugation by colonial hunters. On this see Ryan (1997).

22 It is only recently that Mexico has begun to develop a celebrity culture of the type produced in the pages of *Hello* or *Hola*. As a consequence, these women are not famous in the way that Stephanie of Monaco is in Spain, or the Beckhams in the UK – or even, in a rather different sense, in the way the men in their families are. On this see Villoro (2002). An informal survey I conducted among Mexican postgraduates revealed that the only subject recognized by virtually all of them, the only one they saw as 'famosa', was the 'vedette' Lyn May, an outsider to the Rossell clan.

23 Coco Fusco cited Gallo (2004: 8–9). On this see also Beatriz Sarlo (1994).

24 Michael Ryan registers the elision of 'camera hunting' with the 'salvage motive' so often associated with ethnography in a desire to preserve types that are on the point of extinction (Ryan 1997: 140). There is little valedictory sentiment in these images, however, and the legendary extent and regenerative capacity of PRI networks suggests that we are unlikely to be witnessing the moment of its passing. At the same time, taxidermy's reconstruction of the conventionally natural through the unnatural replicates that of photography as technological process and social practice, recalling the photograph's status as the living image of a dead thing or the dead image of

a living one. On this see Barthes (1977) and Sontag (1978, 2003).

25 On the manipulation of such quasi-magical props in the projection of new identifications, see Pels, Hetherington, and Vandenberghe (2002). And on the link between what he describes as the 'aniñamiento bobo' (silly child-ishness) of some of Rossell's subjects and a certain vision of the erotic see López Beltrán (2001: 150).

26 As the theatricalization of eating underlines here, to reduce these processes to an anorexic/bulimic dynamic is to view body modification as exclusively pathological. And, as Lewis Carroll among others reminds us, it is also need-lessly reductive.

27 On this, see Brooksbank Jones (2000a).

28 Over a decade ago, Néstor García Canclini examined the socio-cultural potential of consumption more generally and suggested that it may, in the right conditions, actively support democratizing processes. See his *Consumidores y ciudadanos* (1993), translated in 2001 by George Yúdice as *Consumers and Citizens; Globalization and Multicultural Conflicts*, Minneapolis, Minnesota University Press. For an account of his argument, see Brooksbank Jones (2000a).

29 Notable examples of this self-objectification process include: a woman, in a dress that recalls the clip of a colourful French poodle, who poses beside a row of empty kennels; Rossell's sister sulking in ermine jacket, evening dress and tiara, surrounded by dolls; a mature woman smiling uncomfortably from inside a child-sized wendy house; Itati Cantoral sitting with becomingly downcast expression among empty ranks of brocaded chairs. Here and else-where the traditional 'existence for others' that grounds the theatrics and drives the consumption energizing these habitats is exhibited in a melodra-matized form (Beck 1992: 112). The recurring blank or unhappy expressions, which led agony aunt Gaby Vargas to expatiate on the 'spiritual emptiness assailing these women', recall Featherstone's notion of calculating hedonism, that is, the alternating phases of pleasurable immersion and alienated detach-ment that characterize a certain relationship with consumer culture (Vargas cited Gallo 2004: 5; see also Featherstone 1991 and Lury 1997). It should be noted, however, that Rossell is not a gender essentialist on this point: depen-dent young men, feminized or dematerialized by the camera, may also take up the place of the concubine-object. In one image it is even ceded to yet another (nominally) stuffed animal – a Vietnamese pot-bellied piglet.

30 This was published in Madrid in 2002 and followed by a second edition in the same year: this second edition has a larger format, reorders the images, includes several additional ones, and excludes the photograph of the maid referred to later in this chapter. My characterization of it (below) suggests why.

31 On the racist and colonialist bases of socio-economic inequality in Mexico see Tello (1993: 57).

32 Personal experience suggests a marked disinclination among indigenous Mexicans, when their permission is sought, to appear in photographs.

Part II

Spain

4

Words from other worlds: the Guggenheim Museum, Bilbao

The first part of this study explored the changing roles of visual culture in the construction of national and other forms of identity, in Mexico, in times of globalization and risk. The second part moves from a Latin American megacity to a region in northern Spain, the Basque Country; and from the earlier focus on art and photography to architecture, film, and visual icons. These three chapters shuttle between regional, national and global focuses. Together they explore culture's role in the dramatizing and displacement of risk; art as commerce and aesthetics; and how far belief in a region, a building, or a destiny can generate material consequences. The earlier chapters examined visual culture's role in articulating global, local and individual relations. This one, by contrast, uses the example of the Guggenheim Museum, Bilbao to examine attempts to displace an agonistic regional past by drawing on a particular global presence.

There are suggestive parallels between the role of visual culture in postrevolutionary Mexican identity construction and its role in the construction of what was presented as a properly *modern* vision of Spain following the death in 1975, after almost forty years of dictatorship, of General Francisco Franco Bahamonde. The Partido Socialista Obrero Español (Spanish Socialist Party, PSOE) came to power in 1982, after a period of transition, on a surging will to create this modern profile. Under the national governments of PSOE (1982–96, 2004 to date), but also under the centre-right Partido Popular (People's Party, PP, 1996–2004), the centrality of culture in this construction process, and the need to fund it publicly, has been taken largely as read. Policy on the right and the left has tended to differ more as regards the proportion of public to private funding envisaged, the types of museum prioritized, and the vision of modern Spain – more centralized, or more regionally-focused – they are

designed to promote. In 1982, for example, PSOE's sweeping mandate for change was used to underwrite a national cultural policy of promoting 'an unprecedented number of public spaces dedicated to modern and contemporary art' (Manchado 2000: 92). Spain's new, democratic, constitution (ratified by plebiscite, despite concerted Basque opposition, in 1978) had opened the way for progressive decentralization. Almost as soon as it arrived in power, PSOE set about redressing the regional resentment built up under Franco's repressive and authoritarian centralism by converting this intent to reality. Two of Spain's most important national museums were established during these early years: the Museo Nacional Centro de Arte Reina Sofía (MNCARS, 1986) and the Museo de Arte Thyssen-Bornemisza (1991). But so, too, were key regional museums: the Institut Valencià d'Art Modern (IVAM) in 1983; Seville's Centro Andaluz de Arte Contemporáneo (CAAC) in 1990; and the Museu d'Art Contemporani de Barcelona (MACBA) in 1995.[1] Negotiations for the construction of the Guggenheim Museo, Bilbao began in 1991 though, as will be seen, the role of the Spanish state in this was more marginal. By 1996, drained by the efforts – and considerable achievements – of the democratic transition or 'cambio' period, PSOE had lost energy and direction, and was mired in corruption scandals. Its displacement by PP brought a different vision, and fresh policies, designed to conserve a more unified vision of modern Spain, and of the Spanish past – a past compromised and marginalized, as they saw it, by the Socialists' promotion of cultural contemporaneity and fragmented, regional, identities. The preservation, or construction, of this new vision of the national past, and of the infrastructure to support it, would also entail a turn away from international cultural trends that had shaped policy under PSOE (Reuben Holo 1999: 25–6).

The sometimes contradictory role of national institutions such as galleries and museums represents a key focus of visual cultural studies. They serve as constructors and preservers of national heritage, and as definers and redefiners of national beliefs, values and tastes; they help to shape citizens' sense of themselves and their dynamic relations with other nations and groups of nations; and they are the agents, witting or otherwise, for these purposes of state cultural policy which is itself often overdetermined and contradictory. It is not fortuitous that national state-run museums today represent a small and shrinking proportion of Spain's tally. In her pioneering study of Spanish museums and identity formation, Selma Reuben Holo argues that, during the transition to democracy in the late 1970s and early 1980s, it was

> understood that museums contributed to the balancing act among those
> competing forces that allowed modern Spain to cohere as a nation: some

would serve to advance the power and prestige of the state and some the regions; a growing number would feed the thirst for the modern and others would protect a range of traditional values; some would reflect the desire to be international and others appease anxieties about globalism; some would be dedicated to the rehabilitation of forgotten histories, while a few would stubbornly relate the former official story; some would be a by-product of private enterprise, but would continue to be supported by the state, municipal, provincial or regional governments and by the Catholic church. (Reuben Holo 1999: 4)

While the complexities, compromises and occasional high drama accompanying the transition will have militated against the detailed strategic overview implied here, examples of most of these could still be found today.[2]

The transition coincided with the boom in contemporary art discussed in Chapter 2. Partly because it was fuelled largely by the investment strategies of transnational pension and other fund-managers this boom tended to assume markedly commodified and instrumental forms. As if to underline culture's role as an economic as well as a political driver in the Spain of the 'cambio' period, for example, ARCO (Spain's international art fair) was launched in the year PSOE came to power. Twenty-two years later, it would host the inaugural International Visual Studies Conference, under the co-ordination of José Luis Brea, Professor of Aesthetics and Art Theory at the University of Castilla la Mancha and editor of pioneering art journals *Acción Paralela* and its successor *Estudios Visuales*. With their focus on contemporary art practice and theory, however, strong representation of international (especially North American and British) critics and comparative debates, these publications represent a challenge to the conservative curatorial, museological and critical practices that still predominate in most Spanish universities, and have spearheaded the embedding there of visual cultural studies (Smith 2003).

Although culture for PSOE in the 1980s had a clear pedagogic function – the residue of a more traditional *civilizing* role – it served above all as an antidote to Francoist cultural introversion. As such it was a key factor in the new Spain's self-representations, and part of the government's wider strategy of international integration. The creation of MNCARS as a centre for modern and contemporary art was an important (and, as will be seen, controversial) step in this process.[3] Five years later, Baron Hans Heinrich Thyssen-Bornemisza made a permanent loan to the Spanish state of over seven hundred works, spanning seven centuries, from his internationally-important private collection.[4] Although negotiations were protracted and contentious, and the arrangement

agreed expensive, the works supplement important gaps in the public holdings and, with those in the Prado and MNCARS, form the core of what is now widely seen as one of the world's strongest national collections.[5]

The development of regional collections was given a decisive boost with the staged implementation of the regional autonomy envisaged in Spain's new Constitution. Perhaps unsurprisingly, given the charged political climate of the time, this autonomy was more ambiguous and more qualified that some regions wished (Preston 2004: Chapter 9). Especially in the Basque Country, where radical nationalist groups had had their sights set on something approaching independence and worked hard to derail alternatives, disappointment around the Constitutional formula was intense. With its devolution of key powers and funding, however, the implementation of the new 'state of autonomies' opened up opportunities for decentralized policy-making and patronage and formed a key plank in the strategic reconfiguring of regional identities (Elorza 1995). By encouraging the expansion of independent and cultural tourism it would also help to ease the region's shift from industrial to service industries, as part of the painful process through which PSOE sought to bring Spanish industries rapidly into line with European and world economic developments. As noted, the cultural but also the politico-economic capitalization on museum projects was one element in this process, and one by no means restricted to the Basque Country. The rapid rise of Valencia's IVAM, for example, illustrates how what was conceived in 1983 as 'a modest, marginal project of the periphery of Spain' has been able to achieve an international profile as well as a regional one, by promoting key local artists and resisting political interference from Madrid (Manchado 2000: 95). The international profile achieved by Bilbao's own modern art museum has been of a spectacularly different type, however. The Guggenheim Museum has been used to displace a recent history of economic decline, state repression under the Franco regime, and radical nationalist violence by appealing less to regional or national audiences than to global ones. If, as Reuben Holo contends, museums can be seen as 'open and critical testing grounds for some of the most advanced ideas and best hopes of the civil society in which they are called upon to function', the profile of this museum in particular is an extraordinarily revealing one – and one that underlines the decathection of the Enlightenment narratives from which the modern museum emerged (Reuben Holo 1997: 302).

When the Basque Country emerged into the democratic period it was not well provided with museums. From the turn of the twentieth century it had seen some limited intellectual debate concerning the civilizing and

educational functions of museums, however, and in 1914 this would lead to the opening of Bilbao's first fine art museum, the Museo de Bellas Artes, supported by the profits from steel and agricultural exports during World War I, and the accompanying surge of civic awareness and self-confidence. Some three decades later, Alava acquired its own fine art museum and in the democratic period this became an increasingly important collector and exhibitor of Basque and Spanish works.[6] In its early years, Reuben Holo notes, Bilbao's museum worked

> to integrate the city and the region into what were then considered by Europe to be the most advanced ideas about art[, and was] equally committed to supporting Basque art, Spanish art, and historical master works. (Reuben Holo 1999: 145)

But the recession that followed World War I, the Civil War, and the Franco regime's iron repression of the Basque language (along with any nationalist aspirations) all severely restricted the museum's development. Unwilling as it was to challenge the regime's centralizing policies and promote local self-representations, it also won little support in the city. With the 'cambio' period's devolution of cultural policy and funding, however, it saw a surge of new growth and more contemporary acquisitions, both local and international, supported by national, regional and municipal governments.

With democratic decentralization there arose a will to broaden the range of museums in the region. A number of potential subjects – natural science, agriculture, labour movements, timber – were mooted but none was able to generate the necessary political and popular support. Some of the funding that was to have supported this new venture was rechannelled into the expansion of the city's Museo de Bellas Artes. During this period, Reuben Holo comments, it became one of the first museums in Spain to take a serious and systematic approach to educational and outreach activities (1999: 146). But if the new museum project seemed still-born, there was one new initiative which did find popular support in the years preceding the signing of the contract for Bilbao's Guggenheim Museum. It was a new centre for creative research – with a library, a meeting place, a centre for experimentation and a contemporary Basque art museum – to be designed by Basque architects and based in the city's Alhóndiga building. Its most forceful advocate was sculptor Jorge Oteiza. After extended and heated public debate, however, this too was finally set aside (Zulaika 1997a, Reuben Holo 1999).[7] The attention and expectations it had generated – at a time when *bilbaínos* were casting envious looks at Madrid, Seville and Barcelona, all the focus of considerable excitement in the run-up to *annus mirabilis* 1992 – would

nevertheless make the region's politicians more open to the proposals they were soon to hear.[8]

The expansion of the city's Museo de Bellas Artes would be severely constrained by the regional governments' major new initiative. The construction of the Guggenheim Museum in Bilbao was the focal point of an exceptionally ambitious and costly city regeneration programme. The need for such a programme was widely acknowledged. Since the Middle Ages, the Vizcayan economy had been based on iron ore extraction, and by the turn of the nineteenth century 'the ten mile corridor from Bilbao to the Atlantic produced 20% of the world's steel' (Zulaika 1999). But in 1995, after decades of decline, the cuts and closures associated with the reconversion of Spain's steel industry culminated in the closure of Bilbao's century-old Altos Hornos steelworks; like the indebted and deteriorated port, it became a grey and polluted ghost of the industry on which the city's wealth and cosmopolitanism had been founded. From the late 1980s it had become clear that modernizing and reinvigorating the port area and improving transport networks were economic priorities not only for the city but also for the region. They were the core of a wider policy to attract cleaner and (it was argued) more *modern* activities – and above all service, cultural, and tourist industries. The heart of the regeneration programme would be the city's Abandoibarra riverfront area; and the mantra used to legitimate the scale of the investment required was 'la cultura, motor de la vida económica' (culture, driving economic life) (Guisasola 1998: 34). Before examining the implications of this claim, however, a word on the link between culture, economy and politics. For without some sense of the political dimension of culture and cultural symbolism in the Basque Country, the scale of the investment its politicians were prepared to make seems frankly inexplicable.[9]

As José Antonio Ardanza, then Lehendakari or President of the Basque regional parliament, noted in 1998, the Basque Country in general and Bilbao in particular have tended to be associated in the news media chiefly with 'la violencia o la conflictividad' (violence or conflict) (1998: 5). Most of this violence has been associated with the activities of radical Basque nationalist group ETA (Euskadi Ta Askatasuna). ETA's roots are in cultural nationalism; it began life in 1953 as a cultural discussion group among young left nationalists affiliated to the Partido Nacional Vasco (PNV). Six years later, having failed to radicalize PNV's policy of non-violent opposition to Franco's authoritarian centralism (which the young radicals equated with that of an occupying power) they split to form ETA, with a new political nationalist agenda. In the decade that followed there was intense internal debate (usually cast in marxist or socialist terms) around the group's ideological direction, in which the will of

the most violent factions tended to prevailed. The period saw a series of assassinations designed to elicit violent state repression, typically in the form of '[s]aturation police presence, indiscriminate arrests, torture of suspects and extrajudicial killings' (Woodworth 2004: 170). This, it was calculated, would galvanize popular Basque sympathy and lead to concerted nationalist action. Although this goal was not achieved – and, indeed, was arguably unachievable in the Spanish context (Jáuregui 2000) – the killings would remain a feature of ETA activism into the democratic period, taking over 800 victims. By the end of the 1960s, ETA was becoming a key political and social focus for opposition to the Franco regime in and outside of the Basque Country (Garmendia 2000: 133). But the dying years of the regime saw a widening split between ETAp-m, which gave priority to political activism (participating in strikes, for example, or union activism), and ETA-m, the hard-line military faction which was increasingly prepared to act independently. In 1981, ETAp-m abandoned armed action and some of its core members moved into formal politics; the group's evolution from cultural to military nationalism was complete. The number and intensity of attacks against those perceived as representatives of the state continued to grow, as did attacks against tourists and other soft targets. By this time, violence had become less the expression of a developed ideological position than a way of life, a source of peer esteem and an end in itself. In recent years, however, as its leadership has been progressively weakened by arrests in Spain and its one-time sanctuary France, ETA has shown itself progressively more willing to consider a negotiated exit from the political *impasse*. This became more urgent in the wake of the public revulsion aroused by its killing in 1997 of young PP councillor Miguel Ángel Blanco. Encouraged by the IRA's ceasefire, they entered negotiations with PNV that would lead in 1998 to a cessation of armed activities. The Guggenheim Museum, which had opened in Bilbao the year before, was a direct beneficiary of this, and suffered badly when attacks resumed a year later after intransigence on both sides caused the talks to collapse. This failure, the sense of continuing ideological drift it engendered, the resumption of violence (which has so far produced more than thirty further deaths), and their induction of numbers of young Basques under the age of legal responsibility into low-level street disturbances have all eroded ETA's traditional support in the region. The collapse of the ceasefire encouraged the PP government to step up political pressure on ETA, criminalizing radical Basque nationalist party Herri Batasuna (on the grounds that it was ETA's political mouthpiece), as well as a number of smaller groups associated with ETA, and closing down radical nationalist Basque language newspaper *Egunkaria*. Drained in this way of much

of its popular support and resources, its key figures squeezed by the decapitation strategy being pursued in Spain and France, and coming increasingly into the view-finder of North America's proclaimed 'war on terror', ETA is now directing energy into reaching a negotiated settlement while it retains the power to do so.

As Chapter 6 demonstrates, that fairly standard account of the evolution of one of Europe's most high-profile armed nationalist groups is not the only narrative of Basque nationalism. But it serves here provisionally to frame a regeneration strategy designed to displace discourses and memories associated with an agonistic past and declining industrial modernity, to distract visitors, investors and the media from 'nuestra realidad – crisis económica, desempleo, violencia' (our reality – economic crisis, unemployment, violence) (Ardanza 1998: 5). The Guggenheim Museum (hereafter 'the Museum') and other major architectural projects planned around it as part of the Bilbao 2000 initiative – Santiago Calatrava's Zubizuri bridge, for example, his airport, Foster's metro stations, Cesar Pelli's new waterfront retail and residential development, the Palacio de Congresos y de la Música Euskalduna (Centre for Conferences and Basque Music) by Federico Soriano and Dolores Palacios – were all, in this sense, designed to persuade 'global investors of the Basque Country's transformation into a politically stable, sophisticated, and outward-looking city' (Reuben Holo 1999: 153). To this end, Bilbao's history of wealth wrested from the earth by the labour of its citizens would be displaced by a vision that owes more to the 'casino model' of wealth creation (Zulaika 1999: 266–7).

Partly because much of the region's past trauma was a result of challenges to and from centralizing impulses, this transformation would not be achieved by appealing to the nation-state but by appealing to international actors. There were four lynchpins in this process. The first was the powerful and dynamic director of the Solomon R. Guggenheim Foundation, Thomas Krens; at a time when PSOE's energetic promotion of modern and contemporary art was attracting international attention, his global vision and boundless ambition made him particularly responsive to the approach from the Basque negotiators. The second was influential curator and from 1983 to 1989 director of Spain's national exhibition centre, Carmen Giménez, whose impressive work for MNCARS had brought her to the attention of Krens in 1988. A year later, following the replacement as Culture Minister of her ally Javier Solana by the more 'cost-conscious' Jorge Semprún, she accepted a post with the Foundation (Bradley 1997: 2). By 1991, her energy, expertise and insider's knowledge of Spain's contemporary art-world had made her a key collaborator in Krens's search for a Guggenheim satellite in

Spain. The third figure was Alfonso de Otazu, a Basque historian, influ-ential consultant to Solana, and close friend of Giménez's, who would bring the Basque and New York parties together (Zulaika 1997a: 21). The last was the then cultural counsellor for the Basque region, Joseba Arregui. In an interview for the *New York Times* in 1987, Arregui had affirmed his commitment to supporting the regional initiatives that were then propelling the rebirth of Basque culture; less than four years later he would promote among political colleagues, and then sign, an agree-ment for an art franchise that affirmed global at the expense of regional cultural production while eating up a truly awe-inspiring proportion of the region's resources (Bradley 1997, Reuben Holo 1999).

But why should the Solomon R. Guggenheim Foundation put its authority, its experience of cultural mediation and management and other resources behind a project based, as Krens was only too aware, in a city that was far from 'le centre de la vie culturelle espagnole' (the centre of Spanish cultural life) (Krens 1999: 14). The answer lies, above all, in his decentralizing agenda and global ambitions. Like the opening, three years later, of Mexico's Jumex collection in Monterrey, it was underpinned by US financial interests as much as cultural ones. But the Guggenheim Museum in Bilbao was the initiative not of a single, enor-mously wealthy, individual but of one of the global art-world's best-known and most ambitious institutions. The Bilbao project was one element in its programme of rapid international diversification, prompted by globalizing economic and cultural forces and the acceler-ated growth of international tourism.

That was not the whole story, however; the Foundation was exploring these opportunities because, like Bilbao, it was in crisis and saw the new Museum as part of the solution. Financial pressures linked to reductions in US government support for culture had obliged it to seek increased private funding, in a highly competitive environment, and at a moment when the global art boom was turning to bust. Exploiting the Foundation's collection more fully became a priority; the New York Guggenheim was attracting fewer visitors as work displayed there became overly-familiar, and Krens was anxious to enter into art exchange arrangements with high-profile international institutions in order to freshen its appeal and help defray the Foundation's rising costs. This impetus to renew and develop holdings was also driving an acqui-sition programme that drained resources in the short term while making impossible demands of existing exhibition space. These demands became more pressing still following the purchase in 1990 of over 200 works of (mostly Minimalist) art from Count Giuseppe Paza de Biumo's collec-tion. A year later, moreover, when discussions with the Basque Country

began, Guggenheim projects in Venice, Saltzburg and Japan were being checked by difficulties in finding sufficiently large sites or in securing what were seen as the necessary political and economic guarantees. The same hard economic logic underpins the 'innovative collection-sharing strategies' that have enabled Krens to spread the limited 'content' available to him between the museums in the 'global Guggenheim' network, drawing resources from stronger franchises to support weaker ones (Alsdorf 2001: np, Solomon 2002: np). Tactics which, like these, exploit 'synergy' in order to achieve 'leverage' are familiar in multinational corporate boardrooms; their unapologetic extension to the art world, ostensibly for the production and promotion of an artistic 'international avant-garde' and a global brand, has dramatically divided critics and commentators (*Economist* 2001: np).[10] At no point, however, did Krens attempt to conceal these wider motives from his Basque collaborators.

Spain's rapidly rising (and increasingly chic) profile in the US encouraged Krens and Giménez to approach Madrid early in 1991 with a proposal to rent out some of its modern and contemporary art collection for display there. But by this time the global art boom had peaked and Semprún, who had rejected a proposal from Giménez in 1989 for an exchange of works between the New York Guggenheim and MNCARS, was unwilling to commit large amounts of money to renting a collection that might compete with the capital's own newly-established contemporary art museum, and wary of the highly speculative deal proposed by Krens (Bradley 1997). Giménez and Krens then turned to regional governments they knew to be seeking to expand their cultural offer and in possession of at least some of the resources that such a major initiative would require. In the event, most of these secondary targets declined, unable to raise supplementary funding from central government at a time when preparations for 1992 were draining national and (in the case of Madrid, Barcelona and Seville) regional cultural funding.[11] It was only when all other leads had cooled that Alfonso de Otazu, aware that the proposed Alhóndiga project had been derailed a year earlier by political infighting, initiated contacts with the PNV politicians who would become the key Basque figures in the negotiations (Zulaika 1997a: 23). His insistence from the outset that the initial approach should be to the Department of Finance and Public Administration (rather than the more risk-averse Culture) helps to explain the terms in which the project would be conceived.

Despite his initial reservations about the grey and peripheral Bilbao (then rated 56th among European cities) as site for his new museum, Krens was won over by the massive investment of capital and energy the Basque regional governments were prepared to make in it. Serious

negotiations were quickly under way, and in December 2001, only ten weeks after the surprise signing of the pre-agreement and despite strong reservations among some of Bilbao's key political and artistic figures, 'the museum deal of the century was clinched' (Bradley 1997: 2).[12] Under a

> binding 20-year contract (extendable to 75 years), the Basques would finance the construction and operation of a new Guggenheim museum to the tune of 100%, even down to the fees incurred by SRGF to draw up that very agreement. Expenses, which by some estimates had risen to $250 million by the time the contract was signed, would be borne 50/50 by the governments of the Basque region and Biscay province (unlike other new Spanish museum projects, the Museum would receive no funding from the Spanish state). Costs including building construction ($100 million) plus to-be-determined operational expenses (physical plant maintenance, utilities, overhead and salaries) as well as curatorial and administrative services to be provided by the SRGF. In addition, Basque administrations pledged $50 million for the new Spanish and Basque art collection (a sum to be spent over a four-year period, starting in 1994). [...] But by far the most striking aspect of this unique agreement was the deal-sweetening $20 million donation the Basques would pay the SRGF, free and clear of taxes and withholding, in two consecutive yearly instalments [...] well before the museum would be up and running. [... In] Spain this was quickly – and accurately – dubbed the 'rental fee' [...] In return, the SRGF would exhibit its collection in Bilbao on a rotating basis for the length of the contract. (Bradley 1997: 2–3)

It would also commission and manage all aspects of the design and construction of the building, and subsequently plan, operate and manage all aspects of acquisition, programme design and management, including advising on the hiring of personnel. Despite Otazu's reservations about the regional government's Department of Culture, it was cultural counsellor Arregui who would help to reassure Basque socialists (by then sharing power with PNV) in the face of local concerns that 'the agreement was "vergonzosamente unilateral"' (shamefully one-sided) (Zulaika 1997a: 12–13).

There would be many more concerns expressed, in Bilbao and more widely, on this and other aspects of the project before its completion. Its most vocal opponents were not convinced that it transcended politics and culture, or that it was an investment in the future that would act as a stimulus in the medium term for 'el progreso y bienestar de nuestro país' (national progress and well-being) (Zulaika 1997a: 289). While there was broad initial enthusiasm among many politicians, artists and intellectuals at the prospect of the cultural kudos attaching to the Foundation's arrival in Bilbao, this was tempered almost immediately by

unease at the rapidity with which the agreement was drawn up, and the lack of detailed strategic planning and local consultation in advance of it. The project's harshest critics represented its supporters as provincials posturing as global operators while being bounced into a risky, half-baked, deal by a self-serving imperialist trickster. Concerns about the Foundation's cavalier attitude towards Basque culture and cultural production were partly allayed during the construction of the Museum – principally by piecemeal concessions at the fringes of the project, designed to mollify key intellectual and artistic figures. These included supplementing the Museum's much-debated 'global' perspective with 'a few small but fine avant-garde museums and museum-like institutions in Bilbao and the vicinity'; this, it was argued, would intensify Bilbao 2000's regenerative effects by deepening and diversifying the broader art-tourist appeal of the city and its surroundings (Reuben Holo 1999: 149). Although some of the funding for this was diverted from Bilbao's Museo de Bellas Artes, and some of the institutions it established were short-lived, the strategy reassured a number of influential objectors who had been concerned that Basque artistic aspirations and achievements were being marginalized.[13] A vocal minority (which included Oteiza) nevertheless remained implacably opposed.

If the city's and the region's politicians were prepared to take this extraordinary gamble in the face of concerted high-profile opposition it was partly because they saw it as both a historic challenge and a strategic necessity. From the perspective of the director of the region's Ministry for Tourism, for example, the city's reconversion would simply not have been possible without a *grand projet* (Rodríguez Larrauri 2003). With the construction of the Guggenheim 'hemos logrado pasar de una ciudad industrial, degradada, sin interés turístico a una imagen de ciudad moderna' (we have been transformed from a degraded industrial city with no tourist appeal to the image of a modern city) (2003: np). But it was precisely this association with promotion, marketing and image that unsettled many of its critics: a traditional understanding of Basque culture as rooted deep in history, place and 'heavy' modernity was being displaced, it seemed, by the culture of 'liquid modernity' conceived as an economic driver (Bauman 2000: 57, 15). In the 'postmodern globalized world' in which Krens was operating 'economic regeneration is as much about image as investment and production' (Zulaika 1999: 262, 263). But for his opponents (as for Buck-Morss) the image is volatile and risky. An iconically postmodern museum would only be able to remake Bilbao and instil confidence and dynamism in the region if enough Basques had prior confidence in its ability to do so. The strength of local opposition to the Museum revealed serious doubts on this score; and it underlined

once again the extent to which the world is experienced as postmodern and globalized only fitfully and in certain places by certain (albeit often influential) people.

His standing in the international art market ensured that Krens was one of these. For this globally-articulated market depends on museums, publishers and academics and impresarios

> que manejan los criterios estéticos, los prestigios de los artistas y de los expertos que los consagran, [... y] cuya formación no se establece básicamente por el arraigo en una sociedad nacional, ni por la residencia en *una* metrópoli, *una* universidad, o *un* museo de algún centro líder, sino por la capacidad de desplazarse con flexibilidad entre muchos centros de varios continentes. (García Canclini 1999: 147–8)

> who manage aesthetic criteria, and the prestige of artists and of the experts who legitimate them, and whose training is based not on rootedness in a national society, or residence in a *single* metropolis, a *single* university, or a *single* museum in an influential centre, but on their ability to move flexibly between centres in different continents.

If the cultural hegemony of New York nevertheless persists in matters relating to modern and contemporary art, it is partly because changes in imaginaries lag behind changes in the external conditions that helped to shape them. But it is also, partly, because this hegemony is sustained, assumed and exploited by entrepreneurs like Krens, who travel the world supplementing their institutions' lacks and reinvigorating programmes with loans, exchanges and acquisitions from Europe and, increasingly, newer sources such as Mexico. As seen in Chapter 2, the impact of these transnational interrelations resonates in the wider contexts, accelerating partial shifts in cultural legitimacy away from the old metropolises, throwing up fresh forms and concerns, marginalizing some and making global novelties of others. Different works respond differently to these deterritorializing (and partial reterritorializating) processes. The work of Oteiza, for example, is thoroughly embedded in regional iconography and symbolizations, and these affirm a powerful continuity with the cultural legacy – presented as part historical, part mythical – that globalizing processes are transforming.[14] As with Zapotec-inspired Mexican artist Francisco Toledo, these ties to locale favour the circulation of Oteiza's work in deterritorialized form chiefly as exotic or folkloric. The price for avoiding this would be to surrender or downplay the rooted character that is fundamental to it, and in the process to transform it. In this sense, the less locally-marked work of fellow-Basque Eduardo Chillida, for example, for all its monumental scale and weight, travels lighter.[15]

Krens was clear from the outset that he was not interested in 'un gran museo regional' (a great regional museum); the locale, in his view, was utterly irrelevant to his grand vision. Indeed, he was disinclined to include Basque artists at all until the strength of local opposition (mediated through regional politicians) forced his hand (Portocarrero 1997: np). The discourse that energized his negotiations was an explicitly neoliberal one – 'es ridículo mencionar intereses nacionalistas en temas que tienen que ver con el libre intercambio de la cultura' (it's ridiculous to talk about nationalist interests when what's at issue is free cultural exchange) (cited Zulaika 1997a: 222). The highly-conditioned nature of his model of 'libre intercambio' is a reminder that Krens is not simply colluding in ethically-neutral globalizing processes but advancing a very particular globalist agenda that seeks actively to debilitate cultural differences. The project will only triumph, he declares, 'donde existen débiles conotaciones culturales' (where weak cultural connotations exist); were the project to fail, that is, it would be the fault not of the international Foundation but of nationalist sentiment among local franchise-holders (cited Zulaika 1997a: 232). And what he sees at the heart of this clash between Basque culture and 'international culture' is Basques' centuries-old 'permanence in the same place' (cited Zulaika 1997b: np). It is only by delocalizing, he insists, by loosening this attachment to place that they can access the global network in which the Museum will function as a hotspot.

Herri Batasuna was not the only nationalist grouping to see the Basque administrations' attempts to purge the region's history and cultural symbolism of their more atavistic features as colluding with Krens in this cultural neutralization.[16] With the finalizing of the Museum's design, however, it would be argued that the locale was triumphantly reasserted in the building's symbolism and styling. The sight of its clustered fish and boat forms emerging from the landscape of the city's old port area, for example, and the melting of the Museum's reflective surface into its surroundings were widely seen as affirming the reputation of Canadian architect Frank Gehry as a 'fine topographic interpreter' (Steele 1997: 402). But they also reaffirm the tendency (observed in Chapter 2) of global visual culture to render locale as décor, while the specificity of his interpretation is undermined by the fact that these forms and reflective surfaces recur obsessively in Gehry's international portfolio.[17] In this sense, too, the museum seemed to have 'little to do with "Basque culture" much less "Basque reality"' – a state of affairs that affronted bilbaínos unhappy to be financing what they saw not as 'international culture' but as the 'imperial art of America' (Jencks 1999a: 168, Zulaika 1997b: np, Jencks 1999a: 168).

Deterritorialization has pleasures as well as risks. Contemporary culture no longer requires a passport or passport controllers; foreign bodies may be more desirable and more compelling than familiar ones; and, as some young Mexican artists have found, 'una territorialidad desarraigada' (a rootless territoriality) may be a more fruitful source of identifications than geographically-rooted forms (Ortiz 1996: 77, García Canclini 1999). But anxieties around the displacement of regional culture or visuality by the globalizing visions of the international (or New York) art market need not imply a regressive nostalgia. For, once again, if these deterritorialized visions are a pleasurable response to politico-economic, social, aesthetic or individual crises, it is a response accessible chiefly to visitors with a certain cosmopolitan cultural capital. And although this volume assumes that such visions may help to channel or dramatize the risks inherent in advanced modernity, it finds little evidence that they can actively resolve them. The Museum would become a monument to the proliferating crises and insecurities linked to the displacement of industrial modernity, the unintended consequences of the techno-scientific developments underpinning its construction, and the lost historical consciousness that haunts every corner of it. It was, in this sense, overdetermined from the outset: as a symptom or point of intersection for economic, social, and cultural-ideological crises, but also the projection of competing political-managerial-curatorial strategies for addressing them – a projection that would need to beguile neutral spectators, to suspend provisionally the doubts of some of the less neutral, and to engage the world-weary global connoisseur. What manner of building could hope to achieve this?

On the banks of the Nervión a cluster of bright, metallic petals is opening onto Bilbao, its flower-heart; glistening boats and giant leaping fish are poised beside the water; a spaceship hums in a dark landscape. Spaceship, fish, boat, flower, all these epithets and more were used by commentators to evoke a new phenomenon in the international cultural firmament: the Basque Country's, Spain's and, for some, the world's most spectacular new museum. They do not describe its appearance so much as conjure the visual impact of 'una de las grandes obras arquitectónicas de este siglo': 'a viscous steel dragon[, ... an] incredible urban presence[, ...] an explosion of light, a starburst of energy, unstoppable white larva, overlapping waves[, ...] silvery eruptions', '[una] catedral de titanio [...] tan nuev[a, ...] tan irreal [...] que pronuncia palabras de otros mundos' (one of the century's great works of architecture ... a titanium cathedral, so new, so unreal, that it speaks words from other worlds) (Guisasola 1998: 34, Jencks 1999a: 167–8; Kortázar 1998: 64). Now picture this:

this unique Museum built on a 32,500 square meter site in the center of Bilbao represents an amazing construction feat. On one side it runs down to the waterside of the Nervión River, 16 meters below the level of the rest of the city of Bilbao. One end is pierced through by the huge Puente de La Salve, one of the main access routes into the city. [...]

The building itself is an extraordinary combination of interconnecting shapes. Orthogonal blocks in limestone contrast with curved and bent forms covered in titanium. Glass curtain walls provide the building with the light and transparency it needs. Owing to their mathematical complexity, the sinuous stone, glass and titanium curves were designed with the aid of computers. The glass walls were made and installed to protect the works of art from heat and radiation. The half-millimeter thick 'fish scale' titanium panels covering most of the building are guaranteed to last one hundred years. As a whole, Gehry's design creates a spectacular, eminently visible structure that has the presence of a huge sculpture set against the backdrop of the city.[18]

The Museum's internet home-page retains the sinuous curves and fish metaphors of the earlier evocations. But the euphoric tone is displaced here by a cooler awe aroused by the construction's technologico-aesthetic sophistication. Together, this euphoria and sophistication form the basis of the Museum's claims (now commonly made for international cultural centres) to art status in its own right. Yet the extreme visual qualities triumphantly realized by Gehry have been taken to undermine both its claims to art status and the status of the art it houses.

These visual qualities derive partly from the brief given to international architectural firms competing for the Museum commission: to envisage a construction that would be a distillation of visual pleasure and awe comparable with the impact of Chartres in the fourteenth and fifteenth centuries (Jodidio 1999: 22). It is not fortuitous that the construction of the French cathedral marked the peak and early decline of a representational epoch: by the end of the fifteenth century, the beginning of the modern era was displacing the earlier imitative tradition with 'the cult of the new' (Vattimo 1992: 2). Five centuries later the Museum highlights not only how far culture, in its economic acceptation, has displaced religion as a public focus but also how far its status within the secular cult of the new rests on a powerful and problematic identification with the visual. Within the Platonic tradition, representations in general were seen as 'fundamentally to be mistrusted, or at least accused of being severely limited to the appearance of the world', while visual representations traditionally figured as the province of the non-literate, or as exceeding, simulating or otherwise traducing the assumed essence of the real (Evans and Hall 2000: 18). While this prejudice persists in some

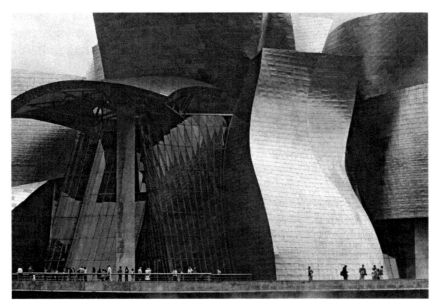

5 Guggenheim Museum, Bilbao (side view) (Ken Brodigan)

quarters, there has been a growing recognition that, for good or ill, modernity's project has been 'effectively achieved through the privileging of sight', that late-modern culture has made the visual its master discipline, its main communications medium, and its principal access to shared symbolic repertoires (Jay 1993, Jenks 1995a: 2, Martín-Barbero 2001). The visual analysis associated in my introduction with Nicholas Mirzoeff has tended to present the vertiginous circulation of the image – whether pleasurable or disturbing – as a condition of post- or late-modern existence (1998: 3–5). Left cultural studies has been more interested in 'the ways in which "the image" is [...] articulated within the picturing sensibilities of a wider culture' and with its materialization in practices traversed by networks of heterogeneous interests and asymmetrical relations of knowledge and power (Evans and Hall 2000: 7). Although the Museum's pleasures and power have excited responses from within both of these traditions, there has been little detailed engagement with the interaction of its visual qualities and its locale. Resonating in the Museum's anxious reception, for example, and compounding concerns about the cultural imperialism or economic viability of the project, is an archetypically finisecular unease that the myths which once structured the perception of objects have themselves become the object of perception, that the real is draining or has already drained away. It is as if the brilliant new pace-maker designed to re-energize the old heart of the

city were in fact overtaxing, abstracting or extracting it, as if a vampire (reminiscent of those haunting the previous century's end) were consuming Bilbao, reducing this historic locale to the home of an endlessly substitutable architectural novelty.

These echoes attest to the alien quality that Krens actively promoted by isolating the project so early and insistently from its locale. The politicians' motor for regeneration has exceeded its mechanical brief to become an international visual phenomenon extreme enough, perhaps, to dynamize the grey, machinic, heartland of postindustrial Bilbao. As befits the conflicting investments in it, however, the energy it radiates is both hot and supremely cool. On the one hand, it fuels the vivid verbal imagery noted above and guarantees the iconic function of its visual counterparts: the surreal postcard-images that identify this exceptional building unequivocally with Bilbao. On the other hand, it detaches these images from Basque social and cultural geography. For while the titles of the postcards insist on its location, their images obliquely affirm other worlds: the Museum's 'poderosa identidad icónica' (powerfully iconic identity), guarantee of its ability to transform the city's identity, has been designed to abstract it from local contexts in order to ensure its pre-eminence in self-styled global ones (Van Bruggen 1999: 29). The construction that has placed Bilbao squarely on the map is, in this sense, ageographic and departicularized – a fact that intensifies its cultural and economic magnetism while debilitating the regional, provincial and municipal integrationist discourses that cast it as one jewel in the Basque crown (Ardanza 1998: 5). As in the case of its boat and fish figures, its exterior seems designed to bridge these divergent imperatives by integrating the Museum theatrically into its locale: it swoops under the La Salve bridge and makes the Nervión its mirror as if attempting to 'make of the city a large museum, and the museum a small city' (Boyer 1996: 421). But the limits of this rhetorical bridging are highlighted by the fragments of other imaginaries deployed in its interior: architecturally, in echoes of Escher's surreally-misconnected spaces or the white-cool lines of Lang's ambivalent *Metropolis*; and in the permanent collection, by Mario Merz's 'Unreal city', for example, an *arte povera* installation in which fabricated and natural worlds hold each other antagonistically in check.

Contemporary architecture has been charged by some practitioners and critics with responsibility for resuturing fragmented, deterritorialized lives:

> the psychic spaces and the shape of buildings should assist the human memory in restructuring connections through time and space so that those of us who lead lives complicatedly divorced from a simple place in which

we can find roots can have, through the channels of our minds and our memories, through the agency of building, something like those roots re-established. (Charles Moore cited Lash 1999: 51)

But the Museum's impact rests precisely on its challenge to this rooting function. Its effects are designed to unsettle, to precipitate (by powerfully affirming) a break with an agonistic and provincial past. So intense was this sense of discontinuity that early responses to the new Museum repeatedly liken it to a spaceship, pulsating (it seemed to some) with 'reflejos de otros mundos' (reflections of other worlds) (Cirlot cited Kortázar 1998: 64). This resonates with the sense of dislocation that, for Gianni Vattimo, typifies aesthetic experience in late modernity, a shock that arises from the 'disorientation and oscillation connected with anxiety and the experience of mortality' (1992: 58). There is a sense in which this shock marks the limit potential of museums like the Bilbao Guggenheim, and the art they house, in an age of generalized communication. But there is more to its visual impact than the interaction of shock and strangeness, awe and anxiety. At its core are the reflexivity and euphoric speculation that, a decade before it was built, Fredric Jameson described as recurring features of postmodern or late capitalist logic (1984). The reflexivity can be traced from the old industrial water of the Nervión through the shallow, decorative, pools that make up the Museum's mirrored *mis-en-scène*. For Gaston Bachelard, water is the seeing eye of the landscape; it affords the universe's first view of itself and is the source of cosmic narcissism (1964). But in late capitalist modernity it seems rather to collude in the narcissism of major contemporary structures and their cosmopolitan makers. Within this elemental 'loop' a powerfully restricted energy is produced which drives the vertigo, intoxication or trance-like state allegedly induced by the Museum in its most ardent supporters. Critic and close friend of Gehry, Charles Jencks, associates these narcissistic pleasures with what he calls 'ecstatic architecture' or (since he sees Gehry's flagship as its most potent realization) 'Bilbaoism' (Jencks 1999a). It is not fortuitous that Jencks's other key example of ecstatic architecture is Disneyland – a parallel reinforced by Gehry's association with notable dream-factory commissions, from the incomplete Disney Concert Hall to the surreally improbable Sam Goldwyn Library.

Writing in Argentina, however, while the Museum was under construction Beatriz Sarlo suggests a more persuasive parallel: this time, between stranded spaceships and the positioning and commercial aesthetic of shopping centres. The ecstatic, vertiginous or disoriented state described by Jencks and its suspension of spectators' rational judgement

have clear affinities with the excitation conjured, in her account, by the mirrors and false perspectives used in shopping centres to neutralize consumers' inhibitions (Sarlo 1994: 13–23). Two years later Diane Ghirardi would trace the global rise of the cultural centre directly to economic imperatives (the high market value of art, the types and sources of financing, tax laws, and the ebb and flow of international tourism) and note that these are obliquely substantialized in architectural features typical of shopping malls and theme-parks. The link is still more explicit in the lament of David Levi Strauss that Bilbao's Guggenheim Museum, an 'incredibly beautiful building [and] one of the great architectural achievements of our time, [...] is in operation nothing more than a retail outlet. Culture is produced elsewhere and exported to be consumed' (Levi Strauss 2001: np). Though overstated, his point reflects a certain convergence there of art, leisure, consumption, education, rationality and fantasy.

The Foundation's elite artistic profile might have been expected to distinguish the Museum from more exuberant instances of this convergence even where its progressive credentials are affirmed in less hermetic or more popular exhibits.[19] As Zulaika observes, however, it is often far from clear whether the Museum's conception was informed by an understanding of culture as sensitive to the laws of the market (as Krens insists) or at the service of the market. Jorge Oteiza is in no doubt: the cultural dimension of the Bilbao Guggenheim is 'un mero engranaje de una estética comercial cuyo objetivo es sencillamente vender más y hacer más negocio' (no more than a gear driving a commercial aesthetic that's designed simply to sell more and generate more business) (cited Zulaika 1997a: 275). Zulaika levels his own criticism at 'la cosificación intrínseca del arte como mercancía' (the intrinsic reification of art as commodity) in Krens's pronouncements (301). Critical international museologists go further: the Foundation is commercializing art museums to the point where 'scholarly integrity and the museum's mandate' are compromised (*Economist* 2001: np). The fact that the entrance to the SoHo Guggenheim in New York was via the gift-shop is seen as emblematic of what one critic has called a GuggEnron tendency in the arts: one that has flourished in the US, where minimal public funding has led to increased commercial influence and pressure on the arts (Saltz 2002: np). For García Canclini, this has been a key factor in the globalization of art markets. Institutions that were once guided by aesthetic and symbolic considerations, he argues, are now driven by imperatives once associated with industry: to become self-financing, to expand, to generate profits (1999: 149).

In Bilbao's case, this dynamic is figured in the Museum's titanium cladding: at night, its cryptic colouring reflects carefully-sited spotlights;

during business hours, it modulates from silver-grey to gold as the periodic sunlight reflects back the building's stone faces. Gehry's mounds of silver and gold are, at first sight, an apt monument to a Foundation born of Yukon Gold and the multimillion dollar investment of its Basque collaborators. If potential investors are endlessly shown the colour of its promoters' money, however, it is because the Museum is both a monument to corporate or broader capital relations and a strategy for actualizing the region's potential by assuming those relations, for generating economic capital with a prodigal display of cultural capital. As one early commentator noted, citing the *New York Times Magazine*: 'el milagro "no está en el propio edificio, por muy maravilloso que sea", sino en el "extravagante optimismo" que invade a los que viajan a la ciudad' (the miracle lies not in the building itself, marvellous though it is, but in the extravagant optimism that imbues visitors to the city) (Guisasola 1998: 25). For its more acerbic critics, this optimism consolidates the commercial relations through which visitors participate in the manipulation, by city tableaux, of the once-private spheres of desire, nostalgia and imagining (Sorkin 1994: 204).

For visitors whose sensibilities are jaded by the drama of the Museum's exterior, the interior and the art itself 'become a kind of anticlimax' (Venturi, cited Tipton 2003: np). Its promotional literature works to redress this, speaking lyrically of the atrium with its flower-shaped skylight at the heart of the building, the broad stairs leading to the sculptural tower, the exhibition galleries arranged on three levels around the atrium and connected by curved walkways like vertical motorways, the glass elevators and stair turrets that climb the interior walls, the echoes of Willem de Kooning in the atrium's plaster curves. Some architectural commentators underscore the technological challenges resolved here, the inspired 'manipulation of volumes' underpinning bold and innovative spaces (Modigliani 2005: np). One compares the atrium with a cruise-liner, its 'white curves [...] sliced by dark metal and glass and [... the] flying bridges that jump the atrium space'; another admires the labyrinthine galleries and vertiginous 'pasarelas trepando por las paredes, entre curvas de escayola, vidrio y titanio' (walkways climbing along the walls, between curves of plaster, glass and titanium) (Jencks 1999a: 172, Geo 1998: 51). In general, however, visitors seem to be more often ambivalent; having had their sensibilities heightened by the fantasy of the exterior, they reportedly find the interior bland (Kortázar 1998). More than a decade before the Museum was built, Jameson (1984) registered a certain theatricality in the postmodern vogue for internal folding and warping – a vogue reaffirmed here in the interweaving of titanium plates, the glass walls, and the shimmering flower-lights – and

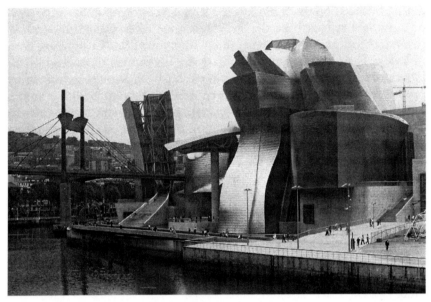

6 Guggenheim Museum, Bilbao (rear view) (Ken Brodigan)

suggested that it raised and delegitimated the distinction between the apparently authentic and the commercially *ersatz*. Xon de Ros aligns this with the Expo aesthetic, in which the desire to impress through the exterior renders the interior almost inevitably disappointing (2002). There are, once again, echoes of the shopping mall in the disposition of the spaces and walkways: despite the irregularity of some, and the names (Pez, Nemo, Zorro) conferred on them, the galleries lack the character, the sensuous appeal and the intellectual shock of the exterior; they seem 'un peu plus classiques' (a little more classical) by comparison, too readily and too thoroughly intelligible (Jodidio 1999: 34). Even Jencks, Gehry's most consistent advocate, initially registered 'too much background white [... and] a sense of claustrophobia' (1999a: 173). Museums are conventionally heterotopic, in the sense that they juxtapose incompatible spaces in a single, conventionally real, space. In the Museum's interior, however, this aleatoric dimension seems too ordered, its characteristic thrownness or 'decontrol' more coolly calculated, with most exhibits displayed in classically ascetic 'white boxes' reminscent of sensorily-deprived environments (Lury 1997: 242).

This sensory restriction is one aspect of a certain reification of the visual linked, here, to ritual. For the euphoria cultivated by the Museum's exterior is wanly parallelled inside it, in an automatized awe. This awe is linked partly to the sequestering of features that might trouble blank

spaces or clash with occupied ones. But there are other strategies at work here for regulating disorderly energies – rather as the building's surroundings are kept clear of crime and importunate beggars – that might otherwise compromise the displays' severe or mocking integrity. Particularly in the fine-art galleries every effort is made to restrict spectators' interaction with their environment to the non-haptic, the exclusively visual. Visitors are encouraged to walk in 'somnambulant reverence', their responses determined by carefully-selected contextual details, their progress regulated by black tape on floors, by warnings of 'potential problems' and unspecified risks to exhibits from 'the slightest touch', from 'sharp objects or from any other objects that might be used as a marker, such as pens, papers or magazines', from unaccompanied or running children, from animals or 'packages, rucksacks and bags', or 'large objects like umbrellas (except collapsible ones)'.[20] The limits on even visual interaction are marked by a prohibition on photographic or video equipment; teams of uniformed attendants watch the watchers, taking notes and occasionally challenging visitors who betray a desire to *take* photographs that must be purchased in one of the gift-shops.

A similar will to order motivates certain displays. The Guggenheim family collection made its reputation in the 1920s and 1930s with non-objective (abstract) art with a particular emphasis, in the decades that followed, on the quintessentially US form of abstract expressionism. This is broadly associated with spontaneous and powerfully individualistic challenges to representational painting styles, with few (if any) transparently symbolic elements to guide spectators unfamiliar with the objects of its critique; and for some exponents its expressive method could be as important as the end result.[21] That these messy challenges are themselves isolated, canonized and authoritatively interpreted here is not the least of the Museum's ironies. Reduced to its aesthetic dimension, even the anti-art of Andy Warhol is transformed. Excised from popular culture, it is resutured here, stitched up in a high-cultural frame that authenticates his first challenging gesture, recasting its regular repetitions in neatly-tailored contexts. Absorbed into this art-cultural periodization his images slip into a history that has lost faith in broader histories, in a Museum dedicated to history's overwriting.

Here and elsewhere, the regulatory practices of the Museum's gallery management underline the extent to which its visual authority can no longer be taken for granted. The accelerated transformation of physical and cultural geography, and the relation of culture and its institutions to locales and local bodies, are eroding museums' traditional mission, and authority, to stage the quest for original artefacts that might illuminate what is past and to come. Yet they continue to be haunted by a nostalgia

for the pleasures of collecting and recollecting – pleasures to which they were once monuments – in an era of globalizing decollection, deterritorialization and risk. Against this background, elite cultural institutions compromised by the decline of the values and distinctions that gave birth to them are supplementing new regulatory practices with compensatory ones. The Museum's dazzling exterior is one example. Its sunken entrance is guarded by another, in the form of Jeff Koon's huge flower-puppy. As the Museum catalogue notes of Warhol's work, and rather like the building itself, this kitsch Cerberus 'se puede contemplar bien como una celebración o como una crítica subversiva de la cultura consumista' (may be interpreted as either a celebration or a subversive critique of consumer culture). But compensation has triumphed over critique as, by popular demand, its flower-body is repeatedly remade so that young couples unmindful of consumer ironies can continue to have their photographs snapped alongside it.

But the Museum is as vulnerable to the waning of novelty as is the globally-appropriated art discussed in earlier chapters. For the spaceship has now eased into its surroundings, becoming a social space in an incontrovertibly physical location; and in the process the familiarity that has eased the anxieties of most *bilbaínos* has eroded the Museum's appeal for the international visitors who were to transform the city's fortunes.[22] Almost miraculously, the Museum has remade itself to reflect this irony, assuming the colours of its surroundings under a new form: not the green hills and lowering skies envisaged by its makers, but the corrosive residue on its titanium plates of a polluting past that is not so easily displaced. The seductions of the building have become more locally congruent in this process and (in ways that Gehry did not anticipate) more globally incongruent.

These changing fortunes can be tracked, if rather imprecisely, in the curve of economic activity associated with the Museum's presence. Partly because of the extravagant national and international advertising campaigns that preceded its official opening in October 1997, early tourist revenues for Bilbao far exceeded the (already optimistic) forecasts of consultancy firm KPMG (Brooksbank Jones 2004a). A key factor in the maintenance of these levels over the next twelve months – though difficult to quantify, and despite an attack in the week of the opening – will have been the impact of ETA's ceasefire during its negotiations with PNV in 1998. *Bilbaínos'* desire to participate in the anticipated success of the project led to 40,000 applications for the seventy-three posts at the Museum, while a two-fold increase in hotel and catering business was reported in its immediate vicinity in the three months following its opening (Ros 2002: 283). The longer-term financial benefits and wider

impact of the Museum have been less clear, although within less than a year the number of individuals visiting Bilbao primarily to see it had fallen significantly.[23] A consultants' report, commissioned by the Museum to mark the fifth anniversary of its opening, estimated that its broader economic impact over the period was equivalent to ten times the initial investment in its construction (de Garay 2002). It might be argued that the Museum's growing network of corporate supporters and sponsors is firmer evidence of a more buoyant economic climate.[24] There is little sign so far, however, of growth in the advanced services that the Museum was designed to attract.

The Foundation's own fortunes, meanwhile, have declined significantly since the opening. In the three years that followed it, Krens opened three more Guggenheim satellites 'with mixed results': 'the Berlin museum [has now] scaled back its programming, and the Guggenheim Las Vegas – one of his two museums in that city – has shut down', as has the more established New York SoHo outpost (Saltz 2002: np, Irvine 2003b: np). To those critical of Krens's flamboyant institutional and self-promotion, the deepening economic crisis of recent years – the closures, the staff redundancies, the programmes cut and exhibitions cancelled, the cancellation or indefinite postponement of some major developments, and the periodic rumours of his imminent replacement – must all look like *hubris* (Solomon 2002). In the words of Herbert Muschamp, 'the global merry-go-round has stopped spinning [raising the possibility that] the Guggenheim brand is no longer an asset, but has become a curatorial liability in the eyes of many who once thought of themselves as fans' (Muschamp 2002: np). And in this looking-glass world of boom and bust some of the Museum's fans are even beginning to suggest that it is 'beguiling from the outside but ridiculously overscaled on the inside', that this 'architectural marvel [is] already perhaps becoming a little dated' (Saltz 2002: np, Kimmelman 2002: np).

Writing in its heady early days, Charles Jencks attributed the delight produced by the Bilbao Guggenheim, even among its more sophisticated and world-weary visitors, to a sense that it was a new and less determinate construction for our 'subjunctive epoch': a phenomenon combining the end of one set of possibilities with the barely-articulate promise of new ones; a re-enchanting space irreducible to utopian nostalgias, market chimeras or critical attempts to conflate them (Jencks 1999a: 173). For Gehry it declared the pre-eminence of art (among which he includes architecture) as 'le moteur de l'âme collective' (the motor of the collective soul) (cited Jodidio 1999: 34). But that familiar mechanical metaphor conflates Jencks's new age with a sub-Jungian New Age, the postmodern with a version of the premodern. But more than a new age,

what transports Jencks are glimpses (as he sees them) of novel forms from which a new visual knowledge might be inferred, broken phrases that seem to hint at a fractal grammar which has as yet no correlative in modernity but is insinuated in the Museum's computer-generated curves and spaces. It is from this perspective that he views the large museum as 'perhaps the best public focus we have found this century' (1999a: 169). But he also acknowledges Bilbaoist architecture's potential to be transcendentally 'anti-social, anti-nature, anti the public realm' (1999b: 14).

This chapter has argued that the Museum works to sequester some risks in late modernity and to theatricalize others while – as Jencks underlines – introducing new ones. But the decline in the Foundation's fortunes reveal another and, until recently, largely unpredicted vulnerability in the global energies that colour his vision and that of Krens. If 'global culture sounded inevitable a few years ago', it has been argued, 'Sept. 11 put an end to that [by making] people less willing to travel, the American public poorer, more attuned to protecting itself and what it has' (Kimmelman 2002: np).[25] Two-and-a-half years later the Madrid bombings would have done little to reassure Krens's global tourists, or to rebuild the confidence required to energize Basque support for the Museum and dynamize their locale.

But there are alternatives to globalist euphoria and defensive retrenchment. Writing around the same time as Jencks, Zulaika suggests that the Museum project was conceived in a postnational context in which the nation is becoming irrelevant for ascendant Basque culture. This, he contends, and a strong history of international trade that has historically exposed it to less provincial and nationalistic world-views, underpinned the Basque willingness to approach a foreign collaborator without Madrid's mediation (Zulaika 1999: 272). While he puts his finger on an important tendency, the case is overstated. Even Krens, the archglobalist, did not think of approaching potential regional collaborators until he had been turned down by the national Minister for Culture – a minister, moreover, who interpreted his proposals as the work of an only partly-reconstructed North American imperialist masquerading as a global entrepreneur. Reuben Holo is readier to include the national in her account of Basques' overlapping identifications, noting that in democratic Spain they can 'freely project themselves as Basques first, if they so wish, and then, in varying degrees, as Spaniards, Europeans, or citizens of the world' (1999: 147, 141). This radically underplays the factors conditioning such choices in practice and fails to acknowledge that 'this non-linear, variable, and at times overlapping sense of self' has, for some Basque citizens, proved at times to be life-threatening as much as 'life-sustaining' (Reuben Holo 1999: 141). The broader point remains,

however: that national identifications remain in play with local, regional and international ones and each may be differently assumed in different contexts. Chapter 6 examines premodern elements within Basque modernity, their significance as the irrepressible, 'unintegrated residue of a different economy and a different culture', and their role in facilitating the creative reappropriation of a decentred modernity (Raymond Williams cited Martín-Barbero 2001: 58). The Museum project suggests that the construction of thrilling global phenomena can actively block this process; it has, nevertheless, productively complicated the debates around strategies for asserting the autonomy of the local while accommodating the global.

Notes

1 These are respectively the Queen Sofia National Museum and Art Centre, the Thyssen-Bornemisza Art Museum, the Valencia Institute for Modern Art, the Andalusian Centre for Contemporary Art, and the Barcelona Museum of Contemporary Art.

2 The Plan Museológico elaborated by the current PSOE government (in place one year at the time of writing) under Culture Minister Carmen Calvo Poyato is designed to achieve this kind of overview and to iron out some of these disparities by bringing all state museums up to specified national standards. See www.mcu.es/museos/planmuseológico, accessed 03.05.05. As part of this strategy, December 2004 saw the launch in of the Ministry's *Museos.es*, an annual publication designed to share best practice within Spain's museums, partly by promoting contacts and debate between specialists working in them. See www.lukor.com.ciencia/noticias/0412/2214230.htm.

3 On earlier failed attempts to create a national centre for contemporary work, the competing political, cultural and economic demands that bedevilled the project's establishment and development, the compromises these produced, and the early criticisms that resulted, see Bolaños (1997).

4 This was five years after a temporary loan (originally for nine years, from 1988) was agreed for the housing of 775 works from his private collection – which had outgrown the available space – in the Palacio de Villahermosa in Madrid for display to the public. Its success, however, especially among foreign visitors who had come to the see the nearby Prado, was a factor in the early conversion of the loan from temporary to permanent in 1992. So, too, was the anticipated influx of foreign visitors as a result of Madrid's installation as city of culture, Seville's Expo, and the Barcelona Olympics in that year.

5 Under PSOE, the Prado's public profile was altogether less dynamic and less outreach-oriented than the Thyssen-Bornemisza's, illustrating the degree to which state support was being channelled towards newer initiatives. As

indicated there was some attempt to redress this under the more culturally conservative Partido Popular after 1996. On the Prado's changing relations with the Thyssen-Bornemisza and MNCARS see Reuben Holo (1999), Chapters 1 and 2.

6 For a useful discussion of debates around art in the nineteenth-century Basque Country (including those published in the art journal *Hermes* at the turn of the century) see Reuben Holo (1999: 142–5).

7 Bilbao's architects had consistently opposed the proposed conversion plans for the Alhóndiga, which had been constructed in 1909 and declared a Monumento de Interés Cultural in 1989. These tensions would lead to the resignation of mayor José María Gorordo. See below and Zulaika (1997a: 23). The Alhóndiga was at one stage considered as a possible home for the Guggenheim museum.

8 It has been suggested that those seeing their expectations of healthy commissions from the proposed Alhóndiga project frustrated were among the first to support this potentially lucrative alternative (Zulaika 1997a: 27). The year 1992 saw the Barcelona Olympics, Madrid's selection as European Capital of Culture, and the mounting of the International Exposition in Seville.

9 The political uses of culture are clearest in, but by no means exclusive to, the promotion of the Basque language. On this see Lasagabaster (1995) and Mar Molinero (1995: 351–5, 336–42) and, in a broader frame, Brooksbank Jones (2000b).

10 On this see also Alsdorf (2001), Saltz (2002), Kaufman (1997) and Reuben Holo (1999). Krens freely acknowledged in 1995 that 'everything he has done for Bilbao has been driven by New York's financial needs'. The Basque administrations pay a large rental fee and will 'share the expenses and risks associated with the organization of major traveling exhibitions. Furthermore, Krens acknowledged that, though the Guggenheim's permanent collection is important to the history of modern art, it will never again have blockbuster status in New York City. In Bilbao, on the other hand, the display of the collection is elevated to a blockbuster event and, simultaneously, its dollar value continues to be enhanced for the mother institution' (Reuben Holo 1999: 155–6).

11 Bradley states that the other cities on the list were Barcelona, Seville, Badajoz, Santander, and Bilbao, of which Santander showed strong initial interest in the summer of 1991 (Bradley 1997: 2). While confirming the inclusion of Seville, Zulaika simply notes rumours that Salamanca, Valencia and Santander were among a number of cities to consider the proposal 'pero no surgió nada positivo' (but nothing positive came of it) (1997a: 23).

12 For a detailed account of the negotiations see Bradley's comprehensive article (1997) and Zulaika's full-length study (1997a).

13 On the role of the Sala Rekalde and its first director, Javier González de Durana, in this process see Reuben Holo (1999: 155ff). On opposition to the Museum see Brooksbank Jones (2004a).

14 Another stage in this process was marked in February 2005, with the first major exhibition of Oteiza's work in the Museum. See El Correo Digital (2005).

15 I saw my first major exhibition of Chillida's work in Yorkshire, in the North of England. My companion had assumed until that point that the artist was North American – an utterly unthinkable error where Oteiza is concerned.

16 Herri Batasuna formed in 1978, in the wake of the Basque rejection of the Constitution, as a coalition of left nationalists, winning 13% of the vote in the national elections of the following year. In 2003, it was declared a mouthpiece for ETA and banned by the PP government.

17 See, for example, the reflecting surfaces of Gehry's Vitra International Furniture Museum in Weil-am-Rhein (1989), the Frederick R. Weisman Museum, Minneapolis (1990), and his installation in the same city's Walker Art Center (1986). Elsewhere, reflective plates become the scales of his iconic fish forms: in the glass fish (1986) that rears over his fountain in the Walker Art Center, his 'Fish' lamp of 1984, or at the Fish Dance restaurant in Kobe, Japan (1987). In his 'Pez' sculpture for Barcelona's Olympic village (1992) this shape is half-metamorphosed into a boat. Gehry, who apparently did not register these parallels until much later, has observed that '[a] veces pienso que todas las formas se pueden reducir a peces y serpientes' (I sometimes think all forms can be reduced to fish and serpents) (cited Van Bruggen 1999: 33, 42).

18 From www.guggenheim-bilbao.es/inglés/edificio/el_edificio.htm, page 1.

19 One of the more popular, Gehry's motorcycle exhibition for the New York and Bilbao Guggenheims, has been described as 'a pathological display of institutional least-common-denominator bragadoccio'. See *The Guardian*, 19 April 2000, 3.

20 The first quotation is from Boyer (1996: 489); the remainder are from the Museum's website, www.bilbao.net/ ingles/villabil/ IMS00006.htm, np.

21 Abstract expressionism arose in New York in the 1940s and 1950s. It remains strongly associated with US artists such as Jackson Pollock, and with European-born artists such as Dutch-born Willem de Kooning and Latvian-born Mark Rothko who took US citizenship in the wake of World War II. The expressive method frequently involves large brushes or (most famously in Jackson 'Jack the Dripper' Pollock's case) the dripping, spattering or throwing of paint. See Anfam (1990).

22 On changing attitudes to the Museum among Bilbao residents see Ros (2002) and Brooksbank Jones (2004a).

23 In a report commissioned by the Museum, accountants KPMG estimated that it had generated a net inflow of tourists of 97,525 during June/ July 1998; academic evaluations of this estimate, however, suggest a figure closer to 35,600 (Plaza 2000: 264). Despite this major divergence, KPMG's data continue to be used uncritically in municipal publications. This preference for optimistic performance statistics over more academically sustainable ones seem to reflect the perceived role of confidence in maintaining the

Museum's appeal to visitors and sponsors.

24 Although, for the reasons suggested at the beginning of this chapter, the
 Spanish tradition of business sponsorship for the arts is more recent than its
 US equivalent, and its expectations as yet quite different, the inducements
 offered by the Museum to its sponsors are rapidly embedding US models.
 Incentives offered to potential business partners include: public recognition
 (in the form of enhanced cultural profile); hospitality during exhibitions;
 media exposure; high-profile involvement in public education programmes;
 the possibility of purchasing works for investment and/ or for display in the
 corporate premises; space, catering and other facilities for conferences,
 cocktail-parties, meetings and gala dinners. See www.guggenheim-
 bilbao.es/inglés/patrocinadores/contenido. While it is difficult to predict how
 this will develop, it seems unlikely to allay the charges of commercialism that
 have dogged the Museum or to promote more opportunities there for non-
 consumer-based cultural experiences.

25 Even before September 2001, some US-based critics, convinced that the
 'heart of American art' could now be found in Bilbao, were resentful and
 wary of having to travel in order to do so to a 'small, rusty city in the north-
 east corner of Spain; it's inconvenient, not much fun, and, by the way, you
 may get blown up' (Muschamp, cited Ros 2002: 287).

5

Countdown: figuring risk and the Real

Chapter 4 considered the risks of regional decline and terrorism – as a label and as a set of practices – in the Basque Country, and Bilbao's negotiation of a certain global consumer identity in response to them. This chapter explores the filmic appropriation of terrorism itself, and passion, as palliatives in a time of complex national crises. Risk figures here as more generalized but also more individualized. And if Bilbao's Museum was designed to sequester risk, to bind, displace or distract attention from it, the film discussed here seems wilfully alarmist by comparison. It amplifies and melodramatizes contemporary anxieties, taking them to the limit of the psychically-manageable before despatching them in a cataclysmically therapeutic climax – or something very like one.

As in Chapter 3 the analysis here aims to engage more subjective, as well as more general, perceptions of risk. To this end, it combines the socio-political focus of the earlier chapters with aspects of psychoanalytic theory. This strategy is itself hardly risk-free, for there are many tensions, both real and apparent, between them. Using a psychoanalytic optic to examine the Guggenheim Museum in Bilbao, for example, might render it an object sublimely irradiated by that which it seeks to mask or displace – the negativity of ETA, for example, as a force not bound by Symbolic authority – and might read the stains on its titanium plates as the insistence of that which cannot be repressed.[1] But their condensation of complex social relationships, institutions and processes, their failure to engage social complexity plausibly in its material specificity, can make such readings appear uncomfortably reductive.[2] Conversely (and in a way not wholly at odds with some variants of cultural studies), these socio-political and cultural narratives can themselves be read within a psychoanalytic frame as objects designed to conjure a relatively coherent world of meaning from otherwise incoherent material singularities.

My account of Imanol Uribe's *Días contados* (1994) shuttles between these frames. It makes no systematic attempt to resolve their tensions, but teases out important analogies between them which are underlined in the film's characterization and dynamics.

Both frames are treated here less as explanations of the world than as illuminating a specific moment: the Spain of the early 1990s. For, in common with almost all of the other images and visual cultural projects discussed in the volume, this film, and the core histories, social commentaries and psychoanalytic theorizing to which it is referred, were all produced in the early 1990s. This reflects no Pierre Menard-like attempt to recreate the urgency of the period, but rather a desire to let diverse overlapping anxieties resonate across the analytical field. Once again, the aim is not so much to interpret a cultural product as to investigate one instance of the management of risk in visual culture. The analysis turns on risk's cultural figuring in *Días contados*. It traces how the film works to mediate anxieties by staging, from the perspective of the individual subject, the relationship between reality and what sustains it; and it considers how, in the process, Uribe helps to maintain the balance between them – or to reconfigure it.

The psychoanalytic dimension of the argument is informed by two influential volumes of film analysis published by Slovenian cultural theorist Slavoj Žižek in 1992.[3] Following Jacques Lacan, Žižek assumes that the child becomes a subject when it enters the realm of language (the Symbolic order, or 'reality'), and that this becomes possible through two acts of repression. The first, and most traumatic, of these acts converts the child's animal instincts to drives; the second represses the memory of that trauma.[4] These repressed elements, which lie outside of 'reality', outside of language and Symbolic law, Lacan terms the Real. Although these acts of repression become second nature, however, they are never wholly successful; for the Real erupts repeatedly into our everyday lives in slips of the tongue, jokes and dreams, as a surplus or a stain on 'reality'.[5] These eruptions or manifestations of the repressed Real are associated with what Lacan calls 'jouissance' and Žižek calls 'enjoyment'. Cultural forms are a particularly rich source of this enjoyment, which is experienced as at once pleasurable and transgressive or, at its most intense, as both thrilling and horrific. The Real is, in this sense, what exceeds 'reality', the obscene underside that makes it possible. It has been described as shaping 'reality' in the way a hole shapes the doughnut, for those founding acts of repression produce in the subject an enduring sense of hollowness, of a void at the heart of the Symbolic order (Kay 2003: 4). Žižek contends that we use cultural and other objects – things, but also people and parts of people – to supplement this

lack: to sustain the illusion of truth by helping to plug gaps in 'reality'; to support our fantasies of wholeness by masking lack, or by drawing attention away from it; or to signify, pleasurably and transgressively, the failure of 'reality' to present us with a consistent world of meaning.[6] Objects are central to his examination of how attempts to manage the repeated eruption of the Real in our lives are mediated and dramatized in fantasies and in visual and other cultural forms, The parallel here between my characterization of risk and his characterization of the Real is one of several that structure the analysis that follows, and certainly the most important.

In *Días contados,* Uribe's acclaimed 1994 thriller, an ETA commando travels down to Madrid to prepare and detonate two car bombs, but their plans are complicated when one of them, Antonio (Carmelo Gómez), becomes obsessed with Charo (Ruth Gabriel), an 18-year-old heroin-addict.[7] His betrayal by her seedy friends will bring the ETA mission and their affair to bloody crisis. The film's opening shots establish a visual link between driving, danger and surveillance, and sex as business, pleasure and risk. A Renault speeds at nightfall along an empty highway. Aerial shots track its trajectory diagonally to the top right of the screen as an extradiegetic drum pulse mimics the rotor-beats of a police helicopter.[8] A Lancia heading in the opposite direction flashes its lights. The urgent glances of its two passengers and their terse exchange against the background crackle of a shortwave radio reveal that the Renault is expected to follow them. It duly slows and makes a U-turn. With a menacing brass chord the drumbeat quickens. Linked from the outset with surveillance, the rising tension is about to be compounded by a different type of look as the Renault, driven by Antonio, passes a young hitchhiker (Marga Sánchez) and slows down. He stares in his rear mirror at the black leather miniskirt and jacket, the black thigh-boots. His calculations complete, he reverses and winds down the window. She smiles, half-ironically, with glistening vermilion lips: 'Hola me llamo Clara . . . Si quieres te la chupo por cinco mil' (Hi, I'm Charo; if you like I'll give you a blow job for 5,000 pesetas). The drumbeat swells.

The scene switches abruptly to Madrid, where Antonio is now installed in a dingy apartment. There, he spies a cable running from the meter-box and tracks it visually out of his window and into that of the neighbouring apartment. A sudden, urgent knocking precipitates an exchange with Antonio's attractive young neighbour, Charo, who is locked out of her own flat, cannot afford to call a locksmith, and cannot seek help from her husband, a professional criminal presently in prison. When Antonio reluctantly allows her in to use his bathroom she ties a red scarf to the handle of his outer door. He eyes it warily. 'Es por si llega

Vanesa', she explains, 'así sabrá que estoy aquí' (It's in case Vanessa comes, so she'll know I'm in here). But Antonio is right to be wary: their relationship is established and energized by the wire that diverts his power to Charo; once it is lit visually by her scarf – a second vermilion flash – it becomes the fuse that flickers and spurts with an unsteady inevitability towards the last of their 'días contados'.

The film's title and most elements of its construction contribute to a powerful sense of predestination. This is linked explicitly to a series of heavily overdetermined events and processes, widely seen as crises, that were resonating across the socio-cultural, politico-ideological and cultural fields at the time the film was made. In the late 1980s and early 1990s Spanish cultural life, especially in the capital, was going through 'una etapa de actividad casi palpitante' (a period of almost throbbing activity) following the youth-cultural emphasis of the Madrid 'movida' that had begun in the late 1970s and petered out in the mid-1980s (Fusi and Palafox 1997: 397).[9] But by 1993 the 'cambio', or period of democratic change, with which this dynamism had been largely associated was played out. The PSOE government had benefitted from a prolonged period of political exuberance following its election in 1982, and had come to seem the natural party of government. In the 1993 national elections, however, it held on to power but lost its national parliamentary majority amid a hail of scandals – fuelled by the newly-established centre-right daily *El Mundo* – and recriminations. Two years earlier, corruption charges against his brother had obliged Vice-President Alfonso Guerra to resign, while the FILESA affair shone the spotlight on covert trading of influence and illegal party funding. Though tainted by these cases, President Felipe González attempted to distance himself from events, thereby contributing to a widespread sense of institutional crisis. Nor were powerful non-governmental figures charged with the management of the national economy exempt from these scandals: within months, the Bank of Spain was rocked to its foundations as Governor Mariano Rubio was tried for tax fraud and insider dealing while Mario Conde, head of Banesto, was forced to resign and later imprisoned for embezzlement. This spiralling sense of institutional impotence or worse further undermined economic confidence and stability. It was compounded by high-profile corruption cases touching the heart of Spain's security forces: in 1994, Luis Roldán, Director General of the Civil Guard, was found to have siphoned off public funds to finance covert anti-terrorist activities, while the reopening of the GAL case by judge Baltasar Garzón saw prominent politicians implicated in these activities and imprisoned. A few months later, the bodies were recovered of two ETA militants who had been kidnapped by GAL operatives a decade earlier.

The atmosphere of crisis, of social and institutional breakdown, that pervades the film can be read in the light of these and related events. The political disenchantment evident in many (especially younger) Spaniards as the 'cambio' period progressed was reinforced in 1989, when the fall of the Berlin wall divided the political classes. In an influential account from the period, Francisco Umbral notes that the ideologico-symbolic impact of 'la caída de la gran utopía del siglo' (the fall of the century's great utopia) was not restricted to a certain disorientation among militants on the left (Umbral 1993: 9).[10] It undermined 'el discurso del siglo, el andamiaje, el socialismo y el capitalismo, [. . .] el rito y el mito, su ritmo y religión' (the discourse of the whole century and its underpinnings, socialism and capitalism, their ritual and myth, rhythm and religion) (208).

If ideology appeared to have ended so too, it seemed, had history itself as dialectic and struggle. When Carrero Blanco was assassinated, Umbral notes, radical Basque nationalists were widely perceived as 'la única fuerza antifranquista' (the only force opposing Franco) (1993: 280). This view was reinforced by the execution of five ETA members, despite an appeal for clemency from the Pope himself, two months before Franco's death. But in recent years, the commentator observes

> la lucha de ETA [. . .] se ha ido desvalorizando, desfigurando, desintegrando, y hoy es difícil reconocer sus señas de identidad, salvo un nacionalismo que la actualidad mundial refuerza tanto como delata. [. . .] Ahora, entre la confusión de cadáveres, guardias, niños mutilados y millonarios secuestrados, el español medio ya no sabe muy bien qué se propone ETA. (Sus comunicados, por otra parte, van siendo cada vez más confusos, lo que manifiesta una decadencia del discurso.) (Umbral 1993: 280)

> Little by little, ETA's struggle has lost its legitimacy, becoming distorted and fragmented, so that today it's hard to make out its identifying features – other than a nationalism that is both reinforced and undermined by the current state of the world. Today the average Spaniard, confused by the dead bodies, police, mutilated children and kidnapped millionaires, doesn't really know what ETA is trying to achieve. (What is more, their communiqués are themselves becoming increasingly confused, demonstrating the decadence of their discourse.)

While this discursive decadence is registered obliquely in Uribe's film, a related decadence seemed to be afflicting the field of Spanish cinema production and distribution themselves at the time. In this case, signs of the anxiety documented by Umbral tend to be more oblique and more technical. Writing in 1993, Miguel Juan Payán records his sense of frustration and disenchantment:

falta dinero para el cine español, falta apoyo institucional, pero sobre todo
[. . .] falta adhesión por parte del público español [que] no acude a las salas
a ver películas con la misma frecuencia y pasión que dedica a las produc-
ciones norteamericanas. (Payán 1993: 10–11)

Spanish cinema needs more money and more institutional support, but
above all it needs more support from the Spanish public, who don't go out
to see home-produced films with the same frequency and passion that they
devote to North American productions.

Within a larger context of perceived crisis, Payán is expressing the
anxiety and pessimism of some critics and industry professionals before
the rapid acceleration of cinematic globalization from the 1980s – in pro-
duction, distribution and marketing, and in the growth of video sales –
as well as the proliferation of films on the expanding network of regional
and (from 1989) new private television channels. Domestic film produc-
tion had slumped by almost two-thirds over the course of the 1980s, and
by the decade's end her successor was obliged to dismantle the film
subsidy system introduced by Pilar Miró in 1984. This had sustained
certain genres of cinematic production at the expense of others and by
the end of the decade was itself terminally weakened by charges of elitism
and nepotism. In 1993, Payán was not alone in seeing the future for
Spanish film as 'muy negro, ya que no parece haber en estos tiempos de
convulsión política y pública, oposiciones al poder, [y] crisis económica
internacional [. . .] un verdadero próposito de enmienda (very black;
there seem to be no real proposals for addressing the current political and
public upheaval, the opposition to power and the international economic
crisis) (Payán 1993: 51). As he underlines, in the cinema as in politics,
this sense of crisis was inextricable from a belief there were no radical
new policies in prospect for addressing difficulties. And once again, glob-
alization is associated here with a perceived shrinking of alternatives.

While his cinematic style and priorities have been conformed largely
by this wider world, some of Uribe's most resonant films have addressed
Basque themes, producing an important tension at the heart of his work.
Within the Basque Country, the 1950s had seen the rise of zine-clubs
(film clubs) making amateur films usually on Basque themes and, in 1953
and on the back of these clubs, the founding of the San Sebastian Film
Festival. By the 1960s, this and documentary festivals arising around it
were encouraging the production of films that took more technical and
political risks. The most high-profile of these attracted the attention of,
and revisions by, the regime's censors. But they also raised the standard
for the aspiring Basque film-makers who, in the absence of regional
alternatives, registered at Madrid's Escuela Oficial de Cinematografía

(Official School of Cinematography, or EOC) (Roldán Larreta 1999, Stone 2002).[11] Imanol Uribe was a member of the last cohort to graduate from the School before its closure and studied there under influential mentor, Pilar Miró.[12]

Spain's emergence from the Franco years saw the end of censorship (which had banned the use of the Basque language in films) and the return from exile of some film-makers opposed to the regime. Almost immediately, *zine-clubs* found themselves divided as to whether Basque film production should now aim to advance nationalist ideals through the medium of Euskera (Basque language) or seek to win new audiences and new support through films with wider commercial appeal. Uribe's relation to these and other nationalist debates of the time is markedly ambivalent.[13] Born to a Basque family in San Salvador in 1950, he returned to Bilbao at the age of 7 but spent most of his childhood in boarding schools outside of the Basque Country. A non-Basque speaker with an early taste for US cinema, Basqueness for him developed as 'a mythic thing, of longing, of melancholy. Film-making for me was a means of getting to know the real Euskadi' (cited Stone 2002: 138). Uribe's interest in ETA was, in this sense, from the outset more personal than political, although the balance has shifted over time.[14] In the last years of the regime, many anti-Francoists across Spain had come to see ETA militants as the only effective opposition, conferring on them heroic, quasi-mythic, status. Partly for this reason, ETA recruitment levels between 1977 and 1979 were vertiginous (Elorza 2000: 285). This was the period in which Uribe's first full-length documentary, *El proceso de Burgos* (The Burgos trial, 1979), was made, and this account of the high-profile trial of 16 alleged ETA members remains his most unambiguously political film. But those early post-Franco years saw the definitive displacement by ETA's exclusively military wing of those prepared to seek their aims through both military and political means; they also saw the end of militants' earlier role in strategic discussions or decision-making, with the imposition of a rigidly-centralized command structure, headed by a leadership to which all operatives were 'totalmente supeditadas en nombre de la clandestinidad' (were wholly subordinated in the name of clandestinity) (Elorza 2000: 277). Against this background Umbral's next film, *La muerte de Mikel* (The death of Mikel, 1983), highlights tensions within ETA and presents them more critically, with attention centred on the personal marginalization of Mikel, an *abertzale* (radical Basque nationalist) activist unsure of his sexuality. The apparently accidental death of ETA leader Txomín Iturbe in 1989 and the detention in France of three other key figures three years later temporarily halted ETA's campaign of attacks on Civil Guard barracks and softer

civilian targets; even in the Basque Country, its public support declined significantly. In 1994 the reopening of the GAL case would discredit the government's anti-terrorist strategy and taint an already weakened executive, enabling ETA to muster its forces for further attacks on politicians and others in a bid to reignite support (Fusi and Palafox 1997: 403). But *Días contados* was made during the period of deepest decline. Like Payán, it insists on what has gone wrong, on opportunities lost, on the apparent absence of alternatives. ETA figures as an ideologically-empty force, and the focus on its operatives is almost entirely personal. The once-heroic figure of the militant is fatally compromised here by a distant and incompetent leadership as much as by police surveillance – but, above all, by his character.

Uribe's film provides a powerful sense of an ending for the seemingly endless crises it conjures – a sense which is not reducible to (nor, of course, wholly independent of) interpretive will.[15] Structure, source, sound, colour and character dynamics all seem to conspire in this process. Most explicitly, the film's countdown is structured around a dramatic irony that brings two separate projects into convergence: one by the ETA commando to blow up a police-station, the other by officers based there to trace ETA operatives they believe to be planning an attack of some kind. The narrative thrust, time constraints, violence, covertness, the seedy *mise-en-scène*, the mood of claustrophobic foreboding, the pursuit and surveillance sequences, some of the interpersonal tension, and their explosive culmination all derive, and take power and scale, from this structure. It is underlined aurally by a driving drum pulse, the pace and volume of which register variations in narrative tension and are punctuated periodically by guitar motifs; and it is heightened chromatically in alternating blacks and reds.

The force driving forward the ETA project is visualized in aerial and other long, panning shots of cars travelling along roads and highways that describe predominantly horizontal or diagonal trajectories. Intersecting these trajectories, however, and ensuring that predestination does not subside into predictability, are the narrative equivalent of road-blocks, illicit sexual encounters figured chiefly on the vertical: in Clara's thigh-boots, for example, or Charo's hanging scarf. As signalled in the makeshift cabling that diverts energy to her flat from Antonio's, another type of power and scale is being generated here and this too is maximized by blockages: between the drivenness and reticence of Antonio, for example, or the openness and unavailability of Charo. As a result, their relationship appears grounded in sexual attraction and heightened by a deferral of consummation. A similar rhythm of predestination and deferral, of predestination as deferral, drives the film's narrative towards its

final, climactic, moment, and is one of a number of factors in the accompanying sense of powerful release.

But there is a more literal sense in which the film is prefigured. For in common with many other films made under PSOE this object of visual-cultural analysis is a literary adaptation: in this case, of Juan Madrid's best-selling novel *Los días contados* (1993). It has been suggested that in the move from novel to film it is characteristic differences, what makes visual culture 'visual', that are most evident (Gimferrer 1985). But the easy transition from Madrid's 'novela negra' (dark or *noir* novel) to Uribe's thriller with *noir* overtones underlines the novel's graphic *mise-en-scène* in 'el submundo de los drogadictos madrileños' (the underground world of Madrid's drug-addicts) (Gutiérrez Carbajo 1993, Torres 1997: 457). Juan Madrid's Antonio is a photographer whose mission is to produce a pictorial history of the 'movida'. During the course of it, he becomes increasingly concerned to make his name and his fortune, to construct a photographic account of the underworld that briefly opens up to him – the corrupt politicians, characters marginalized by political instability and economic crisis, petty criminals, drug-dealers and users, pimps and prostitutes – and thereby exploit their exploitation. Uribe's Antonio uses his neighbours in a different way: the undercover ETA operative poses as a photographer to justify his presence and interactions in their 'submundo' (underground world), evading police surveillance by theatrically training his eye on their seedier goings-on. As in the paradigmatic encounter with Clara, he avoids exposure by courting it, enjoying it, by exposing himself recklessly to its risks.

The ETA commando consists of three individuals: Antonio, Lourdes (his former lover, played by Elvira Mínguez) and their technical support, Carlos (Joseba Apaolaza). Their mission is to plant two car-bombs in the capital, both of which are detonated but not quite in the way planned. The first explodes before the arrival of its police targets as a vagrant attempts to steal a handbag that Lourdes has left inside. The second reaches its target, the police headquarters, and runs like clockwork until Antonio unthinkingly blows his cover, and more, on seeing Charo being escorted into the building. What compromises these operations is, at one level, a lack of care, wilfulness, the subordination of ideology to the personal at a moment when reports of ideology's end were placing individuals under increasing strain. This strain is clearest in the loss of faith in the ETA leadership, which emerges in a pivotal conversation between the operatives mid-way through the film. After having asked Carlos whether the explosive they have been sent for the second car-bomb is fit for its purpose Lourdes remarks, drawing deliberately on her cigarette, that last time, in Barcelona, they had been given out of date material. When

Carlos mildly enquires whose fault this was Antonio explodes: '¿[d]e quién va a ser? De ese mierda que ha llegado hasta arriba en la dirección sin tener ni puta idea de dónde tiene la mano derecha. ¡Así nos va! ¡Nosotros pringamos y él se pone las medallas!' (Whose do you think? It's that shit who's got to the top without having a bloody clue what he's doing. And look where it's got us! We sweat our guts out and he gets the medals!).[16]

This loss of authority resonates in different forms across the film and is linked repeatedly to eruptions of sexualized risk. Picking up Clara figures as the first, paradigmatic, example. As witnessed through the rear window of the Lancia by Lourdes, it illustrates Antonio's tendency to 'jugarse la vida [. . .] y de paso jodernos a los demás' (risk his life and in the process fuck things up for the rest of us). In practice, however, the presence of Clara enables Antonio to pass unchallenged through a road-block designed to stop the mission in its tracks. A certain abstraction in his gaze suggests that he had this, too, in mind, that he was knowingly mixing business with pleasure. Once he becomes obsessed with his neighbour Charo, however, that element of calculation rapidly declines.

Antonio's first job in Madrid is to reconnoitre their primary target, the police-station. Before he does so, however, he photographs Charo. He does this in the first of four bathrooms that figure in the film. These provide the conventional opportunities for displaying (usually female) bodies and mark key stages in the development of Charo as object and, to a lesser degree, subject. The second is in a hotel room in Granada, site of the consummation and transformation of her relationship with Antonio. The third, in her own flat, is the setting for a pivotal exchange with her flatmate Vanesa (Candela Peña) as they cleanse themselves in readiness for the 'fiesta' or 'orgía' (party or orgy) scheduled for that evening. And the fourth, in the flat where the party is drawing to a close, is the scene of her abjection.

Antonio's bathroom is the location of her initial photographic configuration and transfiguration. Having invited herself into his flat to use the bathroom she uses the opportunity to shoot heroin. On discovering this Antonio, who had never so much as puffed cannabis before he met her, instructs her to leave. Tired of waiting for her to emerge he finally walks in to find that 'no [ha] podido resistir la tentación [de bañarse]' (she couldn't resist the temptation to take a bath). Initially irritated, he is quickly seduced by this childlike impulsiveness and the pleasure both derive from her naked body. A stilted conversation ensues during which, on hearing he is a photographer, she invites him to take a photo of her in the bath. The sequence of poses that follow, and the film's many other shots of Charo nude, topless or (more often) bottomless, certainly leave

the film open to charges of exploitation or gratuitousness (Jordan and Morgan-Tamosunas 1998). In more than one sense, however, these sequences are not gratuitous. First, as noted, they are anticipated in the novel. Unlike Madrid, however, Uribe does not make Antonio's photographs the strikingly perfunctory prelude to a masturbatory climax. In the film, having asked Antonio to take her photograph, Charo asks him how she should pose. But he declines at first to be cast as her director, replying '[n]o lo sé. Tú misma' (I don't know; be yourself). By contrast, Madrid's Antonio knows exactly what he wants and believes he knows how the affair will proceed: he knows the script, that is, because he has read the book – or the magazines. Charo's desire to be looked at rather than to have sex, the twist by which his expectations are confounded, figures simply as nuancing that script. But Uribe's Antonio has none of that sly self-confidence; he deploys the engaging mix of reticence and bewilderment that has become Carmelo Gómez's hallmark. But here, too, the sequence of poses she assumes underlines the extent to which, even when her movements are not shaped explicitly by his commands, expectations or fantasies, her libidinal gratification responds to the conventions of hardish 'glamour' or softish 'porn' photography. Finally, with a child-like desire to please she exclaims 'a ver si te gusta ésta'; whereupon, the screenplay states, 'apoya cada pierna en los bordes de la bañera y se empina mostrando su sexo' (Let's see if you like this . . . she rests a leg on either side of the bath and lifts her body up to display her genitals) (28). For underpinning the apparently essential Charo is that same pleasure in being looked at and a readiness to adopt the most improbable positions in order to display what she wants to see being seen. This is underlined in the emblematic application of lipstick in advance of the shoot, another vivid red flash teasingly anticipating the climax that will be a long time coming. We are not surprised when, on seeing the developed photographs, she affirms 'me has sacado muy auténtico, como yo soy' (you've caught me really well, just the way I am); indeed, she tells Vanesa they are 'preciosas' (lovely) before setting eyes on them.

Despite its conventional elements there are, as suggested, good reasons for not dismissing this scene as wholly gratuitous. The first of these resonates in Jacqueline Rose's observation that the literal or metaphorical directors of such scenes may not simply be exploiting conventions for their own (and their target audiences') gratification; they may be adapting larger scripts, 'drawing out an emphasis that exists [. . .] in the various instances they inherit and of which they form a part [. . ., drawing] on tendencies they also seek to displace' (1986: 231). From this perspective, any surplus enjoyment Uribe derived from theatricalizing his script, from exposing its workings, would complicate this process but not

necessarily invalidate it. But this is not the only sense in which the scene theatricalizes an uncomfortable truth – and one that may be only incidentally more uncomfortable for Charo. Antonio figures here as an initially unwilling participant, an impostor who comes to recognize and take up the position she assigns him: 'pásate la lengua por los labios [. . .] No te muevas. Ahora cierra los ojos' (run your tongue over your lips. Don't move. Now close your eyes).[17] In this sense, the scene theatricalizes the construction process underpinning the emergence of all subjectivity, though a certain asymmetry derives from the fact that, in time-honoured fashion, it does so chiefly from Antonio's perspective. Through this bathroom alchemy, Charo develops into the sublime, arresting, object who will mask the void within him, a void no longer masked by radical nationalist commitment, giving new and intenser form to his desire. From its first moments their relationship is identified with the Imaginary – with images and fantasy – more than the Symbolic register of language and law. By urging him at their first meeting to pick her lock, she casts him as a potential substitute for her criminal husband; but his lack of success indicates that he cannot assume the role of petty criminal, is unable to emulate the *real* burglars who 'en las películas abren las puertas con el carnet' (in films, open doors with a credit card). Away from the landing that separates their worlds, however, in his bathroom-laboratory-darkroom, Antonio raises the blind in order to photograph her and, overexposing her, confers on her the aura he desires. The negative 'fixing' of this scene occurs later when, in solitude and with every glimmer of natural light banished, he develops the photographs, watching his image of her emerge, for the first time, in reds and blacks.

Within this image, the elements that seem to mesmerize Antonio are her breasts, her pubic area, and the large vertical scar on her stomach. As the camera lingers on her invariably, iconically, semi-naked body the first and second of these remain in his eye and ours. The scar, however, is a residual signifier *par excellence* of a past we can only imagine. Diegetically, it reinforces the conventional iconic function of a fragmented body that is desirable to the extent that it is unavailable and risky: because she is married, because her husband is known to be violent, because she figures as 'guarra, puta y drogadicta' (dirty, a prostitute and a drug-addict). This memento of her time at reform school connotes a failed disciplining of that body, its branding as the carrier of a criminal, traumatic prehistory – and, with these, the half-thrilling and half-obscene insistence of what cannot be fully sublimated. To this sordid past is referred a quasi-hysterical recourse to ritual self-cleansing presented from the outset as ambivalent self-indulgence: as witness the fateful Edenic resonance of that initial 'No he podido resistir a la

tentación' (I haven't been able to resist temptation). The object that transfixes Charo, she insists, is her reflection in his eyes, in his camera, on his face. This is not a straightforward instance of narcissistic self-sufficiency, of Freud's 'love directed at the image of oneself': Antonio is not simply a mirror for her desire but the subject through whom she comes to recognize herself as what she 'is' (Freud 1914: 97).[18] What makes her an ideal, idealized, screen for his lack and an object for his desire is, in this sense, also what makes him able to fill, however provisionally, the void within her. As he marshals her poses into familiar patterns he, in turn, is constructed by her as a desiring male subject, the place where a certain truth about her may be articulated. The sense that they have both been made to measure (which underlines a banal but compelling cinematic truth) serves to tighten the film's structure of predestination. Their affair enacts the asymmetrical enjoyment, and the trauma, associated with the misrecognition that Lacan sees as grounding the emergence of all subjectivity.[19] For the reciprocity conjured here rests on a structural non-reciprocity: by choosing Charo – an object whose submission to a menacing husband blocks his desires' satisfaction – Antonio ensures that there will be no immediate consummation, and thus that the relationship cannot function merely as a diversion.

Charo's obsessive ablutions dramatize the conflicting forces acting on her: they attempt to efface the negative assessments others make of her while reaffirming them, through the revelation of the beautiful scarred body, as the source of her desirability. Her yearning to escape to Granada, which keys into Antonio's identification of her with Carmen, underscores the fact that she is not of his illegal but (in principle) disciplined world nor wholly of the seemingly pathologically-disordered underworld in which she finds herself. When she tells him she earns a living by dancing for men, for example, he observes: 'eso tiene un nombre' (there's a word for that). Like him, she declines to utter it: 'Yo no follo con nadie, Antonio. Nunca dejo que me toquen. Lo único que hago es desnudarme' (I don't fuck with anyone, Antonio. I don't let anyone lay a finger on me. All I do is take my clothes off). As Antonio discovered in his bathroom, this is true. Later, it is revealed that her flatmate Vanesa administers the sexual release for which both are paid, positioning Charo somewhere between a prostitute and a go-between. That is another aspect of the marginal status that dramatizes her anxious quest for identification through others. This marginality also underlies the repeated self-cleansing, evoking as it does the struggle to attain an ideal of '"proper" subjectivity and sociality [by expelling] the improper, the unclean and the disorderly' (Grosz 1989: 71). Its repeated failure connotes a borderline abjection that, for the moment, magnifies and stabilizes her fascination.

Antonio's compulsive behaviour manifests itself in the sexual risks that are symptomatic of his role in the film. They connote its structuring around the insistence of the death drive, figured from the opening scenes in the drum pulse and a more general 'driven' quality linked to tight plotting (including temporal compression) and cutting, a tightly restricted range of colour and, above all, the compulsively intersecting and finally converging trajectories of cars and bodies. While his behaviour clearly jeopardizes ETA's objectives, the visual and structural emphasis given to Lourdes's angry claim that he is too ready to risk everything for Charo 'y de paso jodernos a los demás' suggests another motive. It points up the extent to which she is angry not that he might 'fuck' everyone with his penchant for sexualized risk, or that he does so in order to fuck one particular woman; but that only the first of these possibilities includes her. For his former lover is unable to reactivate their relationship once the next link in the chain of desire appears on the scene. This strong and purposeful woman is almost a negative of Charo; slightly older than Antonio, and with a severe hairstyle and clothing, she functions as the phallic mother who desires him, warns him against infractions and, when these threats fail, inaugurates his undoing. This function is clearest shortly after the first bathroom scene when, in a seemingly spontaneous late-night reconnaissance of Antonio's flat, she finds the newly-developed photographs of Charo. She instantly confronts him with the image-fragment that she and the audience know will compromise the mission. A shadowy over-the-shoulder shot of her pointing finger underlines her words' superegoic function, as if to manoeuvre the audience into complicity. But her warning is destined to fail. The angle of the shot is awkward; we are not exactly behind her, and not least because, like the movement of Antonio's desire, the visual narrative already places Charo centre stage. The implications of this displacement become explicit in the commando's operations centre, on the outskirts of the city, the night before the detonation of the first car-bomb. Taking the initiative once again, Lourdes slips into bed beside him, only to have her advances rejected. She weeps quietly beside him, mourning the scale of her loss: 'Pienso en mí, lo que he hecho con mi vida, pienso también en todos nosotros . . . Y no puedo seguir, no puedo . . . Se me cae el mundo' (I think about myself, about what I've done with my life, I think about all of us. And I just can't go on, the world's falling in on me).

The imbrication of desire for Antonio and commitment to ETA in this collapsing world becomes clearer still the next day. After the formal warning has been given to the press, and just as the first car-bomb is about to be detonated, Lourdes realizes that she has left her handbag inside it. The bag immediately attracts the attention of a passing vagrant

who, imagining that it contains something more valuable for him than papers, attempts to break into the car and steal it, triggering a premature explosion in which he is killed. But with that bag, in which Lourdes's anguish finds expression, her cover and Antonio's are also blown. This overdetermined object may be in the diegetically wrong place at the wrong time, but the film's 'fateful enchainment' ensures that the papers inside it, though purloined by others, will reach their destination: the forces determined to establish the couple's identities (Žižek 1992b: 71). But while it will simultaneously expose Antonio to the wrath of the ETA command and betray him to the police authorities, Lourdes's 'slip' once again fails to bring the recalcitrant son into line. In the very next scene we see him discharging his frustration and exposing all three of them to grave danger. Instructing Carlos and Lourdes to carry on without him, he suddenly leaps out of the car at traffic lights, shoots dead a policeman reading a newspaper by a kiosk, and vanishes down a metro entrance. The gratuitous brutality of his act gives diegetic flesh to what the news media will later describe as one of the bloodiest criminal records in recent times – and we know these are particularly bloody times – while reaffirming the nugatory value he places on his own life and others'.

According to the Lacanian schema, the son's repudiation of the mother as a love object and his own development as a libidinal, desiring, subject depend on his submitting to the authority vested in the name of the father. But in Antonio's case this process is doubly blocked: Lourdes will not let him go; and the ETA father will not recognize him. For the head of the commando is a bad father, a greedy and inept one, who claims credit for the risks his operatives take while compounding them with poor logistical support. And because he does not recognize Antonio, Antonio in turn declines to recognize his authority. Instead, in a prescient challenge to the death sentence implied in the summons to 'regresar inmediatamente' once the mission is complete, he declares 'cuando acabemos con todo esto, igual desaparezco' (return immediately . . . when all this is over maybe I'll disappear).

In tension with the ETA narrative, however, and finally converging with it, is another example of waning authority. When Antonio trains his camera on the police-station that is their objective, he is turning back on itself an institutional look that is imbricated in the degradation it is charged with monitoring. This is underlined in the fact that it is a civil target rather than the more usual barracks or other military objective of the time and one located in a *cul-de-sac*, a dead-end that anticipates the building's role in the film's conclusion (Uribe 1994: 44). In this place, locus of a discredited social authority with inadequate surveillance procedures and minimal authority in either of the diegetic worlds, the

marginal activities of Charo and her friends converge apocalyptically
with those of the ETA bombers. Its principal representative in the narra-
tive is known simply as Rafa (Karra Elejalde), one of the group of three
officers who patrol the *barrio*, or locale. Designated in the screenplay 'el
que parece mandar' (the one who seems to be in command), his casual
dress, overbearing manner, and exclusive use of first names bear out this
uncertainty (80–1). The only characters officially licensed to keep a
watchful eye on the *barrio* and its disorderly residents, they rely instead
on the eyes of informers like Lisardo (Vanesa's boyfriend, played by
Javier Bardem) who are as corrupt as the individuals they betray. And
when they push their way into Charo and Vanesa's flat without a warrant
and without knocking and enter their bedroom, it is not the young
women that they want to see. They want to use them to locate someone
else, someone whose name and presence are registered repeatedly by the
barrio's residents yet who seems oddly proof against official detection:
the main local drug-dealer, El Portugués (Chacho Carreras).

Rafa's crude, intimidatory methods are mild by comparison with those
of his colleague Matías (played by David Pinilla). He dismisses Charo in
particular out of hand as 'guarra, puta, y drogadicta': 'si tuviera una hija
como tú la mataba a hostias. Por mi Santa madre' (if I had a daughter
like you I'd beat her till she dropped. By my blessed mother, I would).
His unnamed younger colleague (José Colmenero) also refers the girls to
traditionally unimpeachable parental authority, though in a less con-
frontational tone: '¿Es que no tenéis familia? ¿No tenéis padre ni madre?
Mirad como vivís, peor que los cerdos. Nosotros no tenemos nada contra
vosotros. ¿Por qué sois así?' (Don't you have any family? Don't you have
parents? Look at how you're living; you're worse than pigs. We haven't
got anything against you; why are you behaving like this?). Vanesa's
response insists on the discursive gulf that divides her from this clean-cut,
apparently clean-living young man. Here, a maternal reference is framed
in the ideologically-uncorrupted terms of a wholly sexualized worldview:
'¿Quieres que te la mame? Te lo hago gratis'; then, when this is ignored,
'Vete a hablar con tu puta madre' (Would you like a blow-job? I'll do it
for nothing. Well, clear off then, motherfucker). This failed exchange
highlights a breakdown in the signifying chain: these two representatives
of the law cannot reprehend her because she cannot comprehend them,
and *vice versa*. This mutual misrecognition undercuts any possibility of
reciprocity; it exposes the obscene underside of Symbolic authority,
giving rise to an uncomfortable enjoyment. Moments earlier, Rafa had
symbolically renounced his primary institutional responsibility for mon-
itoring the women while incidentally assuming another. 'Tú, Vanesa,
tápate. Estás medio en pelotas', he snaps, removing his sunglasses and

looking away (Hey, Vanesa, cover yourself up; you're half-naked). Unlike his colleagues, he is not appealing to the authority of the family but simply assuming it, and Vanesa responds. The interaction reaffirms Charo (invariably more exposed than her friend) as the only woman whose nakedness is diegetically licensed and Rafa as the only father, however perversely partial, to administer rough justice in their underworld. This becomes visually explicit soon afterwards, when he finally locates El Portugués.

Rafa only tones down his brusque interrogation of the two women on hearing that Antonio (who was visiting Charo when they arrived and is assumed to be a client) is a press photographer: that is, someone whose views conventionally have an evidential authority which the officer perceives as at least a match for his own, and who could expose this covert misuse of public powers. In a film in which authority figures as fatally weakened, corrupt or unintelligible, the media carry particular communicative force: the shortwave radio to which Lourdes and Carlos are tuned in the critical opening sequence, for example, or the television news bulletins that inform Antonio (and periodically, and only in his presence, also Charo and her circle) of how the ETA commando's activities are perceived or presented. This superegoic media 'voice' has nothing to say about the activities of Charo and her group. Their news circulates in local hearsay and gossip, and when the television news does intervene in their lives the effect seems explosively definitive. Their existence becomes the grey background against which ETA's activities acquire melodramatic scale and colour; are ruled beyond the pale by the likes of Lisardo, himself a small-time dealer and truculently servile police-informer; or (in the Granada hotel-room) are contrasted with public, ceremonial images of the royal family, whose own crises were circulating at the time chiefly as hearsay and rumour.

When Rafa finally apprehends El Portugués, the 'interrogation' takes place away from the centre and the media's watchful eye. At home in the *barrio*, the dealer represents the only, and strikingly visible, model for success. He wears sharp clothes, dines in expensive restaurants, affects a detached formality, and enforces his rules uncompromisingly: 'todo legal, todo en su sitio' (everything right, everything in its place). This makes him feared and respected by the users dependent on his stock-in-trade and helps to explain the officers' marked lack of success in detaining him. If they are able, finally, to do so, it is because even those who compound the sense of encroaching social disorder are not immune to it: there's a crisis, he complains, there is no trust any more, things have changed. Frustrated in earlier attempts to detain him by legal means, Rafa is effectively licensed by this crisis to put him 'en su sitio' by

sublegal ones that El Portugués will find more compelling. The 'sitio' in question is accessed via an isolated rubbish dump on the outskirts of the city: a bright and sunny spot that provides a moment of visual relief, with moral overtones, from the *barrio*'s monochrome. Here the dealer is made to kneel on the ground and beg for mercy as Rafa, holding a gun to his temple, charges him with his crimes. Among these are being 'un gallina' and – giving the place and the movement of expulsion additional resonance[20] – 'además negro y una mierda' (a chicken . . . black, too, and a shit). The click that follows reveals the gun to be empty; in these circumstances it could hardly be otherwise. But this ritual non-execution is not wholly impotent. In the release of tension that follows, the camera shoots from his kneeling victim's perspective as Rafa looms over him. Silhouetted against the sun, which gives him the aura of a perverse avenging angel, the officer declares 'todos tenemos miedo, Portugués, todos' (we're all scared, Portugués, all of us). The heroic *High Noon* overtones make this a cinematically potent evocation of a more general loss of security in the period; one that anticipates Antonio's final transfiguration, and shares something of its therapeutic potential.

Institutions have strategies, missions, and tactics: they do not have psyches. Partly because the individuals embodying them do, however, the tactics of institutions – especially in moments of crisis – may include drawing on myths in order to screen, supplement or justify the risks assailing them. The therapeutic force of the film's ending derives in part from one such: the myth of an imminent 'end of days' which, feeding on the postmodern-tagged decathection of the law, of the state and of meta-narratives as such, found its optimal expression in 1990s Spain in the millennial countdown. It is by crossing this myth with another, a seemingly timeless narrative of doomed and disorderly passion saturated with opportunities for libidinal and visual gratification, that the film generates its most potent effects. For from the moment in which Antonio first fixes Charo's body with his viewfinder it is clear she will divert him from his ETA objectives; and the role in this process of the *Carmen* myth is underscored from his first visit to photograph the police-station under which the second car-bomb is to be detonated. The screenplay refers to two transvestites, positioned in front of the building, giving a costumed street performance of the Habanera from Bizet's *Carmen*. In the film itself, their place-holder status in the chain linking Charo with the police-station becomes explicit with their replacement by a floridly overblown female Carmen and a wheelchair-bound Don José. The dislocation that was to have been signified in transvestism is procured now by cacophony, as *Carmen*'s diegetic aria is musically overwritten by the extradiegetic electric guitar figure associated in the film with danger. The performance

distracts Antonio and the audience from his institutional target, while underlining its inability to suppress pulses of perverse enjoyment even on its doorstep. For a moment, the two worlds are superimposed. But hereafter desire, the desire that has been circulating from the film's opening scenes in a risky mixing of business and pleasure, will ensure that the balance shifts towards *Carmen*. As with the ETA narrative, this process is engineered and sustained aurally and chromatically. The first associates Charo with an Andalusian acoustic guitar motif on which the ETA drum pulse and electric guitar themes are, again, periodically superimposed. The second draws on Carmenesque blacks and reds that prefigure the relationship's (and the film's) development from inflamed desire to bloody destruction; in the contrast between the cold blues and monochrome of Madrid, for example, and the warm browns and reds bathing Granada prior to the consummation of their passion there; in Charo's red clothing and the gypsy black of her hair.

The *Carmen* narrative loosely positions Antonio as Don José, the repressed and moral young corporal who is forced to live outside the law after killing his gypsy lover Carmen in a passion of jealousy. This combination of repressed and passionate elements is compounded with the naming of Charo/ Carmen's lover as Antonio – in Prosper Merimée's novella, the guide who betrays Don José's identity and past to the narrator. This is fortuitous to the extent that the name derives from Juan Madrid's novel. In the film, by contrast, Antonio's diegetically real name is, in fact, José, and Joseba de Elizondo his Basque *nombre de guerra* (alias). But Antonio is soon exposed as a disaffected and at times brutally unheroic José. And while his Carmen may figure initially as the classic reckless, and passionately capricious, daughter of the people this changes rapidly once their passion is consummated and pressure on them both mounts.

These changes, linked as they are to chains of names and identifications, recall how little desire owes to any innate qualities in the other. The first bathroom scene affirms this in its powerful evocation of the process of 'determinate reflection' or sense of mutual recognition that structures relations with other subjects (Kay 2003: 19–20) In this sense, passion is what Charo, as Carmen, is designed physically to excite rather than exude. Uribe prolongs and intensifies this excitement partly by adapting the script he draws on to incorporate elements from other fantasies: a Lolita whose simple openness contrasts with the alternately threatening and pleading Lourdes; a gangster's moll whose brutish, criminal husband temporarily augments illicit desire *in absentia* by damming it. But above all, like her gypsy counterpart, Charo is desirable because she is at once dirty and clean, a state rendered visually in the contrast between the

compulsive cleansing and anointing of her body and the squalor of the surroundings in which these rituals generally take place. Her heroin addiction and chaotic lifestyle are paid for by occasional work that (as noted) falls just short of prostitution. As the film progresses, however, and particularly after she consummates her relationship with Antonio in Granada, the element of abjection becomes dominant, accelerating the radical desublimation that will bring him finally face to face with what her body has been screening.

Structuring this process are the preparations for a party at which Vanesa and Charo will be performing. Intercut with preparations for the bombing of the police-station, this heroically unheroic affair draws in all the key figures of Charo's 'submundo': Lisardo, here an amateurish but devious pimp who secures their invitation in exchange for a cut of the proceeds; the manager of the local bar, Rosa (Raquel Sanchis), who performs with them; El Portugués, who supplies the cocaine they have been told to take along; and Rafa and his colleagues, who detain the three women at the party's end. Preceding it, and providing a vivid contrast for its most degraded aspects, is the visit to the hotel room overlooking Granada's Alhambra. When Antonio's mounting sexual tension drives him to declare 'Quiero follar contigo . . . esta noche' (I want to fuck you tonight) it is here, she insists, that they must come. Her motive is primarily nostalgic: she yearns to re-enact her loss of innocence, which took place in Granada in her husband Alfredo's car. He is desperate to reduce escalating tension by slaking his desire. Both impulses are grounded in the possibility of a more whole, and wholesome, existence. But this fantasy, designed to shield them from the Real, effectively transmits it; their union will be partial and fleeting; the law will ineluctably intervene; the fantasy she has invested in him and the tension that has sublimely dynamized her will drain away, and drive him back with her discharged body to Madrid.

In Granada, when Charo ceases withholding her favours he, and we, see her naked outside of the bathroom for the first time. The conventionally pornographic explicitness of the screenplay's sex act becomes in the film an altogether softer and more obliquely visualized consummation. Already, it seems, the vitality of her body is draining away, its ability to focus the fantasy structuring his desire, to fascinate and shield him, is ebbing. His expression on climaxing prefigures the one that crosses his face on seeing her walk into the path of the second car-bomb, and is followed by same calm blankness. But a less productive form of tension flares almost immediately when Antonio presses Charo to say that sex with him was more satisfying than with her husband. She is non-committal: he is demonstrably piqued. The mutual recognition process

that galvanized their first bathroom encounter is reversed in this, their last: he sees himself diminished in her eyes and thus in his own, which in turn diminishes her in his. Sapped of desire he declines her invitation to have sex in the shower and, with his ETA identification now predominant, goes off to watch the television news. The moment she follows him out of the bathroom the screen confronts her with Antonio's terrorist identity, exposed by the documents found in Lourdes's bag amid the wreckage of the first car-bomb. Charo, whose own relationship with the Symbolic is at best ambivalent, watches in wordless, uncomprehending horror and runs back into the bathroom. This time, however, there are no compulsive attempts to wash away the stains of the Real; instead, in a perverse replay of their first bathroom encounter, she blocks out their source with a heroin overdose. When televised images of the royal family jolt Antonio from his stupor he goes in search of her, his gun still in his hand. The camera tracks his progress slowly through the bathroom's visually distorted spaces to where he glimpses her lifeless body slumped between the lavatory and the elaborately-tiled wall. The weapon falls from his hand, hitting the tiles with the crack of a gunshot that underscores his role in her condition. He bears away her body through the shadowy, labyrinthine hotel corridors and its darker underground carpark, and drives through the night towards Madrid. It is only when he pulls up *en route* and bathes her forehead that we see the man who created and destroyed Carmen restore her to life. But the body once charged with desire, too much desire, now generates too little and will be punished for it. This waning of desire and the reassertion of the death drive it can no longer mediate are underscored in the increasingly urgent drum pulse that will now accompany Antonio beyond the Symbolic to the edge of the Real.[21]

No sooner have they returned to Madrid than Alfredo (Pedro Casablanc), on day release from prison, hears of his wife's infidelity and disciplines her (and, by proxy, her lover) with brutally urgent sex. Like Antonio, we glimpse this though the open door of Charo's flat, and see his eyes meet hers. Within a matter of hours she is being punished again, by other men, at the party. Although we witness only its aftermath, preparations for it structure most of the action among Charo's circle. They include the film's third bathroom scene, which acquires in retrospect an explicitly ritual and sacrificial function as she and Vanesa bathe in readiness for the most debased encounter of all. It is licensed by the 'guarra' (dirty) elements of Charo's construction, her constant readiness for sex, and what these diegetically entail. But the fate that awaits her – for transferring her favours to Antonio, for having withheld them so long, for not lying to him, for permitting desire to ebb and the drives to

reassert themselves – brings this to a new pitch of abjection. Here, it seems, she pays the price for infidelity, for teasing and deflating Antonio, and for reserving her desire partly for herself; the client who pays her will take, and give, more than she bargained for.

The culminating significance of this event is heightened by cross-cutting between the party and the commando's dawn journey towards their target. This is powerfully underscored by musical 'bridges'. In the first, the quickening drum pulse and shrill, brassy chords that modulate pace and tension in the ETA sequences spill over into the party scene and recede before an ominously sustained bass discord. This dissolves over a close-up of Charo's anguished expression and bare shoulders before the camera pulls back to reveal her sitting naked, behind a waist-high tiled wall, on the lavatory, in the bathroom of the house where the party is being held. It is the film's last bathroom scene, and the one in which we see her put 'en su sitio' – though not yet, quite, definitively. The screen-play describes her staring blankly and in evident pain at a piece of lava-tory paper 'manchado con restos de sangre [. . . que forman] casi un redondel perfecto [. . .] como si alguien hubiese besado el papel higiénico con carmín' (stained with blood in the shape of a perfect ring, as if someone had kissed the paper with carmine) (Uribe 1994: 160).[22] Charo's traumatized expression underlines the passage from Granada's consensual sexual act to its brutally non-reciprocal inversion. The echo of Carmen in that carmine kiss recalls the risks of heroin-fuelled prosti-tution as compared with its eroticization, what happens when the Real cuts through the fantasy designed to deflect it. This pivotal object, con-ceived as a love-shaped, wordless mark on a small piece of paper, elides with a savage irony the fantasized heart of the subject – the treasure that we imagine to lie at the core of our selves – and its obscene underside, the smear of the Real that it conceals. That smear works here to detach Carmen and ETA from their ideological matrices, exposing them as immobilizing fantasies to be traversed if new, less agonistic, forms of 'reality' are to emerge. It lays bare how we manage our relations with the Real, the trauma and the surplus enjoyment, at once thrilling and chill-ing, that underpin the film's more complex effects.

We see Charo leave the bathroom and walk awkwardly, still naked, past the remains of the party – where Vanesa can be seen administering half-hearted oral sex to her last client – towards a large picture-window. An external establishing shot frames Charo behind the squared grille of the window-panes as dawn breaks over the capital. Having framed her and put her behind bars, the camera re-enters the building for a deep-focus shot that aligns her silhouette with the church spire dominating the city skyline. Its bell, with the desolate tone of a *dies irae*, prefigures the

apocalypse to come. A rapid cut shows Antonio driving into the jagged planes and verticals of the same dawning city to a rising drumbeat and increasingly shrill guitar chords. One of these bridges the transition to Charo, seen sobbing through the window with mascara streaming down her cheeks. Vanesa and Rosa arrive and try to comfort her, and all three prepare to leave. Once again, however, the women are framed; this time by Lisardo. Emerging from the building, they find him waiting with Rafa and his two colleagues, who want to question the women concerning Antonio. They are driven off in the direction of the police-station, towards which Antonio, Lourdes and Carlos are themselves now speeding.

Having driven the car, with its explosive device, from the suburbs to the police-station Antonio double-parks it, as planned, some eighty metres in front of the building's underground car-park. He stops, gets out and, reaching through the open window as if to collect a forgotten item, restarts the vehicle which immediately begins rolling towards the car-park. When it hits the car-park barrier it will explode. Meanwhile, he has 20 seconds in which to walk to the getaway car in which Lourdes and Carlos are waiting. When asked earlier about the likelihood of the explosive device failing Carlos, the technician, replied that, should this happen, 'automáticamente se pondrá en marcha un segundo mecanismo y ése no hay Dios que lo pare. Es infalible' (a second mechanism will be triggered and God himself can't stop that; it's infallible'. This resonates in Rafa's words to Charo as they start out on their journey to the police-station: 'Me caes bien Charito, pero de ésta no te libra ni Dios.' (I've got a soft spot for you Charo, but not even God can get you out of this hole). These statements place both the ETA and the Carmen narrative beyond divine intervention and the law that conventionally sanctions it, and beyond *hubris*. Antonio raises the stakes still further when, without consulting with ETA command, he decides to expend all their 100 kilos of explosive on the mission. Informers have revealed his identity and are about to reveal his whereabouts; ETA command has already outlawed him for his licence and insubordination, and an implied death sentence hangs over him: once again, it seems, he has nothing to lose.

What Antonio does not see, as he reaches inside the car to restart it, is the police car drawing up and disgorging Rafa, Charo and the other passengers before pulling off. The officer ushers them towards the basement of the building and they head into the car-park's void. As the car-bomb – 'como una máquina infernal' (like an infernal machine) – begins to travel in the same direction, Antonio follows it with his eyes and glimpses Charo among the group (Plate 7). As if intuiting his presence, she turns her head and flashes him a glance, half-afraid and half-alluring. It is the

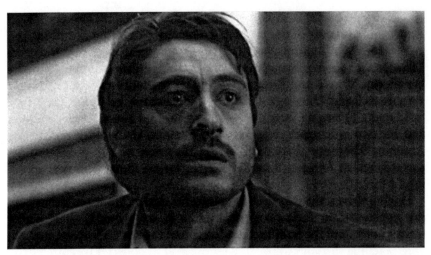

7 Antonio sees Charo entering the underground car-park. Still image, *Días contados*

last we see them exchange, and another mutually determining one: I'm your fate, it affirms, and you're recognizable to me as mine. This perverse Eurydice will not be lost to him when she exchanges one underworld for another, moving from transitional spaces – over-exposed in bathrooms and other intimate settings, framed in doorways and stairwells, her face half in shadow – to seemingly transcendental ones. But first she must cross the film's last transitional marker: the barrier separating the police-station from the world outside, the lawful from the unlawful, which the Carmen and the ETA narratives have fatally undermined and on which they now, finally, converge. Within the ETA narrative, the barrier's destruction is designed, in principle, to permit radical nationalist energies (energies that the state has struggled to contain) to resonate fully in the body politic: within the Carmen narrative, it marks the final abandonment of any attempt to maintain a separation, however provisional, between desire and the drives it seeks to mediate. The conventional continuity narrative slows here under the weight of non-propositional meanings and emotional intensities; the conflicting energies associated with Antonio and which have, until now, oscillated unsteadily between ETA and Charo begin to expand, distorting the visual field; the scene glides into slow motion. As Antonio moves away from the Symbolic, beyond voice and language, the diegetic world is silenced by the drum pulse and nerve-tearing guitar chords. Time, it seem, pauses.

Lourdes and Carlos watch impotently as the preordained drama is played out before them: watch Antonio run after the car, as if to detain it, while the slow motion and racing drum beat suggest a heart about to

explode. When Carlos prepares to drive away without waiting for him Lourdes puts her pistol to his head, heightening within that restricted space the sense of charged suspension. Earlier in the film, on realizing that she had left her bag inside the first booby-trapped car, Lourdes had run shouting towards Antonio, in the vain hope of being able to delay the explosion. Watching him run now, she is aware that his attempt is equally doomed, that the screen will be drenched with red again before subsiding into flames and sirens doubled in hysterical guitar chords. As the second car plunges into the blackness Lourdes lets the handgun drop into her lap; her head bows as her eyes fill with the tears that mark her unmanning. When Carlos again prepares to speed off she makes no attempt to stop him.

For Antonio, however, all urgency has gone. His slow-motion run brakes to a robotic stride as he, too, becomes an infernal machine. He advances, as if mesmerized, towards the gaping target that has merged with his blind-spot, the compulsion which Lourdes recognized would put expose them all to risk (Plate 8). The screenplay is unambiguous: 'la boca negra del parking solitaria, oscura . . . espera a Antonio que la mira sin resistirse ya a su atracción' (the black mouth of the lonely underground car-park . . . awaits Antonio; he looks at it, no longer resisting its attraction) (170). It even includes at this point a street-cleaning vehicle that passes in front of the entrance 'barriendo la calle con sus chorros de agua' (sweeping the street with its jets of water) (170). These climactic 'chorros' once again highlight the pleasure more than the trauma of ritualized cleansing. And they do nothing to dampen the obsession with risk which has placed him in thrall to that underworld vision: the threatening, beckoning hole into which Charo has now disappeared.

That backward glance from a woman beyond saving is reconfigured now as an invitation to join her. He glides past the barrier into the darkness. Above the tightly-packed and out-of-focus buildings of the world he has left, the patch of sky that remains visible is contrastively overexposed, projecting something like a halo around him. This visual intensity is heightened by silence, a sustained, shrieking chord, and an electric stillness. Time stretches, it seems, and runs out. From the right of the screen red seeps and billows. An age seems to pass before it disperses into blackness and the credits roll in silence.

The film's non-realist climax gives the bomb-blast considerable resonance. The ritual cleansing, by water then fire, and the halo of light that transfigures Antonio (as it transfigured Rafa before him) link it perversely to the socio-culturally conservative purification narrative: the energy accumulated in repressed violence and sexual desire is cataclysmically discharged, the familiar Oedipal crisis is resolved, the heroically recalcitrant

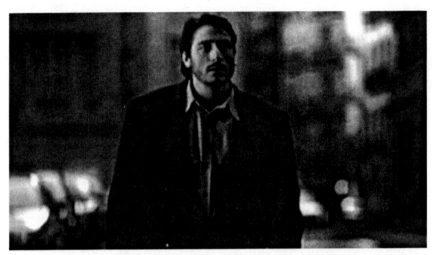

8 Antonio follows Charo into the underground car-park. Still image, *Días contados*

son is brought to order and acquires quasi-redemptive power. For while Antonio's body is lost and symbolically restored in the conflagration, Charo, Vanesa, Rosa, Rafa and Lisardo are simply swept away. And with them, it seems, go the decayed optimism of the 'cambio' years, the perceived degradation of institutional and wider socio-political culture, the widely-reported sense of socio-political tension, of cultural disorientation. It is as if their sacrifice served to absorb these risks and anxieties, 'all the internal tensions, feuds, and rivalries pent up within the community, [. . .], to protect the entire community from *its own* violence, [. . .] to redirect violence into "proper" channels' – to restore it to its proper place (Girard 1972: 7–10). It is here that the millenarian resonances of the film's countdown are clearest.[23] The final, spectacular, discharge of energy anticipates the fireworks that would mark the millennium's imminent culmination and immediate fading into history.

But there is a sense in which Antonio is *not* brought to order. Certainly, we are accustomed to seeing romantic love and sexual obsession used to screen a loss of faith in once-compelling narratives – socio-political and cultural narratives, the narrative of the integrated subject – and *Días contados* is superficially a textbook example of this. Yet there is something in his expression as he moves through the barrier that suggests a larger possibility, beyond the more familiar looks, gazes, angles, perspectives and other visual-social fixatives of compensatory or purgative fantasy. In this more troubling reading, the uncompliant subject-as-scapegoat does not simply sacrifice himself for love, make good the breaches in Symbolic law, and revalidate the *status quo ante*. His actions are more agonistically

therapeutic and more transgressive. It turns on the point between 'reality' and the Real, just beyond symbolization, where we half-perceive that the Symbolic has a limit and are threatened by fear of what may lie beyond it. It is at this limit point, which Žižek terms the Thing, that we feel the drives' pressure most strongly. By following her beyond the barrier into the void Antonio confronts the Thing that Charo once so beguilingly screened, the full force of the threat of what lies beyond the Symbolic's limit. He stops running as the car disappears into the void and, with an expression of calm determination, still in slow motion, walks in after it. The camera, which the screenplay states will remain at the entrance, nevertheless follows him. It is a movement of implied sympathy against the grain, and one which surrenders the conventionally objective point of view to evoke a diegetic world now wholly unable to confine threats to its margins, underlining the 'fatal necessity' of Antonio's act (Žižek 1992b: 19). Beyond the collapsed barrier, the world outside becomes blurred, formless, psychotically undifferentiated. In his robotic automatized state, in diegetic silence, we imagine him glimpsing not his end or the dismembering of his Eurydice, but what her end reveals in its wordless horror. This final revelation comes when he (and we) are no longer distracted by what she seems driven to display. It becomes visible when looked at awry, from his position between two laws and two deaths, as he exits the Symbolic network for a darker place. From this perspective, his final gesture resembles the empty vehicle of 'an authentic ethical act': an act, that is, which exposes and suspends the sublimation processes and ideological and other fictions that support everyday 'reality' (Žižek 1992a: 77). The pulsing of the Real has become increasingly insistent during the course of the narrative, increasingly difficult to absorb into a merely compensatory frame, as the tensions that tear Antonio apart for the relief of those watching reach the limits of the psychically-manageable. His gesture confronts the source of these tensions and of the compensatory narratives designed to displace them; by doing so it enacts an analytic traversing of the fantasy and, with it, the promise of embarking on new relations rather than compulsively re-enacting old ones. The next chapter extends the implications of this move to radical Basque nationalism itself, and to its symbolizations.

Notes

1 For an explanation of the use of the term 'Symbolic' in this chapter, see below.
2 Even, I have argued, irresponsibly so. See 'Julia Kristeva and her Old Man: between optimism and despair' (Brooksbank Jones 1993), written around

the time that Žižek and Uribe were producing the work discussed here.

3 These are *Enjoy your Symptom! Jacques Lacan in Hollywood and Out* (1992a) and *Looking Awry; an Introduction to Jacques Lacan through Popular Culture* (1992b).

4 For Lacan, the trauma of primary repression is overlaid by the castration fantasy. A woman reader in particular is unlikely to feel 'at home' with this and with some other key assumptions of dominant forms of psychoanalytic theory; they are, I shall suggest, troubling in ways that are doubled in the film itself. My response here is to play fast and loose with Žižek and, via him, with Lacan, using the parts I want, and snipping off or ignoring those I do not. For feminist readings of psychoanalysis see Wright (1992) and Grosz (1989, 1990) and on Slavoj Žižek see Kay (2003).

5 Following Lacan, Žižek suggests that the significance of these stains tends to be clearest when they are looked at 'awry' (1992b). He likens this to the process known as anamorphosis, in which a distorted object (for example, the skull in Holbein's painting *The Ambassadors*) becomes legible when seen from an unexpected angle.

6 In Žižek's schema these three functions are assumed by three different types of object: these broadly follow Lacan, though Žižek does not always apply the distinctions consistently in practice. The first object, charged with plugging gaps in 'reality', is 'Objet (petit) a'; the second, Φ, is the fascinating phallic object that conceals what is missing; the third and last is A (ς), which binds and troubles the Symbolic fabric by marking the failure of material singularities to add up to consistent meaning. See Žižek (1992a and 1992b) and Kay (2003: 51–9).

7 *Días contados* (literally 'numbered days' but usually translated as 'Countdown') was awarded the Concha de Oro for best film at San Sebastian's international film festival in the year of its release. It also received Fotogramas de Plata awards for best film and best actor (Carmelo Gómez), and a total of eight Goyas: for best film; best director; best actor (Carmelo Gómez); best screen adaptation; best supporting actor (Javier Bardem); best art direction (Felix Murcia); most promising newcomer (Ruth Gabriel); best special effects. It is intriguing to speculate on what the film might have been if the two lead roles had been taken by Antonio Banderas and Penelope Cruz, as originally envisaged (Uribe cited Stone 2002: 157, n.14).

8 Following Gérard Genette, I use the term diegesis to refer to the narrative level on which the events being recounted (the action) take place, and extradiegesis for elements that lie outside of the action, at a higher narrative level (here, principally, the intensely atmospheric soundtrack).

9 The 'movida' was itself a period of intense cultural effervescence associated with the early years of democratic change. Centred initially on Madrid, it was first registered in music, and especially rock and punk, before extending through film (where it became identified with the early work of Pedro Almódovar) to literature and other cultural forms.

10 Umbral's text is a reference point here because (as Fusi and Palafox (1997)

note) it so vividly conjures the anxieties of the times.

11 The EOC had been opened in 1963 as part of the regime's drive to modernize Spain's image abroad – a strategy that included a strictly limited reduction in censorship and some increased support for new film-makers. See Hopewell (1986).

12 Miró, Spain's best-known woman director and first Director General of Cinematography under Felipe González's 'cambio' government, was herself a graduate of the EOC's screenwriting course.

13 With the institution, in 1980, of the autonomous Basque government under the Partido Nacional Vasco the desire to affirm regional identity was expressed partly in increased funding for film and other regional cultural forms. On this see Roldán Larreta (1999).

14 In addition to writing screenplays for two short films made while he was at the EOC (*De oca a oca y tiro porque me toca* (1974) and *Off* (1976)), and directing *Ez: Centrales nucleares* (in 1977) Uribe has directed the following films: *El proceso de Burgos* (1979), an interview-based documentary account of the 1970 trial of ETA militants under Franco; *La fuga de Segovia* (1981), an adaptation of ex-ETA member Ángel Amigo's book *Operación Poncho*, combining documentary and fiction in an account of the escape of a group of ETA members from Segovia prison, the capture and detention of survivors by French police, and the subsequent amnesty; *La muerte de Mikel* (1983), a fictional account of a militant *abertzale*'s attempts to accept his sexuality in the face of political and family pressures; *Adiós pequeña* (1986), an account of a relationship between a young lawyer and Bilbao drug-trafficker which as Torres (1997) notes, appears to be a first draft of *Días contados*; *La luna negra* (1989), a horror film made for TVE; *El rey pasmado* (1991), his adaptation of González Torrente Ballester's historical novel set in the Spanish baroque period; *Bwana* (1996), a study of racial prejudice in middle-class Spain, based on a play by Ignacio del Moral; *Plenilunio* (2000), a thriller adapted from Antonio Muñoz Molina's novel about the search for the murderer of a young girl by a detective haunted by his years spent fighting ETA; *Extraños* (1998) a thriller with a surreal edge, concerning a private detective employed by a suspicious husband and troubled by a recurring dream; *El viaje de Carol* (2002), in which a twelve-year-old girl makes a life-changing visit to Spain in 1938. He also contributed in 2004 to *Hay motivo*, comprising shorts by thirty-two directors (including Medem, Olea, Bollaín, David Trueba, and Gómez Pereira) each criticising a different aspect of Spain's social and political leadership under PP between 2000 and 2004.

15 In an earlier, and rather different, interpretation of this film I have associated these characteristics with a 'structure of predestination' (Brooksbank Jones 2002: 395).

16 Subsequently, *passim*, page references are supplied for notes taken from the screenplay but not (as here) for dialogue taken from the film.

17 'No te muevas' (don't move) appears in the film but not in the screenplay.

18 On narcissism see Kofman (1982) and Ragland Sullivan (1992). On Lacan's

description of the roots of narcissism in the mirror phase see Laplanche and Pontalis (1973: 250–2) and Grosz (1990: 35–41).

19 On the dynamic underpinning this process see Grosz (1990: 131–7). Charo's balancing act in the bath spatializes the psychic contortions this requires, as well as the uncomfortable positions that many women, and some men, watching the film (or reading the theory) are obliged to assume before certain meanings come anamorphically into view. For the retrospective or *après-coup* dimension of this sense of predestination see Žižek (1992b: Chapter 4).

20 This phrase does not figure in the screenplay and may well have been extemporized or suggested by the actor playing Rafa, the brilliantly wayward Karra Elejalde. It will have carried greater significance at a time when Spain still had relatively low levels of immigration and, partly as a consequence, high (reported) levels of racial tolerance.

21 Drives (of which the death drive is the most compelling) come about with the repression of instincts, a repression which is essential if the subject is to enter the Symbolic order. Their power is experienced most forcefully, however, between the Real and Symbolic; in Žižek's terms, subjects can only shake off the pull of the Real and emerge fully into the order of language and the law by mediating drives *socially* – that is, by converting them to desire (Žižek 1992b: 21). In this process, and its final failure, the figure of Charo is crucial.

22 The screenplay here follows the novel almost verbatim. See Madrid (1993: 310).

23 On the ending's powerfully apocalyptic overtones see Brooksbank Jones (2002).

6

Symbolizing Gernika

The chapters in this book are all concerned with the cultural management of risk at a time when traditional sources of identifications – and the institutions, projects and visions of history in which they are embedded – seem to be losing their power to bind us. They question the ability of global processes to assuage or engage the 'ontological fears and insecurities' that many commentators trace back to that sense of loss, and the power of consumer imaginaries to do more than temporarily distract attention from it (Giddens 1991, Beck 1992, Adam 2004: 89). This final chapter uses two iconically compelling symbols to situate these anxieties in relation to larger narratives of Basque and Spanish nationhood, their limits and strategic possibilities. Its starting point is a sequence of events that has become one of the most resonant in twentieth-century Spanish history.

From our Special Correspondent, Bilbao, April 27 [1937]

Guernica, the most ancient town of the Basques and the center of their cultural tradition, was completely destroyed yesterday afternoon by insurgent air raiders. The bombardment of this open town far behind enemy lines occupied precisely three hours and a quarter, during which a powerful fleet of airplanes consisting of three German types, Junkers and Heinkel bombers and Heinkel fighters, did not cease unloading on the town bombs weighing from 1,000 lbs. downwards and, it is calculated, more than 3,000 two-pounder aluminium incendiary projectiles. The fighters, meanwhile, plunged low from above the center of the town to machine-gun those of the civilian population who had taken refuge in the fields.

The whole of Guernica was soon in flames except the historic Casa de Juntas with its rich archives of the Basque race, where the ancient Basque Parliament used to sit. The famous oak of Guernica, the dried old stump of 600 years and the young shoots of this century, were also untouched.

In these relatively measured terms George Lowther Steer began the dispatch that, published simultaneously in *The Times* and the *New York Times*, would help to establish 'world public opinion about the destruction of Guernica' (Southworth 1977: 14). The bombing of this neutral town, in the second year of Spain's Civil War, killed 200–250 of its 7,000 inhabitants, destroyed 71% of its buildings, and damaged all but 1% of the remainder.[1] From the date and duration of the bombardment, however, to the nationality and motives of the perpetrators, supporters of Franco's rebel forces have contested almost every detail of the bombardment in the intervening years.[2] The main exception to this is the survival of the town's Assembly House, or Casa de Juntas, and the venerable oak. The first part of this chapter examines the significance of the oak, and it role in affirming the community's continuity in the face of external forces perceived as inimical. The second contrasts this with the fitful modernizing energies of Picasso's representation of the bombing. The third reflects on the place of both, and of conceptions of peace and violence, in the symbolic repertoire of the late-modern ethno-nation.

The authority of Gernika and its oak as 'center of [Basque] cultural tradition' was underlined in events that occurred in its shade only six months before the bombing. When José Antonio Aguirre was elected Lehendakari (President) of the Spanish Republic's Provisional Basque Government in October 1936 he took his clandestine oath, in Basque, in the courtyard of the Casa de Juntas: '[b]efore God, in all humanity, upon Basque earth, standing under the oak of Guernica, in remembrance of those who have passed before, I swear to accomplish my mandate with entire faithfulness' (Steer 1938: 82). Aguirre owed his new role and mandate partly to the escalation of the military revolt against Spain's democratically-elected Republican government – a revolt unleashed three months earlier in Morocco and which, with the help of the rebels' German and Italian allies, would see the installation of a dictatorship within three years.[3] But as his oath makes explicit, the investiture was legitimated by the powerful precedent invested in Gernika's oak tree, widely perceived by Basque nationalists and non-nationalists alike as 'el símbolo más universal de los vascos' (Basques' most universal symbol) (Batzar Nagusiak nd: 6).

This status derives from the oak's role in key politico-economic and cultural narratives of the region's past and, above all, from its identification with Vizcayan democracy. The early European tradition of deciding the interests of a community by meeting under a tree (usually an oak) was well established in Vizcaya and other Basque-speaking areas by the medieval period (Caro Baroja 1972). Vizcaya's laws were formulated, by representatives of its administrative areas, at the Juntas Generales or General Council held under the oak of Gernika – a tradition first documented in

1308 and continuing until 1876 (Batzar Nagusiak nd).[4] The power and longevity of the Juntas Generales among these geographically- and culturally-isolated communities has often been taken (chiefly, but not only, among nationalists) as evidence of Basques' independent democratic spirit.[5]

This independence is closely associated with the persistence of the region's *fueros* or historic liberties. These were first committed to written form in 1237 in the *Fuero Navarro*, which was extended to Alava, Guipúzcoa and Vizcaya in the following decades. This formalization of customary law took place across Iberia in the Middle Ages, often in the form of charters in which 'the lord guaranteed certain rights and privileges to the inhabitants of a newly created settlement' (Collins 1986: 201). Although Basque communities were not the only, or the first, communities to receive *fueros* in written form, their repeated struggles to retain these historic privileges when other communities were losing their own made the *fueros* a powerful focus for Basque identity construction. As the region's communities became more complex so too did their charters, and Basque rights and culture were increasingly affirmed through exclusions and appeals to difference. This was powerfully institutionalized from the late fourteenth century when control of Vizcaya passed from the Señorío of Vizcaya to the Castilian crown, as the traditional assertiveness of the Vizcayan population obliged successive monarchs to extend and develop the rights enshrined in the *fueros* to all social groups, recognizing 'la hidalguía de sangre de todos los vizcaínos' and, in the decades that followed, 'la nobleza universal de los vascos (the nobility of Vizcayan blood . . . the universal nobility of Basques) (Caro Baroja 1972: 9, Ortzi 1975: 37). In 1476, Fernando el Católico became the first Castilian monarch to swear under Gernika's oak to observe the *fueros*, affirming the town's status as 'la villa foral' (home of the *fueros*) and easing its oak-tree's transformation into the 'esencia del vasquismo' (very essence of Basqueness) (Cava Mesa 1996: 257).

By the early sixteenth century these claims to difference and distinction were being used as grounds for banning or expelling Jews and other non-Basques from the region. And by further reducing cultural exchange and promoting endogamy they became partly self-fulfilling: Basques still have the least hybrid pattern of blood groups in Europe, for example, while their language is widely recognized as the continent's 'sole surviving, anciently established non-Indo-European language' (Collins 1986: 1).[6] These features have loomed large in nationalist narratives of cultural distinction. In the eighteenth century, for example, Jesuit Fr Manuel Larramendi promoted Basque language and affirmed Basque blood as 'el principio de toda la limpieza de sangre española' (the beginning of Spain's pure blood) (quoted García de Cortázar and Azcona 1991: 16).

And by the late nineteenth century, when modernization was drawing waves of new settlers into the region, Sabino Arana de Goiri (founder of the Partido Nacional Vasco, or Basque Nationalist Party) would use these and other selected claims to specialness to ground his defence of Basque racial exclusivity.

He did so at a time when the *fueros* from which much of this sense of specialness derived were being eroded, as long-standing political privileges were gradually replaced by tax and other economic concessions. Above all, their role in supporting the independence of the Basque provinces and Navarre was making them 'the main political challenge' to the centralizing ambitions of liberal politicians (Carr 1982: 63). In 1875 Don Carlos, whose claim to the Spanish throne and conservative Basque sympathies had triggered the Carlist Wars, swore his support for the foral tradition under Gernika's oak.[7] A year later, following his defeat and flight to France, the *fueros* were abolished, firing deep and lasting resentment among Basque traditionalists. Like the erosion in urban industrial modernity of a rurally-embedded sense of specialness, or the later repression under Franco's dictatorship of independent traditions, this period of struggle and of cultural, politico-economic and military loss continues to resonate in narratives of the Basque past. The abstractions of modern politics or economics could not have sustained such powerful, even violent, identifications as that story of ancient nobility unrecognized and powers usurped. The bombing of Gernika owes it exceptional resonance partly to its place in that narrative.

The miraculous survival of the town's oak-tree appears to reaffirm its status as a unique mediator of the contradictions arising from those processes, and one in which past specialness seems to persist in its fullest form. This reflects the 'valor extraordinario' attributed to an organic symbol that has evolved over time into 'el sagrado roble', 'el santo árbol' (extraordinary value . . . the sacred oak, the holy tree) (Vidal 1997: 90, Rubio Cabeza 1987: 406, Vidal 1997: 88). An early factor in this progressive sacralization was the oak's association with Santa María La Antigua, a small chapel built in the early fifteenth century and site of the religious ceremony that preceded the gathering of representatives and swearing of oaths.[8] Following the addition of a sacristy in 1686, it also served as a repository for the Vizcayan archives (Onaindia 2000). With the institutionalization of these practices, the swearing itself began to take place in the chapel and, in time, also the political assembly. By 1826 the perceived need for 'un espacio más acorde con las necesidades de la institución' (a space more in accord with the institution's needs) would lead to the chapel's demolition and the construction on its site of the Casa de Juntas (Batzar Nagusiak nd: 4). The oathing practices nevertheless retained

their conservative Catholic framing. This reflected their roots in tradition, but also Basque resistance to the centralizing impulse in Spanish Liberal thought. This became decisive at the onset of the Civil War, when Gernika was one of many Basque locales riven with tensions between residents whose nationalist sympathies led them to reject the centralist rhetoric of Franco's rebels, and others viscerally opposed to the secularism of the Republican government and its marxist and anarchist fighting forces.[9] The result was the uneasy neutrality in place at the time of the bombing.

Over the centuries, its role as focus for this potent mix of premodern spirituality, Catholic ritual practices and foral tradition, its association with Basque earth, and its crystallization of a sense of enduring Basque specialness have all eased the Gernike oak's institutionalization and its transfiguration. As Nieztsche notes, '[e]very tradition grows continually more venerable, and the more remote its origin, the more this is lost sight of. The veneration paid the tradition accumulates from generation to generation, until it at last becomes holy and excites awe' (1995/ 1878: 96). It was above all the belief in Basque distinction *over time* that sustained claims to difference and underlined the premodern dimension of the oak's symbolic authority – a dimension grounded in 'primordial attachments' founded on 'the gross actualities of blood, race, language, locality, religion or tradition' (Geertz 1994: 30). Clifford Geertz defines a 'primordial attachment' as

> one that stems from the 'givens' – or, more precisely, as culture is inevitably involved in such matters, the assumed 'givens' – of social existence: immediate contiguity and kin connection mainly, but beyond them the givenness that stems from being born into a particular religious community, speaking a particular language, or even a dialect of a language, and following particular social practices. These congruities of blood, speech, custom, and so on, are seen to have an ineffable, and at times overpowering, coerciveness in and of themselves. (1994: 31).

Narratives of an ancient Basque democracy are grounded in these qualities: they reframe, recombine, displace and renew representations of primordial ties over time in forms similar enough to seem continuous. By this means, some have been able to register change while appearing to transcend it. The process informed Lehendakari Aguirre's description of Gernika in 1936 as 'el santuario que recuerda los siglos de nuestra libertad y de nuestra democracia' (the sanctuary that recalls centuries of Basque liberty and democracy).[10] Half a century earlier, Sabino Arana's affirmations to this effect had been a defensive response to the perceived threat of immigrant workers and encroaching modernity: for the new Lehendakari, by contrast, they mark the integration of a

complexly-mediated awareness of primordial ties and other premodern elements into an overarching, modern, civil order – an order that, within two years, would be catastrophically displaced.

What distinguishes new civil orders from primordial attachments is not simply the former's instrumentality. It is, rather, that such attachments are grounded in ties which are experienced as material rather than abstract and which, to the extent that they seem to link 'human lives in the very nature of things', are profoundly bound up with the sense and location of the self (Anderson 1991: 34). These links to place and the soil are conventionally expressed in terms of a rootedness which, in Gernika's case, acquires literal force: it is 'el alma de todos los vascos y siempre ha sido porque Gernika tiene raíces profundas, aquel *árbol* que tenemos allí' (the soul of all Basques, and it always has been, because Gernika has deep roots, that *tree* we have here) (Cava Mesa 1996: 261). Because civil frameworks demand a less focused and more routine form of alliance they are traditionally experienced as inimical to deeply-felt primordial identifications. Particularly where those identifications are so closely bound up with a sense of historic difference, the will to be 'someone who is visible and matters and the will to be modern and dynamic tend to diverge' (Geertz 1994: 30).[11] Basque writer Adrián Celaya highlighted this tension in 1978, as the ratification of the new Constitution formally inaugurated Spain's new democratic era: '[t]o talk of the *Fueros* today is not to return to the past, nor even to put on [sic] certain old laws. It is, on the contrary, to concede to our people [. . .] their role as a protagonist in social life' (cited Desfor Edles 1998: 135).

But the continuity evoked by the oak has another dimension that is both organic and metaphorical. The 'Arbol Viejo' or Old Tree had stood behind the swearing gallery of the Casa de Juntas, surrounded by stone seats reserved for political representatives and ecclesiastical dignitaries. But its symbolic potency, weakened by the abolition of the fueros in 1876, could not preserve it from organic decay. Given its place in the chain or lineage of precedent, however, the dying tree could not be simply uprooted and destroyed. In 1929 it was accordingly moved closer to the entrance to the grounds, and later dignified by the construction of a small surrounding pantheon. The successor planted in 1859 failed to thrive and, less than a year later, it too had to be replaced.[12] By 2004 this replacement was itself dying. Its roots had become thoroughly entangled with those of its nominated successor, however, a cutting taken from it in 1979; the risks of trying to disengage them in order to remove the dying tree were clear. Instead, Gernika called in another cutting from the 1859 tree which had been in the care of Vizcaya's provincial government, and this was duly installed in January 2005.[13] This alert – amplified at

9 Gernika oak, August 2005 (Ken Brodigan)

10 Old Gernika oak, August 2005 (Ken Brodigan)

the time in images, press articles and emotional farewells – to the risks of cultural introversion hardly needs comment. But it is also a reminder that organic symbols, unlike non-organic ones, cannot be sustained by representational will alone.

It was perhaps with this in mind that a rather different tree was constructed in 1964, when the open patio once adjacent to the courtyard was integrated into the Casa de Juntas and roofed over with a monumental stained-glass evocation of the oak. To the extent that the undistinguished example growing alongside it seems even less resonant by comparison, this supplement is a usurper. Its reassertion of representational will might even be accused of rendering historical memory as décor. But it may be a necessary supplement at a time when the foreshortening of cultural memory has highlighted memory's importance for us, when the time of oak trees and the *longue durée* is so out of phase with the speed that increasingly conditions the practices of everyday life that it is slipping below our threshold of perception. In accordance with these new conditions, where once a single tree bore the accumulated weight of the oak's lineage, the Casa de Juntas and its surroundings have become a symbolic jungle, where the hollowed-out remains of the old – but by no means millennarian – tree jostle the vestiges of its undistinguished late nineteenth-century and late twentieth-century descendants, their freshly-planted

successor, and a mid-twentieth-century glass monument to the hollow-ing out of its model.[14] At its most abstract, this proliferation seems to combine a contemporary awareness of the decline of particularistic rela-tions – relations grounded in traditional notions of presence – with an anxious sense that such relations may after all be necessary to our cul-tural well-being.

The glass tree is not based on any one of those real trees, however, but on a general representation, an ideal image projected by a society in transformation and seeking to recognize and affirm itself there. José María Iparaguirre ended 'Gernikako Arbola', his nineteenth-century paean to Gernika's oak, with the words 'Si caes, estamos totalmente per-didos' (if you fall, we are utterly lost). Over a century later one-time ETA member Mario Onaindia rejects such fetishism, but his own lament for the idealized Árbol Viejo and its lost potential for symbolic mediation is as angry as it is elegaic:

> Ha dejado de ser un símbolo porque ha perdido todo significado para la gente. Al tiempo que le cortaban las raíces y las ramas, perdía también lo que representaba, la era de los fueros, de la armonía social en torno a la lealtad a unas instituciones. [. . .] Porque lo fundamental de un árbol, en cualquier imaginario, es precisamente ser el intermediario entre las raíces – la tierra – y las ramas – el cielo – entre la ciudadanía y el Estado, entre el pasado y el futuro, entre el pueblo y su historia. Convertido en un mero fetiche de una época, [. . .] no podrá volver nunca si no se recuperan los valores que hicieron que se fructificara. [. . .] Este roble seco es así la imagen de la tierra baldía, yerma. (Onaindia 2000: 250)

> It has ceased to be a symbol because it has lost all meaning for people. When its roots and branches were removed so, too, was what it had repre-sented, the era of the *fueros*, of social harmony grounded in loyalty to insti-tutions. Because the fundamental aspect of a tree, however it is imagined, is precisely its mediating role between the roots – earth – and the branches – the sky – between citizenship and the State, the past and the future, a people and their history. It has been converted into the mere fetish of a period and can never recover that power unless the values that made it fruitful are themselves reestablished. In that sense, this withered oak is the image of a dry and barren land.

As his words attest, more than sixty-five years after the bombing of Gernika the primordial customs and historical claims associated with the oak are weaker, but the values enshrined in them have not been wholly sublated within civil society. The recent Basque past is a story of frustra-tions accumulated in battles, mostly lost, against central powers. The region's abrupt, highly-concentrated and traumatic integration into industrial modernity yielded few material benefits; state repression began

to bite in the early part of the nineteenth century and would become more widespread and more intense after 1959 under Franco; the relative geographical isolation once seen as a defence against interlopers is today more often experienced as a source of missed opportunities; above all, modernity has come late and unevenly, mediated by a central state and globalizing forces that seem at best indifferent to the region's established customs and traditional modes of life. These forces, notes Joseba Zulaika (2003), now weigh more heavily than the *fueros*, Basque language or blood, especially in urban contexts.[15] But Onaindia's words illustrate the persistence of unresolved tensions between modern and premodern dimensions in Basque thought; and suggest that, like the roots of the two oaks, these dimensions are not so easily separated.

There is much to criticize in the fantasized or mythological aspects of Basque narratives of the past and their institutionalization, in the seventeenth, eighteenth and nineteenth centuries, in anthropological and other studies; but they cannot simply be dismissed. Compared with the fractured time of late modernity, the *longue durée* of oak-trees is time made richer and more resonant with the inclusion of imagination and desire; it is time out of time in which Basque protagonism is never shared or impugned because interlopers are permanently excluded. Drawing on mythical time need not be simply escapist or defensive, however; nor is it simply *irrational*, though some of its components are well towards that end of the spectrum.[16] It is a strategy for adjusting to changes perceived as inimical, and on terms that are not exclusively external to the community. Like the glass tree that presides over council meetings today, it is a place for projection, for resolving in imagination tensions between how things are and how we would like them to be – tensions that, in globalizing modernity, are not experienced only by Basques.

* * * * * * * * * *

I have presented the Gernika oak as a focus and storehouse for local, particularistic identifications, and as mediating the risks posed for them by contemporary civil society's more abstract relations. I want to turn now to another representation of Gernika: one constructed over the course of a few decades as universal. Where the oak-tree derives its force from Basque narratives of an idealized past, this second symbol figures as the triumphant apotheosis of a complexly 'risk-ridden' cosmopolitan present (Beck and Beck-Gernsheim 2002: 40).

Back in 1936, the installation of the Lehendakari of the new Basque regional government had reaffirmed the customary authority of Gernika and its oak. It was the manipulation of this authority – by the Republican

government, and by Republican sympathizers in the Spanish and inter-
national press – following the bombardment that would make the events
of that Monday market-day reverberate so powerfully across Europe and
beyond. In the days that followed, Gernika became a symbol not only of
'la resistencia de los vascos' (Basque resistance) but also of Republican
Spain in general, as these reverberations were amplified in stark mono-
chrome press and newsreel images, the photographs and eye-witness
accounts of survivors (Fusi 1984: 41). They would trigger a startlingly
different representation of the town and of a new form of warfare, and
new crises that would come to be seen as prototypically modern.

Pablo Picasso's symbolic appropriation of the devastation of Gernika
unleashed politico-aesthetic energies that would be repeatedly reconfig-
ured in the decades that followed. His appointment in September 1936,
two months into the Civil War, as honorary Director of the Prado and
Director General of Fine Art was a propaganda coup for the Spanish
Republic. In this capacity Spain's most internationally-celebrated artist
was prevailed upon to produce a mural to hang in the entrance hall of
the Spanish pavilion at the World Exhibition in Paris, which was due to
open on 24 May 1937. It was 'to convey in one image the sense of the
drama of his fatherland – ravished by the Fascists' (Arnheim 1962: 18).
For this, he would receive 150,000 francs from the Republic's Treasury
Minister, who was convinced that 'the presence of a mural painted by
Picasso is the equivalent in propaganda terms of a victory at the front'
(cited Southworth 1977: 14). Picasso was not in any simple sense a polit-
ical artist and was not accustomed to working to commissions. By 28
March, however, when he heard of events in Gernika, he had already
completed preliminary drawings for the mural 'Painter and his Model',
a work that reflected his continuing aesthetic concerns and made no ref-
erence whatever to the Civil War. He immediately set aside these draw-
ings and, three days later, began the preliminary sketches for 'Guernica'.
Having previously considered the possibility of charting the development
of a painting, and with his role as a publicly-commissioned artist upper-
most in his mind, Picasso catalogued and preserved each stage of the
mural's production in the form of six preparatory drawings and sequence
of photographs taken by his new mistress, Dora Maar. As was his habit
he worked quickly, transferring the sketches to canvas in only ten days.
The work was completed on 4 June and erected in the still-unfinished
Spanish pavilion two weeks later.[17]

It was not what most of Picasso's Republican commissioners had been
expecting. Like many other commentators on the left during this period,
they preferred social realist art to what they saw as elitist vanguardism,
and were disappointed by the mural's hermetic character. They had

hoped for a more direct and manifestly impassioned work that could be 'read' quickly and unambiguously by passing crowds, and shared Max Aub's concern that 'Guernica' might seem 'too abstract or difficult for a pavilion like ours which seeks to be, above all [. . .] a popular manifestation' (cited Van Hensbergen 2004: 71). For the events which had precipitated the painting seemed buried under artistic bravura. In his study of the painting's genesis and impact, Spanish art historian Francisco Calvo Serraller analyses this disappointment:

> Todo el mundo esperaba [. . .] que el cuadro reflejase lo que había pasado y que lo hiciese de forma que expresara la general indignación moral. Frustrando estas espectativas, el mural de Picasso no sólo no proporcionaba ningún dato visual que identifiquase la hecatombe con la ciudad vasca destruida, con la guerra civil española o con un bombardeo aéreo, sino que ni siquiera los elementos figurativos visibles en el cuadro y asociables a una tragedia bélica eran congruentes. Es cierto que allí se podía vagamente distinguir unas mujeres gritando y un incendio urbano, pero no se entendía la presencia de una enorme bombilla, los tres animales y la estatua rota, por señalar sólo lo mas obviamente chocante. Al lado de estas incongruencias, ya casi carecía de importancia que el cuadro fuera monocromo o que las figuras estuvieran dibujadas con las libertades de un estilo moderno. En definitivo, El Guernica resultaba incomprensible ante una mirada ingenua y exigía, por lo menos, una explicación. [. . . Suscitó] un rechazo casi unánime. (Calvo Serraller 1999: 52)

> Everyone was expecting the painting to reflect what had happened, and to do so in a way that expressed the general moral indignation. But Picasso's mural frustrated these expectations: it failed to supply any visual information that might identify the hecatomb with the devastated Basque town, the Civil War, or with an aerial bombardment; and even where figurative elements could be made out in the picture that identified it with a wartime tragedy they were wholly incongruent. Certainly, it was possible to distinguish some women shouting and a town on fire, but the presence of a huge light-bulb, the three animals and the broken statue – to cite only the most obviously shocking examples –seemed inexplicable. Alongside these incongruous elements, it hardly seemed to matter that the canvas was in black and white, or that the figures were painted with all the freedom of a modern style. In short, Guernica proved incomprehensible to an unsophisticated gaze and demanded at the very least an explanation. It provoked almost unanimous rejection.

That is, not *quite* unanimous. For if the painting began to become a legend in this period it was largely because of the conflicting views it excited among Basques and non-Basques, between Republican and Rebel sympathizers, and between political and art-historical assessments of its worth. Responses among Picasso's circle and critics with avant-garde

sympathies ranged from the generally positive to the rhapsodic. At a time when the startling modernity of Picasso's early Cubist experiments seemed to have lost its edge, the essays published in a double edition of the Paris-based *Cahiers d'Art* (Art Journal) soon after the mural's hanging played a central role in mustering informed support for the new work. This support came chiefly from commentators engaged by its formal sophistication, who were not persuaded (or not concerned) that this diminished the painting's power. Herbert Read, for example, insisted on the legibility of this 'cry of outrage and horror amplified by the spirit of genius' (Read 1981/ 1937: 209). But for Christian Zervos, a close friend of Picasso and editor of *Cahiers d'Art*, any attempt to explain 'Guernica' would simply dilute its visionary force (Zervos 1981/ 1937: 203). He was overwhelmed by what he saw as Picasso's ability to purge intense feeling into formality, chaos into order: 'Guernica' represented 'a world of despair, where death is everywhere. [. . .] From Picasso's paintbrush explode phantoms of distress, anguish, terror, insurmountable pain, massacres, and finally peace found in death' (cited Van Hensbergen 2004: 79).

Outside this relatively small circle of avant-garde critics, art historians and practitioners, assessments of 'Guernica' tended to reflect the political sympathies of the spectator and foreground its expressive dimension. Heightened as it was by the circumstances of the mural's production this achieved an extraordinary intensity, prompting even commentators unsure of 'Guernica's' propositional content to take that content on trust (Zervos 1981/ 1937, Southworth 1977). This leap of faith was not restricted to Republican sympathizers. British journalist Brian Crozier, for example, declared his conviction that the bombing was the work of the German airforce 'being encouraged in this belief by the considerable success of Picasso's painting, "Guernica"' (Southworth 1977: 260). But while the mural's impact was rapid and intense it was not necessarily sustained, and Crozier quickly converted to the Rebel view that the town was destroyed by Republican dynamiters. This instability helps to explain why, even on the left, opinions on the painting ranged from the bemused or wary to the frankly hostile. Anthony Blunt – a proponent of the Soviet-style socialist realism that rejected avant-garde art as elitist, passé, even degenerate – disputed 'Guernica's' political potential in a lengthy polemic with Herbert Read. Prompted, perhaps, by the Soviet Union's tense relations with the Republican government at that time, Soviet commentators queued up to dismiss the mural as the last gasp of bourgeois art (Zervos 1981/ 1937). In the words of Vladimir Kamenov:

[e]l arte (de Picasso) es una enfermiza apología estética capitalista que provoca la indignación de la gente sencilla, no de la burguesía. Su patología

ha creado repugnantes monstruosidades. En 'Guernica' no ha representado republicanos, sino engendros. (Cited Talón 1973: 299)

Picasso's art is a sickly aesthetic defence of capitalism which provokes indignation in ordinary people, but not among the bourgeoisie. His pathology has created repugnant monstrosities. In 'Guernica' he hasn't shown us Republicans, but a freak show.

Nor did Picasso find much comfort from Lehendakari Aguirre and many other key Basque figures. Bewildered or affronted by its obliqueness, the organizers of the Spanish Pavilion tried initially to have the mural removed, but desisted in the face of Picasso's international profile and the lack of a suitable replacement. Among them was José María Ucelay, a Basque muralist of some repute who was handling the region's contributions to the Exhibition. The terms in which he damns the painting illustrate the rawness of Gernika's trauma for those closer to it: 'as a work of art, it's one of the poorest things ever produced in the world. It has no sense of composition, or for that anything . . . it's just 7 x 3 metres of pornography, shitting on Gernika, on Euskadi, on everything' (cited Van Hensbergen 2004: 72). Before that rawness had had time to heal, all reference to the bombing would be censored under Franco's dictatorship.

In the decades that followed its exhibition 'Guernica' would be purged of much of its conflictual Civil War symbolism, before being invested with a more conciliatory form after the dictator's death. Yet in the intervening decades it continued to spark often violently opposed assessments as the early 'delirio interpretativo' (interpretive delirium) modulated into a new key (Calvo Serraller 1999: 52). For while its Civil War associations waned the productivity of the mural's symbolism eased the accretion of new ones, making it figuratively very dense in a short space of time. The speed of these shifts and accretions contrasts vividly with symbols rooted in primordial attachments. Where rootedness and continuity are privileged, changes come slowly, depositing traces of older meanings like tree-rings in the collective memory. But 'Guernica''s contentious beginnings helped to make its symbolism unstable from the outset; and this instability, I shall argue, has eased the painting's repeated renewal and powered its exceptional metaphorical vigour.

One reason for this instability is 'Guernica''s lack of attachment to place. This painting is manifestly more entitled than most to evoke place, yet the eponymous township remains strangely absent. *Pace* Arnheim, the tree that symbolizes Gernika, its continuity and survival is not 'in the picture' (Arnheim 1962: 24). The symbolic rootedness of that tree, its embeddedness in traditional particularistic relations, gives it local cultural force with material consequences. Picasso's image represents the

very antithesis of that materiality: with its 'highly abstract qualities of instability, angularity, stark precision, [it is almost] a diagram[, the] visual representation of an idea (Arnheim 1962: 25). These qualities – and the uncertainty of that idea – convey detachment, non-rootedness, a distancing and generalizing of the locale from which it takes its name. And it is above all these rootless, non-traditional, qualities that have eased the canvas's international appropriation and iconization.

As the circumstances of its production were sublimed into history, specialist assessments of the mural worked initially to stabilize it: to locate it within an artistic tradition, to define its style and decode its symbolism, to render its political motivation in art-historical terms. The search for an art-historical lineage reflects at one level a desire to give a sense of temporal depth to 'Guernica''s flat, almost diagrammatic, construction. More importantly, it bespeaks a desire to restore the mural to a tradition from which the shock of its genesis seemed temporarily to wrench it, making the canvas seem 'visionary', a work of 'magic' or even 'witchcraft' (Zervos 1981/ 1937: 203, 206). Integrated into art historical narratives, its explosive qualities could be contained, normalized and remobilized as, for example, 'the clash of the traditions of pastoral and epic in modern art' (Hilton 1992: 244). The reductive effects of this strategy would be strikingly illustrated in 1981 when the mural was finally hung in Madrid: in the new democratic Spain, reduced to its art-historical credentials and juxtaposed with masterworks whose power had accumulated over centuries, it became clear how much of the mural's own power had derived from other, more fitful, sources. Rehoused in a modern art museum a decade later it would be restored to a new form of monumentality.

Still more decisive for the mural's reception, however, has been its symbolic overdetermination. The genesis asserted in its title has encouraged very specific expectations which commentators have then tried to align with the painting's various elements. Their interpretive openness have made this a seductive and frustrating process. First because, like much of Picasso's mature work, and the tree with which we began, 'Guernica''s power rests partly on elements from ancient cultural traditions, both sacred and pagan. As Calvo Serraller notes, these initially favoured an anthropologically-informed 'interpretación milenarista del cuadro' (millennarian interpretation of the painting) (1999: 52). But as later analyses increasingly recognized, even from an anthropological perspective the bull cannot be read simply as the people, for example, the horse as Fascism, the dove as the Holy Spirit, or the dead soldier as a Republican militant. Picasso's own interventions were hardly designed to clarify the issue: having described the seemingly sympathetic bull as a representation

of 'brutality and darkness' he later dismissed all attempts to assign a symbolic significance:

> Este toro es un toro; este caballo es un caballo. Hay también una especie de pájaro, un polluelo o un pichón, no lo recuerdo bien. Este polluelo es un polluelo. Sí, claro, los símbolos [. . .] Pero no es preciso que el pintor cree estos símbolos. De otro modo, sería mejor *escribir* de una vez lo que se quiere decir en lugar de pintarlo. [. . .] Hay animales, son animales destrozados. Para mí, es todo, que el público vea lo que quiera. (Cited Calvo Serraller 1999: 53)

> The bull is a bull; the horse is a horse. There's a sort of small chicken or pigeon, I can't really remember which. This chicken is a chicken. Ah yes, of course, there are symbols [. . .] but the painter doesn't need to create these symbols. If that were the case, it would be better simply to *write* what we want to say instead of painting it. [. . .] There are animals, and these animals are shattered. For me, that's all there is to say; let the public see what they want to see.

Attempts to fix these symbols were further complicated by their assumption of new significance in different contexts across his work, by their uncertain relation to other compositional elements with a specific work, and by the insistence of autobiography: as Hilton observes, he 'did not forget forty years of being a subtle, egotistical and aesthetic artist as the result of a bombing raid' (1992: 242–3). Most obviously, all the symbols deployed in the mural, including those often described as universal (such as the dove, or 'pichón'), had been transformed by the 'acquisition of a cubist vocabulary and classical underpinning' (Mathews Gedo 1980: 173). But at the same time, even 'Guernica', his most public work, is deeply personal in the sense that it draws on a cast of characters that recur in earlier pieces; the Minotaur/ bull and the horse, for example, are present in sketches produced when he was eight or nine. These dynamic (and sometimes interchangeable) personal associations, with their emotional charge, tend to leaven the mural's abstraction. Wherever the image circulates, and in whatever form, they remain one of its most characteristically modern features. Like its symbolic openness, however, they also complicate the question of Picasso's motivation and, above all, the mural's status as the politically-charged denunciation of the bombing of Gernika. For Hilton the figure of the bull, for example, is 'ferocious and bestial', associated with Fascism and other negative energies: for Fisch it is 'a quasi-magical symbol[, . . .] an allegorical representation of Spain and of life as a complex of good and evil'; for Berger, its recurrence invokes power, physicality, sexuality, Picasso himself; while Arnheim contrasts the possibility that it signifies 'the enemy' with its role in earlier

etchings as a power overthrowing Franco, and concludes that 'the towering, timeless figure of the kingly beast' should be interpreted as 'a monument rather than an actor' (Hilton 1992: 212, Fisch 1988: 46, Berger 1966, Arnheim 1962: 24, 19–20).

As noted, these interpretations, which illustrate changing approaches to the mural over the second half of the twentieth century, all respond in their different ways to uncertainties about Picasso's political motivation. The motive for the commission that gave rise to 'Guernica' was overtly propagandistic and Picasso was initially wary of accepting it. He had not previously undertaken explicitly political work, and within the left-leaning Parisian intelligentsia of the time he was widely viewed as apolitical until the fall of Alfonso XIII in 1931 prompted his conversion from royalist to Republican (Palais des Beaux Arts/Stedelijk Museum 1956: 2). What is probably his most forthright statement on the political dimension of art came after 'Guernica', when his political credentials seemed at their strongest; yet its conclusion – that 'painting is not done to decorate apartments. It's an instrument of war for attack and defence against the enemy' – is hardly unambiguous. The artist's financial support for the Spanish Aid Fund before and after the bombing of Gernika; the *ad hoc* support he gave to compatriots who solicited it; his very public support of the Republican cause; and (only months before the end of the Second World War) his affiliation to the French Communist Party: all indicated sympathies far enough to the left of the spectrum to encourage the FBI, at the height of the anti-communist McCarthy era, to maintain a file on him. Yet, as Van Hensbergen observes, 'his relationship to politics as a whole [seemed] quixotic, idealistic, anarchic, contrary, personal, at times almost innocent'; indeed, his close friends Roland Penrose and D. H. Kahnweiler consistently asserted his lack of political commitment (2004: 187).

What matters here, however, is not Picasso's political commitment, nor even his personal motivation at the time of painting 'Guernica', but the mural's de- and repoliticization *post hoc*. For in the decades that followed the Paris Exhibition, its political, stylistic and symbolic indeterminacy would ease its repeated remaking. In the sharply polarized world of the 1950s, for example, critics and curators were increasingly inclined to foreground the painting's personal dimension, to the point of characterizing it as 'entièrement autobiographique' (entirely autobiographical) (Palais des Beaux Arts/ Stedelijk Museum 1956: 2). Where associations with the Civil War were mentioned these tended to be recast or generalized. A year after Spain was admitted to the United Nations Organization, for example, Frank Elgar gave the canvas a recognizably apocalyptic Cold War gloss as a denunciation of 'crime, desolation and chaos[, . . .] the

anguished protest of a soul tormented by the atrocities that set his home-
land running with blood' (Elgar 1956: 173). A decade later John Berger,
in the more restrained language of generic anti-war radicalism, described
'Guernica' as 'a protest against the brutality of Fascism in particular and
modern war in general' (1966: 165). But at a time when the personal was
increasingly viewed as political he also insisted on the mural's 'profoundly
subjective' dimension (169). By the late 1980s, when critical appropria-
tions of traditional formal politics were losing ground to versions
of cultural politics, this subjective/ aesthetic dimension was again
foregrounded. While for some 'Guernica' remained quite simply 'the most
important anti-war picture in the history of art', others sought to wrench
it free from what they saw as its historical baggage (Fisch 1988: 22). For
Hilton, writing in 1992, it was time to reject once and for all 'Guernica's'
'over-interpretation as a major political statement' (1992: 242–3). For the
motifs deployed in the mural were not inherently political; they were
politicized by the circumstances, its title, and the surrounding propa-
ganda. Between leaving Paris and settling in Madrid in 1981, changes in
the mural's circumstances and surrounding propaganda would prepare
the way for radical new transformations.

<p style="text-align:center">* * * * * * * * * *</p>

By the time the Paris Exhibition ended, the Basque government had been
overthrown, Franco's troops occupied Northern Spain, the UK govern-
ment had recognized him as Spain's ruler, and Soviet support for the
Republican war effort was being scaled down. Against this background,
'Guernica' was sent on a tour to raise funds for Republican refugees.
After exhibition in Norway, Denmark, Sweden it arrived in the UK on
30 September 1938, where it appeared at galleries in London and
Manchester but without attracting the attention that had been hoped.
With the onset of World War II in 1939 it was on its way again, this time
to the US, where public support for Spain's Republican cause, though
tardy, had grown significantly in the Civil War's closing months. There,
it was exhibited in major cities and in November 1939 reached the
Museum of Modern Art (MoMA) in New York where it formed part of
a Picasso retrospective. In 1947, after protracted negotiations, MoMA
became 'Guernica's' adoptive home; with the exception of a series of
international exhibitions in the early 1950s, it would remain there until
released to Spain in 1981. This nomadism eroded much of the already
unstable geo-temporal force of the painting, making it seem increasingly
self-referential; it weakened the canvas physically; and it recast some of
its earlier associations, opening up new interpretive possibilities while

closing down some older ones. In the process, Picasso's anguished mon-
ument to the brutality of a specific moment in a specific war would be
reconfigured as a generic anti-war symbol and, with its arrival in post-
Franco Spain, as a guarantee of its possessor's democratic legitimacy.
And once again this process would be energized by the mural's symbolic
polyvalence, its ability to figure simultaneously as a supernatural embod-
iment of truth and truth's monumental concealer.[18]

Although 'Guernica' continued to generate conflicting assessments
during its time in the US, the early interpretive delirium noted by Calvo
Seraller was now behind it. At MoMA the mural was purged of its polit-
ical and territorial specificity, acquiring in its place a series of more
abstract, universalizing, associations and, with them, exceptional status
as the US moved from a postwar to a Cold War footing and through the
anti-Vietnam, anti-nuclear and other radical campaigns that would
follow. In more politically-progressive circles (where its dramatic genesis
still echoed), but above all among those who queued to see it, the mural
became a complexly refined and abstract symbol of peace with which few
could take issue. Detached from the contingencies of its production and
the memory of what it once monumentalized – other than a note to the
effect that it expressed Picasso's abhorrence of war and brutality – it
acquired an aura reminiscent of the 'phoney spell' that Benjamin associ-
ates with the commodity (1977: 233). At the time of the bombardment,
Gernika's oak was venerated for its association with place: stripped of its
own attachment to that place and that event, purged and reconfigured,
Picasso's mural would itself become an object of veneration. The impli-
cations of this were highlighted by two US critics in the late 1960s. By
hanging 'Guernica', one observed, MoMA 'no more protests against the
crime of Guernica than the Metropolitan Museum protests against
the crucifixion of Christ in hanging a painting of that subject'; but in the
process of becoming an icon, another commented, the canvas has
become 'a mystical thing, [. . . and in the process has] lost its effective-
ness' (Van Hensbergen 2004: 273–4). Like the Viejo Árbol, it seemed, the
mural had become hollowed out. And like the cult emerging around
Picasso himself, this transformation had relatively little to do with art-
historical assessments. For while 'Guernica' became a point of reference
for practitioners, specialist opinion on it in the US was divided but
broadly negative.[19] Its status owed more to public demand and, increas-
ingly, political expediency; and these, in turn, rested on its standing as a
symbol of the past and the future, a *memento mori* and, in Spain, as a
herald and catalyst for the democracy to come.

It was this politically-neutralized version of the painting, its authority
and its modern, conciliatory energies that more progressive elements in

Franco's Spain sought to harness in their pursuit of political legitimacy. The prevarication that sustained the regime meant that there was still no admission of its role in the bombardment of Gernika as Spain began to modernize from the late 1950s. Its desire for integration into the wider European and international community prompted some limited relaxation of censorship surrounding the attack, however, and with it attitudes to Picasso's painting. In 1967, students and intellectuals openly paid homage to the artist in the streets of Barcelona. By this time Franco, like Picasso, was elderly and tired, and there was a clear sense that loose ends were being tied up when, two years later, he finally pronounced Prince Juan Carlos his successor. It was against this background that the regime's Director-General of Fine Arts, Florentino Pérez Embid, felt able to declare that the canvas should now 'occupy the place that belongs to it', even claiming – against other evidence – that 'General Franco deems Madrid to be the place for *Guernica*, Picasso's masterpiece' (Southworth 1977: 278, Van Hensbergen 2004: 258). '[Y]a no se considera oficialmente en Madrid como un panfleto político. [. . . E]s la pieza maestra de un gran español dedicada a una guerra sufrida por todos los españoles' (It is no longer considered a political pamphlet in Madrid. It is the masterpiece of a great Spaniard, dedicated to a war suffered by all Spaniards) (Pérez Embid quoted Talón 1973: 304). Talón describes the impact of Embid's words on the regime's more conservative artistic and political figures as 'como una verdadera bomba. Pero esta vez una bomba esperanzadora, toda vez que apoyaba la decantación definitiva de los odios y miserias de la última guerra civil' (a real bombshell. But this time one of hope, as it eased the displacement, once and for all, of the hatred and misery of the Civil War) (Talón 1973: 304). In his own revisionist account of the bombing Francoist historiographer Ricardo de la Cierva agreed that the painting no longer had 'a partisan political value' but helped to make 'the sacred name of Guernica – sacred for the Basque country and for Spain – [. . .] finally a symbol of reconciliation and liberty FOR ALL OF US and not a symbol of resentment and of fear' (quoted Southworth 1977: 284, 282, emphasis de la Cierva's). In 1975, rival claimants to the mural's Republican legacy – Felipe González (the new leader of PSOE) and Santiago Carrillo (venerable figurehead of PCE) – both visited it within a week of each other during trips to New York. Adolfo Suárez had earlier negotiated on the regime's behalf to have the canvas moved from MoMA to the Great Hall of the UN Security Council 'como paso previo a su instalación en España' (in preparation for its installation in Spain) (*El País*, 7 May 1981). He had found limited support, however: reactionary elements within the regime would have no truck with a mural they still considered to be anti-francoist propaganda

(*El País*, 11 September 1981). Outside Spain, left and liberal commentators rejected the approach as a right-wing manoeuvre to exploit the painting's symbolic authority, while influential intellectuals in exile stressed Picasso's insistence that 'Guernica' and its related sketches belonged to the Republic and could only be transferred to Spain 'tras el completo restablecimiento de las libertades individuales de este país' (once the nation's individual liberties had been fully reestablished) (*El País*, 11 September, 7 May 1981).

The ratification of Spain's new, progressive Constitution was a key stage in this process, and in 1978 the US Congress acknowledged as much by resolving that the mural be released. The document was an expression of concerted democratic will, however, rather than democratic fact; Lieutenant-Colonel Antonio Tejero's coup attempt in the year of 'Guernica''s arrival, and the government's hardly draconian response to it, were reminders that a modernizing Constitution could not dispel overnight the volatile, confrontational vestiges of Franco's Spain. Since the end of the Civil War institutions had arisen and functioned, and official public consciousness had been shaped, in accordance with the regime's values. As a result, though riddled with contradictions that would modify them over time, these values persisted in one form or another well into the democratic period. They tended to be most deeply rooted among those who had grown up under the regime and experienced them in their naturalized and institutionalized forms: within conservative sections of the military, for example, or the Catholic Church. In the Basque Country, however, the nature of Franco's triumph in the Civil War had meant that

> the humiliation of the losers became immeasurable. Under a ruthless militarisation of society, the war initiated a process of oppositional culture which had to last to the present day. [. . .] A law decree of 23 June 1937 declared Bizkaia and Gipuzcoa as 'traitor provinces'. 'Since 1936, all mention of the Basques was completely omitted from the administrative record of the Spanish state'. Remembrance of the Civil War, with its heroes and villains, was transmitted to the younger generation in mythical terms. Hence, the legacy of totalitarian violence was felt all through the following decades. Much of these feelings are symbolized in Picasso's *Guernica*.[20]

The point may be overstated but it helps to explain why, in Gernika and in the Basque Country more generally, support for the new Spain's will to unity was heavily conditioned, and support for projecting this will on to Picasso's mural still more so. To many Basque nationalists the manoeuvre seemed nothing short of a provocation, particularly in the prevailing climate. In the first five years after Franco's death, 236 people

died in ETA attacks, most of them at the hands of its military wing (Fusi and Palafox 1997). Unlike its politico-military counterpart, ETA-m was firmly set on destabilizing the transitional process and preventing the implementation of regional autonomy, which it believed would divert energies from the struggle for an independent Basque state. While ETAp-m focused its attacks on tourist areas and airports, ETA-m singled out military, police and other state targets, killing twelve soldiers in 1980 alone; in the first elections of the new Basque regional government, moreover, held in the same year, the two nationalist parties closest to ETA secured around 30% of the vote (Fusi and Palafox 1997: 382–3). By February 1981 Lieutenant-Colonel Tejero believed he had sufficient support from key military figures, alarmed by central government's inability to contain regionalist energies, to use the Spanish Cortes as a backdrop for his attempted coup. It failed largely because of the King's decisive intervention; but in the months preceding 'Guernica''s arrival, tensions between the military, central government and the Basque Country remained at crisis point (Preston 2004).

If the expressions of Basque regional will that were now, finally, finding legitimate democratic channels proved less conciliatory than central government had hoped, it was partly because their experience under Franco made many Basques (and not only committed nationalists) disinclined to support a broad national consensus oriented towards forgetting past differences and moving on. And they were still less inclined to see the most potent symbol of their recent past appropriated for this purpose, which led to bitter clashes over rights to Picasso's mural. This was widely interpreted as reckless intransigence on the Basques' part at a moment when others were observing

> un silencio deliberado sobre el pasado reciente [que reflejaba] la obsesión con la paz, la estabilidad, la especial suspicacia hacia las cuestiones de orden público, la huida sistemática de las cuestiones conflictivas[, . . .] la búsqueda continua del consenso entre las partes. (Aguilar Fernández 1996: 20)

> a deliberate silence concerning the recent past which reflected the obsession with peace and stability, a particular mistrust concerning questions of public order, a systematic avoidance of questions likely to cause conflict, [. . .] a continual search for consensus on all sides.

'All profound changes in consciousness', Benedict Anderson observes, 'by their very nature, bring with them characteristic amnesias. Out of such oblivions, in specific historical circumstances, spring narratives' (1991: 204). The silence that eased the emergence of Spain's new, modern, consciousness was registered by the press as a '*patología*

amnésica' (pathological amnesia) (Aguilar Fernández 1996: 20). But the contradictions that political élites seemed unwilling to confront or even discursively to mediate generated new visual and literary narratives in which past events, and the risks and rancour they excited in the present, were obsessively worked through. In this context, where formal political measures to secure national reconciliation remained limited and timid, the role of symbolic gestures grew.[21] Against this background, the question of 'Guernica''s installation in Spain generated intense debate. In the course of these debates, the bombing of the small Basque township to which it seemed to bear witness became an emblematic national scenario charged with 'encapsulat[ing] the prescriptive memory of an entire generation' (Feldman 2003: 62).

Gernika made its first formal bid for the mural some five months before it arrived. Javier Tusell, then Director-General of Fine Arts, responded that no decision could be made until the painting was in Spain – thereby ensuring that the many missed deadlines before it arrived owed more to external political, ethical, commercial, and family tensions than to internal ones. 'Guernica' was far and away MoMA's most popular exhibit, and this will have stiffened its resolve not to sanction the mural's move without the complete and unqualified agreement of Picasso's family (*El País*, 20 January 1981). This looked increasingly unlikely, however. Since Picasso's death in 1973 members from the separate, and in some cases estranged, branches of his family had been advancing their different interpretations of his wishes. In early 1981, his daughter Maya was among those who read the absence of divorce legislation and the failure to dismantle Franco's security services as evidence of continuing constraints on individual liberties in transitional Spain. Nor were negotiations eased by claims on the part of Picasso's friends and his French lawyer that he did not want the painting to move to Spain before the installation of 'un regimen democrático republicano' (a democratic Republican regime) (*El País*, 20 January 1981).

Within Spain, 'Guernica''s future prompted different concerns. The mural's modulation from Republican pamphlet to signifier and catalyst for national reconciliation was widely recognized. Between the consensus as to its significance, however, and the heterogeneous interpretations of that significance, territorial tensions continued to flourish. In the year preceding its arrival, Barcelona demanded the mural for what was then the only Picasso museum in Spain; Grupo Andalucista claimed it for Málaga, the artist's birthplace; his last wife, Jacqueline, supported claims that it should be housed in the Prado as he had wished; and Javier Tusell, Director-General of Fine Arts, insisted that it would be housed in El Casón del Buen Retiro, behind the Prado. The Basque claim, supported

by the regional government, centred on Gernika's plans to make the town a centre for Basque culture and resistance with Picasso's mural at its heart. In a resonant address supported by every Parliamentary group but right-wing Alianza Popular, Lehendakari Carlos Garaikoetxea related Gernika's plans to the town's historic significance, to the political context of its destruction, and to the painting's conception; but also to the more abstract values invested in the painting during its years in North America.

> En Guernica [. . .] el fascismo arrasó el símbolo de las libertades vascas, pero asestó también un golpe brutal a la sensibilidad y al sentimiento democrático de la humanidad. Por ello la ubicación del cuadro en el mismo escenario del crimen sería el mejor homenaje a la democracia y al mismo tiempo, una reparación moral al pueblo de Guernica que padeció el holocausto. (Cited *El País*, 12 September 1981)

> In Guernica, [. . .] Fascism destroyed the symbol of Basque liberties; but it also dealt a brutal blow to the sensibility and democratic feeling of humanity. To install the painting at the scene of this crime would therefore be the greatest homage to democracy and, at the same time, moral redress for the people of Guernica who suffered the holocaust.

The reference to the 'libertades vascas' (and, through them, to primordial attachments) frames Gernika's bombing as one critical moment in the enduring drama of the Basque people. The allusion to 'el holocausto' broadens it further, for an international audience, by association with a later and conventionally transcendent reference point for racially-motivated brutality. Like the reference to crimes against humanity, this highlights regional politicians' attempts to give resonance to their claims by appealing to the wider discursive frameworks that had helped to make the painting's significance increasingly complex in the intervening decades. So too, in a different sense, does the reference to 'democracia', which figures in post-Franco Spain without the cynical, apologetic or jingoistic overtones it might have carried in Britain or the US at the time. The new nation of regions was emerging from the aftermath of the Franco years, haltingly and challenged by violence, into the 'cambio' period and Garaikoetxea's words declare his high estimate of the painting's politico-symbolic efficaciousness for the next stage of this process. At a time when the remnants of transitional optimism were ceding to disillusion and mounting socio-political tension he affirms a conviction that, applied like a poultice to the suffering region, 'Guernica''s presence could help to heal the past and secure Basque and Spanish futures.

A similarly high estimate of the painting's powers was one factor in Madrid's decision to house Picasso's canvas in the capital. The provocations of ETA, repeated confrontations between Madrid and Basque

nationalist groups, and government indecision had combined to delay the installation of the new Basque regional government until April 1980. Madrid was unwilling to jeopardize the centre's shaky socio-political consensus or risk alienating more reactionary sections of the military by appearing to bow, only months later, to Basque claims to the mural. Despite the arguments and demands of Basque politicians at all levels, of artists and of the people of Gernika itself that the painting be housed the town from which it took its name, it was duly determined that the mural would be installed in Madrid's Casón del Buen Retiro (*El País*, 12 September 1981). Once again, 'Guernica' was at the centre of 'una guerra cargada de símbolos y consignas por ambos lados' (a war heavy with symbols and slogans, on both sides) (Vidal 1997: 90). Madrid's decision may well have been a pragmatic attempt to dampen down demands for a military crackdown on ETA-backed Basque independence claims. From PNV's perspective, however, it was a flagrantly political appropriation of a monument to a historical atrocity: 'nosotros pusimos los muertos y ellos disfrutan los cuadros' (we suffer the deaths, they get the paintings) (*El País*, 12 September 1981).

On 10 September 1981 – the centenary of Picasso's birth and almost a year later than planned – the painting finally left New York for Madrid. Its arrival, associated as it was with the political consensus secured around the Constitution, was widely seen as marking Spain's democratic coming of age. The spokesman for PCE (which had played a key role in the consensus-building) realigned abstract-democratic interpretations of 'Guernica''s symbolism with its earlier conflictual resonances when he admitted to 'una gran satisfacción por el profundo signficado antifascista y democrático de la obra' (great satisfaction with the work's profoundly anti-fascist and democratic significance) (*El País*, 12 September 1981). But the implications of its installation in Madrid rather than the Basque country would continue to undermine Tusell's insistence that 'Guernica' came to Spain as a symbol of reconciliation (*El País*, 11 September 1981). This was highlighted by plans to incorporate an enormous polycarbonate container for 'Guernica', surrounded by infra-red and other security devices, in the new Basque museum in which it was to have been housed. Similar anxieties motivated the bomb- and bullet-proof glass screen that would shield it in El Casón del Buen Retiro. In New York the painting had represented no risk, no threat, and required neither guards nor protection. In Spain it seemed to be politically recharged, restored to history in all its messy complexity, in the clash of state and regional aspirations.

The reorganization of space in El Casón seemed designed to heighten the identification of the mural with the security of the state – and to

suggest that, once inside, 'Guernica' would never leave. The disposition of doors and lifts was changed and a door was bricked up to prevent unauthorized entry, or exit. Guests at the preview held on 23 October 1981 included leading Spanish artists, Picasso's daughter Paloma (the only family member not alienated by Madrid's handling of the final negotiations), some of his friends, Dolores Ibárruri ('La Pasionaria', herself an icon of Republican Spain), Spanish president Leopoldo Calvo-Sotelo, and his Minster for Culture Iñigo Cavero. The closure achieved here was underlined by the speakers: Cavero insisted that the mural before them was 'no longer the banner of any single group [. . . but] the patrimony of all Spain'; at last, Ibárruri observed, the Civil War had ended (Van Hensbergen 2004: 307). Yet conflictual investments in the mural were evident from the moment members of the public coming to see it entered the building, walked through the metal detectors administered by the Policía Nacional, and deposited their bags with cloakroom security. Divested and disarmed, expectation mounting, they passed through the space containing Picasso's early compositional and other more detailed sketches via the ante-room containing Dora Maar's photographs – those frozen moments which have become an integral part of the experience of the mural. Passing, as it seemed, through the artist's evolving conception of it, they finally entered the room in which 'Guernica' was displayed before them, under the even more alert eyes of the first Guardia Civil ever to be deployed in a Spanish museum.

The decade it spent in El Casón consolidated 'Guernica''s place in the democratic discourse it had helped to shape. But by integrating it into a certain version of Spanish art history, into a sequence of great paintings, this process actively compromised the mural's power. For unlike the symbolic force of Gernika's oak, which derived from its place in a chain, the painting's force was a consequence of the exceptional qualities attributed to it. The aesthetic, formal, and art-historical features foregrounded in El Casón were not the mural's strongest claims to distinction in the new Spain, and it suffered by comparison with more traditional works. The decision of the Museo de Arte Contemporáneo to display the wooden packing case in which 'Guernica' had arrived offered a sharper insight into the painting's symbolic authority.

Less than a decade later, however, it would travel to another museum. The political sensitivity of its transfer to Museo Nacional Centre de Arte Reina Sofía (MNCARS) led to months of secret negotiations before the news finally became public in mid-1992. El Casón had repeatedly refused to make the canvas available for temporary exhibition elsewhere in Spain on the grounds of its size and fragility.[22] The possibility of a move to MNCARS, implying as it did that the painting was less fragile than

previously suggested, reignited earlier claims. But this time they did not turn on the painting's role as an affirmation of Spain's democratic will. Despite the politico-economic tension that characterized the early 1990s, by 1992 the painting's presence had helped consolidate a perception of Spain as an increasingly mature European state. In this new context, 'Guernica''s symbolism was invoked chiefly for artistico-commercial ends. As Chapter 4 recalls, MNCARS (informally, 'el Reina Sofía') had been created by decree in 1988 to house the national collection of twentieth-century art, within a wider strategy to establish Madrid as 'la capital mundial de la pintura' (world capital of painting) (*El País*, 20 May 1992). Redressing the decades of cultural introversion and conservative collection policies under Franco had challenged its director Carmen Giménez, however, and almost a decade later it still did not enjoy high international standing. Javier Tusell was thus not alone in seeing the proposal to house 'Guernica' there as a manoeuvre designed to raise the museum's profile and art-consumer appeal. (*El País*, 8 May 1992).

El País canvassed the views of some of Spain's leading contemporary artists on the proposed move. None of them questioned 'Guernica''s power to transform the status and fortunes of MNCARS by its mere presence. For Antoni Tapiès, whose own work is displayed there, contemporary Spanish art was finally about to benefit from 'la presencia del padre' (the presence of its father) (*El País*, 7 May 1992). The newspaper's leader went further: 'Guernica''s significance extended beyond national art: it was 'el cuadro más emblemático del siglo XX' (the most emblematic painting of the twentieth century) (*El País*, 7 May 1992). But it was Antonio Saura – whose own work had been particularly influenced by Picasso – who pushed this associative chain to its seemingly inevitable conclusion: 'el mural simboliza el siglo XX' (the mural symbolizes the twentieth century) (*El País*, 7 May 1992). From the bombing of a Vizcayan settlement 'Guernica' had come to symbolize the horrors of Fascism; Basque history, liberties and primordial attachments; national democracy; and world peace. Now, through the reconfiguring of its history, and the accumulation of cultural-political capital this implied, it could represent the art of a whole century, the century itself, modernity as such.

The delicate and protracted negotiations for 'Guernica''s transfer to MNCARS bore fruit on 20 May 1992, when the painting left for its new home in circumstances that foregrounded both its national importance and its fragility. But first the management of El Casón had to reverse the measures designed a decade earlier to immobilize the painting. Among other things, this meant demolishing a wall to enable the canvas (3.49m

high and 7.76m wide) to leave without being rolled. It then travelled the kilometre separating its old and new homes in an air-conditioned armoured vehicle. As the director of the Prado acknowledged, bigger pictures had been moved before but none shared 'Guernica''s symbolic profile. 'De otra manera no se justificarían las medidas adoptadas, que probablemente el entorno del Prado no vive desde el entierro de Franco' (Otherwise, it would be impossible to justify the measures adopted, the like of which have not been seen in the Prado area since Franco's funeral) (*El País*, 20 May 1992). The contrast with the evacuation of almost all of the Prado's contents to Valencia in camouflaged trucks, as Franco's rebels assailed Madrid, in the year the mural was painted could hardly have been more striking. But the comparison with the dictator's passing, suggesting as it does the apotheosis of one myth in terms of another, was itself revealing. For, as *El País* had obliquely registered two weeks earlier, in order to ease the metamorphosis of Madrid from capital of a modern democratic state to world capital of art, Picasso's painting would itself metamorphose, this time from 'un gran cuadro' to 'la mítica obra' (a great painting, the mythical work of art) (*El País*, 7 May 1992).

Gernika's oak tree had become 'sacred' and 'mythical' through centuries of custom. In the shorter *durée* of secular time, the painting had acquired its own mythical status by virtue of its ability to change 'lo que realmente es una cosa' (what a thing really is).[23] This potential for miraculous conversions – minor museums into major ones, cities into art capitals, transitional nations into new democracies – was already evident when it elevated one bombing raid among others into an internationally-recognized war-crime.[24] In MNCARS, an institution with a mission to celebrate modernity and its myths, the new arrival was remade on what now seemed to be its own terms: as the cosmopolitan and auratified sum of its representations, self-referential now that it had overcome time and place, ingesting into its electric two-dimensionality the events and processes from which its power had once nominally derived and which now figured in interpretive leaflets and displays chiefly as the mural's prehistory.

It is easy to forget that the authority and prestige that eased this metamorphosis are projections, the result of investments (by experts, entrepreneurs, politicians, propagandists) of fitful intensity and uncertain duration. Gijs Van Hensbergen's assertion that '[t]thousands every day are dumbstruck and mesmerized by the power and scale of the image as they stare wide-eyed at the painful drama acted out before them' highlights his own investment in the story he so persuasively details (2004: 332). Without such investments, the monochrome and cubist hermeticism might seem dry, alien or outmoded; the subject and its political

resonances obscure or uncompelling; the symbolism inert, bombastic or inaccessible (Lubbock 2005). But newer, more mobile, investments are replacing them. If Gernika's oak supports a certain fetishization of the past, 'Guernica' the mural has increasingly been exploited in the past's commodification. Today, MNCARS offers visitors the opportunity to see a painting famous chiefly for being famous, and to experience the aura that derives mainly from reproductions that were once part of so many Spanish childhoods – first as a long-banned political symbol, later as décor – and still figure in many Basque ones. The drive to maximize the image's visibility, the waning of its political energies, and the higher security levels common to all museums have conspired to make glass security screens redundant.

Against this background, the mural's use as a bargaining counter has modulated to a new key, as highlighted at the time of the inauguration of Bilbao's Guggenheim Museum. In an interview for the BBC, the Museum's director, Juan Ignacio Vidarte, made his case for borrowing 'Guernica' from MNCARS in the following terms:

> [t]his is not just a request for a painting, even though it is the most famous painting of twentieth-century art. This is much more than that, because what we are asking for is the loan of a painting which has very deep meaning for Basque people. We think that this is the moment when two events of historic importance are taking place at the same time: one is the sixtieth anniversary of the painting and secondly its the year of the opening of the Guggenheim Bilbao Museum of Art which will mark a significative [sic] event in the history of culture, not only to the Basque Country but also to Spain. (BBC Radio 4 1997)

Once again, the regionally-articulated claims of global art consumption are presented to international audiences over the heads of Spain's art establishment. The Basque negotiators were so confident of success that Frank Gehry was commissioned to design a small shrine-like structure to house the painting. Vidarte, meanwhile, worked to neutralize the concerns of the senior curator of MNCARS (herself a Basque) concerning the fragility of the canvas, insisting that the special transport arrangements would include moving 'Guernica' in its frame rather than rolled. Like the painting, however, she remained unmoved: Picasso had dedicated his masterpiece to 'el pueblo español' (the Spanish people), not to Bilbao or even Gernika. The assumption, shared at that time by many other leading art historians, that Madrid is the natural repository for all artefacts dedicated to 'el pueblo español' will have done little to lower the temperature of the debate (BBC Radio 4 1997). Back in 1981, when the legitimacy of the new state and of the capital as the focus of

consensus were still being strongly asserted, the claims of the centre were routinely represented as outweighing particular regional interests. By 1997, however, the profile of Bilbao's new museum as an institution with an international profile and manifestly global ambitions, and Bilbao's own rising profile in the Europe of regions, made Madrid's counter-claims seem presumptuous, anachronistic and parochial – especially to international observers.

Sixteen years earlier, the location of 'Guernica' had become for a time central to the symbolic construction of the democratic state and was, to that extent, primarily a political matter. By 1997 its politico-symbolic energies were more diffuse: Basque politicians bent on regional regener-ation found themselves in a pragmatic alliance with international art entrepreneurs; ranged against them were historians and accountants of the art establishment not only in the capital, but also in regions made uneasy (for their different reasons) by Bilbao's cultural ambitions. When the request was rejected, however, Xavier Arzalluz's response echoed that of the PNV spokesman back in 1981: '[e]n somme, les bombes sont pour les Basques, les oeuvres d'art pour Madrid' (in other words, the bombs are for the Basques, the works of art for Madrid) (*Le Monde*, 3 October 1997). In 2004, the bombs would come to Madrid and 'Guernica' would be mobilized once again as a signifier of bloody atrocity – a process strik-ingly illustrated in Plate 11. But the canvas was no longer the passion-ately unequivocal 'monument to destruction' it had once seemed (Read 1981/ 1937: 209). In this sense, Arzalluz's appeal to that moment of destruction exposed the contradictions straining the modernizing dis-course of Basque economic regeneration in which the loan request was embedded. So, too, did ETA's role in its refusal. For while some key members of the PP government had initially supported the request, the assassination of a prison psychologist in March of that year – which brought the death toll for those three months to more than in the whole of the previous year – had enabled its opponents to carry the day. To the extent that ETA's aspirations are grounded in a vision of the Basque past as special, anchored in the remote, vestigial attachments and scarred by conflict, oppression and loss, the attempt to use Picasso's canvas to inau-gurate a new, modernizing project testifies as much here to the persis-tence of an older one, to a hybridizing of traditional self-representations rather than their displacement. The Basque Statute of Autonomy envis-ages a modern state able to bridge discontinuities associated with the move from historically-embedded perspectives to generalized mass ritual, from traditional kinship relations and primordial attachments to the de-auraticized routines of 'everyday life' in abstract modernity. But these possibilities were compromised from the outset by its framing

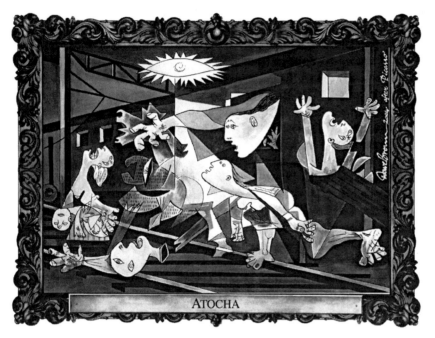

11 'Atocha', *Independent*, March 2004 (Dave Brown)

within a Constitution that promotes emergent modern, centralizing per-
spectives at the expense of culturally-embedded traditional ones. If today
memories of Civil War conflict have given way to more fitful, paroxys-
mal, violence – car-bombs, political assassinations, the 'street struggle'
(*kale borroka*) of certain youth groups – it is partly as a result of this. But
it also reflects a more widespread and characteristically modern sense
that those particularistic relations and traditional conceptions of identity
are less culturally dispensable than has been assumed.

Gernika's own alienated relation to its past can be read against this
backdrop. Despite the survival of its venerable core, the bombardment
and its consequences seem to have ruptured the symbolic continuity in
which its affirmation of Basque identity and cultural difference had been
grounded. After it, the town appeared to recede along a different asso-
ciative chain, in which the bombardment lives on chiefly as a symbol of
something else. In its immediate aftermath, for example, Republican
sympathizers in France and Britain routinely represented Basque dead as
sacrificial surrogates and a grim portent of the War to come: 'ese pobre
pueblo sufría y moría por nosotros' (these poor people suffered and
died for us) (François Mauriac, cited Rubio Cabeza 1987: 406). Fr
Arronategui's lament that Gernika had ceased to exist was the first of

many to suggest that the bombing was 'the day Guernica died' (cited Cava Mesa 1996: 193, Thomas and Scott-Witts 1975). This sense derives partly from the fact that the regime's decision to falsify events obliged survivors to 'guardar silencio durante muchos años[: . . .] todos teníamos miedo de hablar' (remain silent for many years, we were all afraid to speak) (Aguilar Fernández 1996: 245).[25] Until the messy contingencies of the past are selected and ordered as narration they remain unavailable as a social resource, and it was only with the oral history projects of the 1990s that certain details would enter, fill out and modify the narrative of Gernika. Franco's postwar renovation, under the direction of the Comisaría de Regiones Devastadas, was designed to displace memories of the bombardment. In the event, it seemed more effective in obliterating traces of the lost Gernika – the town that was not simply a cultural-historical signifier of something else, where neighbours not only died but lived. For Nelly Ajello, writing thirty years later, it was a 'ciudad fantasmal polvorienta' or dusty ghost town, while for Herbert Kretzmer it was 'un lugar separado, remoto, extrañamente sin alma' (a place apart, remote, and strangely soulless) (both cited Talón 1973: 288). Vicente Talón may be right, of course: these may simply be the prejudices of visitors aware that something terrible happened there (289). Yet similar language can be found as recently as 1995 in Cava Mesa's interviews with survivors of the bombardment. For some of those interviewed, Gernika retains its historic specialness; for others, its politico-symbolic value has largely been lost (Cava Mesa 1996: 262). But a significant number are more ambivalent. Shops open, miniature cribs fill windows at Christmas, the town bustles on market-day, but there has been a hollowing out: '[l]a cosa histórica [. . .] desapareció [. . .] Hoy Guernica es un símbolo[, . . .] un motivo turístico, sentimental [. . .] Ahora ya no es Guernica ni es nada' (its historical core disappeared. Today Guernica is just a symbol, a tourist attraction, sentimental. It isn't Guernica any more, or anything else) (261–3).

Today, the town's museum continues to foreground its role as a symbolic place, a signifier of something else, offering a vision of the 'Gernika of the past, symbol of Freedom, of the Laws [fueros] and of the Gernika of today, symbolizing Peace, Reconciliation, Human Rights, the bombing, the "Guernica" of Picasso' (Gernika Musoea c.1997: np). This mission reflects its establishment in 1998, ten years after German president Roman Herzog formally acknowledged his country's involvement in the town's destruction, as a peace museum. When I visited it for the first time in 2001, however, exhibits continued to focus squarely on the history of the bombing and the story of Picasso's 'Guernica'. It was as if Gernika itself had been preserved in suspended animation by his

unstable icon of modernity, even as images of the bombardment were restored to the *longue durée* from which he had so decisively wrenched it: Gernika and its oak-tree, Gernika in the premodern age, through the birth of nationalism, in the Civil War, the Estatuto de Guernica and, with Spain's entry into the EU in 1986, as part of a 'Europe of the regions'. Like the painting, the jagged trauma of those events had been worn smooth through representation and a certain waning of collective memory, making the visual narrative oddly uncompelling. It would be facile to suggest that Picasso's mural had somehow re-enacted the obliteration it nominally held to shame; as with today's bombings, something of the burnt and bloody materiality of those events will always elude symbolization. But his iconically modern representation of it seemed to have prevented the town from transcending that crisis and fully assuming its own modernity. Or from assuming it as something other than low-key tourism.

An important indication that this had changed came in 2002, when the Basque regional government, Vizcaya's provincial government, and Gernika-Lumo's town council established the Fundación Museo de la Paz de Gernika. The Museum would be redesigned and relaunched a year later as part of the International Network of Museums for Peace, with a mission not to 'impose any absolute truths' embedded in univocal historical narratives or 'war stories', but to serve as a 'theme museum conveying a culture of peace', through a triple focus on 'el conflicto necesario, la empatía y la salida creativa' (unavoidable conflict, and empathetic and creative responses to it).[26] Integrated into this global network, the bombing now figures less in its material and informational thickness than as one manifestation of a more generic experience – even when witnessed visually, and empathetically relived, through 'documents, images and testimonies' and 'un espectáculo audiovisual'. It is framed by exhibits that encourage reflection on international understandings of peace and reconciliation and on 'tragedy, destruction, hope, and also on life'. The mural whose own prototypical abstraction helped to ease this process figures here as one aspect of 'an urgent call for reflection on human rights'.

A year before the Museum opened, the German government finally approved its symbolic reparations to the town. At the request of the majority of residents, it was decided that the three million Deutschmarks would not be invested in a memorial or monument that would block the work of forgetting and immortalize death; Picasso had already, unwittingly, supplied this. Instead they opted for a new sports complex. As Foucault notes, the culture of the body has a long history and sports centres in Spain and more widely have become a key resource for

contemporary life. In the Basque Country, however, they are also the focus for a potentially powerful articulation of tradition and modernity. Sport here has been a means of dramatizing everyday working life for generations; a way of expressing challenge and defiance, and of affirming the self, the family, and the homestead. But as Urza (1999) notes, the work-related activities this has typically involved – stone-lifting, for example, iron-bar-throwing, scything, rowing, long distance running, wood chopping – are largely restricted to rural communities, figuring elsewhere as folklore. At the same time, the pyknic physiology associated with them is at odds with globalizing norms of the sculpted body. Sports centres respond to these changing needs with fresh opportunities for physical display, fitness and pleasure, for mediating aggression and learning to win and lose in symbolic settings. Their satisfactions are more prosaic, less complex and less destructive than *kale borroka*, in which aggression, challenge and defiance, boredom and frustration, the identification with Basque nationhood, a desire to be someone, to be on the side of the warriors *even as martyrs,* all find explosive expression.[27]

The contrast is instructive. Gernika's oak has figured in this chapter as a focus for politico-symbolic energies embedded in a richer, fuller conception of time and a past that was never a present: Picasso's mural has featured as a potent symbol of the waning of those energies in late modernity. The model of democratic rights, freedoms and responsibilities enshrined in the Constitution, and which was to support Spain in its rapid transition from the traditions and personalization of the dictatorship, drastically reduced individuals' opportunities to supplement this more formal abstraction with more particular identifications. The continuing negativity of ETA's radical nationalism was a response to what quickly came to seem like a poor trade-off, but one that has itself been hollowed out by the decathection of once-compelling personal, ethnic, territorial and community-based identifications and trapped, for a time, in a deadly symmetry with the underside of abstract democracy in the form of covert state terrorism.[28] In its cataclysmic closing moments Imanol Uribe's *Días contados* raises the possibility of seeing through this idealization and confronting the hollowness and antagonisms internal to democracy. Like the Basque 'holiday from history' it offers fantasy mediations designed to help us to live with risk, anxiety and loss, to make things more like we wish them to be, to cauterize social wounds and begin a healing process (Zulaika 2003: 139). If we need personal histories for subjective projection, we also need these collective, intersubjective, histories.

Not that long ago, the embeddedness of the personal within the collective was taken for granted, chiefly because a shared understanding of

history bound them even when specific narratives differed (Resina 2000). With the rejection of its authoritarian aspects in late modernity, however, has come the realization that this shared dimension was enabling, as well as constraining. This does not license a return to once-compelling narratives issuing from the centre (and in relation to which competing narratives are marginalized, even pathologized); but it does raise the possibility of empathizing with the bereftness haunting parts of Basque culture. Peripheral nationalism comes to seem less aberrant, less folkloric, exotic or inert when seen in relation to the conditions that gave rise to it. Strategies that are clearly no longer designed to muster a nationalist front in support of a Basque state can be seen to be characterized by defiance, a traditional challenge reminscent of Antonio's gratuitous violence in *Días contados* or, in a quite different key, the Basque negotiations with the Director of the Guggenheim Foundation (Zulaika 1997a). For not all histories or social practices are state-sanctioned or reducible to simple rational choices, and to assume otherwise is to put some compelling factors beyond analysis (Eagleton 2001). However unconvincing their claims seem to members of the wider collectivity, these narratives are a museum and a processing-house for cultural assumptions – assumptions that, even where they appear least rational, may yet be strategic. They are the product of particular social and individual perspectives on the basis of which people who share them may be prepared to die, and to kill. It was in an effort to lay these bare that Walter Benjamin searched among ruins and reordered maps in which every item seemed firmly 'en su sitio', hunting for 'the dreams and desires attached to them that did not find realization as "fact"' (Labanyi 2000: 70). For all the reasons outlined here, Basque cultural imaginaries are a rich and risky huntingground.

Notes

1 While the Basque government's initial figure of 1,654 deaths was clearly an overestimate, the final figure remains uncertain (Gernika-Lumo *c*.1992).

Here and throughout, the Basque spelling, Gernika, is reserved for the town. Following Picasso, the Castilian spelling, Guernica (in inverted commas) is used for the painting's title. Where the Castilian spelling appears in quotations, it is not modified. For all other placenames the standard English or (where there is none) Castilian version is used.

2 The force of the strike suggests a triple objective: 'aterrorizar a la población civil y, a través de ella a las milicias vascas; cortar las comunicaciones del ejército vasco en retirada con la retaguarda; y minar la moral de los vascos, debido al valor simbólico que Guernica presentaba para ellos' (to terrorize the civilian population and, through them, the Basque militias: to cut

communications between the retreating Basque army and its rearguard; to undermine Basque morale, given Guernica's symbolic value for them) (Ortzi 1975: 234). The Astra small-arms factory and the Rentería bridge, the town's only plausible strategic targets, were both left undamaged; given the repeated failure of the German Luftwaffe's Condor Legion to hit their target (an armaments factory) in Durango three weeks earlier this was probably unintentional.

On the rebuttals of General Queipo de Llano (and possibly also Franco), and on the claims and counter-claims surrounding the bombing more generally, see Vidal (1997: Chapter 10). For sustained attempts to discredit Steer see Sencourt (1938) and Talón (1973). *Guernica: the Official Report*, completed in 1938 by a commission set up by the rebel authorities to appease international critics – but which seemed to bear out the Basque accounts – was published, in English only, in the same year.

Steer's (1938) and Southworth's (1977) overviews of the events and their representation remain indispensable for English-speakers, as does Thomas and Scott-Witts (1975). For a sense of the urgency and confusion of the period, see Fraser (1986). Vidal (1997) presents a more accurate and detailed account of the bombing, its military context and its aftermath, while Cava Mesa's (1996) study, based on an oral history project, includes chilling insights into the townspeople's experience of the bombing.

3 The Statute of Basque Autonomy, which provided for the establishment of the provisional Basque government, was approved by the Spanish Cortes, sitting in Valencia, in October 1936. General Francisco Franco Bahamonde, leader of the rebel forces, was dictator of Spain from April 1939 until his death in November 1975.

4 Caro Baroja (1984) relates this practice to Druidic and other ancient dendolatrous traditions in Europe, and to earlier Basque tree worship. Finding no convincing evidence of the veneration of sacred trees in the pre-Christian Basque period, however, Roger Collins (1986) dismisses what he sees as this use of contemporary Basque folklore to ground claims of earlier paganism. For a critique of mythologizing aspects of Basque nationalist thought see, for example, Juaristi (1992).

5 As Gernika-Lumo (1992) recalls, Rousseau, Wordsworth and Tirso de Molina all allude to this democratic tradition.

6 For an overview of theories relating to the origins of Basque see Jacobsen (1999). On the role of the Basque language in nationalist thought see Conversi (1997).

7 Their support for the claims of Don Carlos de Borbón to the Spanish throne pitted Basque conservatives against a more liberal central government suspicious of traditional Basque privileges. It contributed to the eruption of the Carlist Wars, which ended in 1876 with Don Carlos's defeat and the final withdrawal of those privileges.

8 This was an early indication of the institutionalization of Catholicism in the Basque Country. Some accounts of Gernika's origins traces it to a small hermitage in an oakwood of which, over time, only one tree remained and

would become the Árbol Foral. See www.bizkaia.net/Bizkaia_Informazioa/ castellano/Informacion_general/Presentacion/C1ARBOL.HTM. Accessed 28.10.05.

9 PNV, which dominated the autonomous Basque government, was crucial in propagating conservative Catholic ideology: 'defendía la civilización cristiana, [. . .] se proclamaba antirrevolucionario y [. . .] se jactaba, en febrero de 1936, de que, gracias al nacionalismo, las provincias vascas se habían visto libres del extremismo marxista' (it defended Christian civilization, proclaimed itself anti-revolutionary and, in February 1936, prided itself on the fact that nationalism had kept the Basque provinces free of marxist extremism) (Fusi 1984: 42–3).

10 Cited in Vidal (1997: 106). Because of its particular history and its rural position, the Gernika in which Aguirre swore his oath in 1936 retained a relatively strong sense of the primordial attachments on which Basque claims to continuity rested. Elsewhere the emergence of a 'new civil order' was proceeding more quickly, especially in industrialized urban areas.

11 On Basque claims to be descended from Noah, for example, the biblical patriarch Tubal (whom tradition credits with populating Iberia), or the inhabitants of Atlantis, and assertions that Basque was spoken in the Garden of Eden see Merin (1937: 270), Onaindia (2000: 34), Ortzi (1975: 38), Monreal (1985: 30) and Collins (1986: 59).

12 The state of the Árbol Viejo, a cutting from the eighteenth-century tree, was reportedly 'siempre preocupante' (always a cause for concern) (Gernika-Lumo 1992: 11).

13 I am indebted here to Ana Alberdi of the Casa de Juntas (Personal communication).

14 This tally excludes cuttings planted to mark (Iberian and French Basque) sites and moments of nationalist significance – in Itxasu in Labourd, for example, on the occasion (in 1963) of the first postwar Aberri Eguna or Basque National Day.

15 Back in 1971, well before globalization began to bite, the ETA-VI Assembly acknowledged that the ethnic base of Basque nationalism was being weakened by 'la liquidación de las formas de vida en las que tradicionalmente se ha desenvuelto ese grupo humano [lo cual] supone una crisis de las formas de cultura, y pone la peculiaridad en entredicho' (the liquidation of the ways of life in which this human group had traditionally developed, entailing a crisis in cultural forms and calling into question their distinctiveness) (Apalategui 1985: 301).

16 For a thought-provoking discussion of these questions in relation to the Basque 'holiday from history' see Zulaika (2003).

17 Versions of the image, one of the most widely reproduced in Western art, can be found via Google at http://images.google.com/images?q=picasso%27s+guernica&hl=en&lr=&rls=GGLD,GGLD:2004-39,GGLD:en&sa=N&tab=wi&sourceid=tipimg. Accessed 01.07.05. For a detailed account of the production, reception and transformation of Picasso's 'Guernica' see Van

Hensbergen (2004).

18 For Civil War historian Manuel Rubio Cabeza, 'las interpretaciones apasionadas' (impassioned interpretations) triggered by the mural 'producen tal cúmulo de interferencias que, a veces, el historiador desespera de encontrar la verdad' (produce such an accumulation of interference that at times the historian despairs of finding the truth) (1987: 404).

19 For a detailed evaluation of responses to the canvas in the US see Van Hensbergen (2004). On the history of the painting's genesis and the evolution of its reception see also Fernández Quintanilla (1981), Chipp (1989), De la Puente (2002) and other texts cited in this chapter.

20 The quotation is from Conversi (1997: 229). His references are to Gurutz Jáuregui's (1981) *Ideología y estrategia de ETA*, Madrid, Siglo XXI, 229.

21 On this process see Aguilar Fernández (1996). Paul Preston's *Juan Carlos* (2004) offers detailed insights into the complex political dynamics of the period.

22 Its early nomadism had strengthened the international standing of this huge mural at the expense of its physical condition; by 1957, invasive and irreversible restoration work had been undertaken by MoMA's curators and further treatment was needed in 1962, prompting dark warnings about the repercussions of further moves.

23 This definition is from the Real Academia Española's *Diccionario de la Lengua Española*, 1992 edition.

24 As Paul Preston notes, compared with Hiroshima or Dresden the bombing of Guernica seems 'a minor act of vandalism' (1986: 4). But if the fact that 'Guernica was the *first* total destruction of an undefended civilian target by aerial bombardments' loomed largest in its significance for the political classes of the period, Picasso's painting underpins its enduring wider resonance (4).

25 It remains unclear today whether Franco personally had prior knowledge of the air-raid, and the destruction of the town continued to be attributed officially to republican forces until after his death. See Thomas and Scott-Witts (1975) and Aguilar Fernandez (1996). However, Spanish and German historians finally granted access to archives after his death in order to investigate the bombing concluded in 1978 that 'el general Franco no es, en principio, exonerable de responsabilidad' – though de la Cierva would seek (unsuccessfully) to discredit these findings (Aguilar Fernández 1996: 276).

26 All quotations here are from the Museum's multilingual brochure (Fundación Museo de la Paz de Gernika 2002: np). The Spanish version is used where its English translation is unclear.
 The International Network of Museums for Peace arose in 1992 from a conference in Bradford, England, that brought together 'management and staff of peace museums, anti-war museums and similar institutions worldwide'. See www.ppu.org.uk. Broadly speaking, these museums aim to tell 'untold stories' that bring peace to life 'visually and experientially' in order to make a 'real and lasting reconciliation between "visitors and van-

quished", to art (as a form of expression of events and the hope for a better future – Picasso's "Guernica" being one of the world's best examples), and to the culture of peace in general'. See www.ppu.org.uk/peacematters/ pm2000/pm1999x2. html, 1. Accessed 07.08.05.

27 For thought-provoking analyses of this tendency see Zulaika (1988) and (2003).

28 Following Paddy Woodworth, I take terrorism to be 'the illegitimate use of violence to achieve political goals [. . .] by governments, groups and individuals' and assume that 'under circumstances which exclude any possibility of legal democratic opposition, political violence is a legitimate option, and therefore not terrorism' (Woodworth 2004: 170). On 'the importance of terrorism in legitimating the state' see Gabilondo (2002: 65).

Conclusion

This morning as I was reading *El País* – Spain's leading daily, now more readily accessible, electronically, than my local paper – two items caught my eye. The first reported that, as President José Luis Zapatero was outlining in Congress his vision of a Spain without terrorism, ETA was detonating a series of small bombs in Spanish cities. The occasion of his speech, and of the attacks, was the anniversary of the day on which (twenty-seven years earlier and three years after the death of Franco) 88% of Spaniards had approved the new democratic Constitution; the bombs recall that a significant proportion of the dissenting 12% were Basques.[1] Yet, to the annoyance of opposition politicians, the Interior Minister did not feel it necessary to address Congress on the subject. This, and the fact that the same day saw the detention of another member of ETA's weakened 'complejo Donosti' (San Sebastian network), seems to affirm the continuing decathection of ETA as a risk to the democratic Spanish state.

The second item related to a very different risk, and one which politicians in Spain and elsewhere are finding more intractable. In a characteristically polemical piece, Vicente Verdú related Gucci's plans to divert one-fifth of profits on certain of their handbags to sufferers of HIV/AIDS. His analysis of this festive gesture conflated consumption (in which, as García Canclini observes (1993) we are all implicated) and consumerism (concerning which we have a choice). Yet, as he rightly noted, it is part of a wider pattern in which transnational companies are working to associate high-profile brands with selected good causes, often in the Third World.

Meanwhile, somewhere between the First and Third Worlds, Mexico's *La Jornada* reported on an altogether more traditional response to what it presents as the global threat of HIV/AIDS. The Latin American

Episcopal Council (CELAM) was foregrounding the lack of progress to date in eradicating 'conductas de riesgo' (high-risk practices) that are colluding with poverty, migration, national disasters, intravenous drug-use and other factors to accelerate the disease's spread.[2] Their response was to advocate monogamy, fidelity, and commitment in marriage. It is a world away from the visual imaginary of *Días contados*, in which the marital commitment of Antonio's object and her recourse to such high-risk practices as intravenous drug-use actively stimulate her would-be lover's desire. Uribe is concerned not with the practical consequences of the risks he represents but with mobilizing them for other ends; his fantasy mediations work to reconfigure social and visual energies, and pleasurably dramatize anxieties. Gucci, by contrast, aim to heighten pleasure by *easing* anxieties and attenuating the inhibiting effect of consumer guilt, the better to enhance market share and brand-profile. Although the subjects of Daniela Rossell's *Ricas y famosas* are, in some ways, typical Gucci clients this strategy would probably not resonate with them; for it is precisely their seemingly uninhibited assumption of commodified identifications, their apparent absence of consumer guilt against a background of gross economic inequities, that enrages her critics. It dramatizes, for them, a certain national-political degeneration. For the Bilbao Guggenheim project, by contrast, the pleasure of global art consumers is prioritized as part of a wider strategy of economic regeneration: the regeneration of a postindustrial Basque cityscape and its regional setting on the one hand; and, in a way more directly reminiscent of Gucci, that of a global brand-profile on the other.

CELAM'S churchmen and women arguably have a much tougher job on their hands than Gucci, the Director of the Guggenheim Foundation, or his Basque collaborators. For the consumer images exuberantly assumed by Rossell's subjects, or exploited by and in the Museum, are colluding in larger processes – processes that are increasingly disengaging us from family and other traditional sources of support, security and understanding, engaging us to differing degrees in emerging social forms and forces, and leaving us to grapple individually (like Mexico City's commuters) with the unpredictable consequences. The results, as Uribe demonstrates, may be as exciting as they are traumatic. Small wonder, it seems, that tactical, *ad hoc*, responses to these new circumstances include recourse to the more spectacular constructions of visual culture.

But visual culture is not wholly reducible to consumer images and spectacle. As noted in the Introduction, Susan Buck-Morss represents the visual image as covering the entire surface of the globalized world, as globalization's 'imagen-superficie' or image-surface (Buck-Morss 2005: 159). Her analysis recalls that of Guy Debord, for whom concrete life

has become degraded into generalized spectacle and, given over to its contemplation, we cease to live (Debord 1994). It is its superficial yet engrossing character, Buck-Morss insists, that marks out the object of visual culture from that of art history. But the essays in this volume have sketched a rather different understanding of visual culture; they assume that it exceeds consumer imaginaries even when it cannot avoid implication in them. And even if that were not the case a blanket denunciation of the 'imagen-superficie' – as Debord observes of 'the society of the spectacle' – would presumably serve only to reinforce it. Debord was writing in booming postwar France in the second half of the 1960s, and Chapter 1 (and, in their different ways, every other chapter) suggests that the spread of transnational capitalism in the intervening decades has proved less homogeneous than he anticipated. That is not to deny its unevenly homogenizing effects, but rather to acknowledge the limits of globalization's tendency (noted by Moreiras (2001)) to render all that is outside as inside.

This is a useful reminder of the complexity of the processes and phenomena examined here. Though the street circus in Mexico City is respectfully framed by Julio Etchart, for example, it remains 'framed'. Chapter 1 raises in passing the possibility that his strategy is not unlike Gucci's, that the representation of those two young people may be understood at one level as designed to maximize the pleasures of looking by neutralizing a certain guilty First World voyeurism. To say so does not deny the photograph's power but reframes it, this time as a reminder that interconnectedness, with all its risks anxieties, retains enormous potential for solidary action and increased social justice. If I have focused here chiefly on risks and challenges it is from a sense that these are becoming increasingly intensive and extensive, while the means of addressing them remain weak. The cases of CELAM and Gucci, for example, underline the divergent priorities of responses to HIV/ AIDS, but overlapping and often conflicting mandates and agendas can equally be found among international bodies responding to the global risks of climate change, world poverty, or massive trade imbalances. Partly for this reason, García Canclini is not alone in insisting that the dominant neo-liberal model of globalization is not inevitable, that interconnectedness could be imagined – and practised – otherwise, that culture's role in these processes is not restricted to its circulation as (for example) audio-visual goods and services; and that to forget this is to collude in this model's self-representations.

It is with this in mind that the essays here have aimed to provide a more complex set of contexts for the exploration of visual culture. Through these (to paraphrase Buck-Morss) the idea of visuality may be

re-examined, images may be used critically, amplified, given definition and time, in order to help reveal the workings of certain global imaginations, and to keep open space for alternatives to globalist euphoria and defensive retrenchment. This is part of a wider strategy for remobilizing visual energies under fresh conditions to different ends, with the promise of embarking on new, enlarged socio-economic and cultural relations, rather than compulsively re-enacting older ones.

Notes

1 See www.elpais.es./articulo/elpporesp/20051208elpepinac_8/Tes, accessed 08.12.05. As noted in Chapter 4, these dissenters objected to what they saw as the Constitution's promotion of a unified Spanish state at the expense of Basque self-determination. See Tusell (1999), Elorza (2000), and Peces-Barba (2000).
2 See www.jornada.unam.mx/2005/12/6/index.php, accessed 08.12.05.

Bibliography

AA.VV./Various authors (2003), Cuestionario *October* 77 sobre cultura visual, *Estudios Visuales*, 1, 82–125.

Abaroa, Eduardo (2005), Moving, in Museo Nacional Centro de Arte Reina Sofía/Conaculta (2005), 188–94.

Adam, Barbara (2004), *Time*, Cambridge, Polity.

Aguilar Fernández, Paloma (1996), *Memoria y olvido de la Guerra Civil Española*, Madrid, Alianza.

Aizpuru, Juana de (2004), Un sueño compartido / A common dream, in Fundación BIACS/Centro Andaluz de Arte Contemporáneo (2004), 13–17.

Alonso, Andoni and Iñaki Arzoz (1999), Basque identity on the Internet, in Douglass, Urza, White and Zulaika (1999), 295–312.

Alsdorf, Bridget (2001) The global Guggenheim: selections from the extended exhibition, via Irvine (2003b), np. Accessed 21.04.05.

Álvarez Bravo, Manuel (2001), *Cien años/Cien días*, Madrid, Turner Publicaciones.

Anderson, Benedict (1991), *Imagined Communities*, London, Verso.

Anfam, David (1990), *Abstract Expressionism*, London, Thames and Hudson.

Apalategui, Jokin (1985), *Los vascos, de la autonomía a la independencia: Formación y desarrollo del concepto de la nación vasca*, San Sebastián, Editorial Txertoa.

Aptekar, Lewis (1988), *Street Children of Cali*, Durham, Duke University Press.

Apter, Emily (1996), Anamorphic Art History, *October* 77, Summer, 26–7.

Ardanza, José Antonio (1998), Cuando los proyectos se hacen realidad, *Geo* (Special issue: *Bilbao en vanguardia*), 5 only.

Aretxaga, Begoña (2000), Playing terrorist: ghastly plots and the ghostly state, *Journal of Spanish Cultural Studies*, 1:1, 43–58.

Armstrong, Carol (1996), Untitled contribution, *October* 77, Summer, 27–8.

Arnheim, Rudolf (1962), *Picasso's Guernica: The Genesis of a Painting*, London, Faber and Faber.

Arriola, Magali (2005), Apuntes para una (des)contextualización del arte con-temporáneo mexicano, in Museo Nacional Centro de Arte Reina Sofia/Conaculta (2005), 195–8.

—— (2000), Cuando el destino nos alcanza / When destiny is fulfilled, in Olivares (2000b), 176–95.

Ashida, Carlos and Julián Zugazagoïtia (2005), Mexico at ARCO '05 / México en ARCO '05, in ARCO/Ifema, *Catálogo*, Vol. I, Madrid, Ediciones de Umbral, 438–47.

Augé, Marc (1997), *Non-places: Introduction to an Anthropology of Supermodernity*, trans. John Howe, London, Verso.

Bachelard, Gaston (1964), *The Poetics of Space*, trans. Maria Jolas, Boston, Beacon.

Barbour, Eleanor (2005), Innovative notion behind 'Made in Mexico' exhibit is undercut by some uninnovative works, at www.lacitybeat.com./article.php?id=1084&IssueNum=59. Accessed 16.03.05.

Barthes, Roland (1977), *Image, Music Text*, trans. Stephen Heath, London, Fontana.

—— (1981), *Camera Lucida: Reflections on Photography*, trans. Richard Howard, New York, Hill and Wang.

—— (1982), *Mythologies*, trans. Annette Lavers, London, Granada.

Bartra, Roger (2002), *Blood, Ink and Culture: Miseries and Splendors of the Mexican Condition*, trans. Mark Alan Healey, Durham, Duke University Press.

Batzar Nagusiak/Juntas Generales (nd), *La Casa de Juntas de Gernika-Lumo: Guía del visitante*, Gernika/Bilbao, Batzar Nagusiak/Juntas Generales.

Baudelaire, Charles (1970), *Paris Spleen*, trans. L. Varèse, New York, New Directions.

—— (1972), *Selected Writings on Art and Artists*, trans. and ed. P. E. Charvet, Harmondsworth, Penguin.

Bauman, Zygmunt (2000), *Liquid Modernity*, Cambridge, Polity.

BBC Radio 4 (1997), *Kaleidoscope*, 20 September.

Beck, Ulrich (1992), *Risk Society: Towards a New Modernity*, trans. Mark Ritter, London, Sage.

Beck, Ulrich and Elisabeth Beck-Gernsheim (2002), *The Normal Chaos of Love*, trans. Mark Ritter and Jane Wiebel, Cambridge, Polity.

Bencomo, Anadeli (2002), *Voces y voceros de la megalópolis: la Crónica peri-odística-literaria en México*, Madrid, Iberoamericana/Vervuert.

Benjamin, Walter (1973), *Charles Baudelaire: A Lyric Poet in the Era of High Capitalism*, London, Verso.

—— (1977), The work of art in the age of mechanical reproduction, from *Illuminations*, ed. Hannah Arendt, trans. Harry Zohn, London, Fontana, 219–53.

—— (1979), *One Way Street*, London, New Left Books.

Berger, John (1966), *The Success and Failure of Picasso*, Harmondsworth, Penguin.

—— (1972), *Ways of Seeing*, London, BBC/Penguin.

Biesenbach, Klaus (*c*.2002), *Mexico City: An Exhibition about the Exchange Rates of Bodies and Values*, New York, P.S.1 Contemporary Art Center/KW-Institute for Contemporary Art.

Blaffer (2005), www.hfac.uh.edu/blaffer/exhibitions/past_exhibition/2004/daniela_rossell.html, 1–2. Accessed 11.04.05.

Blanco, José Joaquín (2005/1981), Plaza Satélite, in Gallo (2005), 116–18.

—— and José Woldenberg (eds) (1993), *Mexico a fines de siglo*, Vols. I and II, Mexico DF, Consejo Nacional para la Cultura y las Artes/Fondo de Cultura Económica.

Bolaños, María (1997), *Historia de los museos en España*, Gijón, Trea.

Borau, José Luis (ed.) (1998), *Diccionario del cine español*, Madrid, Alianza.

Bordwell, David and Thompson, Kristin (1997), *Film Art: An Introduction*, New York, McGraw-Hill.

Bourdieu, Pierre (1984), *Distinction: A Social Critique of the Judgement of Taste*, trans. Richard Nice, London, Routledge & Kegan Paul.

—— (1990), *Photography: A Middlebrow Art*, Cambridge, Polity.

Boyer, M. Christine (1996), *The City of Collective Memory: Its Historical Imagery and Architectural Entertainments*, Cambridge, MA: MIT Press.

Boyne, Roy (1995), Fractured subjectivity, in Jenks (1995b), 158–76.

—— (2003), *Risk*, Buckingham/Philadelphia: Oxford University Press.

Bradley, Kim (1997), The deal of the century – opening of the Guggenheim Museum Bilbao, Spain – includes interview with Thomas Krens – Cover Story, *Art in America*, www.findarticles.com/p/articles/mi_m1248/is_n7_v85/ai_19628875, 1–8. Accessed 25.04.05.

Brea, José Luis (ed.) (2005), *Estudios visuales*, Madrid, Akal.

Brooksbank Jones, Anny (1993), Julia Kristeva and her Old Man: between Optimism and Despair, *Textual Practice*, 7:1, 1–12.

—— (1998), (Un)covering the environment: some Spanish perspectives, *Intellect: International Journal of Iberian Studies*, 11, 39–54.

—— (2000a), Avon's calling: globalization and culture in Latin America, *New Formations*, 39, 100–12.

—— (2000b), From culture to politics and back, *Politics, Culture and Postmodernism*, 27: 4 (Special issue of *Latin American Perspectives*), eds Anny Brooksbank Jones and Ronaldo Munck, 144–54.

—— (2002), Sensing and ending: predestination in Imanol Uribe's 'Días contados', *Revista Canadiense de Estudios*, 26, 395–422.

—— (2004a), Challenging the seductions of the Bilbao Guggenheim, *Intellect: International Journal of Iberian Studies*, 16, 159–65.

—— (2004b), Photographing the habitats of objects, *Romance Studies*, 22:3, 223–35.

—— (2005), Landscapes of confusion, in Felipe Hernández and Mark Millington (eds), *Transculturation: Cities, Space and Architecture in Latin America*, Amsterdam, Rodopi, 128–41.

—— and Ronaldo Munck (eds) (2000), *Cultural Politics in Latin America*, London, Macmillan.

Buck-Morss, Susan (1996), Visual culture questionnaire, *October 77*, Summer, 29–31.

—— (2005), Estudios visuales e imaginación global, in Brea (2005), 145–59.

Calvo Serraller, Francisco (1999), *El Guernica de Picasso*, Madrid, TF.

Cámara, Ery (2000), Artistas mexicanos en el escenario internacional / Mexican artists in the international arena, in Olivares (2000b), 160–7, 168–75.

Campbell, Federico (2002), Rubias y famosas, *Milenio Semanal*, www.mileniosemanal.com/nota, 1–2. Accessed 25.08.02.

Caparrós Lera, José María (1992), *El cine español de la democracia: De la muerte de Franco al 'cambio' socialista*, Barcelona, Anagrama.

Caro Baroja, Julio (1972), *Los vascos*, Madrid, Istmo.

—— (1984), *El laberinto vasco*, San Sebastián, Txertoa.

Carr, Raymond (1982), *Spain 1808–1975*, Oxford, Clarendon Press.

Casasola, Agustín Victor (1985), *Tierra y libertad! Photographs of Mexico 1900–1935*, Oxford, Museum of Modern Art.

Castellanos, Alejandro (1996), Espacio y espejo, in García Canclini, Castellanos and Rosas Mantecón (1996), 43–60.

Castells, Manuel (1997a), *The Information Age: Economy, Society and Culture, Vol. 1, The Rise of Network Society*, Oxford: Blackwell.

—— (1997b), *The Information Age: Economy, Society and Culture, Vol. 2, The Age of Identity*, Oxford: Blackwell.

—— (1998), *The Information Age: Economy, Society and Culture, Vol. 3, End of Millennium*, Oxford: Blackwell.

Cava Mesa, María Jesús, in collaboration with María Silvestre and Javier Arranz (1996), *Memoria colectiva del bombardeo de Gernika*, Bilbao/Gernika-Lumo, Bakeaz/Gernika Gogoratuz.

Celorio, Gonzalo (2005/1997), Mexico, ciudad de papel, in Gallo (2005), 39–58.

Chant, Sylvia with Nikki Craske (2003), *Gender in Latin America*, London, LAB.

Chipp, Herschel B. (ed.) (1989), *Picasso's Guernica: History, Transformation, Meanings*, London, Thames and Hudson.

Clark, Robert P. (1979), *The Basques: The Franco Years and Beyond*, Reno, University of Nevada Press.

Clarke, Graham (1997), *The Photograph*, Oxford, Oxford University Press.

Clifford, James (1997), *Travel and Translation in the Late Twentieth Century*, Cambridge, MA, Harvard University Press.

Collins, Roger (1986), *The Basques*, Oxford, Basil Blackwell.

Conaculta-INAH/Lunwerg Editores (2004), *Memoria de la Ciudad de México: Cien años, 1850–1950*, Barcelona, Lunwerg.

Connor, Steve (2003), What can cultural studies do?, in Paul Bowman (ed.), *Interrogating Cultural Studies*, London, Pluto, 207–17.

Conversi, Daniele (1997), *The Basques, the Catalans and Spain*, London, Hurst.

Cordero Reiman, Karen (2001), Corporeal identities in Mexican art; modern and postmodern strategies, in Good and Waldron (2001), 53–72.

Creed, Barbara (1998), Film and psychoanalysis, in Hill and Church Gibson (1998), 77–90.

Crimp, Douglas (1999), Getting the Warhol we deserve, *Social Text*, 59, 49–66.

Cyberpresse (2002), Ricas y famosas: l'autre Mexique, www.cyberpresse.ca/ricas-y-famosas.htm, 1–3. Accessed 01.01.03.

De la Puente, Joaquín (2002), *Guernica: The Making of a Painting*, Madrid, Silex.

Debord, Guy (1994/1967), *The Society of the Spectacle*, New York, Zone.

Debroise, Olivier (1987), Mexican photography in the eighties / La fotografía mexicana en los años 80, in Merewether (1987), 48–63.

—— (2000), De regreso/Back, in Olivares (2000b), 108–17, 118–26.

—— (2001a), Mexican art on display, in Good and Waldron (2001), 20–36.

—— (2001b), *Mexican Suite: A History of Photography in Mexico*, trans. and rev. Stella de Sá Rego, Austin, Unversity of Texas Press.

—— (2005), Fin de temporada: Saldos, in Museo Nacional Centro de Arte Reina Sofia/Conaculta (2005), 181–7.

Desfor Edles, Laura (1998), *Symbol and Ritual in the New Spain: The Transition to Democracy after Franco*, Cambridge, Cambridge University Press.

Douglass, William A. (ed.) (1985), *Basque Politics: A Case Study in Ethnic Nationalism*, Reno, Associated Faculty Press/Basque Studies Program, University of Nevada.

——, Carmelo Urza, Linda White and Joseba Zulaika (eds) (1999), *Basque Cultural Studies*, Reno, University of Nevada Press.

Dupláa, Cristina (2000), Memoria colectiva y *lieux de mémoire* en la España de la Transición, in Resina (2000), 29–42.

Eagleton, Terry (2001), Signs, sense and sentiment, *The Times Higher*, 27 April, 26 only.

Economist, The (2001), When merchants enter the temple, via Irvine (2003b), np. Accessed 21.04.05.

Eguiguren, Jesús (1991), *Euskadi: Tiempo de reconciliación*, San Sebastián, Kriselu.

El Correo Digital (2005), Oteiza: Mito y modernidad, http://canales.elcorreodigital.com/guggenheim/oteiza/oteiza.html, np. Accessed 21.04.05.

Elgar, Frank (1956), *Picasso*, London, Thames and Hudson.

Elkins, James (2002), Preface to a book *A Skeptical Introduction to Visual Culture, Journal of Visual Culture*, 1:1, 93–9.

Elorza, Antonio (1995), Some perspectives on the nation state and autonomies in Spain, in Graham and Labanyi (1995), 332–6.

—— (ed.) (2000), *La historia de ETA*, Madrid, Temas de Hoy.

Escobar, Ticio (2002), Memoria insumisa. Notas sobre ciertas posibilidades críticas de la narración, in Moraña (2002b), 169–94.

Evans, Jessica (1999), Regulating photographic meanings: introduction, in Evans and Hall (1999), 125–37.

—— and Stuart Hall (eds) (1999), *Visual Culture: The Reader*, London, Sage/Open University Press.

Featherstone, Mike (1991), *Consumer Culture and Postmodernism*, London, Sage.

Feldman, Allen (2003), Political terror and the technologies of memory: excuse, sacrifice, commodification and actuarial moralities, *Radical History*, 85, 58–73.

Fernández Quintanilla, Rafael (1981), *Odisea del Guernica*, Barcelona, Planeta.

Fisch, Eberhard (1988), *Guernica by Picasso*, Lewisburg, Bucknell University Press/London and Toronto, Associated University Presses.

Fontcuberta, Joan (ed.) (2003a), *Photography. Crisis of History*, trans. Graham Thompson, Barcelona, Actar.

—— (2003b), Revisiting the histories of photography, in Fontcuberta (2003a), 7–17.

Fraser, Ronald (1986), *Blood of Spain: An Oral History of the Spanish Civil War*, London, Pimlico.

Freud, Sigmund (1914), On narcissism: An introduction, in J. Strachey (ed.), *The Standard Edition of the Complete Psychological Works 1914–1916* (1953–74), Vol. 14, London, Hogarth, 73–102.

Frizot, Michel (ed.) (1998a), *A New History of Photography*, trans. Susan Bennett, Liz Clegg, John Crook, Caroline Higgitt and Helen Atkins, Cologne, Köneman.

—— (1998b), Body of evidence, in Frizot (1998a), 258–71.

Fuentes, Carlos (1995), *Henri Cartier-Bresson: Mexican Notebooks*, trans. Michelle Beaver, New York, Thames and Hudson.

Fuery, Patrick and Kelly Fuery (2003), *Visual Cultures and Critical Theory*, London, Arnold.

Fundación BIACS/Centro Andaluz de Arte Contemporáneo (2004), *La alegría de mis sueños: Bienale de Arte Contemporáneo de Sevilla*, Seville, Fundación BIACS/Centro Andaluz de Arte Contemporáneo.

Fundación Museo de la Paz de Gernika (2002), *Un museo para el recuerdo, un museo para el futuro*, Gernika-Lumo, Fundación Museo de la Paz de Gernika.

Fusi, Juan Pablo (1984), *El País Vasco: Pluralismo y nacionalidad*, Madrid, Alianza.

—— and Jordi Palafox (1997), *España 1808–1996: El desafío de la modernidad*, Madrid, Espasa.

Gabilondo, Joseba (2002), Postnationalism, fundamentalism, and the global Real: historicizing terror/ism and the new North American / global ideology, *Journal of Spanish Cultural Studies*, 3:1, 57–86.

Gallo, Rubén (2004), *New Tendencies in Mexican Art: The 1990s*, New York and Basingstoke, Palgrave Macmillan.

—— (ed.) (2005), *México DF: Lecturas para paseantes*, Madrid, Turner.

Gandelsonas, Mario (1999), *X-Urbanism: Architecture and the American City*, New York, Princeton Architectural Press.

Garay, Juan de (2002), El efecto económico del Museo Guggenheim Bilbao cubre ya diez veces su coste inicial, www.juandegaray.org.ar/fvajg/docs/Efecto_economico_del_Museo_Guggenheim, np. Accessed 12.09.03.

García Canclini, Néstor (1989), *Culturas híbridas: Estrategias para entrar y salir de la modernidad*, Mexico DF, Grijalbo. Trans. Christopher L. Chiappari and Silvia L. López (1995) as *Hybrid Cultures; Strategies for Entering and Leaving Modernity*, Minneapolis, Minnesota University Press.

—— (1993), *Consumidores y ciudadanos: Conflictos multiculturales de la globalización*, México DF, Grijalbo. Trans. George Yúdice (2001) as *Consumers and Citizens: Globalization and Multicultural Conflicts*, Minneapolis, Minnesota University Press.

—— (ed.) (1995), *Cultura y pospolítica: el Debate sobre la modernidad en América Latina*, Mexico DF, Consejo Nacional para la Cultura y los Artes.

—— (1996a), Imaginar la ciudadanía en una ciudad posapocalíptica, in García Canclini, Castellanos and Rosas Mantecón (1996), 107–13.

—— (1996b), Los viajes metropolitanos, in García Canclini, Castellanos and Rosas Mantecón (1996), 11–42.

—— (ed.) (1996c), *Culturas en globalización. América Latina – Europa – Estados Unidos: Libre comercio e integración*, Caracas, Nueva Sociedad.

—— (1997), *Imaginarios urbanos*, Mexico DF, Grijalbo.

—— (1998), Remaking passports: visual thought in the debate on multiculturalism, in Mirzoeff (1998), 372–81.

—— (1999), *La globalización imaginada*, Buenos Aires, Paidós.

—— (2000), Un país que podría globalizarse / A country that could go global, in Olivares (2000b), 16–27.

—— and Ana Rosas Mantecón (1996), Las múltiples ciudades de los viajeros, in García Canclini, Castellanos and Rosas Mantecón (1996), 61–106.

—— Alejandro Castellanos and Ana Rosas Mantecón (eds) (1996), *La ciudad de los viajeros: Travesías e imaginarios urbanos: México, 1940–2000*, Mexico DF, Grijalbo.

García de Cortázar, Fernando and Manuel Montero (1984), *Historia contemporánea del País Vasco: De las Cortes de Cádiz al Estatuto de Guernica*, San Sebastián, Txertoa.

—— and José Manuel Azcona (1991), *El nacionalismo vasco*, Madrid, Editorial 16.

García Machuca, M., and E. Sánchez (2002), Exponen a mexicanas y sus lujos, www.elnorte.com, 1–2. Accessed 06.01.03.

Garmendia, José María (2000), Pasión, muerte y resurrección de ETA, in Elorza (2000), 133–68.

Garza, Gustavo (ed.) (1987), *Atlas de la Ciudad de México*, Mexico City, Departamento del Distrito Federal/El Colegio de México.

Gasparini, Paolo (2004), La fotografía debería contribuir al diálogo y al debate cultural: Paolo Gasparini, www.cnca.gob.mx/cnca/nuevo/diarias/180298/ciudadde.html, 1–2. Accessed 12.04.04.

Geertz, Clifford (1994), Primordial and civic ties, in John Hutchinson and Anthony D. Smith (eds), *Nationalism*, Oxford, Oxford University Press, 29–34.

Genovés, Santiago (1980), *La violencia en el País Vasco y en sus relaciones con España*, Mexico DF, UNAM.

Geo (1998), Bilbao en vanguardia: El impacto del Guggenheim, Special Issue No. 2.

Gernika-Lumo (*c.*1992), *El bombardeo de Gernika: Exposición*, Gernika-Lumo, Gernikazarra Historia Taldea.

Gernika Museoa (*c.*1997), *Gernika Museoa*, Gernika-Lumo, Bizkaiko Foru Aldunia/Diputación Foral de Bizkaia.

Ghirardo, Diane (1996), *Architecture after Modernism*, London, Thames and Hudson.

Giddens, Anthony (1991), *Modernity and Self-identity*, Cambridge, Polity.

Gimferrer, Pere (1985), *Cine y literatura*, Barcelona, Planeta.

Girard, René (1972), *La violence et le sacré*, Paris, Grasset. Trans. by Patrick Gregory (1977) as *Violence and the Sacred*, Baltimore, Johns Hopkins University Press.

Gómez, María and Sara González (2001), A reply to Beatriz Plaza's 'The Guggenheim-Bilbao Museum effect', *International Journal of Urban and Regional Research*, 25, 898–900.

Good, Carl and John V. Waldron (eds) (2001), *The Effects of the Nation*, Philadelphia, Temple University Press.

Graham, Helen and Jo Labanyi (eds) (1995), *Spanish Cultural Studies. An Introduction: The Struggle for Modernity*, Oxford, Oxford University Press.

Gray, John (2001), Goodbye to globalization, *The Guardian*, 27 February, 21 only.

Green Duncan (1998), *Hidden Lives: Voices of Children in Latin America and the Caribbean*, London, Cassell/Latin America Bureau/Save the Children/ Rädda Barnen.

Grosz, Elizabeth (1989), *Sexual Subversions: Three French Feminists*, Sydney, Allen and Unwin.

—— (1990), *Jacques Lacan: A Feminist Introduction*, London, Routledge.

Guasch, Ana María (2003), Un estado de la cuestión, *Estudios Visuales*, 1, 8–16.

Güemes, César (2002) Ricas famosas e irritadas, *La Jornada*, 5 January, 3 only.

Guisasola, Marisol (1998), Paseo por el espacio urbano del 2000, *Geo* (Special issue: Bilbao en vanguardia), 34–46.

Gutiérrez Carbajo, Francisco (1993), *Literatura y cine*, Madrid, UNED.

Gutiérrez Galindo, Blanca (2000), Las artes visuales en México 1960–2004 / Visual arts in Mexico 1960–2004, in Olivares (2000b), 28–43.

Hamnett, Brian (1999), *A Concise History of Mexico*, Cambridge, Cambridge University Press.

Hardt, Michael and Antonio Negri (2000), *Empire*, Cambridge, MA/London, Harvard University Press.

Harrison, Miranda (2003), *Picasso: el Guernica*, London, Scala.

Herlinghaus, Hermann (2002), Desafiar a Walter Benjamin desde América Latina, in Moraña (2002b), 157–68.

Herrera, Hayden (1989), *A Biography of Frida Kahlo*, London, Bloomsbury.

Heywood, Ian and Barry Sandwell (1999), *Interpreting Visual Culture: Explorations in the Hermeneutics of the Visual*, London, Routledge.

Hill, John, and Church Gibson, Pamela (eds) (1998), *The Oxford Guide to Film Studies*, Oxford, Oxford University Press.

Hilton, Timothy (1992), *Picasso*, London, Thames and Hudson.

Holly, Michael Ann (1996), Saints and sinners, *October* 77, Summer, 39–41.

Hopenhayn, Martín (2000), Globalization and culture: five approaches to a single text, in Brooksbank Jones and Munck (2000), 142–57.

Hopewell, John (1986), *Out of the Past: Spanish Cinema After Franco*, London, BFI Books.

Hopkinson, Amanda (2002), *Manuel Álvarez Bravo*, London, Phaidon.

—— (ed.) and Julio Etchart (1992), *The Forbidden Rainbow: Images and Voices from Latin America*, London, Serpent's Tail.

Howells, Richard (2003), *Visual Culture*, Cambridge, Polity.

Huque, Ariadne Kimberly (ed.) (2002), *Nudes: The Blue House. The Photographs of Manuel Álvarez Bravo*, New York, Distributed Art Publishers.

Irvine, Mark (2003a), An American in Venice: Thomas Krens' plans for world domination have stalled, but the director of the Guggenheim still towers over the Biennale, *TIME Europe Magazine*, www.time.com/time/europe/magazine/article/0,13005,901030630-460189,00, np. Accessed 21.04.05.

—— (2003b), The Guggenheim museums: case study in contemporary museum issues, www.georgetown.edu/faculty/irvinem/visualarts/museums/Guggenheim.html, np. Accessed 21.04.05.

Iturbide, Graciela (1996), *Images of the Spirit*, New York, Aperture Foundation.

Iturriarte, Alberto, Vicente del Palacio, Alberto Zarrabeitia and Ana Reyero (1992), *El bombardeo de Gernika: Exposición*, Gernika-Lumo, Gernikazarra Historia Taldea.

Jacobsen Jr, William H. (1999), Basque language origins theories, in Douglass, Urza, White and Zulaika (eds) (1999), 27–43.

Jameson, Fredric (1984), Postmodernism, or The Cultural Logic of Late Capitalism, *New Left Review*, 146, 53–92.

Jammes, André (1963), *Charles Nègre, Photographe: 1820–1880*, Paris, André Jammes.

Jáuregui, Gurutz (2000) ETA: Orígenes y evolución ideológica y política, in Elorza (2000), 171–274.

Jay, Martin (1993), *Downcast Eyes: The Denigration of Vision in Twentieth-Century French Thought*, Berkeley, University of California Press.

—— (1996), Visual culture and its vicissitudes, *October* 77, Summer, 42–4.

—— (2002), That visual turn, *Journal of Visual Culture*, 1, 87–92.

Jencks, Charles (1999a), Bilbaoism: The unreasonable effectiveness of sensuous knowledge, in Jencks (1999c), 167–73.

—— (1999b), Ecstatic architecture, in Jencks (1999c), 8–20.

—— (1999c), *Ecstatic Architecture: The Surprising Link*, London, Academy Editions/John Wiley.

Jencks, Charles and Karl Kropf (eds) (1997), *Theories and Manifestos of Contemporary Architecture*, London, Academy Editions.

Jenks, Chris (1995a), The centrality of the eye in Western culture: An introduction, in Jenks (1995b), 1–25.

—— (ed.) (1995b), *Visual Culture*, London/New York, Routledge.

Jodidio, Philippe (1999), De Venise a Bilbao: Interview with Thomas Krens, *Connaissance des Arts* (Special Issue: *Guggenheim Bilbao*), 12–22.

Jordan, Barry and Rikki Morgan-Tamosunas (1998), *Contemporary Spanish Cinema*, Manchester, Manchester University Press.

—— (eds) (2000), *Contemporary Spanish Cultural Studies*, London, Arnold.

Journal of Visual Culture (2002), 1:1.

Juaristi, Jon (1992), *Vestigios de Babel: Para una arqueología de los nacionalismos españoles*, Madrid, Siglo Veintiuno.

—— (1998), *El bucle melancólico. Historias de nacionalistas vascos*, Madrid, Espasa.

Kaufman, Jason Edward (1997), The globalized Guggenheim blossoms in Bilbao, *The Art Newspaper*, October, www.jasonkaufman.com/articles/globalised_guggenheim_blossoms_i.htm, np. Accessed 21.04.05.

Kay, Ronald (1986), The reproduction of the New World / La reproducción del Nuevo Mundo, in Merewether (1987), 18–23.

Kay, Sarah (2003), *Žižek: A Critical Introduction*, Cambridge, Polity.

Kimmelman, Michael (2002), An era ends for the Guggenheim, *New York Times*, via Irvine (2003b), np. Accessed 21.04.05.

Kirkpatrick, Gwen (1997), Ways of thinking in California, in Susanne Klengel (ed.), *Contextos, historias y transferencias en los estudios latinoamericanistas europeos*, Frankfurt am Main, Vervuert, 227–32.

Kismaric, Susan (1997), *Manuel Álvarez Bravo*, New York, Museum of Modern Art.

—— (2004), *Hector García*, Madrid/Mexico City, Turner/DGE-Equilibrista/Conaculta.

Kofman, Sarah (1982), *El enigma de la mujer: ¿Con Freud o contra Freud?*, Barcelona, Gedisa.

Kolbowski, Silvia (1996), Untitled contribution, *October 77*, Summer, 48–50.

Kolker, Robert P. (1998), The film text and film form, in Hill and Church Gibson (1998), 11–29.

Kortázar, Jon (1998), En la catedral de titanio, *Geo* (Special issue: Bilbao en vanguardia), 64–8.

Krauss, Rosalind and Hal Foster (1996), Introduction, *October 77*, Summer, 3–5.

Krauss, Rosalind E. (1998), *The Picasso Papers*, London, Thames and Hudson.

Krens, Thomas (1999), Prefacio, in Van Bruggen (1999), 9–11.

Kunard, Andrea (2003), The mechanical art: some historic debates on art and photography, in Fontcuberta (2003a), 156–74.

La Palabra (2005), Hay cosas que el dinero no puede comprar, www. mexico. com/lapalabra/indez.php?method=una&idarticulo=8471. Accessed 10.04.05.

Labanyi, Jo (2000), History or hauntology; or, What does one do with the ghosts of the past? Reflections on Spanish film and fiction of the post-Franco period, in Resina (2000), 65–82.

Laborde, Denis (ed.) (1998), *La question basque*, Paris/Montreal, l'Harmattan.

Laplanche, Jean and Jean-Bertrand Pontalis (1973), *The Language of Psychoanalysis*, London, Karnac.

Lasagabaster, Jesús María (1995), The promotion of cultural production in Basque, in Graham and Labanyi (1995), 351–5.

Lash, Scott (1999), *Another Modernity: A Different Rationality*, Oxford, Blackwell.

LeGates, Richard T. and Frederic Stout (eds) (1996), *The City Reader*, London/New York, Routledge.

Levi Strauss, David (2001), Transition, tradition, and resistance: I wonder how the angel of history will look crossing the bridge to the 21st century, *NYFA Interactive*, www.archpedia.com/Articles/20040302.html, np. Accessed 21.04.05.

Lister, Martin (2000), Photography in the age of electrical imaging, in Wells (2000), 303–47.

Llobera, Josep R. (1996), The role of commemoration in (ethno-)nation-building. The case of Catalonia, in Mar Molinero and Smith (1996), 191–206.

Loaeza, Guadalupe (2005), Los limpiaparabrisas, in Gallo (2005), 228–9.

Loaeza, Soledad (1993), La sociedad mexicana en el siglo XX, in Blanco and Woldenberg, Vol. I, 108–29.

López Beltrán, Carlos (2001), El espejo negado de *Ricas y famosas*, *Fractal 23*, 6, 149–53.

López Cuenca, Alberto (2005), El desarraigo como virtud: México y la deslocalización del arte en los años 90, *Revista de Occidente*, at www.ortegaygasset.edu/revistadeoccidente/artículos/(285)Alberto_Lopez.pdf, 7–22. Accessed 20.07.05.

Lord, Gail Dexter (1999), How museums build communities, www.lord.ca/publications/articles/How_museums_build.htm. Accessed 21.04.05.

Lowe, Lisa and David Lowe (eds) (1997), *The Politics of Culture in the Shadow of Capital*, Durham/London, Duke University Press.

Lubbock, Tom (2005), Power painting, *Guardian Review*, 8 January, 13.

Lugo, Jesús (2005), www.jesuslugo.com/ing/review.html, np. Accessed 03.03.05.

Lupton, Deborah (1999), *Risk*, London, Routledge.

Lury, Celia (1997), *Consumer Culture*, Cambridge, Polity.

—— (1998), *Prosthetic Culture: Photography, Memory and Identity*, London, Sage.

Maddox, Richard (2004), *The Best of all Possible Islands: Seville's Universal Exposition, the New Spain, and the New Europe*, New York, State University of New York Press.

Madrid, Juan (1993), *Los días contados*, Madrid, Alfaguera.

Manchado, Trinidad (2000), Cultural memory, commerce and the arts: The Valencian Institute of Modern Art, in Jordan and Tamosunas (2000), 92–100.

Mar Molinero, Clare (1995), The politics of language: Spain's minority languages, in Graham and Labanyi (1995), 336–42.

Mar Molinero, Clare and Angel Smith (eds) (1996), *Nationalism and the National in the Iberian Peninsula*, London, Berg.

Martin, Russell (2002), *Picasso's War*, London, Pocket Books.

Martín-Barbero, Jesús (2000), Art/communication/technicity at century's end, in Brooksbank Jones and Munck (2000), 56–73.

—— (2002), La ciudad que median los miedos, in Moraña (2002b), 19–35.

Marvin, Carolyn (1988), *When Old Technologies Were New; Thinking about Electronic Communication in the Late Nineteenth Century*, New York/Oxford, Oxford University Press.

Mathews Gedo, Mary (1980), *Picasso: Art as Autobiography*, Chicago/London, University of Chicago Press.

McCorquodale, Charles (1983), *The History of Interior Decoration*, Oxford, Phaidon.

McCully, Marilyn (ed.) (1981), *A Picasso Anthology: Documents, Criticism, Reminiscences*, London, Arts Council of Great Britain/Thames and Hudson.

Medina, Cuauhtémoc (2001), *Graciela Iturbide*, London, Phaidon.

—— (2002) El ojo breve: Mundos privados, ilusiones públicas. Reseña: *Ricas y famosas*, de Daniela Rossell, *Reforma*, 23 August, 2 only.

—— (2005a), Notas para una estética del modernizado, in Museo Nacional Centre de Arte Reina Sofia/Conaculta (2005), 13–18.

—— (2005b), SEMEFO: La morgue, in Gallo (2005), 341–56.

Mendelson, Jordana (2002), Review of Selma Reuben Holo's *Beyond the Prado: Museums and Identity in Democratic Spain*, *Journal of Spanish Cultural Studies*, 3, 253–7.

Merewether, Charles (ed.) (1987), *A Marginal Body: The Photographic Image in Latin America / Un cuerpo marginal: La imagen fotográfica en América Latina*, Sydney, Australian Centre for Photography.

Merin, Peter (1937), *Spain: Between Death and Birth*, trans. Charles Fullman, London, John Lane/Bodley Head.

Meyer, Lorenzo (2002), Escándalo, www.opcionguerrero.com.mx/meye96.htm, 1–4. Accessed 18.10.02.

Michaud, Yves (1998), Forms of looking: philosophy and photography, in Frizot (1998a), 730–8.

Miller, Nicola (1999), *In the Shadow of the State; Intellectuals and the Quest for National Identity in Twentieth Century Latin America*, London, Verso.

Mirzoeff, Nicholas (ed.) (1998), *Visual Culture Reader*, London/New York, Routledge.

Mitchell, W. J. T. (2005), No existen medios visuales, in Brea (2005), 17–25.

Modigliani, Sergio (2005), Guggenheim Bilbao Museum, www.architectsonline.com/publications/bilbao/, np. Accessed 21.04.05.

Molesworth, Helen (1996), Untitled intervention, *October 77*, Summer, 54–6.

Molina Foix, Vicente (1993), *El cine estilográfico: Crítica recogida 1981–1993*, Barcelona, Anagrama.

Monreal, Gregorio (1985), Annotations regarding Basque traditional political thought in the sixteenth century, in Douglass (1985), 19–51.

Monsiváis, Carlos (1995a), Literatura latinoamericana e industria cultural, in García Canclini (1995), 187–208.

—— (1995b), *Los rituales del caos*, Mexico City, Era.

—— (1997), *Mexican Postcards*, trans. and ed. John Kraniauskas, London, Verso.

Montes, Silvia (2005), The globalization of contemporary Mexican art, in *Actas of the 50th Anniversary Conference of the Association of Hispanic Studies of Great Britain and Ireland*, Valencia, Biblioteca Valenciana.

Morales, Alfonso (2000), Imágenes en tránsito / Images in transit, in Olivares (2000b), 140–59.

Moraña, Mabel (2002a), Introducción, in Moraña (2002b), 9–15.

—— (ed.) (2002b), *Espacio urbano, comunicación y violencia en América Latina*, Pittsburgh, Instituto Internacional de Literatura Iberoamericana/ University of Pittsburgh.

Moreiras Alberto (2001), *The Exhaustion of Difference: The Politics of Latin American Cultural Studies*, Durham, Duke University Press.

Moxey, Keith (1996), Animating aesthetics, *October* 77, Summer, 56–9.

—— (2005), Estética de la cultura visual en el momento de la globalización, in Brea (2005), 27–37.

Mraz, John (2003), *Nacho López: Mexican Photographer*, Minneapolis and London, Minnesota University Press.

Muschamp, Herbert (2002), When art puts down a bet in a house of games, via Irvine (2003b), np. Accessed 21.04.05.

Museo Nacional Centro de Arte Reina Sofia/Conaculta (2005), *Eco: Arte contemporáneo mexicano*, Madrid, Museo Nacional Centre de Arte Reina Sofia/Conaculta.

Nietzsche, Friedrich (1995/1878), *Human, All Too Human*, trans. Gary Handwerk, *Complete Works of Friedrich Nietzsche, Vol. 1*, Stanford, Stanford University Press.

Nora, Pierre (1989), Between memory and history: *Les Lieux de mémoire*, trans. Marc Roudebush, *Representations*, 26, 7–25.

Oc ¡VIVE! (2002), El libro *Ricas y famosas*, www.Oc ¡VIVE!.htm, 1–2. Accessed 06.01.03.

Olivares, Rosa (2000a), Editorial, El ritual del caos / The ritual of chaos, in Olivares (2000b), 8–27.

—— (ed.) (2000b), *Exit México*, Madrid/Mexico City, Olivares y Asociados.

Onaindia, Mario (2000), *Guía para orientarse en el laberinto vasco*, Madrid, Temas de Hoy.

Ortiz, Renato (1996), *Otros territorios*, Buenos Aires, Universidad de Quilmes.

—— (1997), *Mundialización y cultura*, trans. Elsa Noya, Buenos Aires, Alianza.

Ortzi [Francisco Letamendia Belzunce] (1975), *Historia de Euskadi: El nacionalismo vasco y ETA*, Paris, Ruedo Ibérico.

Osborne, Peter D. (2000), *Travelling Light: Photography, Travel and Visual Culture*, Manchester, Manchester University Press.

Palais des Beaux Arts/Stedelijk Museum (1956), *Picasso: Guernica (Exhibition Catalogue No. 147)*, Brussels/Amsterdam, Palais des Beaux Arts/Stedelijk Museum.

Payán, Miguel (1993), *El cine español de los 90*, Madrid, JC.

Payne, Stanley (1975), *Basque Nationalism*, Reno, University of Nevada Press.

Peces-Barba, Gregorio (2000), The constitutional consensus and the Basque challenge, in Monica Threlfall (ed.), *Consensus Politics in Spain: Insider Perspectives*, Bristol, Intellect Books, 61–76.

Pels, Dick, Kevin Hetherington and Frédéric Vandenberghe (2002), The status of the object: performances, mediations and techniques, *Theory, Culture and Society: Special issue on Sociality/Materiality*, 19, 1–22.

Perriam, Christopher (2003), *Stars and Masculinities in Spanish Cinema. From Banderas to Bardem*, Oxford, Oxford University Press.

Plaza, Beatriz (2000), Evaluating the influence of a large cultural artifact in the attraction of tourism: The Guggenheim Museum Bilbao case, *Urban Affairs Review*, November, 264–74.

Porter, David (ed.) (1997), *Internet Culture*, London/New York, Routledge.

Portocarrero, Enrique (1997), Thomas Krens: 'Los resultados son exactamente los provistos', *El Correo Digital*, http://canales.elcorreodigital.com/guggenheim/textos/krens.html, np. Accessed 22.04.05.

Poster, Mark (2002), Visual studies as media studies, *Journal of Visual Culture*, 1, 67–70.

Power, Kevin (2005), Minefields on the Mexican way, in Museo Nacional Centro de Arte Reina Sofía (2005), 212–19.

Preston, Paul (1986), *The Spanish Civil War*, London, Weidenfeld and Nicolson.

—— (2004), *Juan Carlos: Steering Spain from Dictatorship to Democracy*, London, HarperCollins.

Price, Derrick (2000), Surveyors and surveyed: photography out and about, in Wells (2000), 65–115.

Price, Mary (1994), *The Photograph: A Strange Confined Space*, Stanford, Stanford University Press.

Ragland Sullivan, Ellie (1992), Narcissism, in Wright (1992), 271–4.

Ramamurthy, Anandi (2000), Constructions of illusion: photography and commodity culture, in Wells (2000), 165–216.

Read, Herbert (1981/1937), Picasso's *Guernica*, in McCully (1981), 209–11.

Real Academía Española (1992), *Diccionario de la Lengua Española*, Madrid, Real Academia Española.

Reguillo-Cruz, Rossana (2002), ¿Guerreros o ciudadanos? Violencia(s). Una cartografía de las interacciones urbanas, in Moraña (2002b), 51–67.

Resina, Joan Ramón (ed.) (2000), *Disremembering the Dictatorship: The Politics of Memory in the Spanish Transition to Democracy*, Amsterdam, Rodopi.

—— (2003), The concept of after-image and the scopic apprehension of the city, in Juan Ramón Resina and Dieter Ingenschay (eds), *After-Images of the City*, Ithaca/London, Cornell University Press, 1–22.

Reuben Holo, Selma (1997), The art museum as a means of refiguring reginal identity in democratic Spain, in Marsha Kinder (ed.), *Refiguring Spain: Cinema, Media, Representation*, Durham, Duke University Press, 301–26.

—— (1999), *Beyond the Prado: Museums and Identity in Democratic Spain*, Washington, DC/London, Smithsonian Institution Press. Trans. Isabel Bennasar (2002) as *Más allá del Prado. Museos e identidad en la España democrática*, Madrid, Akal.

Richard, Nelly (2002), El drama y sus tramas: Memoria, fotografía y desaparición, in Moraña (2002b),195–202.

Riego, Bernardo (2003), From the 'Newhall school' of photography to the 'Histories of photography': experiences and proposals for the future, in Fontcuberta (2003a), 42–57.

Rodríguez Larrauri, Mercedes (2003), El impacto turístico del Museo Guggenheim-Bilbao, http://suse00.su.ehu.es/euskonews/0039zbk/gaia3909es.html, np. Accessed 12.09.03.

Roldán Larreta, Carlos (1999), *El cine del País Vasco: de Ama Lur (1968) a Airbag (1997)*, Eusko San Sebastián, Ikasuntza.

Ros, Xon de (2002), The Guggenheim Museum, Bilbao: high art as popular culture, in Jo Labanyi (ed.), *Constructing Identity in Contemporary Spain*, Oxford, Oxford University Press, 280–93.

Rose, Jacqueline (1986), *Sexuality in the Field of Vision*, London, Verso.

Rossell, Daniela (2002a), Introductory notes to 'Ricas y famosas', exhibition of photographs by Daniela Rossell, Madrid, Casa de América, June/July [unpublished and unpaginated].

—— (2002b, 1st edition), *Ricas y famosas* [unpaginated exhibition catalogue], Madrid, Turner.

—— (2002c, revised edition of 2002b), *Ricas y famosas* [unpaginated exhibition catalogue], Madrid, Turner.

Rubio Cabeza, Manuel (1987), *Diccionario de la Guerra Civil española*, Barcelona, Planeta.

Ryan, James R. (1997), *Picturing Empire: Photography and the Visualization of the British Empire*, London, Reaktion.

Salazar Cruz, Clara Eugenia (1999), *Espacio y vida cotidiana en la ciudad de México*, México DF, El Colegio de México.

Salazar Cruz, Luis (1993), Agotamiento de la hegemonía revolucionaria y transición política, in Blanco and Woldenberg (1993), Vol. 2, 342–76.

Saltz, Jerry (2002), GuggEnron, via Irvine (2003b), np. Accessed 21.04.05.

Santamarina, Guillermo (2000), Panchito en Baviera / Panchito in Baviera, in Olivares (2000b), 76–91.

Sarlo, Beatriz (1994), *Escenas de la vida posmoderna*, Buenos Aires, Ariel.

—— (1995), Estética y pospolítica. Un recorrido de Fujimori a la Guerra del Golfo, in García Canclini, 309–24.

—— (1996), *Instantáneas: Medios, ciudad y costumbres en el fin de siglo*, Buenos Aires, Ariel.

Schmeltz, Itala (2005), Cinco pruebas acerca de la imposibilidad de este ensayo, in Museo Nacional Centre de Arte Reina Sofia/Conaculta (2005), 35–41,

Schwabsky, Barry (2002), Daniela Rossell, in Rossell (2002b) and (2002c), np.

Segre, Erica (2001a), Reframing the city: images of displacement in Mexico's urban films of the 1940s and 1950s, *Journal of Latin American Cultural Studies*, 10, 205–22.

—— (2001b), Towards a reading of contemporary women photographers in Mexico: issues of allegory and identity, *Journal of Romance Studies*, 1, 45–68.

Sencourt, Robert Esmonde (1938), *Spain's Ordeal: A Documented Survey of Recent Events*, London, Longmans.

Shohat, Ellie and Robert Stam (1998), Narrativizing visual culture: Towards a polycentric aesthetics, in Mirzoeff (1998), 27–52.

Silva, Armando (1992), *Imaginarios urbanos. Bogotá y São Paulo: Cultura y comunicación urbana en América Latina*, Bogotá, Tercer Mundo.

Skidmore, Thomas E. and Peter H. Smith (2001), *Modern Latin America*, Oxford, Oxford University Press.

Sloane, Patricia (2000), Otros recuerdos del porvenir / Other memories of times to come, in Olivares (2000b), 44–75.

Smith, Marquand, Joanne Morra and Raiford A Guins (2002), Editorial, *Journal of Visual Culture*, 1, 5–6.

Smith, Paul Julian (2000), *The Moderns: Time, Space and Subjectivity in Contemporary Spanish Culture*, Oxford, Oxford University Press, 2000.

—— (2003), *Contemporary Spanish Culture: TV, Fashion, Art and Film*, Cambridge, Polity.

Snobissimo (2002), www.casasgente.com/Snobissimo/07_septiembre_2002, np. Accessed 10.04.05.

Solomon, Deborah (2002), Is the go-go Guggenheim going, going, *New York Times*, via Irvine (2003a), np. Accessed 21.04.05.

Sontag, Susan (1978), *On Photography*, London, Allen Lane.

—— (2003), *Regarding the Pain of Others*, London, Hamish Hamilton/Penguin.

Sorkin, Michael (ed.) (1994), *Variations on a Theme Park: The New American City and the End of Public Space*, New York, Hill and Wang.

Southworth, Herbert Rutledge (1977), *Guernica! Guernica! A Study of Journalism, Diplomacy, Propaganda and History*, Berkeley/Los Angeles, University of California Press.

Steele, James (1997), *Architecture Today*, London, Phaidon.

Steer, George Lowther (1938), *The Tree of Gernika: A Field Study of Modern War*, London, Hodder and Stoughton.

Stone, Rob (2002), *Spansh Cinema*, Harlow, Pearson Education/Longman.

Sturken, Marita and Lisa Cartwright (2001), *Practices of Looking: An Introduction to Visual Culture*, Oxford, Oxford University Press.

Szeemann, Harald (2004), La alegría de mis sueños / The joy of my dreams, in Fundación BIACS/Centro Andaluz de Arte Contemporáneo (2004), 18–28.

Tagg, John (1999), Evidence, truth and order: A means of surveillance, in Evans and Hall (1999), 244–73.

Talón, Vicente (1973), *Arde Guernica*, Madrid, Gregorio del Toro.

Tejerina Montaña, Benjamín (1996), Language and Basque nationalism: collective identity, social conflict and institutionalization, in Mar Molinero and Smith (1996), 221–36.

Tello, Carlos (1993), Sobre la desigualdad en México, in Blanco and Woldenberg (1993), Vol. 2, 7–62.

Tester, Keith (ed.) (1994), *The Flâneur*, London, Routledge.

Thomas, Gordon and Max Scott-Witts (1975), *The Day Guernica Died*, London, Hodder and Stoughton.

Tipton, Gemma (2003), The best of spaces, the worst of spaces (or I don't know much about architecture, but I know what I like), *CIRCA*, 102, 54–61, www.recirca.com/backissues/2102/gtipton.shtml. Accessed 21.04.05.

Toluca Project (2004), *México, DF*, Paris/Mexico City, Toluca Project/Galería López Quiroga.

Torres, Augusto (1997), *El cine español en 119 películas*, Madrid, Alianza.

Tuckman, Jo (2002), Outrage as Mexico's super-rich flaunt their tacky lifestyles, *Observer*, 15 September, 21 only.

Tusell, Javier (1989), 'Guernica' comes to the Prado (Afterword), in Chipp (1989), 180–91.

—— (1996), *Vivir en guerra: España 1936–39*, Madrid, Silex.

—— (1999), *Historia de España en el siglo XX. VI: La transición democrática y el gobierno socialista*, Madrid, Taurus.

Umbral, Francisco (1993), *La década roja*, Madrid, Planeta.

Unzueta, Patxo (1987), *Sociedad vasco y política nacionalista*, Madrid, El País.

Uribe, Imanol (1994), *Días contados: Adaptación de la novela de Juan Madrid*, Madrid, Alma Plot.

Urza, Carmelo (1999), Basque sports: The traditional and the new, in Douglass, Urza, White and Zulaika (1999), 245–61.

Van Bruggen, Coosje (1999), *Frank O. Gehry. Museo Guggenheim Bilbao*, New York/Bilbao, Museo Guggenheim.

Van Hensbergen, Gijs (2004), *Guernica*, London, Bloomsbury.

Vattimo, Gianni (1992), *The Transparent Society*, trans. David Webb, Oxford, Polity.

Vidal, César (1997), *La destrucción de Guernica: Un balance sesenta años después*, Madrid, Espasa.

Vidal, Hernán (1997), *Política cultural de la memoria histórica: Derechos humanos y discurso cultural en Chile*, Santiago de Chile, Mosquito.

Villoro, Juan (2002), Ricas y famosas y excesivas, *El País Semanal*, 9 June, 42–50.

Walker, John A. and Sarah Chaplin (1997), *Visual Culture: An Introduction*, Manchester, Manchester University Press.

Wallach, Alan (2003), John Berger, in Chris Murray (ed.) (2003), *Key Writers on Art: The Twentieth Century*, London, Routledge, 49–56.

Ward, Peter and Elizabeth Durden (2002), Government and democracy in Mexico's Federal District, 1997–2001: Cárdenas, the PRD and the curate's egg, *Bulletin of Latin American Research*, 1, 1–39.

Warner Marien, Mary (2002), *Photography: A Cultural History*, London, Lawrence King.

Watson, Sophie and Katherine Gibson (eds) (1996), *Postmodern Cities and Spaces*, Oxford, Blackwell.

Wells, Liz (ed.) (2000), *Photography: A Critical Introduction*, London, Routledge.

Williams, Raymond (1977), *Marxism and Literature*, Oxford, Oxford University Press.

Woodworth, Paddy (2004), The war against terrorism: The Spanish experience from ETA to al-Qaeda, *International Journal of Iberian Studies*, 17, 169–82.

Wright, Elizabeth (ed.) (1992), *Feminism and Psychoanalysis*, Oxford, Blackwell.

www.bilbao.net/ingles/villabil/IMS00006.htm, np. Accessed 3.12.99.

www.guggenheim-bilbao.es.caste/edificio/contenido.htm, p.1 only. Accessed 03.12.99.

www.lukor.com.ciencia/noticias/0412/2214230.htm, La revista *Museo.es* servirá de instrumento de comunicación en materia de patrimonio y museos, np. Accessed 03.05.05.

Zervos, Christian (1981/1937), On *Guernica*, in McCully (1981), 202–6.

Žižek, Slavoj (1992a), *Enjoy your Symptom! Jacques Lacan in Hollywood and Out*, London, Routledge.

—— (1992b/1991), *Looking Awry; an Introduction to Jacques Lacan through Popular Culture*, Cambridge, MA, MIT Press.

Zulaika, Joseba (1988), *Basque Violence, Metaphor and Sacrament*, Reno, University of Nevada Press.

—— (1997a), *Crónica de una seducción: El Museo Guggenheim Bilbao*, Madrid, Nerea.

—— (1997b), Guggenheim Bilbao: The museum of the 20th century Or The seduction of innocence, http://ibs.lgu.ac.uk/forum/czula.htm, np. Accessed 21.04.05.

—— (1999), 'Miracle in Bilbao': Basques in the casino of globalism, in Douglass, Urza, White and Zulaika (1999), 262–74.

—— (2003), Anthropologists, artists, terrorists: The Basque holiday from history, *Journal of Spanish Cultural Studies*, 4, 139–50.

Index

Numbers in *italics* refer to images: 'n.' after a page reference indicates the number of a note on that page.

Abaroa, Eduardo 6, 42, 45
Adam, Barbara 145
Agencia Fotográfica Mexicana 19
Aguilar Fernández, Paloma 176
Aguirre, José Antonio 146, 149–50, 158
Ajello, Nelly 176
Alava 147
Alemán, Miguel 51, 52
Alfonso XIII 161
Alsdorf, Bridget 94
Álvarez Bravo, Manuel 19–22, 27, 63, 64, 74
Alys, Francis 42
Anderson, Benedict 150, 166
Annan, Thomas 18
anthropology 159
Apaolaza, Joseba 123
Arana de Goiri, Sabino 148, 149
architecture
 deterritorialization 102–3
 ecstatic architecture 103
 Guggenheim Museum 99–105, *101, 106*
ARCO 1, 45, 87
Ardanza, José Antonio 90, 92, 102

Armstrong, Carol 7
Arnheim, Rudolf 155, 158, 159, 160–1
Arregui, Joseba 93, 95
Arriola, Magali 42, 44
Arronategui, Fr 175–6
art
 globalization of market 99, 104
 history 5, 6, 186
 reification 104
 valuation 6–7
Arzalluz, Xavier 174
Ashida, Carlos 40, 41
'Atocha' *175*
Aub, Max 156
Azcona, José Manuel 147
Aztecs 39

Bachelard, Gaston 103
Bakhtin, Mikhail 50
Banuet, Beto 65
Barcelona 94, 164, 167
Bardem, Javier 130
Barthes, Roland 50, 61n.22, 77
Bartra, Roger 15, 69–70

Basque Country
 bid for 'Guernica' mural 167–8
 cultural distinction 147–8
 cultural economics 92
 cultural tourism 88, 185
 democratic traditions 146–7, 149
 economy 90, 92
 ETA *see* ETA
 films 120–1
 Francoist repression 148, 165
 global cultural capital 4–5
 Herri Batasuna 91, 98
 historic liberties 147
 language 121, 147
 museums 88–90
 nationalism 10
 Partido Nacional Vasco 148, 169
 past narratives 154, 174–5
 politics 88, 90–2, 168–9
 regional and international culture
 98
 sport 178
 see also Guernica
Bauman, Zygmunt 8, 96
Beck, Ulrich 2, 145, 154
Beck-Gernsheim, Elisabeth 2, 154
Bencomo, Anadeli 48, 49, 57
Benjamin, Walter 6, 28, 50, 163, 179
Berger, John 69, 160, 161, 162
Berlin 44, 109
Bilbao
 Bilbao 2000 initiative 92, 96
 economy 90, 102
 see also Guggenheim Museum,
 Bilbao
Bizet, Georges, *Carmen* 132–3
Blanco, José Joaquín 56
Blanco, Miguel Ángel 91
Blunt, Anthony 157
Boston 45
Bourdieu, Pierre 16, 72
Boyer, Christine 102
Boyne, Roy 8
Bradley, Kim 92, 93, 94, 95
Brea, José Luis 87

Brooksbank Jones, Anny 108
Buck-Morss, Susan 5, 7, 8, 15–16,
 35, 96, 185–6
Buenos Aires 49–50

Calatrava, Santiago 92
Calvo Serraller, Francisco 156, 158,
 159
Calvo-Sotelo, Leopoldo 170
Cámara, Ery 45
Campbell, Frederico 68
capitalism, global capitalism 28–9,
 33
Cárdenas, Lázaro 22, 51
Carrillo, Santiago 164
Carlos, Don 148
Carmen (Bizet) 132–3
Caro Baroja, Julio 146, 147
Carr, Raymond 148
Carreras, Chacho 130
Carrero Blanco, Luis 119
Carroll, Lewis 50
Cartier-Bresson, Henri 19–21, 27, 39
Casablanc, Pedro 135
Casasola, Agustín Victor 19, 21, 22
Casasola, Gustavo 21
Castellanos, Alejandro 21, 29, 38,
 50–2
Castells, Manuel 5, 29–34
Catholicism 68, 69, 149, 165
Cava Mesa, María Jesús 147, 150,
 176
Cavero, Iñigo 170
CELAM 185, 186
Celaya, Adrián 150
Celorio, Gonzalo 47
Chant, Sylvia 33
Chartres 100
Che Guevara 65
Chiapas 41
Chillida, Eduardo 97
Cierva, Ricardo de la 164
Clarke, Graham 18
Coca-Cola 54, 55
Cold War 51, 163

Collins, Roger 147
Colmenero, José 130
Colombia, Cali street children 25–6, 32
colonialism 4
communism 119
Conde, Mario 118
constructionism 3
consumer culture 9
cosmopolitanism 27–8, 29, 34, 154
Craske, Nikki 33
critical theory 15
Crozier, Brian 157
Cuevas, José Luis 40
cultural studies 9–10

Debord, Guy 185–6
Debroise, Olivier 18, 19, 21, 24, 25, 44, 45, 46, 53
Deleuze, Gilles 50
Desfor Edles, Laura 150
deterritorialization 97, 98, 99, 102–3
Díaz, Alberto 65
Díaz, Porfirio 19, 39
Díaz Ordaz, Gustavo 66
Díaz Ordaz family 64, 71
digital technology 16
dislocations 6
Disneyland 103
drug trafficking 69

Eagleton, Terry 179
economy 90
Eisenstein, Sergei 27, 39
Elejalde, Karra 130
Elgar, Frank 161–2
Elkins, James 7
Elorza, Antonio 88, 121
end of art 6
Escher, Maurits 102
ETA
 casualties 165–6
 filmic representation 117, 121–3, 128–38
 Francoist period 119, 121

'Guernica' and 174
 kidnap of militants 118
 negativity 115, 178
 politics 90–2, 166
 post-Francoist period 121–2
 terrorism 184
Etchart, Julio, 'Street circus at traffic lights, Mexico City' 16–22, 17, 25–31, 33–4, 186
ethnography 63–4, 67, 74–5
Evans, Jessica 16, 100, 101
expert knowledge 8

Feldman, Allen 167
Fernández, Claudia 6, 45
Fernández, Mauricio 64
Fernando el Católico 147
FILESA affair 118
film
 globalization 120
 representation of terrorism 116–41
Fisch, Eberhard 161, 162
Fontcuberta, Joan 16
Foster, Hal 5, 6, 7, 8, 27, 50
Foster, Norman 92
Foucault, Michel 177–8
Franco, Francisco Bahamonde 85, 86, 88, 90, 91, 119, 146, 149, 158, 162, 164, 165, 172, 176
Frankfurt School 15
Freud, Sigmund 127
Fusi, Juan Pablo 122, 155, 166

Gabriel, Ruth 117
GAL case 118, 122
Gallo, Rubén 47, 70–2
Garaikoetxea, Carlos 168
Garay, Juan de 109
García, Hector 21, 22
García Canclini, Nestor 4, 5, 8, 15, 29, 34, 38, 45, 50–3, 55–7, 72, 99, 104, 184, 186
García de Cortázar, Fernando 147
García Machuca, M. 63, 66

García Ponce, Juan 40
Garzón, Baltazar 118
Gasparini, Paolo 52–4, *56–7*
Geertz, Clifford 149, 150
Gehry, Frank 8, 98, 100, 103, 105,
 106, 108, 109, 173
Gerszo, Gunther 6
Gernika *see* Guernica
Ghirardi, Diane 104
Giddens, Anthony 1, 2, 145
Giménez, Carmen 92–3, 94
Gimferrer, Pere 123
Girard, René 140
Glasgow 18
Glassford, Thomas 45
globalization
 alien invasion 29
 anti-globalization movement
 34
 art market 99, 104
 cinema 120
 cultural homogeneity 5
 deterritorialization 98, 99
 economic drive 15
 global visual culture 98
 information society 30–1
 material consequences 4–5
 nation states and 57
 national values and 69
 origins 4
 risks 3–4
 visual complicity 5–6
Goethe, J.W. von 50
Gómez, Carmelo 117, 125
González, Felipe 118, 164
Graflex camera 20
Green, Duncan 25, 33
Grosz, Elisabeth 127
Gruner, Silvia 6, 45
Grupo Andalucista 167
Grupos, Los 40
Guadelupe, Virgin of 41, 68
Guattari, Félix 50
Gucci 184, 185, 186
Güemes, César 62

Guernica
 bid for Picasso mural 167
 bombardment report 145
 Casa de Juntas 145, 146, 148, 152
 casualties 146
 contemporary significance 175–9
 oak tree 145, 146–54, *151, 152,*
 158, 163, 170, 172, 173, 178
'Guernica' (Picasso)
 after-life of painting 162–79
 creation 155–6
 fundraising object 162
 location issue 164–75
 MoMA period 162–3
 reception 156–62
 symbol 159–60, 162–79
Guerra, Alfonso 118
Guggenheim family 40
Guggenheim Foundation 93,
 109–10, 179
Guggenheim Museum, Berlin 109
Guggenheim Museum, Bilbao
 architecture 99–105, *101, 106*
 Basque culture and 98–100, 102,
 110–11
 construction 86, 90
 critics 96
 cultural politics 92
 deterritorialization 97, 98, 99,
 102–3
 displays 107
 funding 94–5
 'Guernica' bid 173–4
 Guggenheim strategy 93–5
 interior 105–7
 neo-liberal discourse 98
 opening 91
 psychoanalystic optic 115
 purpose 88
 retail outlet 104, 185
 success 108–9, 185
 symbolic building 8, 98
Guipúzcoa 147
Guisasola, Marisol 90, 99
Gutiérrez Carbajo, Francisco 123

Hall, Stuart 100, 101
Hamnett, Brian 24
Hardt, Michael 57
Hayek, Salma 4
Herrera, Hayden 39
Herri Batasuna 91, 98
Herzog, Roman 176
Hilton, Timothy 159, 160, 161
HIV/AIDS 184, 186
Holmes, Oliver Wendell 28
Hopenhayn, Martin 8
Hopkinson, Amanda 20

Ibárruri, Dolores 170
imaginaries, meaning 9
IMF 41
information technology 30–1
interdisciplinary visual studies 7
Iparaguirre, José María 153
IRA 91
Iturbe, Txomin 121
Iturbide, Graciela 64

Jameson, Fredric 103, 105
Japan 94
Jáuregui, Gurutz 91
Jay, Martin 6, 7, 8, 101
Jencks, Charles 98, 99, 103, 105,
 106, 109–10
Jenks, Chris 101
Jodidio, Philippe 100, 106, 109
Juan Carlos, Prince 164

Kahlo, Frida 39
Kahnweiler, D.H. 161
Kamenov, Vladimir 157–8
Kay, Ronald 116, 133
Kimmelman, Michael 109, 110
Kirkpatrick, Gwen 7
Kismaric, Susan 20, 21
Kolbowski, Silvia 7
Koon, Jeff 108
Kooning, Willem de 105
Kortázar, Jon 99, 103, 105
Kraniauskas, John 24, 50

Krauss, Rosalind 5, 6, 7, 8, 27, 50
Krens, Thomas 92, 93–4, 96–8, 102,
 104, 109, 110
Kretzmer, Herbert 176
Kunard, Andrea 16, 20
Kurtycz, Marcos 45

Labanyi, Jo 179
Lacan, Jacques 116, 127
Lang, Fritz 102
Larramendi, Fr Manuel 147
Las Vegas 109
Lash, Scott 103
Latin America
 cosmopolitanism 27–8
 hybridity 45
 Latin American Episcopal Council
 184–5, 186
 meaning of globalization 4
 social movements 32
Leal, Fernando 20
Lechner, Norbert 29
Leica camera 20
Levi Strauss, David 104
Live8 5
Llopis, Francesca 6
Loaeza, Guadalupe 68–9, 70, 74
Loaeza, Soledad 49
London 29
London bombings 1, 9
López, Nacho 21, 51–2, 53–4, 56,
 57, 74
 'Cuidacoches' 22, 23, 28
 'Trolebús' 54, 55
López Baltran, Carlos 63, 64, 66, 70
López Cuenca, Alberto 40, 43–4
Los Angeles 52
Lubbock, Tom 173
Lucca, Italy 45
Lupton, Deborah 2
Lury, Celia 75, 106

Maar, Dora 155, 170
McDonald's 54
Maddox, Richard 27

Madrid
 bombings 1, 9, 110
 cultural funding 94
 cultural life 118
 drug addicts 123
 filmic representation 133
 'Guernica' location 164, 168–75
 Mexican art exhibitions 45
Madrid, Juan 123, 125, 133
Málaga 167
Manchado, Trinidad 86, 88
MARCO 43
Margolles, Teresa 6
Martín-Barbero, Jesus 6, 72, 101, 111
Matthews Gedo, Mary 160
Mauriac, François 175
Maya culture 75
Mayo, Hermanos 21
Medina, Cuauhtémoc 42, 44, 45, 46,
 48, 58, 73–4
megacities 28–9, 32, 56
Menard, Pierre 116
Mérimée, Prosper 133
Merleau-Ponty, Maurice 50
Merz, Mario 102
Mesoamerican art 74
MexArtes 44
Mexico 8
 corruption 24
 cultural tourism 5
 economy 24
 elections 10
 ethnography 63–4, 71, 74–5
 exoticism 39, 52, 58
 financial crisis 24, 41, 43
 Foro Internacional de Teoría sobre
 Arte 43
 globalization agenda 41–2
 HIV/AIDS 184–5
 idealization of past 39
 indigenous people 75, 77–8
 Jumex collection 43, 93
 modernity 22–4, 57–8
 Museo de Arte Contemporáneo de
 Monterrey (MARCO) 43

'neo-mexicanismo' 41–2, 62
PAN 64, 65
photographic history 19–25, 68–9
post-revolutionary art 22, 38–49
PRI 24, 41, 43, 63, 64–5
scandalous photography album
 62–78
Temístocles group 42, 62
travel photography 27–9
violent repression 40
Mexico City 8
 black economy 33
 early photography 19–21
 earthquake 24, 49
 exhibitions 44
 experience of living in 38, 47–58
 global imaginary 29–34
 modernity 46–8
 photography 18, 38, 49–58, 186
 'pueblo' 49–50, 51–2, 54
 street children 25
Meyer, Lorenzo 65–7, 70, 74
Meyer, Pedro 24, 25
millenarianism 140
Miró, Juan 6
Miró, Pilar 120, 121
Mirzoeff, Nicolas 5–6, 7, 101
MNCARS 86, 87, 88, 92, 94, 170–3
Modigliani, Sergio 105
Modotti, Tina 20, 39
Monsiváis, Carlos 24, 25, 34, 38,
 47–8, 49, 50, 51, 53, 54, 57
Montale, Eugenio 50
Montes, Silvia 45
Moore, Charles 102–3
Morales, Alfonso 23–4, 38, 47
Moreiras, Alberto 4, 5, 7, 34, 53, 57,
 186
Moxey, Keith 8
Mraz, John 21, 27, 52
muralism 19–20, 39, 68
Muschamp, Herbert 109
museums, role and purpose 86–8,
 97
Musil, Robert 50

Nabokov, Vladimir 50
NAFTA 15, 41
Nahua culture 75
narcissism 103
Navarre 148
Nègre, Charles 18
Negri, Antonio 57
neo-liberalism 41, 43
New York
 cultural hegemony 97
 global city 29
 Greene Naftali Gallery 62
 Guggenheim Museum 93
 Musem of Modern Art (MoMA)
 162–3
 photography 18
 Picasso retrospective 162
 P.S.1 Contemporary Art Centre
 44, 62
 SoHo Guggenheim 104, 109
Nieztsche, Friedrich 149

Oaxaca 43
October 77 5
Oles, James 44
Olivares, Rosa 45, 47
Onaindia, Mario 148, 153, 154
oral history 176
orientalism 75–6
Orozco, José Clemente 39
Ortiz, Renato 99
Ortzi 147
Osborne, Peter 27, 28–9, 32
Otazu, Alfonso de 93, 94, 95
Oteiza, Jorge 89, 96, 97, 104

Palacios, Dolores 92
Palafox, Jordi 122, 166
Paris 18, 44, 155
past narratives 9, 10, 39, 154, 174–5
Payán, Miguel Juan 119–20, 122
Paza de Biumo, Giuseppe 93
Pelli, Cesar 92
Peña, Candela 124
Penrose, Roland 161

Pérez Embid, Florentino 164
photography
 Buck-Morss 15–16
 early photography 18–19
 fine art 16
 Mexican history 19–25, 68–9
 Mexico City 18, 38, 49–58, 186
 protest 24
 scandalous Mexican album 62–78
 surveillance 18
 travel photography 27–9
photojournalism 21, 22
Picasso, Jacqueline 167
Picasso, Pablo
 cult 163
 death 167
 family 167, 170
 'Guernica' 8, 146, 155–62
 locating 'Guernica' 165, 167
Pinilla, David 130
Platonism 100
Poland 45
Portanova family 76–7
Poster, Mark 7
postmodernism 5–6, 132
Power, Kevin 42
pre-Columbian culture 39, 74
Preston, Paul 88, 166
Price, Mary 18, 20
psychoanalytic approaches 115–16

Read, Herbert 157
Reguillo-Cruz, Rossana 68
Reportage Visuals 27
Resina, Joan Ramón 32, 34–5, 179
reterritorialization 16
Reuben Holo, Selma 86–9, 92, 93,
 96, 110
Riego, Bernardo 15
Riis, Jacob 18
risk
 cultural figuring 3, 115–16, 145
 Días contados 139
 globalization 3–4
 megacities 16

risk (*cont.*)
 risk society 1–3
Rivera, Diego 19, 39
Rockefeller, Nelson 40
Rodríguez Larrauri, Mercedes 96
Roldán, Luis 118
Roldán Larreta, Carlos 121
Ros, Xon de 106, 108
Rosas Mantecón, Ana 29, 38, 50–3,
 55
Rose, Jacqueline 125
Rossell, Daniela, *Ricas y famosas* 42,
 62–78, 185
 'Harem' 76
Rubio, Mariano 118
Rubio Cabeza, Manuel 148, 175
Ruptura group 40
Ryan, James 18

Salazar Cruz, Clara Eugenia 33
Salazar Cruz, Luis 64, 65, 71
Salinas, Raúl 66
Salinas de Gortari, Carlos 43, 66
Saltz, Jerry 104, 109
Salzburg 94
San Sebastian Film Festival 120
Sánchez, E. 63, 66
Sánchez, Marga 117
Sánchez, Oswaldo 45
Sanchis, Raquel 134
Santamarina, Guillermo 41
São Paulo 52
Sarlo, Beatriz 8, 38, 49–50, 53,
 103–4
Saura, Antonio 171
Save the Children 27
Schmelz, Itala 44
Scott-Witts, Max 176
Segre, Erica 51, 53, 54
Semprún, Jorge 92, 94
Seville 44, 86, 94
Siqueiros, David 39
Skidmore, Thomas 39
Sloane, Patricia 40
Smith, Melanie 42, 45

Smith, Peter H. 39
Solana, Javier 92, 93
Solomon, Deborah 94, 109
Sontag, Susan 61n.22
Soriano, Federico 92
Sorkin, Michael 105
Southworth, Herbert 146, 155, 157,
 164
Spain
 1950s modernization 164
 anti-terrorist strategy 122
 Carlist Wars 148
 Civil War 146, 149
 Constitution 184
 corruption 118
 democracy 163, 165, 168
 film subsidies 120
 locating 'Guernica' 167–9
 MNCARS 86, 87, 88, 92, 94,
 170–3
 museums 86–8
 Partido Popular 85, 86, 91
 pathological amnesia 166–7
 post-Franco culture 85–7, 118,
 121
 postmodernism 132
 Prado 172
 PSOE 85, 86, 87, 92, 118, 123
 regional collections 88
 regionalism 86
 see also Basque Country
Steele, James 98
Steer, George Lowther 146
Stone, Rob 121
Strand, Paul 39, 52
street children 25, 25–7, 32, 33–4
Suárez, Adolfo 164
Surrealism 22, 39
surveillance 18
Suter, Gerardo 45
Szeeman, Harald 44

Talón, Vicente 164, 176
Tamayo, Rufino 43
Tapiès, Antoni 171

Tejero, Antonio 165, 166
Tello, Carlos 25, 66
Temístocles group 42, 62
Tenochtitlán 47
terrorism
 ETA 178, 184
 filmic representation 117–41
 Madrid and London 1, 9, 110
 Spain 122
Thomas, Gordon 176
Thyssen-Bornemisza, Hans Heinrich 87
Tibol, Raquel 24
Tipton, Gemma 105
Tokyo 29
Toledo, Francisco 43, 97
Torres, Augusto 123
Tovar y de Teresa, Guillermo 64
travel photography 27–9
Tuckman, Jo 68
Tusell, Javier 167, 169, 171

Ucelay, José Maria 158
Umbral, Francisco 119
United States
 Cold War 163
 cultural funding 93
 globalization and Americanization 4
 Mexican artists 45
 Mexican policies 40
 releasing 'Guernica' 165
 war on terror 92
 see also New York
urban environments
 Cartier-Bresson 20
 disorder 8
 early photography 18
 fragmented perceptions 29
 global cities 28–9, 32, 56
 rural dislocations 21
 urban-rural split 51
Uribe, Imanol
 Días contados 116–41, 138, 140, 178, 179, 185

El proceso de Burgos 121
La muerte de Mikel 121
Uruguay 27
Urza, Carmelo 178

Valencia 86, 88
Van Bruggen, Coosje 102
Van Hensbergen, Gijs 156, 157, 158, 161, 163, 164, 170, 172
Vargas Lugo, Pablo 42
Vasconcelos, José 39
Vattimo, Gianni 100, 103
Venice 94
Ventura, Miguel 45
Verdú, Vicente 184
Vidal, César 148, 169
Vidarte, Juan Ignacio 173
Villoro, Juan 65, 66, 67, 68, 74
visual culture
 art history and 186
 global visual culture 98
 meaning 7
 modernity and 101
Vives, Carlos 4
Vizcaya 147
voyeurism 186

War on Want 27
Warhol, Andy 107, 108
Wells, Liz 16
Weston, Edward 27, 39
Williams, Raymond 111
Woodsworth, Paddy 91
World Bank 41

Zapata, Emiliano 41, 65, 68
Zapatero, José Luis 184
Zapatistas 41, 49, 57
Zervos, Christian 157, 159
Žižek, Slavoj 116–17, 129, 141
Zugazagoïtia, Julián 40, 41
Zulaika, Joseba 89, 90, 92, 93, 94, 95, 96, 98, 104, 110, 154, 178, 179

Lightning Source UK Ltd.
Milton Keynes UK
02 April 2011

170242UK00001B/57/P